FLICKR HACKS™

Other resources from O'Reilly

FLICKR HACKS™

Paul Bausch and Jim Bumgardner

O'REILLY®

Beijing · Cambridge · Farnham · Köln · Paris · Sebastopol · Taipei · Tokyo

Flickr Hacks™

by Paul Bausch and Jim Bumgardner

Copyright © 2006 O'Reilly Media, Inc. All rights reserved.
Printed in the United States of America.

Published by O'Reilly Media, Inc., 1005 Gravenstein Highway North, Sebastopol, CA 95472.

O'Reilly books may be purchased for educational, business, or sales promotional use. Online editions are also available for most titles (*safari.oreilly.com*). For more information, contact our corporate/institutional sales department: (800) 998-9938 or *corporate@oreilly.com*.

Editor: Brian Sawyer	**Indexer:** Ellen Troutman Zaig
Production Editor: Darren Kelly	**Cover Designer:** Michael Kohnke
Copyeditor: Rachel Wheeler	**Interior Designer:** David Futato
Proofreader: Sada Preisch	**Illustrators:** Robert Romano, Jessamyn Read, and Lesley Borash

Printing History:

February 2006: First Edition.

 This book uses RepKover™, a durable and flexible lay-flat binding.

ISBN: 0-596-10245-3
[M]

Contents

Foreword

When I was in college, I wrote a paper about a poem, "The Changing Light at Sandover," which was about a couple that spent years talking to spirits on a Ouija board, communing with the spirits of poets, emperors, and friends. I'd never tried a Ouija board before, but I drew one on a piece of paper and used an overturned teacup to try it out with my friends. And amazing things happened as a result: we recorded conversations with dead army generals from Prussia who'd climbed Kilimanjaro, and conjured a mysterious spirit who spoke only in riddles: "YR KINGS R JESTRS" she'd write, leaving the meanings to us. It was heady and addictive. Hours would go by, story after story would be told, and eventually the candle, set up for atmosphere, would gutter out, or we had to stop and eat, or go pee, or write another paper, or something.

I wasn't (and I don't think my friends were) under the illusion the we were actually talking to spirits, but I believed that something much more interesting was happening: my subconscious and the subconscious of my various friends were working together to tell a story, a story we couldn't have made up on our own, but which we were both contributing to. If you've ever been in a band, or played a sport, or danced, or done anything with other people (even started a company!), you know what I'm talking about. You make up a riff, and then the bass player picks up the riff, and then the drummer makes a variation on the riff, reversing it, and you jam on the riff all together and make sweet, sweet music together. Hours go by, you are lost in the flow, or the zone, or the jam, or whatever you want to call it. You know when this is happening with your basketball team or hockey team, when you're reaching a sublime level of banter at the dinner table, even when your flirting strategy is really hitting the mark. Your subconscious is working together with everyone else's, time vanishes, peace prevails on earth, and everyone is dissolved together in the great omnipotent Is.

I would like to point out that I am not a hippie.

Sometime in 1999, I became aware of a blog called Sylloge, published by a brilliant, funny, and cranky philosopher/hacker in Vancouver named Stewart Butterfield. I read it for about a year before meeting its author at a geek party in a basement in San Francisco decorated with pillows printed with the streets in Monopoly. I ended up moving to Vancouver and marrying him, and a week after we got back from our honeymoon we started a company called Ludicorp, to build a MMORPG, which, to the uninitiated, is an ugly acronym for "Massively Multiplayer Online Role-Playing Game."

The game was called Game Neverending, and it was, frankly, awesome. It had a map you could wander around in, and you could find things, which you could put together with other things, some of which were silly, some of which were dangerous, and some of which were the inside jokes of people like ourselves. You could, for example, find a Web, a Venture Capital, and a Hype and put them together to form a New Economy. Then you could go into a crowded room and deploy your New Economy, and everyone around you would go broke, while you got very rich. There were things like Wombat Whistles, and if you blew them, a bunch of baby wombats would come and cuddle up against you and anyone else was nearby. There was a dancing Condoleeza Rice action figure, and other absurd and fun things. And you could make and share your own objects in the game.

The most important thing about it was that it was primarily a social game. You could wander around and meet up with people in various locations. You could form a social network (this was the heyday of Friendster and its various imitators), form groups like guilds or town councils, and everyone spent most of their time hanging out and instant messaging with fellow game players, organizing parties, and interacting. The sad thing was that back-end development had gotten six months behind front-end development. Also, the company was broke. Raising money for our eccentric game wasn't easy and the game had already taken much longer than we had thought it would. So, up all night sick in a hotel in New York, Stewart had an idea: why don't we change the objects to photos and create a photo-sharing site? We cranked it out in seven weeks over Christmas and presented it at the O'Reilly Emerging Tech conference in February 2004. It was built on the game's instant messaging client, and you could drag and drop photos into conversations. That was it. Was it awesome? Maybe.

Here's the thing about hackers, which you already know if you're reading this book: a real hacker just keeps hacking. Our team, which included such notable hackers as Cal Henderson, Eric Costello, Serguei Mourachov, and George Oates (who is a she!), just kept on hacking. In June, we even made it

possible to *see your photos on web pages* (gosh!), and soon after that added tagging, annotations on images, slideshows, RSS, send-by-email—you name it. In August, we opened up the API that readers of this book will come to know very well. Eric Costello Ajaxed the hell out of everything. So it was eventually awesome, even if it wasn't awesome at first.

But to me, the thing that really makes Flickr Flickr is that the users invent what Flickr is. Groups, we thought, would be used for weddings, high school reunions, nature photography, stuff like that. But Flickr users were smarter and more creative than we were. They started groups like *Squared Circle*, started by longtime user Striatic, where people crop a photograph of something circular (an orange, a traffic light, an airplane hull) to a square shape, creating a beautiful slideshow. Or *What's In Your Bag?*, in which contributors dump out their bags and annotate everything in them. Or *Sad Bikes*, which consists of photos of abandoned, pillaged, or otherwise miserable-looking bikes.

In short, our users started creating Flickr *with* us, in real time. We'd have an idea, push something out, and see what happened. Wash, rinse, repeat. A rhythm formed and the "product development process" became a call-and-response; Flickr collaboratively hacked its way into existence. Each feature would give us and our users another item to use in our improvisational repertoire. Many of the myriad ways tags were employed by users (see Chapter 2) weren't anticipated by us, and the tricks people came up with for viewing (Chapter 3) and managing (Chapter 5) their photos similarly evolved beyond the foundation we set.

And at the same time, the more technically savvy users didn't just play with the site through the *user* interface, but through a *programmatic* interface (an API, discussed in Chapter 6). Instead of sending stuff to Flickr by pressing buttons, clicking links, and typing text in web pages that had rendered in their web browsers and getting back more web pages, people developing on the API sent stuff in with programs they wrote and got back machine-understandable XML descriptions of the results.

That sounds fancy, but it boils down to this: like us, outside developers could build new features and give Flickr new capabilities. In fact, we used the same API as the outside developers, meaning that they had all the same capabilities we had. We hoped that people would build things that we didn't have the time or resources to build—like an uploader for Linux or plug-ins for desktop photo management software and blogging services—and they did. But we also hoped that they would build things that we hadn't thought of—and they definitely did that too.

I still remember the excitement around the office when someone would shout out a new find and we'd all gather around their monitor to check it out: Jim Bumgardner's Color Pickr **[Hack #45]**, Stamen Design's Mappr, Dan Catt's geotagging Flickr photos **[Hack #12]** on Geobloggers.com, or John Watson's stupefying collection of hacks **[Hack #46]** at FD's Flickr Toys.

This book captures a lot of that magic and excitement and is a great resource for those who want to get the most out of Flickr, either as a "normal" user or a programmer. Whether you're looking at Flickr in your browser window or writing code that looks at Flickr's code, whether you want to create a new group or a new way of using tags, or you want to make a version of Flickr available for some funky piece of equipment in your home theater, this is the best way to get started.

Flickr has become a central nervous system in which the subconsciousnesses (is that a word?) of millions of people have merged to tell stories together, to hold hands and sing Kumbaya around the Flickring fire. (I apologize for that terrible pun, but you'll notice I didn't hit the Delete key).

A photo called "Group Hug" was one of the very first photos shared in Flickr, back when it was just an IM client for sharing photos, little smooshy marzipan figures all hugging one another, so why not have a group hug now? I would like to include in this group hug everyone on the Flickr team, past and present, which includes Jason Classon, Cal Henderson, George Oates, Eric Costello, Serguei Mourachov, Heather Champ, Corey Fake, Aaron Straup Cope, John Allspaw, Paul Lloyd, Ana Zavala, Dathan Pattishall, and Dos Pesos.

Also hugged are Bradley Horowitz, Eckart Walther, Jeff Weiner, and other Yahoos too numerous to enumerate; Paul Bausch and Jim Bumgardner, who wrote this fantastic book of fantastic hacks that will make you smarter, healthier, and get you more dates; all the developers developing stuff off the API; and everyone who ever contributed a photo or added a comment to Flickr—in short, the Flickr community. We love you, in an entirely non-creepy way.

—Caterina Fake
Cofounder, Flickr

Credits

About the Authors

Paul Bausch is an independent web developer living in Corvallis, Oregon. When he's not hacking together web applications, he's writing about hacking together web applications. He put together *Amazon Hacks* for O'Reilly in 2003 and *Yahoo! Hacks* in 2005. Paul also helped create the popular weblog application Blogger (*http://www.blogger.com*), cowrote a book about weblogs called *We Blog: Publishing Online with Weblogs* (John Wiley & Sons), and maintains a directory of Oregon weblogs called ORblogs (*http://www.orblogs.com*). When he's not working on a book, Paul posts thoughts and photos to his personal weblog, onfocus (*http://www.onfocus.com*).

Jim Bumgardner has been making innovative and entertaining software in Los Angeles since the 1980s, including The Palace avatar chat system. He is the founder of the Flickr Hacks group (*http://www.flickr.com/groups/flickrhacks/*) and the creator of the Flickr Colr Pickr, Hipbot, and other Flickr-powered applications. Jim works in the Interactive TV industry and teaches kids how to make video games at Art Center in Pasadena. His personal web site, KrazyDad (*http://www.krazydad.com*), is a showcase for Jim's software experiments and an abundant source of "wonder and delight."

About the Contributor

John Watson contributed code, inspiration, and technical feedback for this book. John has been a professional software engineer for 11 years, has been interested in photography for about 20 years, and has been hopelessly addicted to Flickr (where he is known as *fd*) for the past 18 months. John is married and living happily in southern California with his wife and two young children (who also happen to be his favorite subjects). He is best

known on Flickr for his free Flickr Toys, available at *http://www. flagrantdisregard.com/flickr/*.

Acknowledgments

Thanks first and foremost to Stewart, Caterina, and the entire Flickr crew for building a fantastic playground.

Paul

To my wife Shawnde, thanks for the constant feedback and for taking the time to read yet another draft at 10 o'clock at night. Thanks to my accomplices Jim and Brian for inspiring me to play with Flickr, and thanks to Morbus Iff for straightening out my Perl, again. And thanks to John Watson for combing through the details and offering great advice.

Jim

To my wife Janet, my daughter Jenna, and my son Jason: thanks for your patience and understanding. Thanks to my coauthor, Paul, for inspiration, and editor, Brian, for putting up with my newbie shenanigans. Thanks to Flickr's Cal Henderson and Eric Costello for the inside scoop, and big thanks to the talented and prolific Ty Siscoe (a.k.a. Fubuki), for your photos. A final shout out to the entire Squared Circle group and the entire Flickr Hacks group!

Preface

In February 2004, a tiny startup in Vancouver called Ludicorp launched a web site for sharing photos called Flickr. Using some of the tools they'd built for their primary product (a web game called Game Neverending), Ludicorp quickly changed the way millions of people share photos. Just one year and one month after its launch, web giant Yahoo! purchased Flickr— with rumors putting the price tag at somewhere around $30 million. Yahoo! is now working diligently to "Flickrize" all of its features by adapting the innovations that Flickr brought to photo sharing to Yahoo!'s existing features for searching, shopping, and travel planning.

So, what exactly did Flickr accomplish that attracted millions of users and has an established web company changing the way it does business? The answer isn't an easy one, but studying how Flickr has taken the world by storm can give us some indication of where the Web is headed.

One innovation that Flickr pioneered is the act of *tagging* digital content. Instead of imposing a category system, Flickr lets individual photographers do the hard work of classifying photos. For example, a photo of a car can be tagged with words such as *car* or *automobile*, or with more specific descriptive terms such as *Honda*, *convertible*, or *shiny*. Then, others interested in pictures of cars, convertibles, or shiny things can browse those tags to find photos that might interest them. Tagging is a clever way to loosely connect photos without a structured categorization system.

In addition to tagging, Flickr allows members to create ad hoc groups to share photos of specific subjects. A famous frivolous example is the Flickr Squared Circle group (*http://www.flickr.com/groups/circle/*), which formed to share photos of circular objects cropped to squares. Anyone can participate, and the group has built a library of over 22,000 squared circle photographs at the time of this writing.

In addition to collaborating with strangers on Flickr, you can add friends and family to your Flickr contacts list to easily keep track of new photos posted by people you know. It's a simple but powerful way to share experiences with people you care about.

Another innovation that sets Flickr apart from other photo-sharing services is its open API. Flickr's open architecture allows outside developers to code features for Flickr and show Flickr photos on other web sites and inside other applications. One striking example of the API in action is Jim Bumgardner's visualization of over 1,000 images in the Flickr Squared Circle pool, shown in Figure P-1.

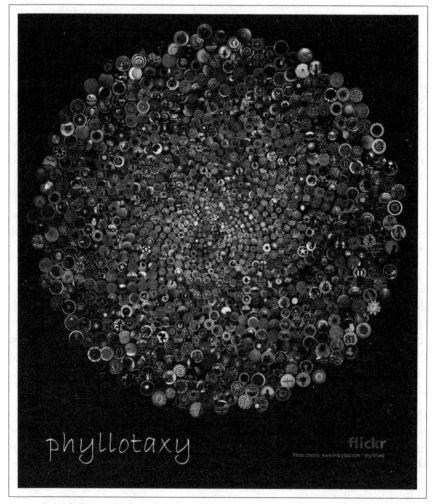

Figure P-1. Flickr Squared Circle poster

The individual photographers contributing to the Squared Circle group had no idea their photos would end up in a colorful montage, but Flickr's API made the visualization possible. Many sites and applications have already integrated with Flickr thanks to the API, and you'll see many examples of how people are using the API in this book.

The power of sharing photos instantly via the Web hit mainstream consciousness soon after bombs ripped through London's subway on July 7, 2005. As television news networks scrambled to get images of the bombing on TV, pictures were already appearing on Flickr, thanks to people with cell phone cameras at the scene. The photo by Adam Stacey shown in Figure P-2 became an early icon of the attacks, and you can still view this photo on Flickr (*http://www.flickr.com/photos/qwghlm/24230239/in/pool-bomb/*) and read the comments posted.

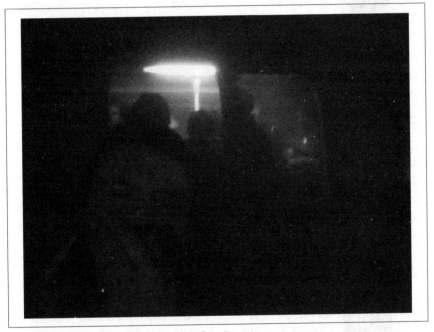

Figure P-2. London bombing photo by Adam Stacey

During a horrific incident, when people were desperate for any information they could glean about the situation, Flickr provided a way to share images from the event instantly, while it was happening. In addition, Flickr provided a space where people could discuss the event and form groups to share bombing photos, and Flickr's tagging features allowed others to find bombing-related photos quickly.

While most of the photo sharing that happens on a daily basis at Flickr isn't nearly as serious as the photos shared on July 7, 2005, the London bombings let the world know that the features Flickr provides make it more important than a simple web toy.

Why Flickr Hacks?

The term *hacking* has a bad reputation in the press. They use it to refer to someone who breaks into systems or wreaks havoc with computers as his weapon. Among people who write code, though, the term *hack* refers to a "quick-and-dirty" solution to a problem, or a clever way to get something done. And the term *hacker* is taken very much as a compliment, referring to someone as being *creative*, having the technical chops to get things done. The Hacks series is an attempt to reclaim the word, document the good ways people are hacking, and pass the hacker ethic of creative participation on to the uninitiated. Seeing how others approach systems and problems is often the quickest way to learn about a new technology.

This book aims to help you gain a deeper appreciation and understanding of the creativity Flickr has made possible by showing you some of the many ways people are using and extending Flickr on their own. By understanding Flickr, you'll have a better sense of where the Web is headed, and how you can participate.

How to Use This Book

You can read this book from cover to cover if you like, but each hack stands on its own, so feel free to browse and jump to the different sections that interest you most. If there's a prerequisite you need to know about, a cross-reference will guide you to the right hack.

How to Run the Hacks

The programmatic hacks in this book run either on the command line (that's Terminal for Mac OS X folks, or the DOS command window for Windows users) or as CGI scripts or PHP scripts—dynamic pages living on your web site, accessed through your web browser.

Command-Line Scripts

Running a hack on the command line invariably involves the following steps:

1. Type the program into a garden-variety text editor: Notepad on Windows, TextEdit on Mac OS X, *vi* or *Emacs* on Unix/Linux, or anything

else of the sort. Save the file as directed—usually as *scriptname.pl* (the *.pl* bit stands for Perl, the predominant programming language used in *Flickr Hacks*).

Alternately, you can download the code for all of the hacks online at *http://www.oreilly.com/catalog/flickrhks/*, where you'll find a ZIP archive filled with individual scripts already saved as text files.

2. Get to the command line on your computer or remote server. In Mac OS X, launch Terminal (Applications → Utilities → Terminal). In Windows, click the Start button, select Run, type command, and hit the Enter/Return key on your keyboard. In Unix... well, we'll just assume you know how to get to the command line.

3. Navigate to where you saved the script at hand. This varies from operating system to operating system, but it usually involves a command like cd ~/Desktop (that's your Desktop on the Mac).

4. Invoke the script by running the programming language's interpreter (e.g., Perl) and feeding it the script (e.g., *scriptname.pl*), like so:

```
perl scriptname.pl
```

Most often, you'll also need to pass along some parameters—your search query, the number of results you'd like, and so forth. Simply drop them in after the script name, enclosing them in quotes if they're more than one word or if they include an odd character or three:

```
perl scriptname.pl '"much ado about nothing" script' 10
```

The results of your script are almost always sent straight back to the command-line window in which you're working, like so:

```
> perl scriptname.pl '"much ado about nothing" script' 10
1. "Amazon.com: Books: Much Ado About Nothing: Screenplay ..." [http://
www.amazon.com/exec/obidos/tg/detail/-/0393311112?v=glance]
2. "Much Ado About Nothing Script" [http://www.signal42.com/much_ado_
about_nothing_script.asp]
...
```

 The ellipsis (...) bit signifies that we've cut off the output for brevity's sake.

To stop output scrolling off your screen faster than you can read it, on most systems you can *pipe* (read: redirect) the output to a little program called *more*:

```
perl scriptname.pl | more
```

Hit the Enter/Return key on your keyboard to scroll through line by line, or use the spacebar to leap through page by page.

You'll also sometimes want to direct output to a file for safekeeping, importing into your spreadsheet application, or displaying on your web site. This is as easy as:

```
perl scriptname.pl > output_filename.txt
```

And to pour some input into your script from a file, simply do the opposite:

```
perl scriptname.pl < input_filename.txt
```

Don't worry if you can't remember all of this; each relevant hack has a "Running the Hack" section that shows you just how it's done.

CGI Scripts

CGI scripts—programs that run on your web site and produce pages dynamically—are a little more complicated if you're not used to them. While fundamentally they're the same sorts of scripts as those run on the command line, they are more troublesome because setups vary so widely. Your content might be hosted on your own server, on an Internet service provider's (ISP's) server, on a corporate intranet server, or anything in between.

Since going through every possibility is beyond the scope of this (or any) book, if you need help you should check your ISP's knowledge base or call their technical support department, or ask your local system administrator.

Generally, though, the methodology is the same:

1. Type the program into a garden-variety text editor: Notepad on Windows, TextEdit on Mac OS X, *vi* or *Emacs* on Unix/Linux, or anything else of the sort. Save the file as directed—usually as *scriptname.cgi* (the *.cgi* bit reveals that you're dealing with a CGI—that's Common Gateway Interface—script).

 Alternately, you can download the code for all of the hacks online at *http://www.oreilly.com/catalog/flickrhks/*, where you'll find a ZIP archive filled with individual scripts already saved as text files.

2. Move the script over to wherever your web site lives. You should have some directory on a server somewhere in which all of your web pages (all those *.html* files) and images (files ending in *.jpg*, *.gif*, etc.) live. Within this directory, you'll probably see something called a *cgi-bin* directory: this is where CGI scripts must usually live in order to be run rather than just displayed in your web browser when you visit the pages that contain them.

3. You usually need to bless CGI scripts as executable—to be run rather than displayed. Just how you do this depends on the operating system

of your server. If you're on a Unix/Linux or Mac OS X system, this usually entails typing the following on the command line:

```
chmod 755 scriptname.cgi
```

4. Now you should be able to point your web browser at the script and have it run as expected, behaving in a manner similar to that described in the "Running the Hack" section of the hack at hand.

Just what URL you use, once again, varies wildly. It should, however, look something like this: *http://www.your_domain.com/cgi-bin/scriptname.cgi*, where *your_domain.com* is your web site domain, *cgi-bin* is the directory in which your CGI scripts live, and *scriptname.cgi* is the script itself.

If you don't have a domain and your site is hosted by an ISP, the URL is more likely to look like this: *http://www.your_isp.com/~your_username/cgi-bin/scriptname.cgi*, where *your_isp.com* is your ISP's domain, *~your_username* is your username at the ISP, *cgi-bin* is the directory in which your CGI scripts live, and *scriptname.cgi* is the script itself.

If you come up with something called an "Internal Server Error" or see the error code 500, something's gone wrong somewhere in the process. At this point you can take a crack at debugging (read: shaking the bugs out) yourself, or ask your ISP or system administrator for help. Debugging—especially CGI debugging—can be a little more than the average newbie can bear, but there is help in the form of a famous Frequently Asked Question (FAQ): "The Idiot's Guide to Solving Perl CGI Problems." Search for it and step through it as directed.

PHP Scripts

PHP scripts—programs in the PHP language that run on your web site and produce pages dynamically—are set up in a manner very similar to CGI scripts, but are generally easier to manage. Unlike CGI scripts, the files do not need to live in a special *cgi-bin/* directory, but can coexist with your HTML files. Also you usually don't have to change the file permissions.

Most of the scripts in this book require PHP Version 4, which is commonly available from most hosting providers.

For more information about PHP, check out the online manual at *http://www.php.net/manual/en/*.

Learning to Code

Fancy trying your hand at a spot of programming? O'Reilly's best-selling *Learning Perl (http://www.oreilly.com/catalog/lperl3/)*, by Randal L. Schwartz

and Tom Phoenix, provides a good start. Apply what you learn to understanding and using the hacks in this book, perhaps even taking on the "Hacking the Hack" sections to tweak and fiddle with the scripts. This is a useful way to get some programming under your belt, since it's always a little easier to learn how to program when you have a task to accomplish and existing code to leaf through.

How This Book Is Organized

The book is divided into seven chapters, organized by subject:

Chapter 1, *Sharing Photos*
> This chapter shows you how to master the basics of sharing photos on Flickr, including editing images for Flickr, managing extended information about your photos, and posting directly from your cell phone. You'll also find an overview of tools to help you upload photos more efficiently and a look at ways to use Flickr to publish photos on your own web site.

Chapter 2, *Tagging Photos*
> Flickr is famous for tagging. This chapter shows how to take advantage of tagging for organizing and publicizing your photos. You'll also see some unique ways people are using tagging to group photos by location, and you'll find some external games that use Flickr's tagging features for fun.

Chapter 3, *Viewing Photos*
> This chapter introduces you to some unexpected ways to find and view Flickr photos. You'll get an overview of the many ways Flickr uses RSS to distribute photos, a look at how you can use Flickr Mobile to stay in touch on the go, and the lowdown on how to view Flickr photos on your TV.

Chapter 4, *Community*
> Use the hacks in this chapter to learn more about your Flickr community. In addition to the basics of adding and viewing contacts, you'll find hacks that show how to view your contacts on a map and browse their non-Flickr activities. You'll also see how to find out which tags are most popular among your friends and which photos they're marking as their favorites.

Chapter 5, *Maintenance*
> In this chapter, you'll see how Flickr experts manage large collections of photos and maintain large Flickr groups. You'll find out how to back up your Flickr photos for safekeeping and how to create a contact sheet of your Flickr photos for quick reference.

Chapter 6, *API Basics*

This chapter introduces you to the Flickr API, which is a back door that Flickr provides for developers. You can use the hacks in this chapter as building blocks for your own Flickr applications. You'll see concrete examples for talking with the API, authenticating with the API, and using existing tools for rapid Flickr development.

Chapter 7, *Custom Applications*

See how people are using Flickr photos in their own applications and games, and have a bit of fun in the process. This chapter shows how to turn your photos into beautiful collages, ransom notes, motivational posters, sliding puzzles, and more.

Conventions Used in This Book

The following is a list of the typographical conventions used in this book:

Italic

Used for emphasis and new terms where they are defined, and to indicate Unix utilities, URLs, filenames, filename extensions, and directory/folder names. For example, a path in the filesystem will appear as */Developer/ Applications*.

Constant width

Used to show code examples, the contents of files, and console output, as well as the names of variables, commands, and other code excerpts.

Constant width bold

Used to highlight portions of code, either for emphasis or to indicate text that should be typed by the user.

Constant width italic

Used in code examples to show sample text to be replaced with your own values.

Gray type

Gray text is used to indicate a cross-reference within the text.

You should pay special attention to notes set apart from the text with the following icons:

This is a tip, suggestion, or general note. It contains useful supplementary information about the topic at hand.

 This is a warning or note of caution, often indicating that your money or your privacy might be at risk.

The thermometer icons, found next to each hack, indicate the relative complexity of the hack:

beginner moderate expert

Using Code Examples

This book is here to help you get your job done. In general, you may use the code in this book in your programs and documentation. You do not need to contact us for permission unless you're reproducing a significant portion of the code. For example, writing a program that uses several chunks of code from this book does not require permission. Selling or distributing a CD-ROM of examples from O'Reilly books *does* require permission. Answering a question by citing this book and quoting example code does not require permission. Incorporating a significant amount of example code from this book into your product's documentation *does* require permission.

We appreciate, but do not require, attribution. An attribution usually includes the title, author, publisher, and ISBN. For example: "*Flickr Hacks* by Paul Bausch and Jim Bumgardner. Copyright 2006 O'Reilly Media, Inc., 0-596-10245-3."

If you feel your use of code examples falls outside fair use or the permission given above, feel free to contact us at *permissions@oreilly.com*.

How to Contact Us

We have tested and verified the information in this book to the best of our ability, but you may find that features have changed (or even that we have made mistakes!). As a reader of this book, you can help us to improve future editions by sending us your feedback. Please let us know about any errors, inaccuracies, bugs, misleading or confusing statements, and typos that you find anywhere in this book.

Please also let us know what we can do to make this book more useful to you. We take your comments seriously and will try to incorporate reasonable suggestions into future editions. You can write to us at:

O'Reilly Media, Inc.
1005 Gravenstein Highway North
Sebastopol, CA 95472
(800) 998-9938 (in the U.S. or Canada)
(707) 829-0515 (international/local)
(707) 829-0104 (fax)

To ask technical questions or to comment on the book, send email to:

bookquestions@oreilly.com

The web site for *Flickr Hacks* lists examples, errata, and plans for future editions. You can find this page at:

http://www.oreilly.com/catalog/flickrhks/

For more information about this book and others, see the O'Reilly web site:

http://www.oreilly.com

Got a Hack?

To explore Hacks books online or to contribute a hack for future titles, visit:

http://hacks.oreilly.com

Safari Enabled

 When you see a Safari® Enabled icon on the cover of your favorite technology book, that means the book is available online through the O'Reilly Network Safari Bookshelf.

Safari offers a solution that's better than e-Books. It's a virtual library that lets you easily search thousands of top tech books, cut and paste code samples, download chapters, and find quick answers when you need the most accurate, current information. Try it for free at *http://safari.oreilly.com*.

Sharing Photos
Hacks 1–9

Sharing photos has been a popular activity since the invention of the portable camera. Most of us regularly pore over photos during gatherings with friends and family, whether flipping through a stack of photos, looking through albums, or enduring projected slideshows chronicling every detail of a recent vacation. Flickr helps you share photos in many similar ways [Hack #1], and it gives you control over who sees which photos [Hack #2].

Now, instead of waiting for a gathering to share your photos, you can make them available to your friends and family almost as soon as you take them [Hack #6]. You can even add the photos to your own web site [Hack #9] if you want. And in addition to friends and family, Flickr can connect your photos with a wider audience of people who might be interested in them. Sharing photos is nothing new, but Flickr gives you the opportunity to share your photos in new ways.

To get started sharing photos with Flickr, you just need a minute or two to create your account. Browse to Flickr (*http://www.flickr.com*), and click the "Sign up now!" button shown in Figure 1-1.

Flickr is owned by Yahoo!, and if you already have a Yahoo! account, you can use your Yahoo! ID and password to create a new Flickr account. If you don't have a Yahoo! ID yet, clicking the "Sign up now!" link will walk you through the account creation process. The whole process takes a few minutes, and once your Flickr account is created, you can start sharing photos.

When you return to Flickr in the future, you can click the "Sign in" link at the top of the Flickr front page. From there, you'll see the two sign-in options shown in Figure 1-2.

If you created your Flickr account after August 15, 2005, you'll use the Yahoo! option for signing in. Otherwise, you can choose the Flickr option on the right. Most likely, Flickr accounts created before August 15, 2005

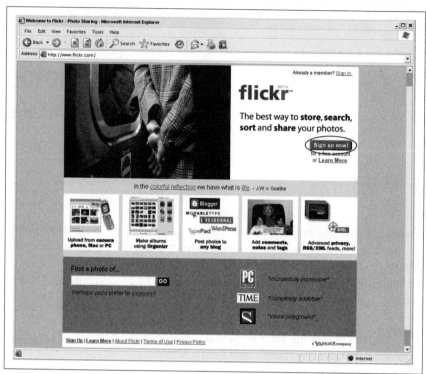

Figure 1-1. The Flickr front page

will eventually be moved to standard Yahoo! accounts, but at the time of this writing, the sign-in page is a visual reminder that Flickr is a new addition to the Yahoo! family of applications.

This chapter will show you the basics of using Flickr to share photos, and it will take you beyond the upload form [Hack #5] so you can be sharing photos like a Flickr power user in no time.

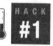

HACK #1 Store, Sort, and Share Your Photos

To get started with Flickr, you need to understand its basic features.

At its most basic, Flickr is a web application that helps you create a public journal of photos. You can upload your photos to Flickr and see them appear on a web page, with the most recently added photo on top. But once you start playing with Flickr, you'll quickly find that it's much more sophisticated. In fact, Flickr is an open platform for storing, arranging, sharing, discussing, and discovering photos with people across the globe.

Figure 1-2. Flickr sign-in page

What began as an independent project by a small company called Ludicorp was quickly snapped up by Yahoo! and is now reaching a much wider audience. If you don't already have a Yahoo! account, you can sign up for one via the Flickr home page.

> A basic Flickr account is free and lets you upload up to 20 MB of photos per month, show up to 200 of your photos, and create three individual galleries (which Flickr calls *sets*). You can also upgrade to a paid Flickr Pro account, which gives you much more storage and unlimited sets. At the time of this writing, a Flickr Pro account costs $24.95 per year.

Once you've created an account, you can add some information about yourself to your profile that will tell others a bit about you. Flickr is a social application, and unlike some sites where uploading photos feels like a lonely process, adding photos to Flickr feels like a group activity.

Store

The first step in getting to know Flickr is uploading some of your photos. The steps required to move photos from your camera to your computer vary

widely, so that will have to be an exercise for the reader. But once the photos are on your computer, there are several ways to add them to Flickr.

From your browser. When you're getting started, the simplest way to upload photos is via your web browser and the "Upload photos to Flickr" page (*http://www.flickr.com/photos/upload/*). Click Browse... next to one of the blank fields on the page, and a new window will let you choose an image file on your local computer. Figure 1-3 shows what choosing a file looks like on Windows XP.

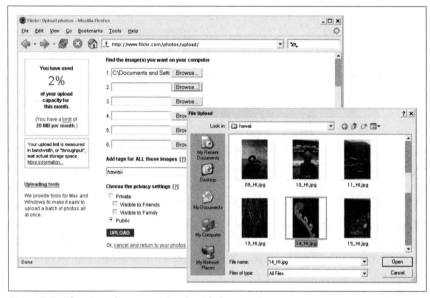

Figure 1-3. Choosing photos to upload to Flickr

When you highlight a photo and click Open, the previously blank field will be filled with the local path to the image file. You can upload up to six photos at a time and set tags and privacy settings for each photo in the group. Clicking Upload sends your photos to Flickr, which might take some time, depending on the size of your photos and your connection speed. Once your photos have been uploaded, you'll have the option to add titles and descriptions to each of them. It's easy to add titles and descriptions later as well.

You can set default privacy options [Hack #2] for every photo you upload by clicking Your Account at the top of any Flickr page and choosing Default Photo Privacy from the menu. Or you can browse directly to *http://www. flickr.com/profile_photoconf.gne* to set options such as who can see your photos, who can comment, and who can add notes and tags.

From your desktop. Once you're completely hooked on Flickr, you might want to upload entire sets of photographs at a time. You can find a number of ways to upload photos on the Tools page (*http://www.flickr.com/tools/*). The tools are programs you can download and install on Windows or Macintosh computers that allow you to upload a number of photos at once.

Figure 1-4 shows the Windows Flickr Uploadr in action; you can simply drag images from the file explorer and drop them onto the Flickr Uploadr window.

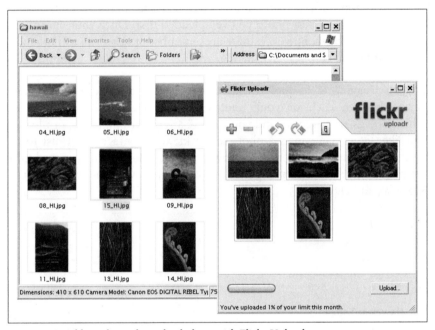

Figure 1-4. Adding photos from the desktop with Flickr Uploadr

Once you've added all of the photos you want to send to Flickr into the Flickr Uploadr, click the Upload... button. You'll also have the option to add tags to the photos or change the default privacy settings for those photos. There are many uploading tools available [Hack #5], so be sure to take a look at your options to see which tool might work best with your system.

From an email address. In addition to uploading photos via the Web or a desktop application, you can send photos to Flickr by email. Click the Your Account link at the top of any Flickr page, and choose "Uploading by email" under the Photo Settings heading. You can also browse directly to *http://www.flickr.com/profile_mailconf.gne*.

Once there, you'll find a randomly generated email address that's unique to your Flickr account. You can use the address to send photos to Flickr as an email attachment. This option is particularly handy for cell phone cameras, because you can snap your photo on the go and post it directly to Flickr [Hack #6], without making a trip to your home computer.

Sort

You'll find every photo you upload in your Flickr *photostream*. A photostream is simply a list of every photo you've uploaded in reverse-chronological order, with the latest photo you've uploaded first. Once your photos are in your photostream, however, there are a number of ways you can organize them beyond the chronological listing.

Tagging. Tagging is a simple form of organization that lets you associate keywords with each of your photos. Unlike traditional categorization schemes, tags are freeform, and you can use any words, numbers, or phrases you like. Figure 1-5 shows a photo at Flickr, with its tags listed just to its right. The photo was taken in the town of Kaneohe, Hawaii, at a Buddhist temple, and the photographer has tagged the photo with the words *temple*, *Kaneohe*, and *Hawaii*.

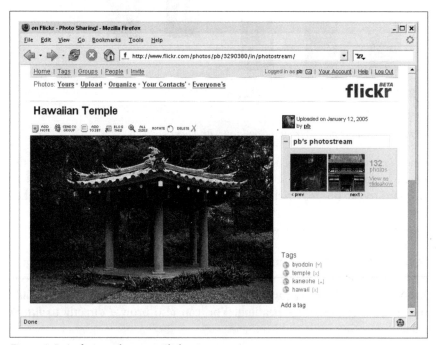

Figure 1-5. A photo with tags at Flickr

Clicking on any tag will show you all of the photos that you've tagged with that word. Clicking the globe icon next to any tag will show you photos by everyone at Flickr tagged with that word. Tagging photos is a fairly simple process, but learning a few tagging hints [Hack #10] can help you determine which keywords to use.

Organizing. The key to more complex organization is the Flickr tool called *Organizr*. Organizr runs in your browser, and you'll need to have the free Macromedia Flash Player (*http://www.macromedia.com/go/getflashplayer/*) installed to use it. You can fire up Organizr by clicking the Organize link at the top of any Flickr page.

You'll find your photos in Organizr's main window. You can view all photos; limit your photos by date; or search your titles, descriptions, and tags. The sliders below the main window adjust the dates you'd like to view, as shown in Figure 1-6.

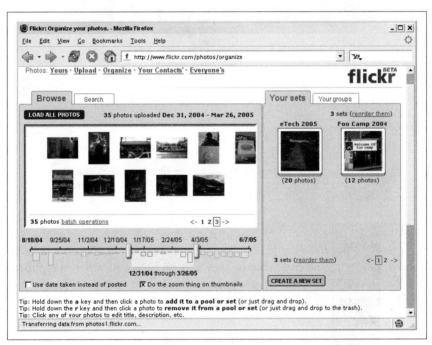

Figure 1-6. Sorting photos with Flickr Organizr

Inside Organizr, you can create and edit photo sets. A *set* is group of photos that you assemble into an individual gallery. Once you've created a set and given it a title, you can drag a photo from the main window and drop it into a set on the right to add the photo to that set. From there, you can arrange

the photos in a set into a specific order. Figure 1-7 shows what the cover page of a set looks like to someone browsing the set for the first time.

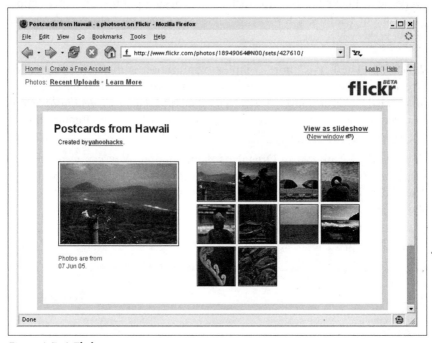

Figure 1-7. A Flickr set

Free Flickr accounts are limited to three sets, but you can create an unlimited number of sets with a Flickr Pro account.

The "View as slideshow" link on the front page of a set will let people see the group of photos as a Flash presentation. Viewers don't even have to press keys or click mouse buttons; they can sit back and watch the photos dissolve in and out as the presentation automatically moves from one picture to the next.

Share

One of the primary benefits of using Flickr is that once your photos are uploaded, they are accessible to anyone with a web browser.

Free to the public. The easiest way to share all of your photos is to create a simple URL, called a *Flickr address*, that you can share with others. Browse

to *http://www.flickr.com/profile_url.gne*, and choose a simple word as your address. The format of the URL will look like this:

```
http://www.flickr.com/photos/insert your word/
```

It's important to choose your Flickr address carefully, because your choice is permanent; you can't edit your Flickr address once you've created it. The newly created URL will point directly to your photostream, and you can give the URL to your friends and family or link to your photostream from another web site using the URL.

Once your photos are on Flickr, you can also share them by automatically posting them to a weblog [Hack #9], or by displaying your latest photos with a Flickr badge [Hack #7]. Flickr also provides RSS feeds for photostreams, groups, and tags, so once your photos are in the system, there are myriad ways for others to view them.

One benefit of these methods of sharing is that others viewing your photos don't need to be members of Flickr to see them; they don't have to go through the account creation process simply to look at your photos. However, if they do go the extra mile and become Flickr members themselves, you'll have several more ways to connect and share photographs.

Flickr community. Flickr works best when your friends and family are also participating at the site. You can add anyone with a Flickr account as a friend, family member, or contact.

> Keep in mind that the category another Flickr member is in will determine which photos of yours that person can see if you alter your photos' default privacy settings.

As you build a group of contacts [Hack #24] at Flickr, you'll be able to easily browse their photos, just as they can browse yours. Clicking the Your Contacts' link at the top of any Flickr page will show the latest photos added by all of your contacts, and it's a great way to keep up with your friends.

You can also browse a full list of your contacts by clicking the People link at the top of any page; clicking a name will take you to that person's photostream. Figure 1-8 shows a contact list at Flickr.

The Groups feature lets anyone form a public discussion and photo sharing space at Flickr. In addition to sending photos to a *group photo pool*, you can post messages to the group and carry on conversations. For example, there's a group called The Bookshelf Project, available at *http://www.flickr.com/groups/bookshelf/*, whose members share photos of their home bookshelves and discuss the topic of storing books.

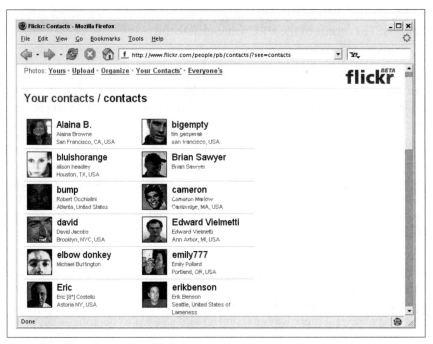

Figure 1-8. A list of contacts at Flickr

If you're interested in a specific topic, chances are good that someone has created a specific Flickr group devoted to it. You can browse a full list of groups, organized by topic, at *http://www.flickr.com/groups_browse.gne*. Figure 1-9 shows the Flickr group for *Yahoo! Hacks* (my previous book for O'Reilly), which you'll find online at *http://www.flickr.com/groups/yahoohacks/*.

Beyond contacts and groups, Flickr members can comment on each other's photos, help out with tagging, and even add notes to specific areas of a photo. (As always, these features are contingent on the permissions you set for your photos [Hack #2].)

HACK #2 Control Who Sees Your Photos

Flickr has a flexible privacy system that enables you to share photos with your friends, your family, or the world—or keep them to yourself.

Flickr exists so that you can share photos, but you might not want everyone in the world to see all of your photos. Your friends would love to see photos of you knocking back a few beers at your favorite bar, but your boss might frown on them. Your family would love to see photos of you dressed up for your cousin's wedding, but your friends might not appreciate your powder-

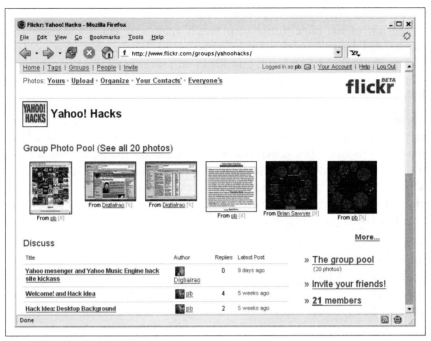

Figure 1-9. A Flickr group page

blue tuxedo. With a bit of planning, you can make sure that your Flickr photos are shared with only the people whom you want to see them (or not shared at all).

Every photo sent to Flickr has a privacy setting, and the default setting is Public. When a photo is Public, anyone visiting Flickr can see the photo. If you want to control access to your photos more closely, you can set them as Private. But the term "Private" is a bit misleading, because there are different levels of privacy. To understand how the levels of privacy work, you need to know a bit about how Flickr contacts work.

Flickr Contacts

When you mark a photo as Private, the ability to view the photo is limited to you (of course) and certain people among your Flickr contacts. Say you want to share a slightly embarrassing baby picture of yourself with members of your family, but not the rest of the world. First, you'll need to add your family members to your contact list by inviting them to join Flickr (or, if they already have accounts, browsing to their photostream pages and adding them as contacts).

To invite people, browse to your Flickr home page and click the Invite link at the top of the page. Enter your family members' email addresses and names, and designate their relation to you by checking the box next to "This person is family." Click Send, and Flickr will send out invitations. Once a family member receives the invitation, she can register at Flickr, and she'll be added to your contact list as a family member.

Flickr contacts can have three different statuses: Family, Friends, or Contact. Once someone on your contact list is designated as Family, she'll have the ability to view photos that you've designated at Private, Visible to Family. You can also designate photos as Private, Visible to Friends or Private, Visible to Friends and Family to limit access to just friends, or just friends and family members. Contacts without a Friends or Family designation will be able to see your Public photos only.

You can change a contact's status at any time by clicking the People link at the top of any Flickr page. From there, navigate through your contacts and hover over the icon of the contact you'd like to change. A pink box like the one in Figure 1-10 will appear, asking if you'd like to change the status of your contact.

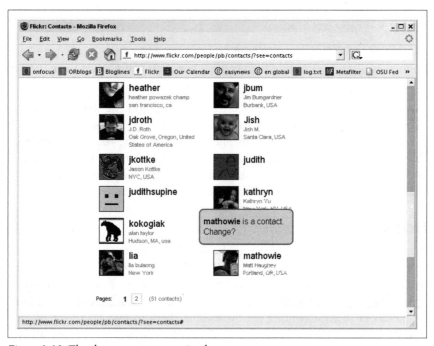

Figure 1-10. The change contact question box

Click the box, and you'll see a change contact status dialog like the one shown in Figure 1-11.

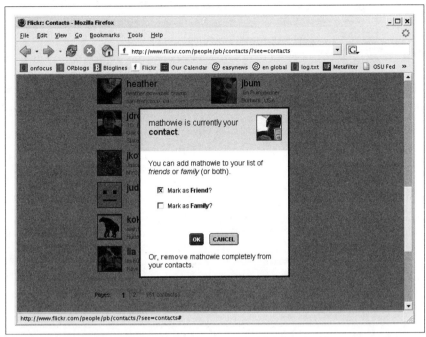

Figure 1-11. The change contact dialog

Adjust the settings and click OK, and the contact will have the ability to see photos (or not), depending on his status.

Setting Privacy

You can set the privacy settings for specific photos at any point, but it's best to do so when you initially upload the photos to Flickr. Figure 1-12 shows the privacy settings on the basic upload form.

Even if you're using a desktop uploading tool [Hack #5], you'll find that they all offer a way to set the privacy level for the batch of photos you're uploading.

> Be aware that if you add a photo to a Flickr group pool, any member of the group will be able to see that photo, regardless of its privacy setting.

You can always see how a photo is marked in Flickr by checking the settings underneath the photo. Browse to your photostream and look for a square icon directly underneath the photo. The color of the icon indicates its

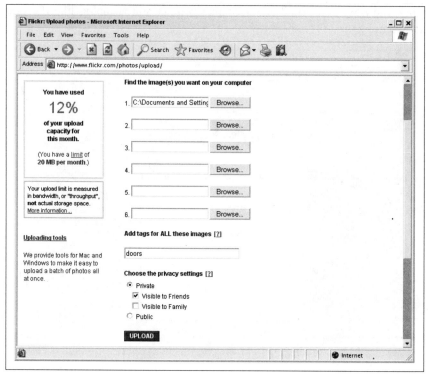

Figure 1-12. The privacy settings on the image upload form

privacy status. Green means the photo is Public, yellow means the photo is Private but friends or family members can view it, and red means you're the only user that can view the photo. You'll also find a phrase next to the icon that indicates who can see the photo, as shown in Figure 1-13.

You can click the "set privacy" link at any time to change the privacy of a photo.

> To publish a photo to your weblog with the Blog This feature at Flickr, the photo will need to be marked as Public. If you publish a Public photo and then change its status later, the photo will still be visible on your weblog, but people clicking through to the photo at Flickr will not be able to see the photo detail page.

If you find that you're marking every photo you upload to Flickr as Private, you can set this as the default privacy setting. At the bottom of any Flickr page, under the Your Account heading, click the Photo Privacy link to set your privacy preferences, as shown in Figure 1-14.

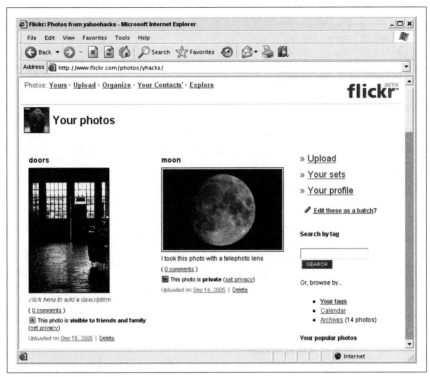

Figure 1-13. Private photos on Flickr

As you can see, you can set a default privacy value for your photos, and you can set the level of participation you'd like other Flickr users to have with your photos.

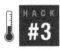

Manage Image Metadata
#3 Flickr will display the information that most digital cameras embed inside a photo, and with the right tools, you can control this data.

If you take photos with a digital camera, chances are good that the original files that come from the camera contain information about the camera settings when you snapped the photos. This information can include the date and time, how long the shutter was open, the settings you chose for the shot, and whether your lens was zoomed in or out. This type of information is called *metadata*, which literally means data about data.

In the days before digital cameras, one of the best ways to store information about a photo was by flipping over a print and physically writing on it. In the digital world, information about a photo can be embedded within the

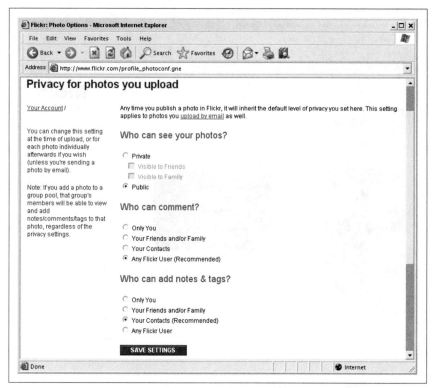

Figure 1-14. Global privacy settings

image file itself. Viewing the info can help you remember how you got a great shot, or tell others how they can achieve a similar effect.

If metadata is present in your photo when you upload it to Flickr, you'll find your camera make and model along with a "More properties" link on the photo detail page, as shown in Figure 1-15.

Figure 1-15. The "More properties" link on a photo detail page

Clicking the "More properties" link takes you to a page like the one in Figure 1-16, with many more details about the photograph.

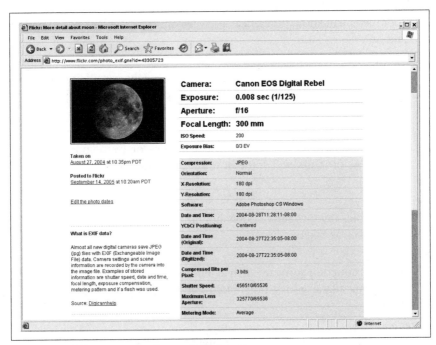

Figure 1-16. "More properties" page on Flickr

As you can see, Flickr has chosen to highlight certain properties and include others in a gray box. All of this data that Flickr can display comes from a few different sources, and it helps to be familiar with some of the terms before you start editing and refining your photo metadata. The exact metadata will differ by camera and software, but here's a look at some common metadata properties you'll find:

Camera

 This property shows the manufacturer and model of camera that was used to take the photograph.

Exposure

 This is the length of time in seconds that the shutter was open on the camera.

Aperture

 The aperture controls light coming into a camera, and this property shows the aperture setting in its standard f-stop measurement.

Focal Length

This property shows the focal length (in millimeters) when the photo was taken. If the camera has a fixed lens, this will be a fixed value. A zoom lens will show differences between shots as the lens is zoomed in and out.

ISO Speed

Many digital cameras allow adjustments for light sensitivity, and this property shows the ISO speed set on the camera when the photo was taken.

Exposure Bias

If the photographer set the camera to under- or overexpose a photograph, this property will show how far the setting was pushed in either direction.

Orientation

If available, this property shows how the camera was positioned when the photo was taken.

Software

Image-production software such as Photoshop usually embeds its stamp on any metadata, letting others know the software used to produce the image.

Dates and Times

Several dates and times can be embedded in a photo, including when the photo was taken, when the photo was opened in production software, and when the photo was last modified.

Exposure Mode

This property can let you know what type of exposure mode the camera was in when the photo was taken, including automatic, manual, or aperture priority.

Artist Name

This property can be set to the name of the photographer.

Copyright

Photographers can add specific copyright information to a file, and that info is shown in this property.

Keywords, Title, and Description

Much like titles, descriptions, and tags at Flickr, these properties, embedded as metadata by the photographer, can help identify the subject of the photo.

The most common metadata format is called EXchangeable Image File (EXIF) data, and it contains most of the camera settings. In addition, some

cameras and programs embed metadata in the International Press Telecommunications Council (IPTC) format, which includes detailed artist information, and the more recent XML-based eXtensible Metadata Platform (XMP) format endorsed by Adobe. You'll see these acronyms used quite a bit (and often interchangeably) in different image software programs; just be aware that when you see them, you're dealing with image metadata.

You can use Flickr and your digital camera without ever knowing that image metadata exists, and you won't be missing much. But if you're interested in the craft of photography and want to see the technical details behind your favorite photos, this metadata can be a great learning tool. And, in turn, you can share your technical details with others so they can learn from your photos.

Viewing Metadata

The first step to understanding image metadata is simply to take a look at the data embedded in your photographs. Here are a few image tools that can both read and edit metadata in your images.

Photoshop CS. Open a photo in Photoshop and choose File → File Info... from the menu to display the metadata window shown in Figure 1-17.

Choose a page of data on the left, and you'll see the details on the right. The Camera Data 1 and 2 pages show the technical info about the photo embedded in the file. You can't edit this information within Photoshop, but you can view the info so you'll know what others will see once you've added the image to Flickr.

If you click the Description page, though, you have the option to add a title, author, description, keywords, and copyright information to the image metadata. Figure 1-18 shows the metadata entry form.

Once you've added the data, click OK. Back in the main Photoshop window, save the image to be sure the metadata is added. It's always a good idea to use the File → Save As... feature to make a copy of the file; that way, no matter what changes you make to the image metadata, you'll always have the original file with the original metadata intact.

In addition to the File Info metadata window, you can edit metadata within Photoshop from the File Browser. Choose File → Browse from the menu and navigate to a folder with images. Highlight an image on the right, and open the metadata palette in the lower-left corner of the browser. Fields that you can edit are noted with a pencil, as shown in Figure 1-19.

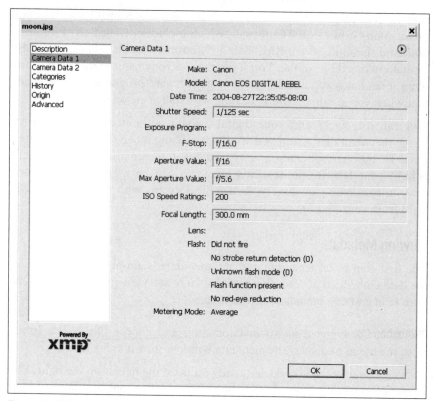

Figure 1-17. Viewing camera metadata in Photoshop CS

Using the File Browser is a quick way to add titles and descriptions to photos before you upload them to Flickr. Flickr will automatically extract the title, description, and keyword information from the image file if it exists in the image metadata.

Exifer. Exifer is a free program specifically designed to read and edit image metadata. Once you open Exifer (*http://www.friedemann-schmidt.com/software/exifer/index.htm*), browse to a folder with images and highlight a specific image to see the metadata in the right pane, as shown in Figure 1-20.

Data that you can edit in Exifer is noted with the paper-and-pencil icon. Double-click an editable field to change the value. Unlike Photoshop, Exifer will let you adjust the time an image was taken; this is especially handy for correcting the timestamp set by a camera with the wrong time setting, or if you took photos in a different time zone without adjusting the setting.

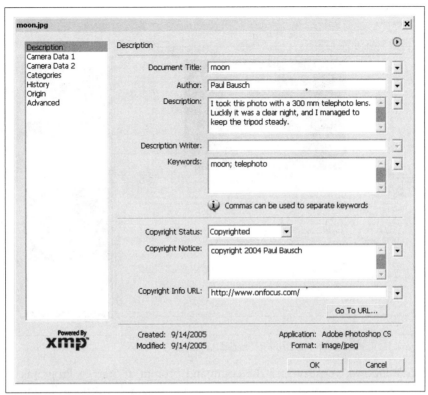

Figure 1-18. Adding a title and description and other metadata to an image file with Photoshop

 Flickr does not set the date and time the photo was taken based on the EXIF data. If you upload a photo that was taken years ago, you'll have to update the "taken on" date by hand, even if the EXIF data is accurate.

Exifer will give you the option to save the original metadata in a separate file. You may want to do this, because there's no Save As... option in Exifer, and any metadata changes are written into the file.

jhead. Another free program that can read and write some image metadata is jhead (*http://www.sentex.net/~mwandel/jhead/*). jhead is a command-line program, so once you've downloaded the version for your operating system, you'll need to open up a command prompt to use it.

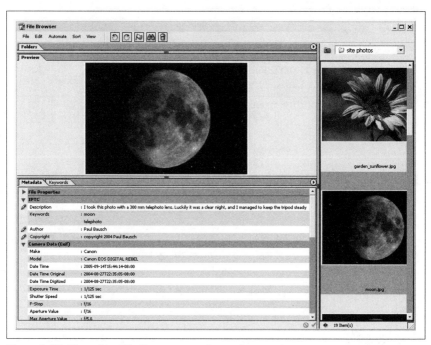

Figure 1-19. Photoshop File Browser metadata palette

On Windows, you can find the command prompt at Start → Programs → Accessories → Command Prompt. Mac users can simply open the Terminal app.

From the command prompt, call the program and include an image file to analyze, like so:

```
jhead moon.jpg
```

The output will include common EXIF data, like this:

```
File name    : moon.jpg
File size    : 38366 bytes
File date    : 2005:09:14 15:07:28
Camera make  : Canon
Camera model : Canon EOS DIGITAL REBEL
Date/Time    : 2004-08-27T22:35:05
Resolution   : 510 x 343
Flash used   : No
Focal length : 300.0mm  (35mm equivalent: 2871mm)
CCD width    : 3.76mm
Exposure time: 0.0080 s  (1/125)
Aperture     : f/16.0
ISO equiv.   : 200
Jpeg process : Progressive
```

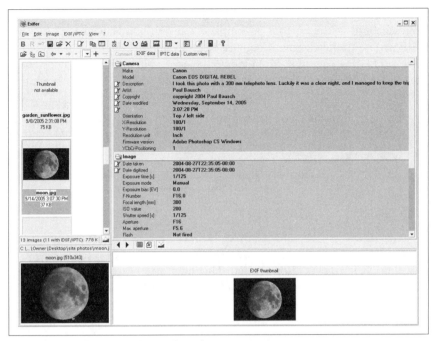

Figure 1-20. Viewing metadata with Exifer

You have a number of options for changing the metadata with jhead. You can adjust for time-zone problems by moving the time forward or backward. Use the -ts switch to change the date and time of a photograph, like this:

```
jhead -ts2003:08:27-22:35:05 moon.jpg
```

Even though the camera noted that the photo was taken in 2004, editing the metadata will tell Flickr and the world that the photo was really taken in 2003. To see all of the metadata editing options in jhead, bring up the help documentation, like this:

```
jhead -h
```

While not as friendly as the other programs, you might find jhead useful for editing the image metadata of entire folders of photos at a time.

Hiding Metadata

If you'd rather not share your image metadata with the world, there are some steps you can take to keep the info to yourself. First, Flickr provides a way to turn off the "More properties" link on your photo detail pages.

To hide this link, browse to Flickr and choose the Profile Privacy link under Your Account at the bottom of the page. Check the box next to "Hide my EXIF data?" and click Save Changes. Keep in mind, though, that while the EXIF properties page will be hidden from other Flickr users, a determined user will still be able to download the original file and extract the metadata.

Removing metadata from image files will reduce the file size by 5 to 10 kilobytes, so if you're really trying to squeeze every extra byte from your photos, removing EXIF data will help. You won't notice a difference in upload times or Flickr bandwidth usage with a change that small, though many programs (including Photoshop) remove the data if you use the "Save for Web" option.

To remove image metadata completely, you can use any of the programs mentioned for editing image metadata. In Photoshop, open the File Info window and click Advanced on the left. Highlight EXIF Properties on the right and click Delete. Do the same for any other metadata you'd like to delete, and then be sure to save a copy of the file. With Exifer, click EXIF/IPTC → Remove from the menu, and with jhead, use the -de switch. For example, the following command would remove all of the image metadata from a file called *moon.jpg*:

```
jhead -de moon.jpg
```

The choice to use metadata and share it with others is up to you, but be aware that even if you do nothing, some of your data might be available inside your photographs.

Resize Photos for Flickr

HACK #4

Images coming directly from a digital camera or scanner are often quite large. Resizing them before sharing them can save your Flickr bandwidth.

Digital photos come in all shapes and sizes, because they're taken by devices with varying capabilities and used for a number of different purposes. If you're going to print a digital photo, you want the highest resolution possible—the more pixels there are in a photo, the better the print quality will be when translating that photo to paper. If you're just going to display an image on a computer screen, on the other hand, you can use a smaller image, because the screen doesn't need as many pixels to display a sharp image. Because Flickr images are primarily used for display on computer screens, you can take advantage of that fact and tailor your images just for Flickr by resizing them.

Why Size Matters

When you're using Flickr, you don't need to think about the size of an image. However, there are several reasons why you should keep image size in mind. Possibly the most important reason is conserving bandwidth. The free version of Flickr allows 20 megabytes of transfer each month, and larger image dimensions usually mean a larger file (in megabytes) to upload. It takes longer to upload larger photos, and you can upload fewer photos per month at the large size.

If you don't pay attention to your bandwidth you might not ever know you're uploading extremely large images, because Flickr automatically resizes them to a number of different standard sizes. For example, all photos in your photostream will be displayed at a maximum of 240 pixels wide (or high, depending on their orientation), allowing people to view many of your photos at once. Each image is displayed at a maximum of 500 pixels at the longest dimension on its detail page, so that viewers can see a bit more detail than was available in the photostream listing. In fact, if you upload a photo that's 1,000 pixels wide, no viewers will see it at its full size unless they click the All Sizes button on the photo detail page.

This means that 500 pixels is as wide or tall as an image ever needs to be for normal browsing at Flickr. If you cut that 1,000-pixel image in half, you'll save some time uploading, and you'll save your Flickr bandwidth for more images.

Another reason for resizing your images is that you might not want other Flickr users to have access to larger versions of your photographs. Large (high-resolution) versions of photos not only show more detail on the screen, but are also better for printing. So, if you'd rather not give other Flickr members print-quality versions of your photos, resizing them before you upload will make sure that people have access only to versions that look good on a computer screen. This will allow you, for example, to give everyone access to screen-quality versions of your photos, but charge for print-quality versions at your own web site.

Programs to Resize Photos

To resize an image, you'll need a program that can handle the task, and there are probably several hundred available. This hack shows how to resize images with five different programs. You might have one of these programs installed on your computer already; if not, you'll probably want to acquire one of these or any of the numerous other offerings.

Photoshop CS. Adobe Photoshop (*http://www.adobe.com/photoshop/*) is the standard for image professionals, and it's available for both Macs and PCs. At $599 (at the time of this writing) it's not cheap, but Photoshop will give you a full-featured digital photo lab that lets you adjust images in many different ways, including resizing them. Adobe also offers a light, less-fully-featured version of Photoshop called Photoshop Elements for $99.

Open the image you want to resize in Photoshop and choose Image → Image Size from the top menu to bring up the Image Size dialog. (Or, in Photoshop Elements, choose Image → Resize → Image Size.) Change the units to pixels in the top drop-down menu, and enter your desired width, as shown in Figure 1-21.

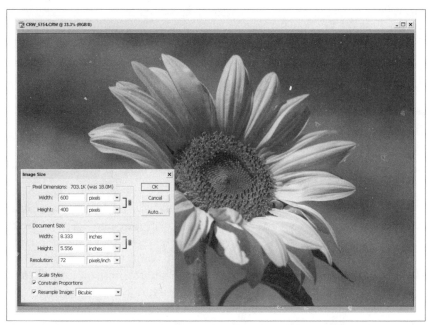

Figure 1-21. Resizing a large image with Photoshop CS

Photoshop will automatically calculate the proper height in pixels. (If your image is oriented vertically, change the height instead and Photoshop will calculate the proper width.) At the top of the Pixel Dimensions section of the Image Size dialog, you'll see an estimate of the new file size. In Figure 1-21, resizing the image reduces the photo of a flower from 18 megabytes to less than 1 megabyte. Uploading this photo will now use up only a fraction of your bandwidth, instead of consuming practically your entire month's allocation.

With the new width and height set, click OK to resize your image. Choose File → Save As... from the menu, and give your newly resized image a new name that you'll recognize. (It's always a good idea to keep a copy of your original photo, rather than overwriting it, so you can go back and print the file or use it for some other reason down the road.)

Paint Shop Pro X. Paint Shop Pro X (*http://www.corel.com/paintshoppro/*) is an alternative to Photoshop offered by Corel for $129. You can bring up the Resize dialog, shown in Figure 1-22, by choosing Image → Resize from the menu or using the keyboard shortcut Shift-S.

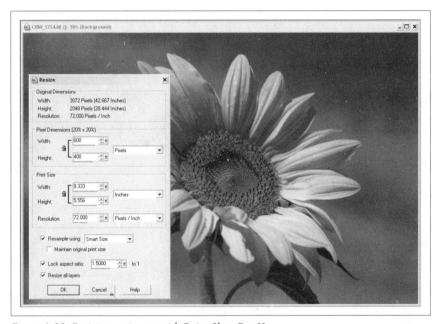

Figure 1-22. Resizing an image with Paint Shop Pro X

Enter a new width or height, and Paint Shop Pro will automatically calculate the other dimension. Click OK and save the new file under a new name, preserving the original.

IrfanView 3.97. IrfanView (*http://www.irfanview.com*) is a lightweight image-editing tool that's free for noncommercial use. To bring up its "Resize/Resample image" dialog, press Ctrl-R or choose Image → Resize/Resample from the menu. Enter the new size, as shown in Figure 1-23.

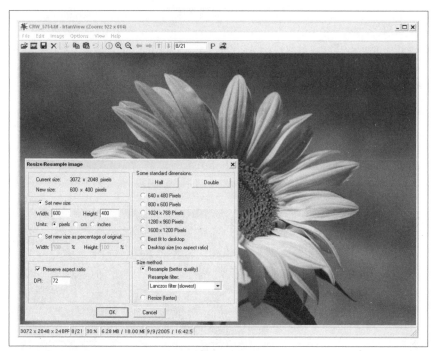

Figure 1-23. Resizing an image with IrfanView

You can also choose an alternate size from the "standard dimensions" list on the right side of the window. Once you've entered the new size, click OK, and then save the file as a new image.

Windows XP Image Resizer PowerToy. Microsoft offers a series of small, free applications that you can add to Windows XP, called "PowerToys." Each PowerToy performs some specific task that's not included with the basic operating system installation, and the Image Resizer PowerToy does just what you'd expect. To get a copy, browse to *http://www.microsoft.com/ windowsxp/downloads/powertoys/xppowertoys.mspx* and search for "image resizer" on the right side of the page.

Once the PowerToy is installed, you can resize any image by right-clicking the image file and choosing Resize Pictures from the menu. You can also resize a whole batch of images at once with this program, and it's a quick way to resize an entire folder of images.

When you click Resize Pictures, you'll see a window like the one shown in Figure 1-24.

You can choose a size from the options available, or click Custom and enter your own size. Unfortunately, the Image Resizer won't automatically calcu-

Figure 1-24. The options available in the Image Resizer PowerToy

late the corresponding height or width, so you'll need to do some math on your own if you go with a custom size.

Once you've made your choice, be sure that the "Resize the original pictures" option is not checked, and click OK. The Image Resizer will create new images with the same names, but you'll find the words Small, Medium, Large, WinCE, or Custom added to the new filenames. For example, a file called *sunflower.jpg* would be copied, resized, and saved as *sunflower (small).jpg* if you chose the small image size from the menu.

iPhoto. Mac OS X users can rely on iPhoto, an image-organizing program that is included with OS X by default. To resize photos in iPhoto, simply select the photos you'd like to resize and choose Share → Export... from the menu. Choose the File Export tab and set your maximum width or height in the "Scale images no larger than" boxes shown in Figure 1-25.

Be sure to change the format to JPG in the drop-down menu, and make sure the "Use extension" option is checked. Click Export and choose a memorable location for your resized photos.

Thinking Small

You can now upload your newly resized images to Flickr, using your favorite method [Hack #5]. You should notice that it takes less time to transfer the files, and you'll have more room in your Flickr account to upload files.

Figure 1-25. Resizing images in iPhoto

Also note that many Flickr upload tools will automatically resize photos for you, so be sure to check the options available to you in your uploading tool of choice.

> The tools discussed here are just a few of the available image programs that you can use to resize your photographs. A quick search for "image resizing program" on Google will return dozens and dozens of potential candidates.

Add Photos Quickly

#5 Flickr uploading tools can speed up the process of adding photos to Flickr.

Adding a photo to Flickr isn't hard. If you browse to Flickr, log in, and choose Upload from the menu, you'll find the upload page [Hack #1], with six empty fields waiting for photos. Click the Browse... buttons next to the fields and choose some local files, and your photos will soon make their way from your desktop to Flickr.

If you want to add more than six photos at a time, though, the upload page begins to look like an awfully slow way of transferring files. You have to upload in batches of six, and wait for each group to transfer before starting

the next group. Uploading 30 photos would require 5 trips to the upload page, and constant monitoring to find out when the last batch of photos was done transferring.

 Another factor to consider when uploading photos is the size of the photos themselves. A larger image file will take longer to transfer, so you might want to resize your photos [Hack #4] before adding them to Flickr.

Luckily, Flickr has provided several tools to make uploading easier. An uploading tool is simply a program you can install on your computer that communicates with Flickr. You can find a list of uploading tools created by Flickr developers at *http://www.flickr.com/tools/*, along with some tools written by outside developers. This hack discusses how to use some of the available Flickr upload tools.

Granting Your Permission

Any tool that uses the Flickr API to add photos to your photostream needs your explicit permission. As you install software that communicates with Flickr, you'll likely encounter a Flickr permissions page like the one shown in Figure 1-26.

This process ensures that you give access only to programs that you're aware of, and you can view a list of the applications you've approved at any time by logging into Flickr and browsing to the Authentication List page (*http://www.flickr.com/services/auth/list.gne*). If you see the permissions page while using an upload tool, you'll need to click the OK, I'll Allow It button; otherwise, the upload tool won't be able to add your photos to Flickr.

Batch Uploading Tools

Batch uploading tools save you time by letting you upload entire groups of photos at once. Let's take a look at some of the available options.

Uploadr for Mac. The official uploading tool for Mac OS X users is called Uploadr. Download the program from the Flickr Tools page (*http://www.flickr.com/tools/*), and double click the *.dmg* file to mount it. Drag the Flickr Uploadr application icon from the Flicker Uploadr window to your desktop or *Applications* folder to install it. Once it's installed, double-click the Uploadr icon and grant your permission to the application. After you're logged in, you can start dragging and dropping photos into the left pane of the Uploadr, as shown in Figure 1-27.

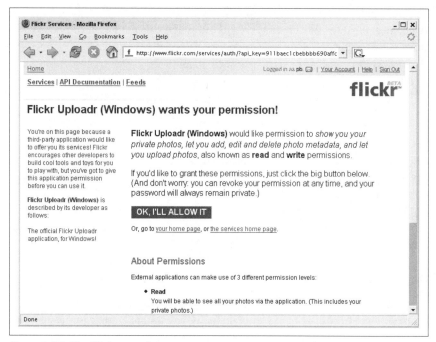

Figure 1-26. The Flickr permissions page

You can set titles, descriptions, and tags for each individual photo, or you can click the Batch tab to set global privacy attributes and tags for the entire group of photos. You can also set the Uploadr to automatically resize your photos before sending them to Flickr, saving transfer time and bandwidth. Choose Flickr Uploadr → Preferences from the menu to set your preferred maximum photo size.

Once your photo attributes are set, you can click Upload to send your photos to Flickr, and they'll be transferred in the background.

FlickrExport for iPhoto. If you manage your photos with iPhoto on your Mac, you might want to try the FlickrExport plug-in written by Fraser Speirs (*http://www.connectedflow.com/blog/*). The plug-in lets you use the iPhoto interface to select photos to send to Flickr.

Download the plug-in from *http://www.connectedflow.com/flickrexport/*, and follow the installation instructions once it's on your desktop. Once the plug-in is installed, open up iPhoto and select a batch of photos from your Library. Choose Share → Export from the iPhoto menu, and click the Flickr button at the top of the page. You'll see the Flickr Export dialog shown in Figure 1-28.

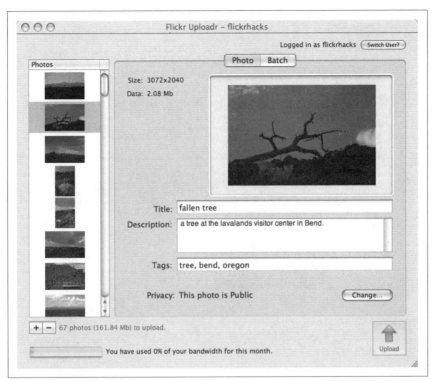

Figure 1-27. Flickr Uploadr for Mac

As with Uploadr, you can set titles, captions, tags, and privacy settings for each photo, or you can use the "Apply to All" buttons to set attributes for the entire batch. Once your settings are in place, click Export to send the photos to Flickr.

Uploadr for Windows. Mac users aren't the only ones who can benefit from official Flickr tools, and there's a version of Uploadr for Windows available at the Flickr Tools page (*http://www.flickr.com/tools/*). Be sure to choose the proper version of Uploadr for your version of Windows; download the program and double-click the icon to start the installation.

Uploadr for Windows is a bit more simplistic than its Mac cousin, and you won't be able to add titles, captions, or tags until you've transferred the photos to Flickr. To transfer photos, simply drag the images to the Uploadr window, as shown in Figure 1-29, and click the Upload... button.

Uploadr will automatically resize your photos if you'd like, and you can set that preference by clicking the light switch icon in the main Uploadr window. Figure 1-30 shows the Flickr Settings window.

Figure 1-28. FlickrExport for iPhoto

Windows XP Import Wizard. Windows XP has some nice built-in features for working with photos, and Flickr has a tool that extends the publishing features to send photos directly to Flickr. On the Tools page, look for a link titled Download "Send To Flickr" Windows XP Explorer Wizard, right-click the link, and choose Save As... to save the file *wizard.reg* to your computer. Double click *wizard.reg*, and approve the additions to your Registry. This will install the necessary settings to export images to Flickr.

To try out the wizard, browse to any folder that contains pictures with the Windows file explorer. Choose "Publish this folder to the Web" to start the wizard. If you don't see the Publish option, choose Tools → Folder Options... from the menu and make sure the "Show common tasks in folders" option is selected.

After you click "Publish this folder to the Web," you can select the photos from the folder that you want to add to Flickr. Figure 1-31 shows the selection process.

Once you've made your selections, click Next and choose Flickr from the list of options. The first time you run the wizard, you'll need to grant per-

Figure 1-29. Flickr Uploadr for Windows

mission to the program. Once you grant permission, you'll get an authorization code to enter into the wizard. Enter the code into the application, click Next, and you'll be set to send your photos.

You can't add titles or captions to photos before sending them, but you can set tags and privacy options for the batch. You also have the option of resizing the photos automatically before they're sent. Once your photos are available at Flickr, you'll have the option to add titles and descriptions, and you can use batch editing [Hack #35] to speed things up.

Desktop Uploading Widgets

Desktop uploading *widgets* are small applications that run on your desktop and transfer images to Flickr. They won't help you upload images in large batches, but you can drag-and-drop a single photo onto the widget to send it to Flickr. This can save you the steps of opening your browser, finding the upload page, and browsing around for the photo you'd like to send. Instead, you simply drag the photo onto the widget, drop it, specify your tags, and click Upload. (Unfortunately, you can't specify a title and description while uploading—the widget is built for speed, so it's tags only.)

Figure 1-30. The Flickr Settings window in Uploadr for Windows

Flidget. If you're running Mac OS X Tiger (Version 10.4) with Dashboard, you can use Flidget (*http://www.apple.com/downloads/dashboard/blogs_forums/flidget.html*). Download the widget and double-click it to add it to your dashboard. Click the "i" icon in the lower-right corner to set your Flickr login and password.

You'll need to be sure you have an Active Screen Corner set for Dashboard so that you can drag a file to the widget. To set an active corner, click and hold Dashboard in your Mac Dock and choose Dashboard Preferences... from the menu. Choose Dashboard from one of the Active Corners.

Once you're set to go, grab a photo you'd like to send to Flickr and drag it to the active corner you set up. You should see Flidget appear on the screen. Drop the file onto Flidget. You'll see a thumbnail of the image, and you can add tags to the photo, as shown in Figure 1-32.

Click Upload, and Flidget will send your photo to Flickr.

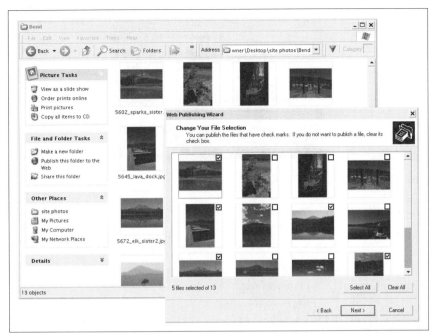

Figure 1-31. Selecting photos to upload with the Windows XP Import Wizard

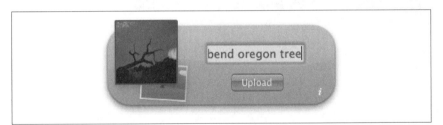

Figure 1-32. Flidget Dashboard Widget for Mac OS X

Konfabulator. If you don't have the latest version of Mac OS X, or if you're on a Windows machine, you can still play along by using widget engine Konfabulator (*http://www.konfabulator.com*). Once you have Konfabulator installed, you can grab the Flickr Upload Widget from *http://flagrantdisregard.com/flickr/uploader.php*.

As with Flidget, you can simply drag-and-drop an image file onto the Flickr Upload Widget. In addition to tags, you can add a title and a description and set your privacy preferences before clicking Upload to transfer the file, as shown in Figure 1-33.

If you find yourself posting one or two photos at a time rather than large sets, these desktop widgets might speed up your routine.

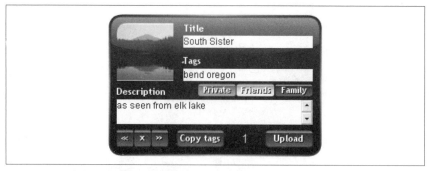

Figure 1-33. Flickr Upload Widget for Konfabulator

Beyond the Tools

If the tools mentioned here aren't quite right for your Flickr-flow, you might want to investigate rolling your own [Hack #42]. The Flickr API gives you programmatic access to all of Flickr's features, including uploading photos, so with a bit of development you might be able to build your perfect uploading tool. Also, be sure to look at the official Tools page (*http://www.flickr.com/tools/*) at Flickr to find the latest available tools.

H A C K

#6 Post Pictures from Your Cell Phone

Using Flickr's post via email feature, you can send photos directly from your cell phone while you're out and about.

Imagine you're out walking around your city, and you notice that the annual fair is setting up for its week-long extravaganza. You'd like to share the news with your friends and family. You could take a picture of the newly unloaded carousel with your digital camera, walk home, transfer the photo to your computer, and then upload it to Flickr. If you have a cell phone with a built-in camera, however, you can take the picture and post it to Flickr on the spot. Hooray for convergence!

To post from your cell phone, you'll need a cellular plan that lets you send photos via email. The data-transfer plans are usually $5 to $10 more per month than standard plans, or you might have a pay-per-use option that lets you pay for the number of messages you send. Check with your cellular service provider to get details about sending email from your phone. Once your plan is in place, posting from your cell phone relies on Flickr's "Upload-by-email" feature. Most camera phones can send any of their photos via email. With the proper phone and plan, you simply need a Flickr email address.

Uploading by Email

Every user at Flickr has a unique email address for uploading pictures. You can find out yours by looking under Your Account at the bottom of any Flickr page and clicking the appropriately titled "Upload-by-email" link. You'll see a page like the one in Figure 1-34, which lets you in on your secret address.

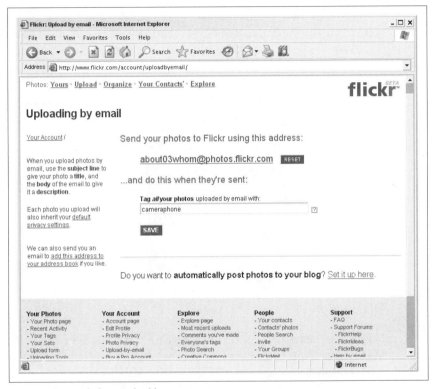

Figure 1-34. A Flickr email address

Notice that the email address is made up of random words and numbers before the @ symbol, followed by *photos.flickr.com*. Keep in mind that the domain is not simply *flickr.com*, because without the *photos.* prefix, your photos will be sent into the void.

The "Uploading by email" page also lets you specify any tags to automatically add to a photo when it's uploaded via email. Popular tags for cell phone users include *cameraphone*, *mobile*, and *moblog* (short for *mobile blog*). If you're going to be taking photos from a specific location with your mobile phone, you could include the location name as an auto-tag as well.

> Every cell phone has a different way of taking pictures and entering contacts, so you might have to consult your cell phone manual for some of these procedures. The screenshots in this hack show a Sony Ericsson S710a—an excellent phone for mobile photos.

While the page is still up on your computer, grab your cell phone and start a new entry in your phone's contacts list. If you enter your private Flickr address now, you won't have to remember it while you're out and about. Figure 1-35 shows how entering the address looks on a cell phone; be sure to add it to the email field of a contact.

Figure 1-35. Entering the Flickr address into a phone

Give the contact a name you'll recognize, like *Flickr*, and you'll be all set for easy uploading from the field. Be sure to click Save on the "Uploading by email" page at Flickr to associate your Flickr email address with your account.

Sending a Photo

So, you're out about town, armed with a camera phone and a Flickr address stored as a contact. When you capture the perfect image, you'll be set for sharing it with the world.

Every cell phone has a different method of sending a photo, but generally, the rule is to push buttons until you see an option called Send (see Figure 1-36).

Once you select Send, you'll usually have the option to review the email before you send it. If you have great cell-phone-keypad dexterity, you can set a Subject line for your email like the one shown in Figure 1-37, and Flickr will use the subject as the title of the photo.

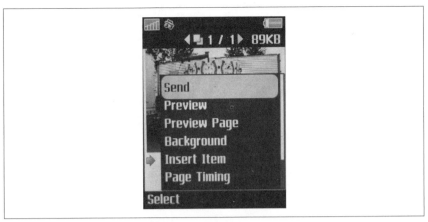

Figure 1-36. Choosing Send from picture options

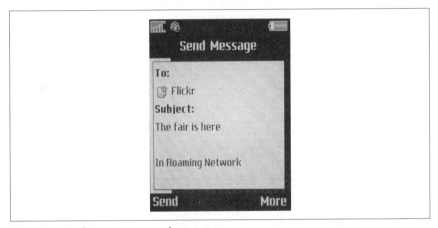

Figure 1-37. Editing a message subject

If you don't set a subject, most cell phones use the internal filename of the photo as the subject of the message—something along the lines of *DSC00025*. Of course, you can always change the title of a Flickr image once you're back at your home computer.

When the message is ready to go, click Send, and your phone will send the message through powerful cell networks directly to Flickr. Your phone might even provide a Sending Message graphic like the one shown in Figure 1-38 to let you know the message is on its way.

A minute or two later, your photo will appear on Flickr with your subject and preselected tags, as shown in Figure 1-39.

The entire process of sending a photo takes about a minute, and then you can slip the phone back into your pocket. Once you're back at your computer,

Figure 1-38. Sending email via a cell phone

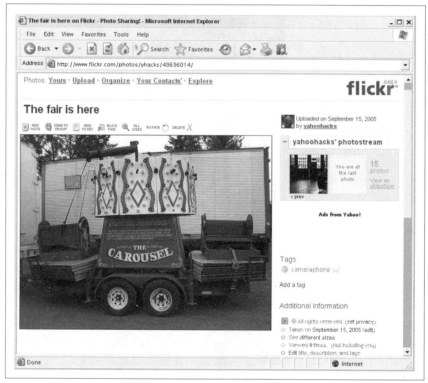

Figure 1-39. A cell phone picture posted via email on Flickr

you can log into Flickr and add any additional information, such as a description or more detailed tags—the hurdle of transferring the photo will be a distant memory.

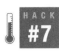

Feed Your Latest Photos to Your Web Site

Flickr provides a number of ways to syndicate your photos to another web site.

Adding photos to an existing web site can be a complex chore. You have to upload each photo to your site, write some HTML to display each photo on a page, and create duplicate, resized images if you want to show thumbnails of the photos. Fortunately, there are several tools at your disposal that simplify the process of sharing your photos on a remote web site.

Even though you upload your photographs to Flickr—and they're stored on Flickr's servers—your photos aren't locked in at the site. Flickr is an open system that allows you to access your photos in a number of ways and display them anywhere you'd like. One of the easiest ways to show your photos on another site is with a Flickr badge.

Flickr Badges

Though it sounds like something you might wear on your uniform, a Flickr *badge* is simply a bit of code that displays photos on a remote web site. Figure 1-40 shows a simple Flickr badge with three photos on a remote web site.

Figure 1-40. A Flickr badge on a remote site

You can create your own Flickr badge in a simple five-step process. Browse to the "Create your own Flickr badge" page (*http://www.flickr.com/badge_new.gne*), and log in if you haven't already. Creating a Flickr badge is the process of making a number of decisions about the badge. Here are the steps:

Choose the type

You can decide between basic static HTML, or an animated Flash-based badge. The animated badge shows a bit of movement and fades thumbnails in and out. Choosing Flash will mean your visitors will need the Macromedia Flash plug-in installed for their browsers in order to see your photos.

Choose the photos

You can choose to display your latest photos, or any of your photos that are tagged with a specific term. In addition, you can display photos from a group you're a member of, all Public photos with a certain tag, or, if you're feeling generous, all Public photos.

Set the layout (HTML only)

When you're building an HTML badge, you have a number of options for the layout. You can choose to show your personal buddy icon, which links to your Flickr profile page. You can choose the number of photos you'd like to show, the size of the thumbnails, and the orientation of the badge (horizontal or vertical). Finally, you can choose to show the latest photos or a random sampling.

Choose colors

If you want the badge to fit in seamlessly with your remote site's design, you can adjust the background, border, and link colors. The preview at the bottom of the page will show your changes in progress.

Copy and paste code

On the last page, you can preview your badge, and copy the code for your unique badge by highlighting it and clicking Ctrl-C.

The code for a static HTML badge is a combination of CSS, HTML, and JavaScript. It should look something like this:

```
<!-- Start of Flickr Badge -->
<style type="text/css">
#flickr_badge_source_txt {padding:0; font: 11px Arial, Helvetica, Sans
serif;
    color:#666666;}
#flickr_badge_icon {display:block !important; margin:0 !important;
    border: 1px solid rgb(0, 0, 0) !important;}
#flickr_icon_td {padding:0 5px 0 0 !important;}
.flickr_badge_image {text-align:center !important;}
.flickr_badge_image img {border: 1px solid black !important;}
```

```
#flickr_www {display:block; padding:0 10px 0 10px !important;
    font: 11px Arial, Helvetica, Sans serif !important; color:#3993ff
!important;}
#flickr_badge_uber_wrapper a:hover,
#flickr_badge_uber_wrapper a:link,
#flickr_badge_uber_wrapper a:active,
#flickr_badge_uber_wrapper a:visited {text-decoration:none !important;
    background:inherit !important;color:#3993ff;}
#flickr_badge_wrapper {background-color:#ffffff;border: solid 1px #000000}
#flickr_badge_source {padding:0 !important;
    font: 11px Arial, Helvetica, Sans serif !important; color:#666666
!important;}
</style>
<table id="flickr_badge_uber_wrapper" cellpadding="0" cellspacing="10"
border="0">
 <tr>
    <td>
    <a href="http://www.flickr.com" id="flickr_www">
    www.<strong style="color:#3993ff">flick
    <span style="color:#ff1c92">r</span></strong>
    .com</a>
    <table cellpadding="0" cellspacing="10" border="0" id="flickr_badge_
wrapper">
       <script type="text/javascript"
src="http://www.flickr.com/badge_code_v2.
gne?count=3&display=latest&size=t&layout=v&source=user&user=33853652177%40N0
1">
       </script>
    </table>
    </td>
 </tr>
</table>
<!-- End of Flickr Badge -->
```

The Cascading Style Sheet (CSS) style definitions at the top of the code format how the badge looks. You can modify this CSS at any point to change how the badge looks on your site. Immediately after the <style> tags, the standard HTML <table> holds the photos.

The <script> tag does the work of displaying the photos. As you can see in the src attribute, the JavaScript file resides at *http://www.flickr.com* and displays photos based on the parameters passed in the URL. Many of the decisions you made while running through the badge-creation process are encapsulated in this URL. For example, the count variable will be set to the number of photos you told the badge to display, and the layout variable will be set to v or h, depending on your choice of vertical or horizontal layout.

If you need to change your badge, try studying the fairly self-explanatory variables in the URL and changing their values. That way, you can make changes quickly without running through the whole badge-creation process again.

Flickr Feeds

Another way that Flickr makes photos available for use on other sites is through standard XML syndication formats [Hack #17]. You'll find news feeds at the bottom of many Flickr pages that relate to the content you see on those pages.

Each Flickr feed contains the 10 most recently added photos for a particular user, group, or tag. The item nodes in the feed contain all of the details you need to display the photo on a remote site: the title, a link to the photo on Flickr, and a bit of HTML for displaying a thumbnail and caption. Here's a look at an item in a Flickr RSS feed (this example has been formatted for readability; the actual feed includes escaped HTML, with tags such as <p> rendered as the escaped <p>):

```
<item>
    <title>Ultimate Championships</title>
    <link>http://www.flickr.com/photos/pb/16469233/</link>
    <description>
        <p><a href="http://www.flickr.com/people/pb/">pb</a> posted a photo:
</p>
        <p><a href="http://www.flickr.com/photos/pb/16469233/"
            title="Ultimate Championships">
            <img src="http://photos10.flickr.com/16447365_40ac8021f5_m.jpg"
            width="240" height="161" alt="Ultimate Championships"
            style="border: 1px solid #000000;" /></a></p>
        <p>the women's championship game was washington vs. stanford</p>
    </description>
    <pubDate>Mon, 30 May 2005 11:01:15 -0700</pubDate>
    <author>nobody@flickr.com (pb)</author>
    <guid isPermaLink="false">tag:flickr.com,2004:/photo/16469233</guid>
</item>
```

The <title> and <link> elements hold the title of the photo and a link to the photo, as you'd expect. The <description> element holds the block of HTML that you can use on a remote site.

The most common use of RSS is viewing new items in a newsreader, but there's no reason you can't use this same feed to create a custom Flickr badge. Parsing XML is the perfect job for Perl, and with a few lines of code, you can build your own badge.

The code. This Perl script uses the LWP::Simple module to fetch a Flickr feed and the XML::RSS module to parse the feed and display its contents. Make sure you have these modules on your server, and then add this code to a file called *flickr_feed.pl*. Be sure to include a valid Flickr feed URL that contains the photos you want to syndicate.

```
#!/usr/bin/perl
# flickr_feed.pl
# Transforms a Flickr Feed into HTML
# Usage: flickr_feed.pl

use strict;
use XML::RSS;
use LWP::Simple;

# Grab the feed.
my $flickr_feed = 'insert Flickr feed URL';
my $feed = get($flickr_feed);

# Start RSS Parser
my $rss = new XML::RSS;

# parse the feed
$rss->parse($feed);

# initialize item counter
my $i;

# print the title, link, and description of each RSS item
foreach my $item (@{$rss->{'items'}}) {
    $i++;
    my $desc = "$item->{'description'}\n";

    # remove the "posted by" text
    $desc =~ s!<p>.*?posted a photo:</p>!!;

    # use thumbnails instead of medium images
    $desc =~ s!_m!_t!;

    # remove the width and height attributes from image tags
    $desc =~ s!width=".*?" height=".*?"!!;

    # remove the paragraph tags
    $desc =~ s!</?p>!!g;

    # print the item
    print "$desc<br />";
    print "<a href=\"$item->{'link'}\">";
    print "$item->{'title'}</a><br /><br />";

    # set the number of photos
    last if ($i == 3);
}
```

This code downloads the Flickr feed and massages the HTML in the
<description> tag, removing some text. It then prints each item in the feed,
until it hits the number specified in the last line of the script.

Running the hack. You can run this code from the command line by calling the script like this:

```
perl flickr_feed.pl
```

You'll probably want to set the script to run on a regular schedule with the Windows Task Scheduler, or *cron* on Unix-based systems.

Using an XML feed instead of a preprogrammed Flickr badge requires a bit more work, but it gives you more control over the presentation. You can create your own CSS styles and classes to make the photos appear exactly as you want them to. Figure 1-41 shows a custom Flickr badge created with the script provided in this hack, viewed on a remote site.

Figure 1-41. A custom Flickr badge

Hacking the Hack

Even though the Flickr feeds contain most of the information associated with each photo, you can still do more with the Flickr API. The API provides programmatic access to anything at Flickr, not just photos. (You can read the full documentation at *http://www.flickr.com/services/api/*.)

In addition to titles and captions, you can get access to everything from the number of comments people have left about a photo to notes left by others to technical data (EXIF tags) from the camera that took the photo. Building

a custom badge with the API will be more technically complex than parsing an RSS feed, but if you really want access to all of the data you have stored at Flickr, it's available!

#8 Make a Photo Gallery in 30 Seconds or Less

This online form will create ready-to-paste HTML code for your next photo gallery.

There are a number of tools available for building galleries or albums from your Flickr photos. One of my favorite free tools is CK's Flickr Album Maker, which can be found at *http://webdev.yuan.cc*.

CK is a Taiwanese Flickr Hackr who has made an excellent collection of code generators, most of them driven by forms.

CK's Flickr Album Maker presents an online form in which you're requested to fill out a few fields. It then produces either a static gallery of your photos, or a slideshow. In both cases CK provides you with the HTML code, so you can copy it and paste it into your own web site.

Since CK's code talks to the Flickr API to get information about your photos, you don't need to actually know anything about the API yourself. All of that stuff happens under the hood.

Making an Album

To begin making an album, go to CK's site at *http://webdev.yuan.cc* and click on the Flickr Album Maker navigation link. You'll be presented with the form shown in Figure 1-42.

After filling out the form with the personal information needed to access your Flickr photos, press the submit button. CK's Album Maker will then produce a sample album and provide you with the HTML source code for copying, as shown in Figure 1-43.

If you want to tweak the result, you can modify the embedded stylesheet.

Making a Slideshow

If you select the Slideshow option at the top of CK's form, it will produce source code for a very spiffy interactive slideshow, instead of a static gallery. The slideshow will look something like Figure 1-44.

Flickr Album Maker

Your Flickr Photo URL:

http://www.flickr.com/photos/ `krazydad` /

⦿ Album ◯ Slideshow

☑ Enable Time Search

	Year	Month	Day
Start Date:	2005	10	1

	Year	Month	Day
End Date:	2005	10	23

Timezone:

-08:00 Pacific Time (US & Canada) ▼

⦿ By date posted ◯ By date taken

Tags: [] Mode: OR ▼

☑ Title: `ibum's wall of terror`

☑ Show Buddyicon ☑ Show Album Info

⦿ Square ◯ Thumb ◯ Small ◯ Medium

Style:

```
<style>
.Album { width: 730px; background: #f5f5f5;
padding: 5px; }
.AlbumHeader { text-align:center;
padding:20px; }
.AlbumHeader h3 { font: normal 24px Arial,
Helvetica, sans-serif; color: #FF0084;
text-align: center; }
.AlbumHeader h4 { font: 16px Caflisch
Script,cursive; color: #660033; text-align:
center; }
```

Max. photos `28` ☐ HTML body only

[Reset] [submit]

Powered by Oberkampf Get HTML Source

Guestbook

You are welcome to sign up the guestbook to let us
know who are using my album maker. This is not
mandatory.

Signup my guestbook at flickr.
Join my Flickr Tools Group and post bug report
here.

Figure 1-42. CK's Flickr Album Maker

Figure 1-43. CK's Album Maker—the result

Figure 1-44. Flickr Slideshow

If the slideshow interface looks familiar, it's because you've probably seen it before. This is the same Flash-based slideshow used on the Flickr web site. If you look at the source code that CK produces, you'll notice that it is merely summoning Flickr's slideshow and putting it into an `iframe`:

```
<iframe width="500" height="500" frameborder="0" scrolling="no" src = "http:
//www.flickr.com/slideShow/index.gne?nsid=&text=&tags=&tag_mode=any&user_
id=94832693@N00&firstId=&v=1.6&codeV=1.26"></iframe>
```

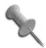

Another nice tool for adding a Flash slideshow to your web site is the $20 Slideshow Pro, which can be found at *http:// www.slideshowpro.net.*

Rolling Your Own

There are a few other web sites that work in a similar way. A lot of CK's stuff either uses or is inspired by Oberkampf, a PHP library of useful routines for building slideshows and galleries. The Oberkampf web site (*http:// www.entrauge.com/tools/oberkampf/index.php*) also employs an online form to collect your personal information, which it then embeds directly into a personalized copy of the Oberkampf source code.

Armed with Oberkampf, you can reduce the task of producing a strip of your thumbnail images to a single line of PHP code.

See Also

* CK provides excellent support for the Album Maker and other tools he makes. He has created a Flickr group for this purpose at *http://www. flickr.com/groups/flickr_tools/.*

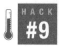

Post Photos to Your Blog

HACK #9

If you take a few minutes to enter some information about your weblog at Flickr, you can post photos directly to it with a single click.

Many weblog systems offer tools to help you upload and include images with your posts, but you might find that Flickr is a nice alternative to the standard photo tools. Once you upload a photo to Flickr [Hack #1], you have several options for including that photo in your weblog posts.

Blog This

The most direct way to send a photo from Flickr to your weblog is through the Blog This button that you'll see above each of your photos, as shown in Figure 1-45.

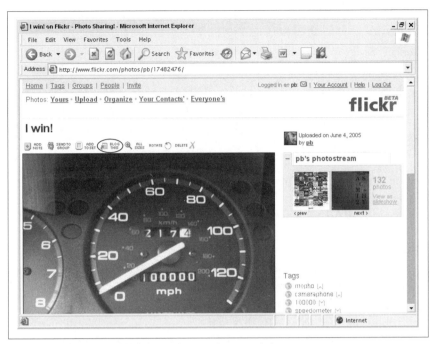

Figure 1-45. The Blog This button above a photo at Flickr

To enable the Blog This button, you need to give Flickr some information about your weblog.

Configuring a weblog. Setting up Flickr to post to a weblog is a simple three-step process. Click Your Account at the top of any page at Flickr, and click Your Blogs under the section labeled Blogging. You'll find a list of any weblogs you've set up; to add a weblog to your account, click "Set up a new blog."

The first step to setting up a new weblog is telling Flickr which weblog tool you use. Flickr supports the following weblog systems:

Blogger
 http://www.blogger.com

TypePad
 http://www.sixapart.com/typepad/

Movable Type
 http://www.sixapart.com/movabletype/

LiveJournal
 http://www.sixapart.com/livejournal/

WordPress

> *http://www.wordpress.org*

Manila

> *http://www.manilasites.com*

If you use a weblog tool that's not listed, check your tool's documentation to see if it uses one of the supported weblog application programming interfaces (APIs). An API allows a third-party tool such as Flickr to add posts to your weblog. Flickr supports the following APIs:

Atom

> This API is an emerging independent standard for programmatic weblog access and is supported by many tools, including Blogger and the latest versions of Movable Type. You can see the details of the API at *http://www.atomenabled.org*.

BloggerAPI

> This was the first weblog API implemented by Blogger. It's no longer actively developed, but some tools still support it.

MetaWeblogAPI

> This is another older API that some tools, including WordPress, support. You can read more about the API at *http://www.xmlrpc.com/metaWeblogApi*.

If your weblog tool supports one of these APIs, you just need to know the *API Endpoint*, a URL to which Flickr should send API requests. The documentation should give you the API Endpoint URL, and with that in hand, you can move on to the second step.

Once you've chosen your tool or supported API, you'll need to enter the username and password you use for your weblog. Flickr will use this information to contact the weblog tool and fetch information about your weblog (or the multiple weblogs you maintain there).

Choose your weblog from the list, click Next, and verify the information on the following page. If you don't feel comfortable storing your weblog tool's password with Flickr, you can uncheck the box labeled "Store your password?" Click All Done, and you'll be ready to start posting pictures!

Posting to your weblog. With your weblogs set to go at Flickr, browse to one of your photos that you'd like to post to a weblog. Click the Blog This button above the photo and choose one of your weblogs from the list, as shown in Figure 1-46.

Once you choose your weblog, you'll have the option to compose your post at Flickr (Figure 1-47).

Figure 1-46. *Choosing a blog with the Blog This button*

Figure 1-47. *Composing a weblog post at Flickr*

Click Post Entry, and Flickr will automatically send the text and photo to your weblog. Figure 1-48 shows the example post at a Blogger-powered weblog.

The nice thing about using Flickr's Blog This feature is that you don't have to write the HTML necessary to link to a photo—you can simply point and click to add a post with a photo to your weblog, and Flickr assembles the necessary HTML behind the scenes.

If you want to change the HTML that Flickr uses, you can alter the way Flickr lays out the photo and text for your weblog posts. To customize a post layout for one of your weblogs, browse to the Your Blogs page at Flickr and click Layout. You'll see several options, as shown in Figure 1-49.

Figure 1-48. A weblog post via Flickr

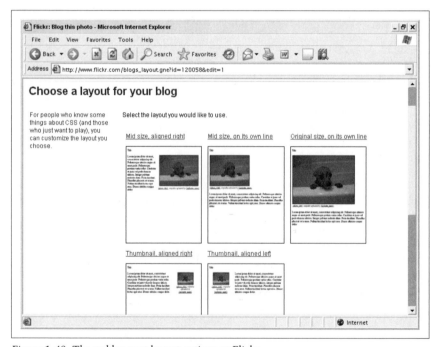

Figure 1-49. The weblog post layout options at Flickr

You can even create a custom post layout template, if you want to go beyond the existing options.

Roll Your Own Post

While the Blog This feature at Flickr works well for posting a single photo along with some text, it doesn't work as well for posting multiple photos within a single post. And you might find that your post layouts are so unique that a single template won't work. In either of these cases, you'll need to write your own HTML to display images in your weblog posts. Even though you'll be doing some of the work on your own, Flickr can still make your life easier by hosting and processing your images.

The key to writing your own HTML to display images is finding direct URLs for the images you upload. But each image has more than just one URL—for every image you upload to Flickr, there are five image sizes available, each with its own URL. This lets you choose the appropriate image size for the post, or use a thumbnail instead of a full image.

> Keep in mind that the larger your photo is, the longer it will take your readers to download it. And large photos won't always fit within the design constraints of a standard weblog. If your weblog text fits within a 400-pixel-wide column, posting an 800-pixel-wide photo will break the design.

To find URLs for each of the image sizes available, click the appropriately titled All Sizes button above any photo you've uploaded to Flickr. This will take you to the All Sizes page (Figure 1-50), which includes the size options listed across the top of the page, along with the dimensions of the photo in each size.

As you click each image size in the menu, you'll find a unique URL listed underneath the photo. Each URL has a similar format that looks something like this:

```
http://photos11.flickr.com/17447365_fff01711bb_o.jpg
```

Notice that the URL starts with a Flickr domain and that the filename includes two alphanumeric IDs separated by an underscore, followed by a final letter (again separated by an underscore) before the .jpg extension. That final letter is a *URL code*, which represents the size of a Flickr photo; understanding the codes can help you create or change links to different photo sizes on the fly. Here's a quick look at the different photo sizes available at Flickr:

Large

This size is the original size of the photo before it was uploaded to Flickr. If you uploaded a photo that was 800 pixels wide by 600 pixels

Figure 1-50. The All Sizes page for an image at Flickr

high, you can access the original by clicking the Large size. The URL code for this size is o, which probably stands for *original*. If the original image you uploaded was extremely large (more than 1024 pixels at its longest dimension), an Original photo size will also be available at Flickr. In this case, the Large size will have the URL code b, and the Original size will have the code o.

Medium

The Medium size is what you see on a Flickr photo detail page. This size will be 500 pixels at its longest dimension, depending on the orientation of the photo. There is no URL code for Medium photos, because this is the default size.

Small

Small photos are 240 pixels at the longest dimension and are used on photostream pages as thumbnails. The URL code for Small photos is m.

Thumbnail

This size is 100 pixels at its longest dimension and can be used to link to a larger version of the photo. The URL code for Thumbnail-sized photos is t.

Square

A Square photo is a version of the original cropped to a 75×75-pixel square. You'll find this size photo in use on your Flickr homepage when you're logged in. It's a handy size to use if you need to know the exact width and height of a photo. The URL code for square photos is s.

Once you've determined the size of the photo you'd like to display in your post, copy its URL. Then, you can use the URL in an HTML image tag to display the photo, like this:

```
<img src="http://photos11.flickr.com/17447365_fff01711bb_m.jpg" width="240"
height="180" alt="speedometer" />
```

When you're writing your own HTML, you can combine multiple images, link images to unique web pages, or create more complex layouts than are possible with Flickr's Blog This feature. Figure 1-51 shows a single post at LiveJournal with several photos hosted at Flickr.

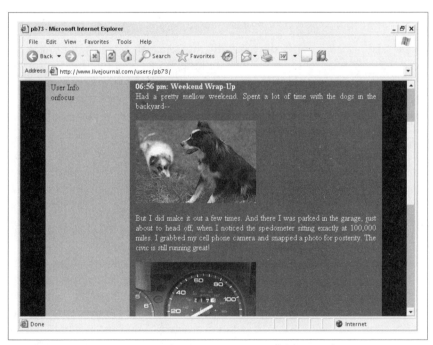

Figure 1-51. A post at LiveJournal with images hosted at Flickr

While you might not need this level of control for every post you make, knowing what's available to you can give you the freedom to get creative with your weblog posts.

Tagging Photos
Hacks 10–14

Before web applications borrowed the term *tags* to mean keywords about pieces of digital information, we thought of tags as something you added to a product to give a bit more information. For example, you might add a sale tag to a shirt to let everyone know its new price.

Photo tagging isn't much different, in the sense that you're adding keywords to a photo to let everyone know a little more about that photo (and to provide terms that people can search for to find photos of specific subjects). You can think of tagging as a way of describing your photos [Hack #10] for a larger audience, while organizing them for your own use.

Imagine you have a picture of a shirt, and you'd like to be able to find that picture in the future. If you add a few tags to the photo, such as *shirt*, *clothes*, or *fashion*, when you want to see that picture in the future you can simply browse your tags and view all of your photos tagged with *shirt* as a separate collection of photos. Also, anyone else interested in pictures of shirts will be able to see your photo as part of the larger, global collection of photos tagged with *shirt*.

Flickr was one of the first applications on the Web to allow tagging of content, and Flickr members have come up with many ways to use tagging to their advantage. Some have created alternate interfaces and games [Hack #11] for browsing global tag collections. Others have found a way to use tags to indicate the location a photo was taken [Hack #12]. You can also use Flickr's tags to create your own visualizations of how people are using tags [Hack #14].

Whether you're tagging photos for personal organization or to take part in the larger Flickrverse, you'll find you can improve the way you tag by seeing how others are using tags to create new spaces for sharing photos.

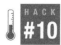

Describe Your Photos

Taking some time to think about how you describe your photos on Flickr might help you find a wider audience for your pictures.

A photo might be worth a 1,000 words, but you can't extract those words from a photo automatically. To pool like photos together, Flickr needs your words, and there are several ways to describe your photos so that you can organize them and place them within their proper spaces in the larger Flickr ecosystem.

Titles and Descriptions

The most obvious photo descriptors you can use in Flickr are photo *titles* and *descriptions*. Titles are listed above photos and are usually just a few words long. Descriptions appear under photos and can be anything that won't fit into a short title. You can describe the photo in a few sentences, or tell an entire story about the photo in a few paragraphs.

You can add titles and descriptions when you upload a photo, or later (simply click the "Edit title, description, and tags" link to the right of the photo on the detail page). You can also edit them at any point by simply clicking the title or description. Figure 2-1 shows what editing a title looks like.

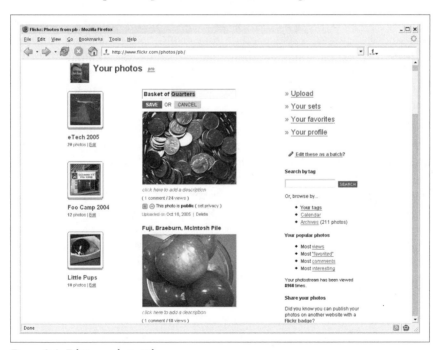

Figure 2-1. Editing a photo title

Click Save once you've made your changes, and your new title or description will be set.

In addition to appearing with the photo in your Flickr photostream, keep in mind that the photo title will be available in group photo pools, on your contacts' photo pages as they hover over a thumbnail of the photo, and anyplace on Flickr where your photo is shown. In other words, the title will be associated with your photo in many ways. Your descriptions will also appear in Flickr news feeds [Hack #17].

Tags

Tags are keywords you can add to your photos. There are two main reasons to add tags to your photos. The first is for your own categorization. If you tag every photo of your cat that you post to Flickr with the word *cat*, you can instantly view all of those photos in a group by clicking on your *cat* tag. The other reason to tag photos is to take part in the larger community of Flickr users. By clicking the global *cat* tag, you can see other photos that people have tagged with that keyword.

Tags appear to the right of a photograph, and you can add them to your own photos at any time by clicking the "Add a tag" link. Figure 2-2 shows a photo tagged with the words *cameraphone* and *watermelon*.

As described above, tags are also links. Click one to see all of your photos that you've tagged with that word or phrase, and click the globe icon to see all the Flickr users' photos that share that tag. On the global tag page, you'll see the latest photos tagged with that particular word or phrase, and *clusters*, or groups of related tags. Figure 2-3 shows the clusters page for the *watermelon* tag.

Once you get into the habit of tagging your photos, you'll find that tags can help you navigate your own collection of photos. But the art of tagging can be awkward at first, so here are some rules to keep in mind.

Tag selfishly, think globally. Though you can tag for the completely selfish reason of organizing your own collection of photos, keep in mind that others might be interested in your photos. If your tags are completely unique or made-up words, it might be hard for others to find your photos. If you use fairly generic words, you can be sure they'll be included on related global tag pages.

If you *don't* want your photos to be found, you should tag carefully or skip the tagging altogether. Tagging is a way of drawing attention to your photos, and if you want to share your photos with the world but don't want them to show up on global tagging pages, you should leave off the tags. (Of

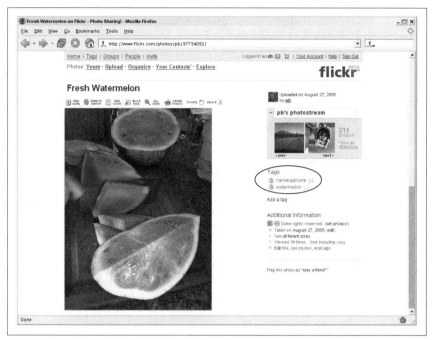

Figure 2-2. Tags on a photo at Flickr

course, you can always mark your photos Private [Hack #2], and tag for your-self without attracting any attention to your photos.)

Describe what you see in the photo (mostly). Tags are most often used to describe what appears in a photograph, but not necessarily *everything* that appears. For example, Figure 2-2 shows someone slicing a watermelon. In addition to the watermelon, the photo includes hands, a large knife, a cut-ting board, and a kitchen counter, but the only tag that's needed to capture the essence of the photo is *watermelon*. The photo might disappoint some-one looking for pictures of kitchen counters, but not someone looking for pictures of watermelon.

Describe how you took the photo. In addition to the main subject of a photo, many people include details about the photo that aren't immediately appar-ent. The photo in Figure 2-2 also includes the tag *cameraphone*, which indi-cates something about the camera used to take the photo. If someone were looking for pictures of cameraphones, this photo wouldn't fit the bill, but there's no reason you can't tag your photos with a keyword indicating the type of camera you used to take the photo.

Figure 2-3. A tag clusters page at Flickr

You'll also find many photos tagged with the name of the location where the photo was taken; it might make sense to tag a photo with a place name, especially if the photo is a shot of a specific area. (The photo in Figure 2-2 was taken in Oregon, but as the photo is not specifically related to Oregon in any way, an *Oregon* tag wasn't included.)

Get suggestions. One way to improve your tagging skills is to look at suggestions for related tags. Flickr doesn't suggest related tags, but if you use the Firefox browser, a Greasemonkey script by Alan Taylor (Flickr member kokogiak) can help you tag your photos.

Make sure you have the Greasemonkey plug-in (*http://greasemonkey. mozdev.org*), and then install the script by browsing to *http://www.kokogiak. com/webtools/greasemonkey/flickrelatedtags.user.js* and choosing Tools → Install This User Script... from your browser's menu. With the script installed, browse to the photo upload page at Flickr, enter a tag, and click the new See Related Tags link pictured in Figure 2-4.

Seeing related tags can often spark ideas for tags you can add to your photos.

Browse tags regularly. One of the best ways to learn how to tag photos is to see how others are using tags. Click the Tags link at the top of any Flickr

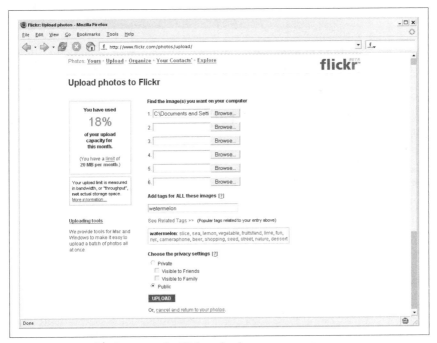

Figure 2-4. See Related Tags on the Flickr upload page

page to see the most popular tags in use across Flickr. With a bit of scripting, you can also see which tags are most popular among your friends **[Hack #26]**.

Once you add a tag to one of your photos, click the globe icon for that tag and see if your photo makes sense within the larger set. Watching the global pages for the tags you use is another great way to get a sense for what to tag and what not to tag.

Don't spam. A completely open tagging system such as Flickr's is extremely flexible, but it can also be abused. If you want to be a good Flickr citizen, you should keep your tags related to your photos. If your photo isn't remotely related to a sunset, why tag your photo with *sunset*? If you think in terms of what's useful for your own categorization, chances are your tags will blend perfectly with the larger Flickr community and you won't be tag-spamming.

Notes

Pointing out a specific part of a photograph is something we do all the time when we're sharing print photos with people face to face. We point out specific people in a photo that someone else doesn't know, or a critical portion of the photo that someone should study more closely. But when we're sharing

photos on the Web, it's not as easy to point out just a portion of a photo. That's where Flickr notes come in handy.

Notes are one of the most unique features of Flickr—they provide the ability to annotate photos by highlighting a portion of the photo and including brief text notes about that section. As visitors hover their mouse pointers over a photograph, they can see the note for a particular region of the photo. It might not be immediately apparent why you'd need to annotate a specific section of a photo when you can include extended descriptions and tags with each photo, so let's look at some of the reasons you might want to do so.

Describe everyone in a photo. If you have a group photo, you can use notes to highlight everyone in the photo and include their names. You could do the same with a photo description, but the notes provide a more immediate way for viewers to see who's who, rather than going back and forth between the photo and caption and counting people in a list of names.

Make personal maps. Another interesting use of notes is for annotating maps with personal stories. In April 2005, Matt Haughey (Flickr member mathowie) posted a satellite image of his childhood neighborhood and used the notes feature to highlight areas and tell stories about them. Figure 2-5 shows the original image.

The resulting *memory map* was very popular, and numerous Flickr users have done the same since. You can find hundreds of memory maps by looking at the global *memorymap* tag page (*http://www.flickr.com/photos/tags/memorymap/*). In addition to childhood memories, you could use Flickr to annotate maps in this way for planning or recounting the details of a trip, sharing your favorite walk in your hometown, or discussing locations with others.

Link photos together. Because you can use HTML links within notes, it's possible to string a series of photos together using links in notes. For example, you could take a wide-angle photo of a landscape in one photo, and use a note to highlight a specific element of the landscape. Within that note, you could link to a close-up photo of that element, as a way of zooming in on the element you want to highlight.

Flickr member GustavoG used linking notes to build a "walkthrough" of a part of Seattle. You can see the results at *http://www.flickr.com/photos/gustavog/22054241/*.

Collaborate. Notes can also be a collaborative activity, and you can use them to share thoughts with others. You can specify whether or not other Flickr

Figure 2-5. Using notes on a map at Flickr

users can add notes to your photos by clicking the Photo Privacy link under Your Account at the bottom of any Flickr page. If you allow others to post notes, you could end up with something like the annotated version of the Merode Altarpiece that a group of Art History students put together (*http:// flickr.com/photos/ha112/901660/in/set-129006/*).

Summary

Effectively describing your photos at Flickr is a fairly easy task, but it's one that can benefit from some forethought. Thinking about how your photos fit with the larger community will help you connect with other Flickr members and organize your photos more efficiently.

Play with Tags

Photo tags let you explore photos around a specific theme at Flickr, and thanks to the Flickr API, several applications let you explore Flickr photos interactively.

The Flickr API gives developers access to the photos stored there, and many developers have imagined new ways to view photos. Photo tags have given developers a new way to arrange photos in third-party applications.

Here are a few interactive examples that will give you a sense of how others are reusing Flickr images. By playing some of these games, you'll see how Flickr images can be used in new ways (and probably have some fun in the process).

Memry

Remember those memory games you played as a kid, where you had to turn over cards of matching pictures? Spanish developer Anna Fuster Fabre has recreated the game with Flickr images and Flash. To play, you'll need the Flash Player, which you can download from *http://www.macromedia.com/ flashplayer/* if you don't already have it. With Flash in place, browse to *http:// www.pimpampum.net/memry/enter.php*, enter any tag, and click "play!" to start your game.

You'll see a 4×4 block of white tiles. Clicking a tile reveals an image that has been gathered from the Flickr API. Somewhere under another tile is the same image, and it's your mission to find all of the matches in as few plays as possible. The blue plays count lets you know how many times you've clicked on tiles. Figure 2-6 shows a game in progress for the tag *infrared*.

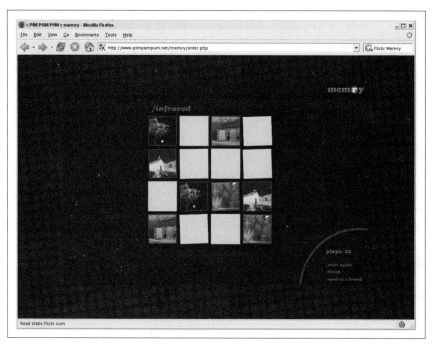

Figure 2-6. Memry game using the tag "infrared"

If you get frustrated and want to see what's under the tiles, click the "finish" link on the right side of the page. For a more challenging game, reload the page or click the "start again" link, and choose the 6 × 6 option.

You can use any tag you like, but patterns make for particularly difficult matching. If you can't think of any tags, try *bricks*, *leaf*, *fractal*, or *texture*.

When you're finished with a game, you can click on any of the photos to view the full photo on Flickr. And if you want to share a particular game, you can add a tag to the URL to bring up that tag immediately, like this:

```
http://www.pimpampum.net/memry/enter.php?tag=infrared
```

Replace *infrared* in this example with any tag of your choice. After a few games, you might even begin to remember where you've left your keys.

flickrTagFight

German developer Nils K. Windisch (Flickr member netomer) thought it would be fun to pit two tags against each other to see which is used most often across Flickr. When you browse to flickrTagFight (*http://www. netomer.de/flickrtagfight/*), you'll find two blank fields. Fill them in with any two tags and click "fight" to see which tag is more popular. Figure 2-7 shows *kitten* and *puppy* going to head to head.

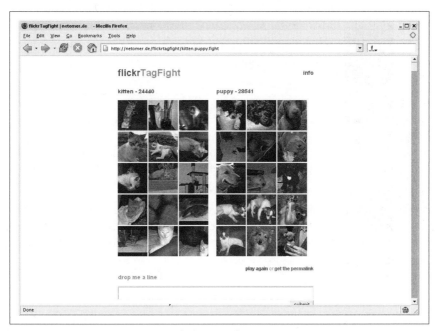

Figure 2-7. "Kitten" vs. "puppy" at flickrTagFight

Beside each tag is the total number of times photos have been tagged with that particular word. The winner is shown in pink, the loser in blue. You'll also see the last 15 photos tagged with each tag. Click a photo to see the larger version at Flickr.

If you'd like to link to a particularly interesting battle to share with others, you can use the following format:

```
http://netomer.de/flickrtagfight/kitten.puppy.fight
```

Replace the words *kitten* and *puppy* in this example with the two tags you'd like to see instead.

Related Tag Browser

The Flickr Related Tag Browser is an interactive Flash application by Airtight Interactive (*http://www.airtightinteractive.com*). To use it, make sure the Flash Player is installed for your browser, and go to *http://www. airtightinteractive.com/projects/related_tag_browser/app/*. You'll find a blank field; type any tag and click Go.

When the Browser starts, you'll see the tag you chose in the center surrounded by a circle of around 50 related tags. For example, if you typed in the tag *water*, you'll find related tags such as *waves*, *pool*, *waterfall*, *ocean*, and *river*. Clicking a related tag will put that tag in the center and show further related tags in the circle.

Any tag in the center includes a block of 36 recently added photos that have that tag. Clicking on a photo will bring up a larger version of the photo, as shown in Figure 2-8.

If you want to see a particular photo at Flickr, bring up the larger size and click the View Flickr Photo Page link. You'll go to that photo's detail page at Flickr in a new browser window. As you move the pointer around the application, you'll see the tags or photos zoom in or out following your focus, giving the application a very interactive feel.

Using the Related Tag Browser is a radically different experience from browsing tags at Flickr, and the Flickr API has made reinventing its interface possible. These games could never replace Flickr for browsing photos, but they show what's possible with the combination of tagging and an open platform like Flickr.

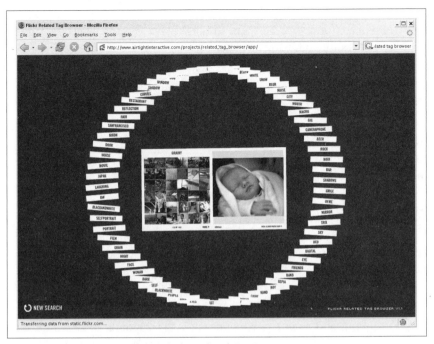

Figure 2-8. Browsing "grainy" with the Related Tag Browser

HACK #12 **Geotag Your Photos**

You can use Flickr tags to describe the exact location where you took a photo, and then display your geographically precise photos on a map.

Any location on Earth can be addressed with a set of two-number coordinates called *latitude* and *longitude*. While you probably learned about coordinates in school, chances are you haven't had much need for reading them, unless you make maps or go hiking in the wilderness. With the proliferation of handheld GPS units and online maps, though, latitude and longitude have wandered back into our everyday vocabulary—and into the world of Flickr photos.

Using Flickr's tagging features [Hack #10], some members describe the exact latitude and longitude of their positions on Earth when they took particular photos. This practice is called *geotagging*, and it can lead to fun activities such as viewing your photos on a map and finding other photos that were taken in specific locations.

The recipe for geotagging your photos is simple. Note the locations where you take your photos, upload them to Flickr, and add three specific tags to the photos with the following formats:

```
geo:lat=latitude
geo:lon=longitude
geotagged
```

The *geotagged* tag lets others know that the photo has been given a specific location, and the other two tags describe that location. As you know, latitude and longitude aren't exactly found on every street sign, so the work involved with geotagging is finding out your coordinates.

Without a GPS Unit

Your first thought might be to rush out and buy a handheld GPS unit or a cutting-edge camera with GPS built in, and those are indeed great ways to find out your latitude and longitude at any given moment. However, there are also some free mapping tools on the Web, such as Geocoder.us, that you can use to find out where you are or where you've been.

If you're taking photos in a city, your task is fairly simple: take a notebook with you and write down cross streets or addresses as you take photos. You can easily find the coordinates for just about any address or intersection—to try it out, simply browse to *http://geocoder.us* and type in an address or intersection, along with the city and state.

For example, entering the phrase "23rd and Lovejoy ST, Portland OR" will give you a map of Portland, and the latitude and longitude for that location: 45.52974, -122.698307. Once you have the coordinates, you can add your three tags to your photo taken in that location, as shown in Figure 2-9.

If you're taking photos in the Oregon backcountry, or at any location without a street address, you'll probably need to turn to GPS if you want to include precise coordinates.

With a GPS Unit

The only trick to coordinating a handheld GPS unit and a digital camera is synchronizing their clocks. By looking at EXIF data [Hack #3] embedded in your photos and coordinating it with your GPS track logs, you'll be able to tell exactly where you were when you took any of your photos.

Each GPS unit will have its own method for looking at track logs from an outing, so you'll need to consult your manual to see how you can find your tracks. Figure 2-10 shows a track log from a Garmin eTrex Vista in the MapSource software that comes with the unit. As you can see, each log includes

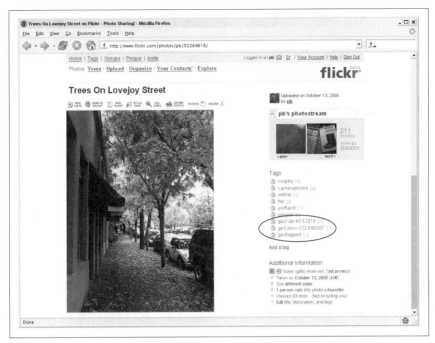

Figure 2-9. A geotagged photo at Flickr

precise points along the way and the time when the device was at each of those points.

You can then view the EXIF data for the photos you took with a program such as Exifer (*http://www.friedemann-schmidt.com/software/exifer/*), as shown in Figure 2-11, to see exactly when you took a particular photo.

Once you have the time when a particular photo was taken, you can easily match it to your coordinates at that specific time. Then, simply add your three geotags to the photo at Flickr.

Mapping Your Photos

Once you have a number of your photos geotagged, you can view those photos on a map with a couple of different applications. One quick way to see your photos displayed on a Google Map is with an application called Flyr, by Paul Downey (Flickr member psd; *http://www.flickr.com/photos/psd/*). Browse to *http://flyr.whatfettle.com* and type your Flickr username in the field labeled "within this user's photos." Click the Google Maps button, and you should see your geotagged photos appear on a map, as shown in Figure 2-12.

Figure 2-10. Viewing a GPS track log with time and coordinates

You can use the arrow buttons below the map to navigate between your geotagged photos, or return to the main form to search for geotagged photos by others in your area.

Another project, called Geobloggers (*http://www.geobloggers.com*), also displays geotagged Flickr photos on a large Google Map, and you can find geotagged photos taken around the world.

This hack has just scratched the geotagging surface. In the future, as our cell phones and cameras become location-aware, the process of geotagging photos is bound to become more automated. Until then, a bit of manual gluing between camera, coordinates, and Flickr can tie your photos to the locations where they were taken.

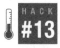

Exploit Compound Tags

H A C K
#13

Compound tags make it easier to embed application-specific data into photos.

My friend Leo created a new group called One Word (*http://www.flickr.com/groups/one-word/*), which collects photos of single words. This is similar to the groups One Letter (*http://www.flickr.com/groups/oneletter/*) and One

Figure 2-11. Viewing the time a photo was taken with Exifer

Digit (*http://www.flickr.com/groups/onedigit/*), which collect photos of individual letters and digits.

"Help!" Leo wrote to me, "What is a good way to tag the photos so they can be used for scripting purposes?"

Leo would like to enable people to make nice ransom notes **[Hack #47]** out of these photos, by identifying them with tags. Unfortunately, simply adding tags that match the words in the photos is not enough.

Why not? Consider the problem here. Let's say Leo adds the photo shown in Figure 2-13, of a gravestone containing the word *PEACE*, and tags the photo *peace*.

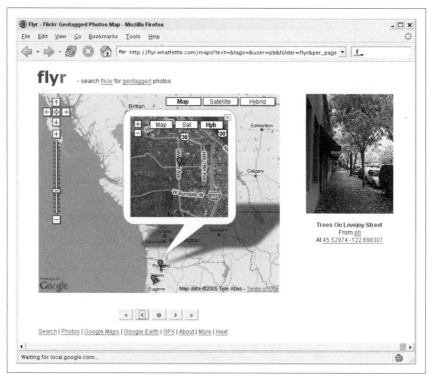

Figure 2-12. Geotagged photos on a map with Flyr

Figure 2-13. Leo's photo of a gravestone

There are lots of other photos on Flickr tagged with *peace*, and finding the one of the gravestone is going to be nigh on impossible unless you plan to write some fancy image-recognition software. And we really don't want to be wasting our computer cycles like that, do we?

"Aha!" you say, we can collect just the photos that are in the One Word group, using group membership as a filter. This will reduce the list to just photos that contain words. Or, we can add an additional tag to the photo, *word*, which will identify it as containing a word.

Certainly, we can use either of these filtering methods. However, it is probable that many of these photos will have multiple tags. Consider Leo's gravestone. It contains the following tags:

> *leo130*
> *word*
> *cemetery*
> *peace*

With multiple tags, it's difficult to know which one represents the actual word in the photo. Does the gravestone say *peace*, or does it say *cemetery*?

The trick to embedding application-specific data is to use a compound tag, such as this:

> *oneword:peace*

The tag contains a unique prefix, *oneword*, which is unlikely to collide with other tags. The colon separates the prefix from the embedded tag content.

Unfortunately, Flickr does not currently do wildcard matching on tag searches, so retrieving the embedded data from such a compound tag is a little more time-consuming than doing a tag search, because we have to retrieve them individually for each photo. Therefore, an additional grouping method, such as keeping the photos all in one group or using an additional grouping tag, is still needed.

This hack demonstrates a PHP 4 script that retrieves data from photos with compound tags. You'll need to host it on a web server.

If you haven't used the Flickr API before, check out the first few sections of Chapter 6. You might want to try some of the hacks in that chapter before using this particular script.

What You'll Need

To use the PHP script, you'll need your own Flickr API key. (See [Hack #40] for information on how to get an API key.)

You'll also need the phpFlickr scripts [Hack #41]. These scripts also make authenticating other people a snap, but you won't need authentication for this hack. You can download these scripts from *http://www.phpflickr.com*.

The Code

To retrieve all the "one-word" photos and their corresponding words, this script performs the following steps:

1. Download the list of photos that are in the One Word group.

2. For each photo, issue the flickr.photo.getInfo API method, which will produce XML containing the photo's tags, among other information.

3. Walk through the tags and find the ones with the matching prefix; then, extract the data using string manipulation.

Here's the PHP script that performs these tasks, producing a list of photos from the One Word group and their embedded words. In your favorite text editor, create a file called *retrieveTags.php*, and add the following code:

```php
<?php
// retrieveTags.php
ini_set("error_reporting ", E_ALL);

// Configuration stuff
$flickrAPIKey = "your API key";
$cachingenabled = true;
$dbUser = "user"; //database user here
$dbPass = "pass"; //database password here
$dbAddress = "localhost"; //location of database
$dbTable = "table"; //location of table, will create one if it doesn't exist

// Create new phpFlickr object
require_once("phpFlickr.php");
$f = new phpFlickr($flickrAPIKey);
if ($cachingenabled == true)
{
  $f->enableCache("db", "mysql://$dbUser:$dbPass@$dbAddress/$dbTable");
}

// By default, we use the group_id of the One Word group
// You may pass in other group_ids as parameters
$group_id = '79664019@N00';
if (isset($_GET['group_id']))
    $group_id = $_GET['group_id'];

$photos = $f->groups_pools_getPhotos($group_id);
?>

<html>
<head>
```

```
<title>retrieve tags</title>
</head>
<body>

<table><tr>

<?php
$n = 0;
foreach ($photos['photo'] as $photo) {
  if ($n && $n % 6 == 0)
      echo "</tr><tr>";

  $photos_url = $f->urls_getUserPhotos($photo['owner']);

  echo "<td><a href=$photos_url$photo[id]>";
  echo "<img border='0' alt='$photo[title]' ".
      "src=" . $f->buildPhotoURL($photo, "thumbnail") . ">";
  echo "</a><br>";

  $info = $f->photos_getInfo($photo['id'], $photo['secret']);
  foreach ($info['tags']['tag'] as $tagn => $tag)
  {
    if (strncmp(strtolower($tag['raw']),'oneword:', 8) == 0)
    {
      $embeddedData = substr($tag['raw'], 8);
      echo "$embeddedData</td>\n";
    }
  }
  ++$n;

}

?>
</td></tr></table>
</body>
</html>
```

Before uploading the script, edit the following line to use your own API key:

```
$flickrAPIKey = "your API key";
```

The phpFlickr wrapper has an optional cache feature. If you wish to use it, modify these lines to provide access information for a database on your server:

```
$cachingenabled = true;
$dbUser = "user";//database user here
$dbPass = "pass";//database password here
$dbAddress = "localhost"; //location of database
$dbTable = "table";//location of table, will create one if it doesn't exist
```

If you do not wish to use caching, turn it off by replacing this line:

```
$cachingenabled = true;
```

with this:

```
$cachingenabled = false;
```

Running the Hack

To run the hack, upload the edited script to your web server and invoke it by typing its address into your web browser:

```
http://www.yourwebsite.com/retrieveTags.php
```

You should see a list of photos from the One Word group, each with its associated word, as shown in Figure 2-14.

Figure 2-14. Photos from the One Word group, as displayed by retrieveTags.php

If no words show up beneath the photos, check the photos to make sure they have been tagged correctly.

Compound tags are used for many of the more sophisticated applications on Flickr. One of the more well-known uses is geotagging **[Hack #12]**. Longitude and latitude coordinates are attached to photos using the tags *geo: lon=longitude* and *geo:lat=latitude*, respectively. Since these photos are not all contained in a group pool, the additional grouping tag *geotagged* is also applied to each geotagged photo, so that they can be collected using a simple tag search.

See Also

- "Authenticate Yourself" **[Hack #40]**
- "Authenticate Users" **[Hack #41]**
- "Make a Ransom Note" **[Hack #47]**
- "Geotag Your Photos" **[Hack #12]**

Make a Flickr-Style Tag Cloud

#14 Adding a tag cloud to your web site is easier than getting a bad haircut!

If the illustrations in these next few pages look familiar, you've seen tag clouds before. *Tag clouds* are clusters of tags rendered with differently sized fonts to indicate the relative popularity of the tags in a dataset. Click on any of the tags to retrieve data matching that tag (such as photos).

Flickr used tag clouds first, followed by other Web 2.0 sites such as Technorati. Now, tag clouds seem to be ubiquitous, appearing on nearly every new web site that wants to join the Web 2.0 party. Perhaps that's why Jeffrey Zeldman proclaimed tag clouds "the new mullets."

Fortunately for those of us who are still mulletless, Dan Steingart has written a script that makes a tag cloud from the tags associated with your Flickr photos. The script is nearly ready to go and requires just a few minor modifications.

What You'll Need

To use Dan's script, you'll need your own Flickr API key [Hack #40].

You'll also need the phpFlickr scripts [Hack #41] (which also make authenticating other people a snap, although you won't need authentication for this hack). You can download these scripts from *http://www.phpflickr.com*.

To get started, install the phpFlickr scripts on your web site, as described in [Hack #41]. Then download and unpack Dan Steingart's cloudTagFlickr script, which is available from *http://www.allthingsalceste.com/cloudtagflickrphp/*.

The Code

In the *cloudTagFlickr.php* script, edit the following two lines to use your own username and API key:

```
$username = "flickruser"; //flickr user name here
$flickrapikey = "flickrapikey"; //key in here
```

The phpFlickr wrapper has an optional cache feature. If you want to use it, modify these lines to provide access information for a database on your server:

```
$cachingenabled = true;
$dbUser = "user"; //database user here
$dbPass = "pass"; //database password here
$dbAddress = "localhost"; //location of database
$dbTable = "table"; //location of table, will create one if it doesn't exist
```

If you do not want to use caching, turn it off by replacing this line:

```
$cachingenabled = true;
```

with this:

```
$cachingenabled = false;
```

Now, prepare a second file that makes use of *cloudTagFlickr.php* as part of a more complex web page. Call the file *testCloudTag.php* and add the following code:

```
<? require_once("phpFlickr/phpFlickr.php"); ?>

<html>
<head></head>
<body>

This is a tag cloud.

<center><table width=50%><tr><td>

<? include "cloudTagFlickr.php"; ?>

</td></tr></table></center>

That was a tag cloud.

</body>
```

Upload both files (*cloudTagFlickr.php* and *testCloudTag.php*) to your web server.

Running the Hack

First we'll test just the cloudTagFlickr script, to make sure everything is copacetic. Invoke the script by typing its address into your browser:

```
http://www.yourwebsite.com/cloudTagFlickr.php
```

If all is right with the world and your karma, you should see something like Figure 2-15.

If you have problems, you might need to turn on PHP error reporting to allow you to see what's going on. I would suggest turning off the caching feature first and getting it working without caching, since that's simpler.

Once you get it working, try the second script, which includes the tag cloud as part of a more complex web page:

```
http://www.yourwebsite.com/testTagCloud.php
```

The result looks something like Figure 2-16.

For both of these scripts, you can pass a few options to modify the appearance of the tag cloud. Here are a few examples:

Figure 2-15. Testing cloudTagFlickr.php

- You can specify the name of some other user, like my friend Special:

 http://www.*yourwebsite*.com/testTagCloud.php?name=special

- You can use the minsize and maxsize parameters to specify the range of font sizes:

 http://www.*yourwebsite*.com/testTagCloud.php?minsize=10&maxsize=64

- By default, the tags are sorted alphabetically by tag name, but you can also get a random sort:

 http://www.*yourwebsite*.com/testTagCloud.php?sort=random

 or an ascending sort by size, which looks nice:

 http://www.*yourwebsite*.com/testTagCloud.php?sort=asc

 or a descending sort by size, which looks even nicer (Figure 2-17)::

 http://www.*yourwebsite*.com/testTagCloud.php?sort=desc

Dan has also added some nice coloring options, such as grayscale:

http://www.*yourwebsite*.com/testTagCloud.php?color=greyscale

and a hot/cold color gradient:

http://www.*yourwebsite*.com/testTagCloud.php?color=hotcold

Figure 2-18 shows a final cloud tag with a random sort and hot/cold coloring.

This is a tag cloud.

ackids artcenter bronzeshield bunnies bunnyhop calarts cg
cherrypickers circles collage colorfields cool **descansogardens**
digit **dilomar05** fibonacci flickrati flower food fullmoon
generative **geotagged** graph hexodus hollywood jbum
jbummosaics kaleidoscope kra05 labunnyhop **laflickrmeetup**
lego licensing **machineproject** malibucreekstatepark
markallen mindstorms monalisa moon **mosaic** neon number
numeral oneletter onesentence **pbutton** photomosaic phyllotaxy
platinum portrait **poster** procedural robotics **santamonica**
santamonicapier sign **spiral** spring
squaredcircle striatic striaticdoesamerica
sunset sunvalley thai topf25 topf50 topv1111 tribe tulip tulips watthai
wfgna wildflowers wow yellow

That was a tag cloud.

Figure 2-16. Testing testTagCloud.php

squaredcircle mosaic geotagged
dilomar05 descansogardens poster
striaticdoesamerica santamonicapier santamonica
laflickrmeetup striatic spiral machineproject pbutton spring
lego mindstorms labunnyhop bunnyhop bunnies artcenter tribe
portrait bronzeshield wfgna generative fibonacci oneletter
malibucreekstatepark licensing kaleidoscope hollywood sign procedural
photomosaic ackids yellow robotics phyllotaxy jbum flower calarts
hexodus wow tulip sunvalley sunset onesentence neon graph flickrati cg
wildflowers watthai tulips topv1111 topf50 topf25 thai platinum numeral number
moon monalisa markallen kra05 jbummosaics fullmoon food digit cool colorfields
collage circles cherrypickers

Figure 2-17. Tag cloud with descending sort

More recently, Dan has added a new option, threshold, that allows you to
filter for more common tags. For folks who have posted enormous numbers
of photos, this makes the tag clouds much more manageable.

Figure 2-19 shows an example using Fubuki's rather large photostream,
which contains far too many tags to be shown without a tag threshold:

```
http://www.yourwebsite.com/testTagCloud.php?name=fubuki&threshold=40
```

Now that's a pithy tag cloud!

topf25 **santamonica** oneletter kra05 **striaticdoesamerica** wow
jbummosaics artcenter graph portrait tulips platinum hexodus
dilomar05 santamonicapier numeral sunvalley onesentence
mindstorms licensing **poster** bunnies neon **striatic** digit

kaleidoscope wfgna thai squaredcircle circles yellow

sunset mosaic topf50 phyllotaxy sign photomosaic monalisa
bronzeshield **pbutton descansogardens** fullmoon moon number
tribe food procedural cg collage hollywood generative robotics jbum
fibonacci calarts topv1111 **machineproject laflickrmeetup** flower

markallen cherrypickers malibucreekstatepark colorfields geotagged
labunnyhop cool lego watthai bunnyhop ackids flickrati **spiral** spring
wildflowers tulip

Figure 2-18. Tag cloud with random sort and hot/cold coloring

blue flower winter alize portrait **nyc** bar food white stone autumn circle
durham navy spring south analog night viewed bw technology abandoned
savory fleamarket **red** texture yellow statefair personalopiumden pink

systems northcarolina noir military sign decay

interestingness naval rust macro milspec collection water religion

raleigh florida green rodeo orange newyears rural southport cowboy

statue battleship southern wilmington bird ofme beach

catchycolors charleston curves sea

Figure 2-19. Essence of Fubuki, tags matching over 40 photos

See Also

- "Authenticate Yourself" [Hack #40]
- "Authenticate Users" [Hack #41]

CHAPTER THREE

Viewing Photos
Hacks 15–23

One of the most fun aspects of using Flickr is discovering amazing photographs. Clicking through the pages of Flickr is like walking through an enormous public gallery where anyone can hang a photo and have a conversation about that photo with someone else. You'll find several ways to view photos on Flickr, and getting to know the basic page layouts will help you navigate this gallery and find photos that you connect with.

One basic page you'll encounter frequently is a Flickr *photostream*. A photostream is all of the photos that belong to a specific photographer, displayed in order from newest to oldest. For example, Figure 3-1 shows a Flickr photostream for one of the authors of this book, with the most recently added photo at the top and the rest following in reverse-chronological order.

From the photostream page, you can navigate to other Flickr areas related to a particular photographer. Clicking the Profile link will reveal more information about the photographer; the Favorites link will show you photographs by other members that this user has marked as favorites, and the Sets link will show you all of the photographer's groups of photographs.

Clicking a photo in the photostream will take you to a larger version of the photograph on a photo detail page, as shown in Figure 3-2.

You can end up at a photo detail page from many locations across Flickr, and it's probably where you'll spend most of your time at Flickr. From the photo detail page, you can find all of the information related to a photo, including the title, description, tags, copyright details, date taken, and number of times the photo has been viewed. You'll also be able to see which photo sets the photo belongs to, which groups the photo has been added to, and a link to the photographer's photostream. Any comments related to the photo will be displayed below the description on the photo detail page.

Figure 3-1. Flickr photostream

Sets are another important type of page at Flickr. Sets are groups of photographs that a photographer has put together for easy viewing. Figure 3-3 shows a set called "Little Pups" by one of the authors.

A set can be used to display a group of photos—often around a specific theme—even if they weren't all uploaded at the same time.

This chapter will take you beyond the basics of Flickr photo viewing, into more advanced ways of enjoying photos available at Flickr. From integrating Flickr photo search with your browser [Hack #15] to using Flickr photos as a screensaver [Hack #22], you'll find ways to connect with photos you might not have found by simply wandering the gallery.

HACK #15 Add Flickr Search to Firefox

To find photos quickly at Flickr, you can add a Flickr option to your Firefox quick search box.

If you use the Firefox web browser (*http://www.mozilla.org/products/firefox/*), you're probably already aware of the useful search box in the upper-right

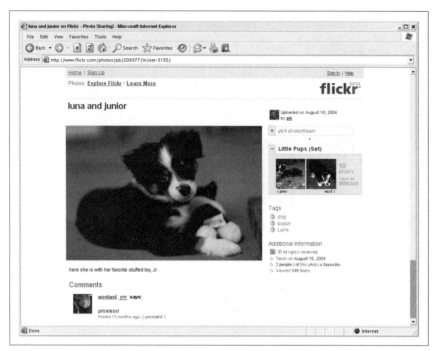

Figure 3-2. Flickr photo detail page

corner. From any page, at any time, you can simply type a search term into the box and press Enter, and the results page will come up in the browser.

Though Google is the default search engine, you can click the arrow to choose another search engine via the search box's handy drop-down menu, as shown in Figure 3-4.

The nice thing about this list of potential search engines is that you can add any search engine of your choice. In the drop-down list is an Add Engines... option that takes you to a page with more search choices, which you can install with a few clicks. The New Search Engines section of the Mozilla site contains a page with seven different Flickr-related searches you can add to the Firefox search box (Mozilla is the technology behind Firefox). These searches are primarily for searching through Flickr forums, groups, and tags.

To add a Flickr search engine, simply go to *http://mycroft.mozdev.org/ download.html?name=Flickr* and click the name of the search engine you'd like to add. A pop-up box will ask you to confirm your choice; click OK, and the new choice will be available in the Firefox search box menu. Behind the scenes, Firefox has copied a small *.src* file and icon to the *searchplugins* directory of the Firefox installation. This text file defines how the search works.

Figure 3-3. Flickr set page

Figure 3-4. Firefox quick search options

If you don't find the perfect Flickr search at the Mozilla page, it's fairly easy to build your own specialty Flickr search and add it to your list of available search engines. This hack shows you how.

Flickr Search

To search for photos at Flickr by a specific tag, a set of tags, or words in the titles and descriptions, browse to the Flickr Search page (*http://www.flickr.com/photos/search/*). Enter some words into the "tags" field or the "titles, tags and descriptions" field, and click Search. You'll see results like the ones shown in Figure 3-5.

Figure 3-5. Flickr photo search

To integrate this search into the browser, you'll first need to note the URL. A search for photos with the tags *needle* or *haystack* has this URL:

```
http://www.flickr.com/photos/search/tags:needle%2Chaystack/tagmode:any/
```

Notice that the tags are separated by the symbol %2C, the URL-encoded version of a comma. tagmode:any lets the search know you want to match any of the tags mentioned instead of all of the tags mentioned. Armed with this knowledge, you can put together your own Firefox quick search.

The Code

Because Flickr search result URLs are formatted a bit differently from the result URLs of many other search engines, the Firefox quick search format can't send queries to Flickr directly. But that shouldn't stop a Flickr hacker

from adding a quick search entry. A bit of JavaScript can do some translating, but for that you'll need a quick Flickr search proxy script.

Create a text file called *flickr-search.htm* and add the following code:

```
<html>
<head>
    <title>Flickr Proxy</title>
</head>

<body>
<script language="JavaScript" type="text/javascript">
    // Find the tags
    var esign = document.URL.lastIndexOf('=');
    var tags = document.URL.substring(esign+1);

    // Convert spaces to URL-encoded commas
    tags = tags.replace(/%20/g,"%2C");
    tags = tags.replace(/\+/g,"%2C");

    // Build the search results URL at Flickr
    var action = "http://www.flickr.com/photos/search/";
    var query = "tags:"+tags+"/tagmode:any/";

    // Send the user to Flickr with the formatted URL
    document.location = action + query;
</script>
</body>
</html>
```

This code grabs the incoming query from a Firefox search and formats a proper search response URL for Flickr. Spaces in the search are transformed into commas, just as they are on Flickr, and the search mode (match *any* or *all* tags) is set here as well.

Note that the variable query holds the tags coming in on the command line and the search mode, tagmode:any. You can change tags: to text: if you'd rather search titles, descriptions, and tags, but if you do, be sure to also change the mode to one of the text options: specify sort:relevance or sort: interesting, or leave out the sort option to sort by most recent.

Upload *flickr-search.htm* to a publicly available web server and note the URL, which should look something like this:

```
http://www.example.com/flickr-search.htm
```

Now that you have a quick Flickr-URL proxy set up, you can write the file that will tell Firefox where to send search requests. Create a file called *flickr-tags.src* in a text editor such as Notepad and add the following code:

```
# Flickr Tag Search
#
# Created September 17, 2005
```

```
<SEARCH
    version="7.1"
    name="Flickr Tags Search"
    description="Search for photos by tag at Flickr!"
    method="GET"
    action="http://www.example.com/flickr-search.htm" >

<input name="q" user>

</search>
```

As you can see, this file begins with an opening <SEARCH> tag that holds the name of the search and a brief description. Be sure to point the action attribute to your Flickr proxy URL. The <input> tag lets Firefox know that the value should come from user input, and that it should be added to the action URL.

Running the Hack

Save *flickr-tags.src* and add it to the Firefox *searchplugins* directory (on Windows, usually located at *C:\Program Files\Mozilla Firefox\searchplugins*). When you restart Firefox, you'll find a new option in the search list called Flickr Tags Search. Choose this option, and type a query such as needle haystack in the search box. If all goes well, you should see the same page of images shown in Figure 3-5.

To go the extra mile, you'll want to create a Flickr icon to accompany the search engine in the drop-down list. A good candidate is the Flickr favicon, available at *http://www.flickr.com/favicon.ico*. Copy the icon to your desktop, and transform it into a GIF or PNG file. (You can use the ICO plug-in for Photoshop, available at *http://www.telegraphics.com.au/sw/*.)

Name the file *flickr-tags.gif* or *flickr-tags.png*, and copy it to the *searchplugins* directory. The next time you start Firefox, you should see the Flickr icon next to the new search engine.

By taking some time to examine the different search options at Flickr you can usually find a way to integrate those searches into Firefox, giving you quick access to information you use frequently.

Find Pictures You Can Reuse Legally
HACK #16
Use the Flickr Creative Commons tools to find photos with special licenses or let others know how they can use your photographs.

Most of the photos you see at Flickr are copyrighted. The default license setting at Flickr is a standard copyright, which means the original photographer controls how the photo can be used. Unfortunately, you can never be

sure how a particular photographer will react if you use part or all of her work in your own project.

Say you're preparing a public presentation and you'd like to use a photo of the Liberty Bell to illustrate a point. Unless you specifically obtain permission (and possibly pay a fee), you can't be sure the creator of a photo you find on the Web won't sue you for copyright violation. While there is a legal term called *fair use* that protects some use of copyrighted materials—especially for educational purposes—it's hard to know exactly what uses fall under this legal definition, because the concept of fair use is only vaguely defined. Without contacting the photographer or owner of the copyright, there's no way to know what they'll consider a fair use of their materials.

This legal ambiguity is one of the reasons that the nonprofit group Creative Commons (CC) has made several alternative licenses available to artists who want to license their work in more specific ways than a general copyright provides. For example, you can make your work available to anyone who wants to use your photos on the condition that they're used for noncommercial purposes, but you can still require payment for any commercial use. This means someone can freely use one of your photos licensed in this way for, say, a school report, but he'd need to pay you for your photo if you he were compiling a book he intended to sell. With a Creative Commons license, everyone knows exactly how you would like your work to be used—or not used.

Using photos under a CC license is just as easy as sharing them. One compelling aspect is that as long as you're following the conditions set forth in the license, you don't need to pay a photographer to use her work—or even contact her to ask permission. If for any reason you'd like to use the work in a way that's not covered by the license, however, you'll need to get in touch with the photographer. Basically, you just need to know how the Creative Commons licenses work to make sure you're playing by the rules.

Understanding CC Licenses

Creative Commons offers four primary conditions in its licenses, in different combinations:

Attribution
> No matter how you use the work, you must give the author credit. All licenses include this condition.

No Derivatives (NoDerivs)
> You can use only exact copies of the work in its entirety, not pieces of the work arranged in a different way.

Non-Commercial
> The work can be used for a noncommercial project only.

Share Alike
> You can use the work as long as your work is licensed in the same way.

Here are the six licenses offered:

- Attribution
- Attribution-NoDerivs
- Attribution-NonCommerical-NoDerivs
- Attribution-NonCommercial
- Attribution-NonCommercial-ShareAlike
- Attribution-ShareAlike

So, if you spot a photograph of the Liberty Bell with an *Attribution-NoDerivs* Creative Commons license on Flickr, you know that the photographer has made the photo available to anyone who wants to use it for any purpose, provided that credit is given and that the photo is used in its entirety, rather than being cropped or blended with other images.

The other licenses work in a similar way. Once you know the four conditions, you can quickly determine how the photographer would like you to use her work by looking at the license.

Licensing Your Photos

By default, any images you upload to Flickr will be under the standard copyright license. However, you can switch any Public image to a Creative Commons license at any time.

To apply a license to a photo, browse to the photo's detail page and note the copyright statement—"All rights reserved"—under the Additional Information heading to the right of the photo. Click the "set privacy" link, and you'll be taken to the "Privacy and control" page [Hack #2] for that photo. On the lower-left side of the page, click the "Add a license for your photo" link to bring up the License page, shown in Figure 3-6.

Choose the license you'd like to use for the image, and click Save License. Once you've set the license, others will be able to tell which license you've selected by looking at the new copyright statement—"Some rights reserved"—under Additional Information, as shown in Figure 3-7.

If you click the "cc" logo, you'll go directly to the license page for that photo, where you can switch to a different Creative Commons license or back to the traditional copyright. Other viewers who click the "cc" logo on your photo's detail page will be taken to the Creative Commons page for that particular

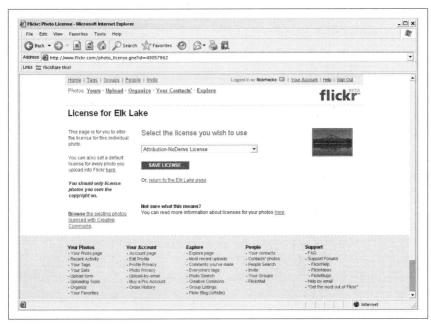

Figure 3-6. Flickr License page for a single image

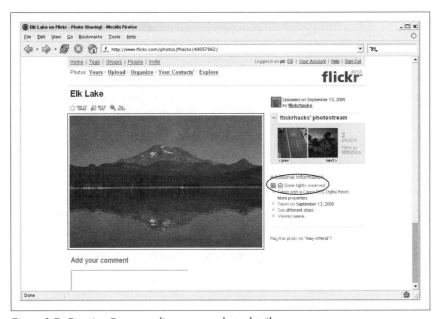

Figure 3-7. Creative Commons license on a photo detail page

license, which explains how the photo can legally be used. Figure 3-8 shows the *Attribution-NoDerivs* license page at Creative Commons.

Figure 3-8. The Attribution-NoDerivs license explanation

If you'd like to make all of your photos available under a particular Creative Commons license, you can set a global licensing preference. Under Your Account at the bottom of any Flickr page, click the "Account page" link. From your account page, click Photo Licensing under the Photo Settings heading. You'll find more information about Creative Commons licensing on this page, and a form that will let you set a default license for any photos you add to Flickr.

Finding CC-Licensed Content

As you browse photos on Flickr, you're bound to run into some of the thousands of images that are CC-licensed. Keep your eye out for the Creative Commons logo on photo detail pages.

If you're specifically looking for photos you can use in your own projects, browse to the Flickr Creative Commons page (*http://www.flickr.com/creativecommons/*). You'll find recently added photos listed by license type, as shown in Figure 3-9.

Figure 3-9. Flickr Creative Commons page

To search for images with a certain license, click the "See more" link under any of the license headings. From there, you can use the search form at the top of the page to find specific images under that particular license.

So, the next time you're looking for supporting text or photographs, you can use the Flickr Creative Commons search to find something appropriate, such as the photograph of the Liberty Bell in Figure 3-10 by Flickr member rdesai (*http://www.flickr.com/people/picdrop/*).

rdesai published the photo under an *Attribution* license, which means this member simply wants credit in exchange for use of the photo. Targeting CC-licensed material takes the ambiguity out of the standard copyright system and lets you know how you can use some of the photos you find on Flickr.

HACK #17 Subscribe to Flickr

Flickr offers RSS and Atom news feeds of much of its data, making it easy to keep track of your favorite people, groups, and tags.

News feeds have revolutionized the way people read sites on the Web. Instead of browsing hundreds of pages across the Web every day, you can use software called *newsreaders* to subscribe to news feeds and display any new information in a friendly, consistent format.

Figure 3-10. CC-licensed image of the Liberty Bell

The folks at Flickr have recognized the demand for news feeds and have made most of the data you see on the web site available in a number of different feeds. For example, if you want to track a particular photographer, you can add that person's photostream feed to your newsreader and see any new photos he posts without ever visiting Flickr.

The first step to subscribing to a Flickr feed is finding a feed URL that you can copy and paste into a newsreader. You can spot news feeds on Flickr by looking at the bottom of the page for feed options like the ones shown in Figure 3-11.

Feeds for pb's photostream Available as RSS 2.0 and Atom MY Y!

Figure 3-11. The feed options found at the bottom of many Flickr pages

News feeds are structured XML documents intended to be read by machines rather than humans. Flickr offers feeds in both RSS (Really Simple Syndication) and Atom formats; you won't notice a difference between the two, and you can use either format in most newsreaders. To copy a feed URL, right-click (Command-click on a Mac) on either the RSS 2.0 link or the Atom link and choose Copy Link Location from the menu. The feed URL will then be available on your virtual clipboard.

In addition to links to the feed URLs, you'll notice an "Add to My Yahoo!" button that lets you automatically add the feed to Yahoo!'s news portal (available at *http://my.yahoo.com*). Click the button to add that particular feed to My Yahoo!

Flickr Feeds

By far, the easiest way to add a feed to your newsreader is by copying the URL from the bottom of a Flickr page. If you pay attention to the feed URLs, though, you may be able to construct your own Flickr feed URLs in less time than it would take to browse to the appropriate pages and copy the links.

Every feed URL starts with the base `www.flickr.com` domain. From there, the feeds vary widely, but they standardize again at the end of the feed with the `format` attribute. The format can be set to `rss_200`, indicating the RSS 2.0 format, or `atom_03`, if you'd rather use the Atom 0.3 format. Changing the `format` setting of a URL changes the format of the feed.

Another important component of many Flickr feeds is an internal ID called an *NSID*. Every member and group on Flickr has an internal alphanumeric ID that represents that particular entity in the Flickr database. Many feed URLs use the NSID. If you're examining a feed URL and see a group of 12 to 15 characters that contains an @ symbol, you know you're looking at a Flickr NSID.

You can often change the contents of the feed by tweaking the attributes in the URL, either by swapping out NSIDs or changing the `format` attribute. Here's a look at the feeds available at Flickr, along with the URL format for each type of feed.

Members. To see every new public photo by a particular photographer at Flickr, you can subscribe to her photostream. The photostream feed URL requires a member NSID and looks like this:

```
http://www.flickr.com/services/feeds/photos_public.gne?id=insert member
NSID&format=rss_200
```

You can find the NSID for any particular member (including yourself) with just a little bit of work; see "Add and Track Contacts" [Hack #24] for details.

You can also keep tabs on your contacts' photos with a Flickr feed. If you'd rather see photos from your contacts in your newsreader instead of going to your contacts page (*http://www.flickr.com/photos/friends/*), you can subscribe to a URL of the following format:

```
http://www.flickr.com/services/feeds/photos_friends.gne?user_id=insert your
NSID&friends=0&display_all=1&format=rss_200
```

To keep track of comments people are posting about your photos, sub-
scribe to the recent comments feed:

```
http://www.flickr.com/recent_comments_feed.gne?id=insert your
NSID&format=rss_200
```

Substituting your contacts' NSIDs in a URL of this format provides even
more tracking fun.

Groups. Flickr groups give members a chance to congregate and discuss and
share photos. There are two types of feeds associated with groups. The first
feed is the discussion associated with the group. The discussion feed con-
tains all new posts and replies to posts. Its URL has the following format:

```
http://www.flickr.com/groups_feed.gne?id=insert group NSID&format=rss_200
```

One easy way to get the NSID for a particular group is to copy the NSID
from a feed link at the bottom of the group home page. Of course, if you
have the feed URL, you don't need to worry about finding the NSID to build
your own!

You can subscribe to the group photo pool for any given group with a URL
like the following:

```
http://www.flickr.com/groups/insert group URL name/pool/feed/?format=rss_200
```

Notice that instead of the group NSID, the photo pool feed uses the group
name. You can find the group URL name by examining the URL of the
group home page. For example, the Flickr Hacks group is available at:

```
http://www.flickr.com/groups/flickrhacks/
```

You'll find the group name (in this case, flickrhacks) at the end of the URL,
after /groups/.

Tags. To subscribe to all photos tagged with a particular keyword, you can
use the following URL format:

```
http://www.flickr.com/services/feeds/photos_public.gne?tags=insert
tag&format=rss_200
```

Imagine you're interested in photos of the moon and you want to keep track
of any photos that flow through Flickr that are tagged with *moon*. You can
simply insert the tag and subscribe to the feed, and you won't miss any new
photos.

To subscribe to multiple tags in the same feed, separate the tags with com-
mas. For example, if you want to see pictures of both the moon and the sun,
you could build the following URL:

```
http://www.flickr.com/services/feeds/photos_public.
gne?tags=moon,sun&format=rss_200
```

Note that multiple tags are an *OR* match, meaning the feed will show photos tagged with *moon* or *sun*. Unfortunately, Flickr doesn't offer *AND* matches in this feed, but you can always build your own feed **[Hack #20]** with the API.

Flickr news. While not directly related to Flickr photos and discussion, you can also subscribe to news sources about Flickr itself. You'll find RSS feeds for the Flickr Blog (*http://feeds.feedburner.com/Flickrblog/*), the Flickr Help Forums (*http://www.flickr.com/forums/help/feed/?format=rss_200*), and the Flickr News and Development Change Log (*http://flickr.com/news_feed. gne?dev=1&news=1&format=rss_200*).

Reading Feeds

If you don't already have a favorite newsreader, you'll need to choose one before you can subscribe to Flickr feeds. A newsreader can be an application you download or a web site you visit. Here's a look at some popular newsreaders and how they work with Flickr feeds.

My Yahoo! My Yahoo! (*http://my.yahoo.com*) is one of the most widely used newsreaders, though you might not even know it's a newsreader. You can add any RSS feed to My Yahoo! by clicking the Add Content link at the top of the page. From the Add Content page, click the "Add RSS by URL" link next to the Find button. Paste the feed URL into the form and click Add. Figure 3-12 shows how feed for a photographer's photostream looks at My Yahoo!

Figure 3-12. Flickr photo feed at My Yahoo!

The Flickr photo feed will be added to the narrow column of My Yahoo! content on the side of the page. You can navigate between the five latest

photos from the photographer using the arrow keys in the upper-right corner of the box. Alternately, you can click the Show All... link to see all five photos at once, as shown in Figure 3-13.

Figure 3-13. Showing all photos in a feed at My Yahoo!

As you can see, the photos are smaller, but you can see them all at a glance. You can click the edit button in the upper-right corner to change the number of photos you see, or click any of the photos to go directly to that photo's detail page at Flickr.

Bloglines. Bloglines (*http://www.bloglines.com*) is a free web-based news-reader. To add feeds, click the Add link at the top of the My Feeds page. From the Subscribe page, paste in the URL, click Subscribe, and follow the prompts for adding a feed. Once the feed is added, you'll find it in your feed list on the left side of the page, as shown in Figure 3-14.

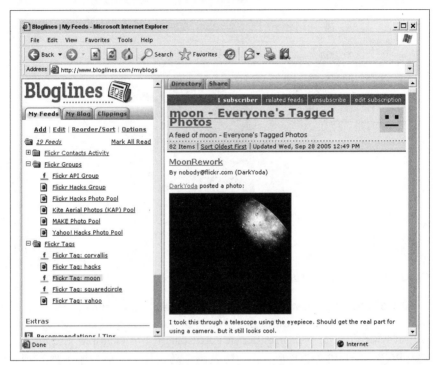

Figure 3-14. Flickr tag feed at Bloglines

Bloglines will show the title of the photo, a thumbnail, the description, and the Flickr member name of the person who posted the photo. You can click the photo or title to browse to that photo's detail page at Flickr.

NetNewsWire. Mac users can install and download a newsreader called Net-NewsWire (*http://www.ranchero.com/netnewswire/*). A free 30-day trial version is available, but at the time of this writing if you want to keep it past that it will cost you $24.95. To add a feed in NetNewsWire, click Subscribe and paste in the feed. You'll find a link to the feed in the left pane, as shown in Figure 3-15.

Entries in the feed are shown at the top right, and the entry details are shown in the bottom-right pane. NetNewsWire shows Flickr photos along with titles, descriptions, and member names.

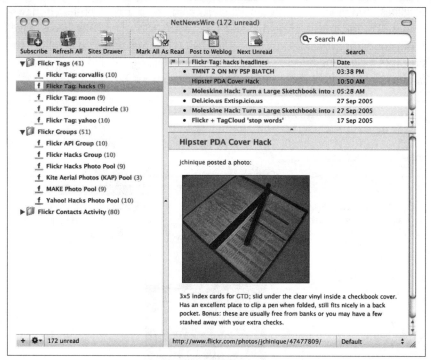

Figure 3-15. Flickr tag feed in NetNewsWire

Email and browser solutions. News feeds are being baked into the fabric of many applications, and you might be able to subscribe to Flickr feeds from within your favorite web browser or email client. For example, the Firefox web browser (*http://www.mozilla.org/products/firefox/*) supports Live Bookmarks. As you browse around Flickr with Firefox, look for an orange Live Bookmarks icon in the lower-right corner of the browser window. Click the icon to see your subscription options. Once subscribed, you'll see the titles of new posts or photos in your Bookmarks menu.

Outlook users might want to try the Newsgator (*http://www.newsgator.com*) plug-in, which lets you view news feeds as you would incoming email messages. Thunderbird (*http://www.mozilla.org/products/thunderbird/*) users have RSS subscriptions built in, but at the time of this writing, there's no HTML support, so you won't see Flickr photos.

Beyond the Basics

Flickr feeds don't cover every conceivable combination of data available at Flickr, but you can keep track of the most common bits through the built-in feeds. However, if there's some piece of data you want to track in your

newsreader that isn't immediately available in a feed, chances are good that you can roll your own feed [Hack #20] with the Flickr API. Once you're subscribed to the relevant Flickr feeds, you may never have to visit the site again!

See Also

- "Build a Custom Flickr Feed" [Hack #20]

 ## Rate Photos

An independent application called flickRate adds a rating system to Flickr, allowing you to judge which photos are funny, original, or beautiful.

A puzzling aspect of Flickr is that there's no way to rate the photographs you see. Amazon lets you rate any of its products, eBay lets you rate sellers, Netflix lets you rate movies, and there are hundreds of other sites that let you use a star or other rating system to voice your opinion about products on offer or elements of the site.

Flickr's creators have distinctly chosen not to include ratings—possibly to avoid turning it into a competition. Every photo has value to someone, and they might have felt that a ratings system wasn't the atmosphere they wanted to provide. Instead of ratings, Flickr provides a way for you to mark certain photographs you see as "favorites."

Above any photo on the photo detail page, you'll find a button that says "Add to Favorites." Click the button, and you'll essentially bookmark that picture so that you can view it anytime in the future. To see all of your favorites on one page, as shown in Figure 3-16, click the "Your favorites" link on your Flickr home page.

Even though thousands of Flickr users are adding favorites day in and day out, there's no way to see global patterns to answer this question: "Which photos across Flickr are most often added as favorites?"

Just because Flickr doesn't offer ratings doesn't mean that you can't take part in a ratings system, though. An application called flickRate by Nicolas Hoizey lives a parallel life alongside Flickr and gives Flickr users a way to rate the photos they see. flickRate also gives you a look at the highest-rated photos, determined by people using flickRate.

Rating Photos

flickRate lets you rate photos based on three criteria: Aesthetics, Originality, and Fun. Instead of giving a photo a simple star rating, you rate based on these three criteria on a scale of 1 to 7. If you think a photo is beautiful

Figure 3-16. Flickr favorites page

but lacks originality or a sense of fun, you could rate it high for Aesthetics, but low for Originality and Fun. Similarly, a photo that's very funny and unique might not be all that attractive. In this case, you could give high marks for Fun and Originality, but low marks for Aesthetics.

To start rating photos, you'll need a free flickRate account. Browse to the flickRate site (*http://flickrate.gasteropod.com*) and enter your email address and a password for your account in the form on the right side of the page. Figure 3-17 shows the flickRate home page at the time of this writing.

You'll need to validate your account by following a link sent to your email address, and then you'll just need one of the flickRate tools available on the site. These flickRate tools let you browse the Flickr site as you normally would, but they put the rating features close at hand so that you can rate any photos you see. To install one of the tools, click the Tools link at the top of the flickRate home page to browse to the tools page.

A simple option that will work for any browser is the "flickRate this!" bookmarklet. Drag the "flickRate this!" link to the links toolbar on your browser to install the bookmarklet. Then, click the bookmarklet from any Flickr photo detail page to open a flickRate pop-up window like the one shown in Figure 3-18. In the new window, choose your ratings and click Rate, and your ratings will be saved at the flickRate web site.

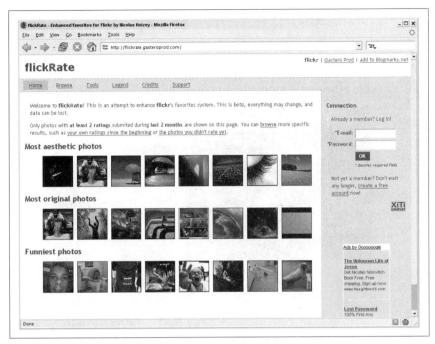

Figure 3-17. The flickRate home page

Because many browsers block pop-up windows (Firefox does by default), you might need to set your browser to allow pop-ups for the *www.flickr.com* domain in order to use the "flickRate this!" bookmarklet.

If you use the Firefox web browser and have the Greasemonkey plug-in (*http://greasemonkey.mozdev.org*) installed, you can use the flickRate Greasemonkey script, which integrates ratings directly into Flickr. Click the Greasemonkey script link from the flickRate tools page and choose Tools → Install This User Script... from the Firefox menu. With the script installed, browse to any Flickr photo detail page, and you'll see the flickRate form underneath the photo, as shown in Figure 3-19.

Once you've chosen your rating, click Rate to send the rating to flickRate, all without leaving your main browsing window.

Browsing Ratings

Half the fun of using flickRate is seeing how other users have rated photographs. As you can see on the flickRate home page in Figure 3-17, the site lists the top-rated photos in the three rating categories. You can also click

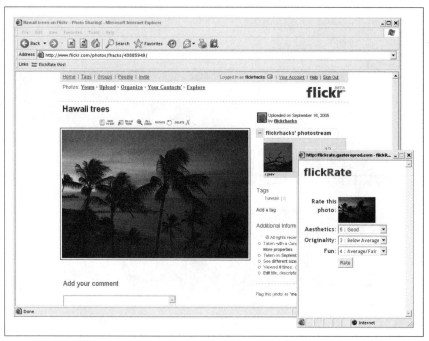

Figure 3-18. flickRate bookmarklet window

the Browse link at the top of the home page to see photos that have been rated by other users.

Keep in mind that flickRate is a completely independent program and is not affiliated with Flickr or Yahoo! in any way. In addition, flickRate is a new program that's still being tested, and there's no guarantee that it will be here tomorrow. Use flickRate for fun, but don't count on your ratings being around forever.

To see just the photos you've rated, change the value in the second drop-down box to "with only my ratings," and click OK. You'll see just the photos you've rated (which can act as a second "favorites" page to bookmark photos you'd like to view again).

Unfortunately, at the time of this writing, there's no way to look up a specific photograph to see how it's been rated, but the application is new and this feature might be added in the future. And you can always help the author develop his application by joining in the discussion at the flickRate group (*http://www.flickr.com/groups/flickrate/*).

Figure 3-19. flickRate Greasemonkey rating form

HACK #19 Travel with Flickr

Flickr Mobile puts Flickr on your cell phone, and once it's in your hand, you can use Flickr on the go.

You probably know the feeling of arriving home from traveling to find a pile of unread mail, hundreds of unread email messages, and dozens of web sites to catch up with. Without access to your home computer, you might not be able to keep up, but Flickr Mobile lets you at least drop in on Flickr once in a while to keep tabs on your friends.

To use Flickr Mobile, you'll need a cell phone that can browse the Web and a phone plan that allows data transfer. Most cell phones made within the past few years can browse the Web, but you might need to activate the ability with your cell provider.

Once you've got things working, fire up your mobile web browser, point your phone to *http://www.flickr.com/mob/*, and log in. You should see the Flickr Mobile home page shown in Figure 3-20.

Of course, viewing the standard Flickr web site on your phone could be a chore because of the large image sizes, but Flickr Mobile shows you small thumbnails only. It's not an ideal environment for viewing pictures, but it's

Figure 3-20. Flickr Mobile home page

great for keeping up with photos and comments when you're on the go. Figure 3-21 shows the photo size available at Flickr Mobile.

Only a few of the features from the standard web site are available on Flickr Mobile. You'll find your and your contacts' photos and comments, and you can browse photos from everyone. You can also upload photos from your phone [Hack #6] and add comments if you're dexterous enough to use the keypad.

The features might be limited at Flickr Mobile, but thanks to the Flickr API, with some scripting you can add your own mobile features.

Visual Dictionary

Images transcend language. A picture of a French tree is still a picture of a tree, and we all know the word for tree in our own language. This is the idea behind the Flickr Visual Dictionary, a mobile phone application by Flickr member Steeev (*http://www.flickr.com/photos/steeev/*) that lets you search for photos with specific tags and acts as a universal translator.

Imagine you find yourself in Tokyo, no cabs in sight, and you need to get across town. If you knew Japanese you could easily ask someone where you could catch a cab, but with the language barrier, you could be stuck in a

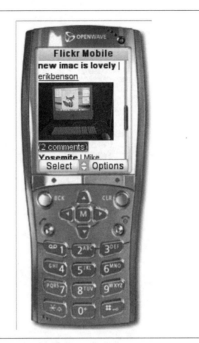

Figure 3-21. Flickr Mobile friends' photos page

tough spot. One option is to bring up the Flickr Visual Dictionary on your phone by firing up its web browser and pointing it to *http://steeev.f2o.org/flickr/search.php?mode=mobile*. Type in the word taxi, and you'll find a number of images on Flickr tagged with the word *taxi*, as shown in Figure 3-22. With a picture of a taxi in your hand, chances are you can get your message across.

If you'd like to build your own Flickr Translator so that you can customize the look and feel, the Flickr API gives you all the access you need.

The Code

The following code is a simple Flickr Translator written with PHP 5. Copy the following code to a file called *t.php* (for simple keying on a phone), and be sure to include your own Flickr API key:

```php
<?php
// t.php
// A quick mobile search for Flickr that you can use
// as a universal translator while traveling. Search
// for a word you don't know how to say in a foreign
// language on Flickr, and point to a picture of it.
//
```

Figure 3-22. Flickr Visual Dictionary by Steeev

```
// You can get an API key and read the full documentation
// for the Flickr API at http://www.flickr.com/services/api/

// Set your unique Flickr API key
$api_key = "insert your Flickr API key";

// Get the query
if (isset($_GET['q'])) {
    $query = $_GET['q'];
    $query = urlencode($query);
} else {
    $query = "";
}

// Get the page
if (isset($_GET['p'])) {
    $page = $_GET['p'];
} else {
    $page = 1;
}

print '<?xml version="1.0"?>';
?>
<!DOCTYPE html PUBLIC "-//WAPFORUM//DTD XHTML Mobile 1.0//EN" "http://www.
wapforum.org/DTD/xhtml-mobile10.dtd">
```

```
<html>
<head>
    <title>Flickr Translator</title>
    <meta http-equiv="Content-Type" content="text/html; charset=UTF-8" />
</head>
<body>
<h1>Flickr Translator</h1>
<?
if ($query == "") {
?>
<form action="t.php" method="get">
    <input type="text" name="q"/><br />
    <input type="submit" value="Search"/>
</form>
<? } else {
// Construct a Flickr query to grab contacts
$req_url = "http://www.flickr.com/services/rest/";
$req_url .= "?method=flickr.photos.search";
$req_url .= "&api_key=$api_key";
$req_url .= "&tags=$query";
$req_url .= "&tag_mode=all";
$req_url .= "&per_page=5";
$req_url .= "&page=$page";

// Make the request
$response = file_get_contents($req_url);

// Parse the XML
$xml = simplexml_load_string($response);

// Loop through the photos returned, printing them out
foreach ($xml->xpath('//photo') as $photo) {
    $id = $photo['id'];
    $secret = $photo['secret'];
    $server = $photo['server'];
    $baseURL = "http://static.flickr.com/";
    $thumbURL = "$baseURL$server/$id" . "_$secret" . "_t.jpg";
    $mURL = "$baseURL$server/$id" . "_$secret" . "_m.jpg";
    print "<a href=\"$mURL\">";
    print "<img src=\"$thumbURL\" />";
    print "</a><br />";
}

// Add navigation for next page, last page, home
$nextpage = $page + 1;
print "<a href=\"t.php?q=$query&p=$nextpage\">next 5</a>";
if ($page > 1) {
    $lastpage = $page -1;
    print "<br /><a href=\"t.php?q=$query&p=$lastpage\">last 5</a>";
} ?>
<br /><a href="t.php">new search</a>
<? } ?>
```

```
    </body>
    </html>
```

This script presents a single form field where you can type a single tag, or a number of tags separated by commas. The script contacts the Flickr API using the flickr.photos.search method and displays the photos in the response five images at a time. Each image is linked to a larger version of the image, so you can zoom in if you find the perfect picture.

Running the Hack

To run the script, upload *t.php* to a web server. Open your phone's browser and type in the URL, which will look something like this:

```
    http://www.example.com/t.php
```

You should see a blank form that you can use to enter a search term. Choose Search, and the script will display matching photos, as shown in Figure 3-23.

Figure 3-23. Flickr Translator search for "bus"

Flickr photos might not be able to form complete sentences in another language for you, but you'll at least have another tool you can use when traveling.

Build a Custom Flickr Feed

#20 Subscribe to any data available at Flickr by using the Flickr API to build a custom RSS feed with Flickr photos.

If you already use an RSS newsreader, you know how convenient it is to have information come to you via RSS rather than seeking it out. You can have Flickr content delivered to you via a news feed [Hack #17], and you can also use Flickr RSS feeds to publish photos on other web sites [Hack #7]. The RSS format is so popular that you'll find many existing tools that can consume the format.

Custom Feeds

Flickr offers a number of news feeds for most of the data you'll find on the site, but you might run into times when you want to build a custom RSS feed that Flickr doesn't provide. Here's a quick look at some situations where you might want a custom feed:

To view a different image size
 Flickr offers small thumbnails in its news feeds—if you'd rather see large images or the smaller square thumbnails in your newsreader, you can build your own feed.

To add extended data to a feed
 If you're interested in the extended camera data [Hack #3] that is stored with some photos, you might want a feed that includes this data (it's not available in the default Flickr feeds). You can also add other bits of information, such as member icons, license information, and details about the sets to which a photo belongs.

To control the number of items
 Flickr provides the 10 most recent photos in its photo-related news feeds, but in a custom feed you can include any number you'd like by specifying a different number of photos as you make your API call.

To control the look and feel
 A custom feed gives you complete control over how titles, descriptions, and photographers' names appear in the feed. If you want to show a photo's tags in the feed description, you can. If you'd like to view photos in a particular way in your newsreader, you'll need to create a custom feed.

To follow nonfeed data
 Flickr doesn't provide information about photos marked as favorites [Hack #25] in an RSS feed. If you'd like to subscribe to someone's favorites or follow other types of data that aren't available in the default news feeds, you can build your own.

This hack presents a very basic way to build a custom Flickr feed with Perl. You can use the code as a starting point for creating your own custom feeds to track your favorite Flickr data.

The Code

The following script contacts the Flickr API with the `flickr.photos.getContactsPublicPhotos` method and creates an RSS feed with the list of photos. The result is similar to the feed associated with the Your Contacts' page (*http://www.flickr.com/photos/friends/*), but this custom feed displays large images instead of the standard small thumbnails.

You'll need to make sure you have two nonstandard Perl modules before you begin: `LWP::Simple` (*http://search.cpan.org/~gaas/libwww-perl-5.803/lib/LWP/Simple.pm*) contacts the API, and `XML::Simple` (*http://search.cpan.org/~grantm/XML-Simple-2.14/lib/XML/Simple.pm*) parses the response. You'll also need to add your NSID and Flickr API key, both of which you can find at the Flickr API site (*http://www.flickr.com/services/api/*).

Once the prerequisites are in place, copy the following code to a file called *flickr_contact_feed.pl*:

```perl
#!/usr/bin/perl
# flickr_contact_feed.pl
# Builds a custom RSS feed of contacts' photos for a
# given Flickr user NSID.
#
# You can get an API key, find your NSID, and read the
# full documentation for the Flickr API at:
#
# http://www.flickr.com/services/api/

use strict;
use LWP::Simple;
use XML::Simple;

# Set your NSID and API key
my $nsid = 'insert your NSID';
my $api_key = 'insert your Flickr API key';

# Start the RSS file
print <<"END_HEADER";
<?xml version="1.0"?>
<rss version="2.0">
<channel>
<title>My Contacts' Photos</title>
<link>http://www.flickr.com/photos/friends/</link>
<description>Photos from my contacts at Flickr</description>
<language>en-us</language>
END_HEADER
```

```
# Construct a Flickr Query with only required options
my $language = "en";
my $req_url = "http://www.flickr.com/services/rest/";
    $req_url .= "?method=flickr.photos.getContactsPublicPhotos";
    $req_url .= "&api_key=$api_key";
    $req_url .= "&user_id=$nsid";

# Make the request
my $flickr_response = get($req_url);

# Parse the XML
my $xmlsimple = XML::Simple->new( );
my $flickr_xml = $xmlsimple->XMLin($flickr_response);
my $photolist = $flickr_xml->{photos}->{photo};

# Loop through the items returned, adding as items to feed
foreach my $id (keys %{$photolist}) {
    my $secret = $photolist->{$id}->{secret};
    my $server = $photolist->{$id}->{server};
    my $owner = $photolist->{$id}->{owner};
    my $username = $photolist->{$id}->{username};
    my $title = $photolist->{$id}->{title};
    my $img_src = "http://static.flickr.com/$server/$id\_$secret\_m.jpg";
    my $img_tag = "&lt;img src=\"$img_src\" /&gt;";
    my $link = "http://www.flickr.com/photos/$owner/$id/";
    print "<item>\n";
    print "  <title>$title</title>\n";
    print "  <link>$link</link>\n";
    print "  <description>$img_tag &lt;br&gt; photo by $username</
description>\n";
    print "</item>\n";
}
print "</channel>\n";
print "</rss>";
```

The five print commands toward the end of the script determine how RSS items will appear in your newsreader. As you can see, each RSS item includes a title, link, and description. This script sets the photo title as the item title and a link to the photo as the RSS item link. The description includes the HTML necessary to display the photo and a line that indicates who took the photo.

It's important to note that the HTML is escaped for RSS. This basically means that HTML brackets have been turned into their HTML entity equivalents: < becomes < and > becomes >, which means that, for example, a standard
 tag is represented as
. Escaping HTML makes for some confusing code, but it ensures that most RSS readers will be able to display the HTML properly.

Running the Hack

You can run the code from a command prompt, piping the results to an XML file:

```
flickr_contact_feed.pl > flickr_contact_feed.xml
```

Upload the output file to a publicly addressable web site and note the URL, which should look like this:

```
http://www.example.com/flickr_contact_feed.xml
```

With your URL in hand, you can add the new feed to your favorite newsreader. Figure 3-24 shows the feed in the Bloglines web-based newsreader.

Figure 3-24. Viewing a custom Flickr feed with Bloglines

To keep the custom feed up to date, you'll want to generate the file on a regular schedule. You can use *cron* on Unix-based machines or the Windows Scheduler for Windows.

This hack should give you a starting point for building your own feeds based on data from the Flickr API. With a few minutes of scripting, you can have much more control over your Flickr subscriptions.

See Also

- "Subscribe to Flickr" [Hack #17]
- "Feed Your Latest Photos to Your Web Site" [Hack #7]

HACK #21 Set Random Desktop Backgrounds

Use the Flickr API to spin a virtual roulette wheel, and let fate choose your desktop background image based on a Flickr tag you specify.

People love to change their desktop backgrounds. It's one of the first skills that new computer users learn, and even old computer pros tend to fiddle with their desktop background images on a fairly regular basis. Browsing through the aisles of your local computer shop, you'll find CDs full of scenic imagery that you can use as desktop background pictures. But why shell out money for custom backgrounds when you can use Flickr as your source for background images?

As you're browsing around Flickr, you might spot an image you'd like to use as a desktop background. But if you're like most people, your desktop is set at a resolution of 1024×768 pixels or higher—quite a bit bigger than the 500-pixel-wide images you see at Flickr. If you stretch the image to fit your desktop, you may end up with a blurry, distorted mess, rather than the scenic vista you were hoping for.

Luckily, many people don't resize their images [Hack #4] before they upload them to Flickr, and you can often find larger versions of the images you see at Flickr by clicking the All Sizes button on a photo detail page (Figure 3-25).

Clicking the All Sizes button takes you to the "Available sizes" page, which defaults to showing you a large version of the image, as shown in Figure 3-26.

If you're lucky, you'll find an image as big as or bigger than your current desktop size. Right-click anywhere on this larger image and choose "Set as Wallpaper" in Firefox or "Set as Background" in Internet Explorer. Minimize any open windows, and check out your new background image.

This process is easy to follow anytime you're ready for a new background, but with a little scripting, you can speed things up. This hack automatically sets a random desktop background image based on a Flickr tag you provide.

Backgrounds for Windows

This hack contacts Flickr via its web services API, performs an image search, chooses one of the photos at random, downloads the image, and sets the

Figure 3-25. The All Sizes button on a Flickr photo page

Figure 3-26. The All Sizes page showing a larger version of a photo

photo as your desktop background. Because Windows expects desktop backgrounds to be bitmap (*.bmp*) images and Flickr images are JPEGs, the script will also have to convert the image from a JPEG to a bitmap.

This conversion process is beyond the scope of the Windows scripting environment, and this hack uses the third-party software ImageMagick to convert JPEG files to bitmaps. To install ImageMagick, browse to *http://www. imagemagick.org* and click the Binary Releases link on the left side of the page. Scroll down to the section labeled Windows Binary Release, and choose the latest version. Download the file, follow the installation prompts, and be sure to check the option to install the ImageMagick control for Windows scripting. Once you're finished installing the program, you'll be set to run the script.

The code. Add the following code to a file called *Flickr_Background.vbs*:

```
'-----------------------------------------------------
' Flickr_Background.vbs
'
' Finds a random image via the Flickr API and
' sets it as the desktop background image.
'
' This script depends on Image Magick, which you
' can download here:
'
' http://www.imagemagick.org
'
' Edit the following line to change the "theme" of
' your background. Double-click this file to run it.
'-----------------------------------------------------
strTag = "cityscape"

'-----------------------------------------------------
' Your Flickr API key
'-----------------------------------------------------
Const API_KEY = "insert your Flickr API key"

'-----------------------------------------------------
' Using the query, find a random image via Flickr
'-----------------------------------------------------
'Construct a Flickr search query
strReqURL = "http://www.flickr.com/services/rest/" & _
            "?method=flickr.photos.search" & _
            "&api_key=" & API_KEY & _
            "&tags=" & strTag & _
            "&tag_mode=all" & _
            "&per_page=200"

'Start the XML Parser
Set MSXML = CreateObject("MSXML.DOMDocument")
```

```
'Set the XML Parser options
MSXML.Async = False

'Make the request
strResponse = MSXML.Load(strReqURL)
If MSXML.parseError.errorCode <> 0 Then
    WScript.Echo("Error! " + MSXML.parseError.reason)
End If

'Make sure the request loaded
If (strResponse) Then

    'Find the total available
    Set Photos = MSXML.SelectSingleNode("//photos")
    intTotal = Photos.getAttribute("total")
    intPerPage = Photos.getAttribute("perpage")
    intMax = intPerPage
    If CDbl(intTotal) < CDbl(intMax) Then
        intMax = intTotal
    End If

    'Pick a random number
    Randomize
    RandomNumber = Int(intMax * Rnd + 1)

    'Load the results
    Set Results = MSXML.SelectNodes("//photo")

    'Loop through the results
    For x = 0 to Results.length - 1
    If x = RandomNumber Then
        strImageID = Results(x).getAttribute("id")
        strImageSecret = Results(x).getAttribute("secret")
        strImageServer = Results(x).getAttribute("server")
        strImageTitle = Results(x).getAttribute("title")
        strImageURL = "http://static.flickr.com/"
        strImageURL = strImageURL & strImageServer & "/"
        strImageURL = strImageURL & strImageID & "_"
        strImageURL = strImageURL & strImageSecret & "_"
        strImageURL = strImageURL & "o.jpg"
    End If
    Next

    'Unload the results
    Set Results = Nothing
    Set ResultSet = Nothing

End If

If strImageURL = "" Then
    WScript.Echo "No image found! Try again."
    WScript.Quit
End If
```

```
'------------------------------------------------------
' Save the image locally to the root c:\ folder
'------------------------------------------------------
' MsgBox("Downloading " & strImageTitle & "...")

strImageFile = Replace(strTag,",","_")

Set fs = CreateObject("Scripting.FileSystemObject")
Set xmlhttp = CreateObject("Msxml2.SERVERXMLHTTP")
xmlhttp.Open "GET", strImageURL, false
xmlhttp.Send(Now)

fs.CreateTextFile "c:/" & strImageFile & ".jpg"

' Create a Stream instance
Dim objStream
Set objStream = CreateObject("ADODB.Stream")

' Open the stream
objStream.Open
objStream.Type = 1 'adTypeBinary
objStream.Write xmlhttp.responseBody
objStream.SaveToFile "c:/" & strImageFile & ".jpg", 2 'adSaveCreateOverwrite
objStream.Close
Set objStream = Nothing

Set xmlhttp = Nothing
Set fs = Nothing

'------------------------------------------------------
' Convert the JPEG to a bitmap
'------------------------------------------------------
Set Converter = CreateObject("ImageMagickObject.MagickImage.1")
Converter.Convert "c:/" & strImageFile & ".jpg", "c:/" & strImageFile & ".
bmp"
Set Converter = Nothing

'------------------------------------------------------
' Set the newly created bitmap to background
' and refresh
'------------------------------------------------------
strRegRoot = "HKEY_CURRENT_USER\Software\Microsoft\" & _
             "Internet Explorer\Desktop\General\"
strRegRoot2 = "HKEY_CURRENT_USER\Control Panel\Desktop\"

Set Shell = WScript.CreateObject("Wscript.Shell")
Shell.RegWrite strRegRoot & "BackUpWallpaper", "c:\" & strImageFile & ".bmp"
Shell.RegWrite strRegRoot & "Wallpaper", "c:\" & strImageFile & ".bmp"
Shell.RegWrite strRegRoot2 & "Wallpaper", "c:\" & strImageFile & ".bmp"
Shell.Run "%windir%\System32\RUNDLL32.EXE user32.
dll,UpdatePerUserSystemParameters",1,True
Set Shell = Nothing
```

Note that the first line of the script sets the theme of your desktop background. If you'd like something different from images tagged with *cityscape*, simply edit this line to whatever you'd like to see.

Running the hack. Before you run the script, make sure you understand the risks. This will replace your current desktop background with a random image from Flickr, so be sure you have a backup of your current desktop background image before you proceed; otherwise, you might lose it forever.

When you're ready to run the script, double-click the script file or run it from the command line:

```
Flickr_Background.vbs
```

You should see your desktop background change. If you're not happy with the image, run the script again. You can keep running the script until you settle on something you like—for example, the cityscape in Figure 3-27.

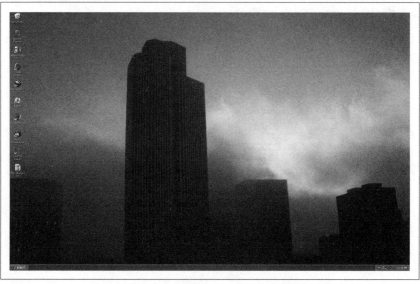

Figure 3-27. A random image tagged with "cityscape" as a background

If you want the random fun to continue, you can place this script in your *Startup* folder, and you'll find a new background every time you log into your machine. You can find your *Startup* folder at *C:\Documents and Settings\[Your Name]\Start Menu\Programs*.

Backgrounds for Macs

Windows users aren't the only ones who can experience the fun that is random desktop backgrounds. If you just use Mac OS X to browse the Web

and do a bit of word processing, you might not be aware that there's a powerful Unix-based operating system under the hood. In fact, in addition to the Mac scripting language, AppleScript, Mac OS X ships with Perl installed. This hack takes advantage of both Perl and AppleScript to bring some randomness to your desktop.

The code. Perl is a great language for making HTTP requests and working with the responses. But it's not as good as AppleScript at performing Mac system tasks, such as setting a desktop image. Luckily, a Perl module called Mac::AppleScript lets you execute AppleScript code from within your Perl scripts. To install this module, you'll need to have the Mac Developer Tools (*http://developer.apple.com/tools/download/*) installed. Once it's installed, open a Terminal window and type the following command:

```
sudo cpan Mac::AppleScript
```

Before you begin, you'll need to install a couple more Perl modules. As with many other Perl examples in this book, you'll need LWP::Simple (*http://search. cpan.org/~gaas/libwww-perl-5.803/lib/LWP/Simple.pm*) and XML::Simple (*http:// search.cpan.org/~grantm/XML-Simple-2.14/lib/XML/Simple.pm*) to make Flickr API requests and parse the responses.

Once the prerequisites are installed, add the following code to a file named *flickr_background.pl*:

```perl
#!/usr/bin/perl
# flickr_background.pl
# Accepts a tag and sets a Mac desktop background
# with an image from Flickr that has that tag.
# Usage: flickr_background.pl <tags>

use strict;
use LWP::Simple;
use XML::Simple;
use Mac::AppleScript qw(RunAppleScript);

# Insert your Flickr API key
my $api_key = "insert your Flickr API key";

# Grab the incoming search query
my $tags = join(' ', @ARGV) or die "Usage: flickr_background.pl <query>\n";

# Construct a Flickr search query
my $req_url = "http://www.flickr.com/services/rest/";
    $req_url .= "?method=flickr.photos.search";
    $req_url .= "&api_key=$api_key";
    $req_url .= "&tags=$tags";
    $req_url .= "&tag_mode=all";
    $req_url .= "&per_page=200";
```

```perl
# Make the request
my $response = get($req_url);

# Parse the XML
my $xmlsimple = XML::Simple->new( );
my $xml = $xmlsimple->XMLin($response);

# Grab a random image ID from the results
my @IDs;
my $photolist = $xml->{photos}->{photo};
foreach my $id (keys %{$photolist}) {
    push @IDs, $id;
}
my $index = rand @IDs;
my $id = @IDs[$index];

# Use the random ID to build a photo URL
my $server = $photolist->{$id}->{server};
my $secret = $photolist->{$id}->{secret};
my $url = "http://static.flickr.com/";
$url .= "$server/$id" . "_$secret";
$url .= "_o.jpg";

# Save the image locally
my $time = time;
my $image = get($url);
open IMAGE,">$tags-$time.jpg";
print IMAGE $image;
close IMAGE;

# Set the image as the current desktop background
RunAppleScript(qq(
tell application "Finder"
    set desktop picture to document file "Aqua Blue.jpg" of folder "Desktop
Pictures" of folder "Library"
end tell));
RunAppleScript(qq(
tell application "Finder"
    set desktop picture to document file "$tags-$time.jpg"
end tell));
```

As you can see, the last few lines of the script are AppleScript inside of Perl. The first line of AppleScript sets a preexisting image as the background, and the second line sets the newly created file as the background. This ensures that the background will refresh when you run the script.

Running the hack. You can run the script from the command line, adding a desktop theme, like this:

```
perl flickr_backgound.pl tags
```

Running the script with the *countryside* tag, for example, will set your background to something that looks like Figure 3-28.

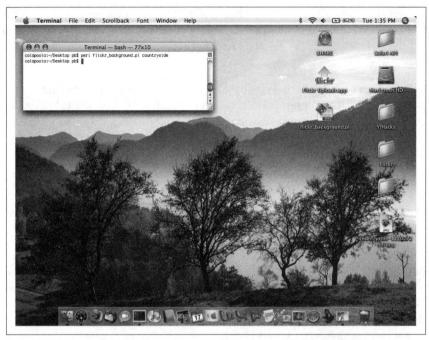

Figure 3-28. A random image tagged with "countryside" as a background

While the idea of leaving your desktop background to chance might seem frightening, you might be surprised at the artistic and truly background-worthy images people have posted to Flickr. This hack is a great way to spice up your desktop.

 HACK #22 **Build a Flickr Screensaver**

With a bit of Perl and the built-in photo screensavers available in Mac OS X or Windows XP, you can create your own screensaver that shows photos from Flickr.

Along with desktop backgrounds [Hack #21], screensavers have always been a feature of personal computers that people feel comfortable changing, tweaking, fiddling with, and hacking for fun. And with a bit of scripting, you can create a photo slideshow screensaver with more meaningful images than flying toasters.

This hack relies on the photo screensavers that ship with Windows XP and Mac OS X. Each screensaver lets you specify a directory on your computer that contains images, and displays those images on your screen during your idle computer moments. This hack uses Perl and the operating system's scheduling features to subscribe to a Flickr RSS feed [Hack #17] with images. At

regular intervals, the script downloads all of the images from a specific feed into a special directory that your screensaver can use.

The Code

This code works on both Windows XP and Mac OS X systems, but you'll need a couple of components that aren't installed by default: LWP::Simple (*http://search.cpan.org/~gaas/libwww-perl-5.803/lib/LWP/Simple.pm*) handles web requests, and XML::Simple (*http://search.cpan.org/~grantm/XML-Simple-2. 14/lib/XML/Simple.pm*) parses the Flickr RSS feed.

Copy the code to a file called *flickr_screen.pl*, and put it in a local folder path where the images will be stored. On Windows XP, you should specify a drive and folder, such as *C:\FlickrScreen*. On Mac OS X, you'll want to specify a full path, such as */Users/pb/Photos/FlickrScreen*.

You'll also need to specify one of the many Flickr RSS feeds available on the site. Group photo pools work especially well—if you need a feed to test, try the Kite Aerial Photography group pool feed at *http://www.flickr.com/groups/ kiteaerialphotography/pool/feed/?format=rss_200*. Remember that the code is designed to read RSS 2.0 feeds only, so be sure to choose the correct format as you're scouting feeds across Flickr.

```perl
#!/usr/bin/perl
# flickr_screen.pl
# Downloads images in a Flickr RSS feed into a local folder
# you can use for a screensaver.

use strict;
use LWP::Simple;
use XML::Simple;

# Set screensaver directory
my $dir = "insert path to a local folder";

# Set Flickr RSS feed (with photos)
my $rss_feed = "insert Flickr RSS feed URL";

# Make the request
my $response = get($rss_feed);

# Parse the XML
my $xmlsimple = XML::Simple->new( );
my $rss = $xmlsimple->XMLin($response);

# Loop through results
foreach my $item (@{$rss->{channel}->{item}}) {
    my $title = $item->{title};
    my $photourl = $item->{'media:content'}->{url};
    my $link = $item->{link};
```

```
my $photog = $item->{'media:credit'}->{content};
my $guid = $item->{guid}->{content};
if ($guid =~ m!photo/(\d{7,10})!) {
    $guid = $1;
}
my $file = "$dir/$guid.jpg";
# If the file doesn't already exist, write it
unless (-e $file) {
    getstore($photourl,$file);

    # And print out the photo info for later reference
    print "Saved $title by $photog\n$link\n\n";
}
}
```

This code reads the feed you specified and downloads the images specified by each URL in the <media:content> element within each <item> in the feed. This is the largest size for the image available at Flickr. As it downloads each photo, the script prints the photo title, the photographer name, and a link to the photo detail page to standard output. You can use this to log your downloads and go back to find and perhaps comment on particularly interesting photos you see.

Running the Hack

How to run the script is dependent on which operating system you're using.

On Mac OS X. To set up your screensaver on Mac OS X, first create your Flickr screensaver photo folder. It can be anywhere, but your *Pictures* directory is a memorable place. Call the new folder *FlickrScreen*, and be sure to set the full path to that folder in *flickr_screen.pl*.

To get the ball rolling, open up a Terminal window (Applications → Utilities → Terminal), change to the directory where *flickr_screen.pl* is located (using the cd command), and run the script from the command line, like this:

```
perl flickr_screen.pl
```

This will download and add several photos to your *FlickrScreen* folder. You can now set up your screensaver. Select System Preferences from the Apple menu, and choose Desktop & Screen Saver. Click the Screen Saver button, and then click the Choose Folder... option. Select your *FlickrScreen* folder in your *Pictures* directory, and you should see the pictures you've just downloaded appear in the preview window, as shown in Figure 3-29.

Your screensaver is now set, and it will display the photos you downloaded. To keep the photos fresh and up-to-date, though, you'll want to run

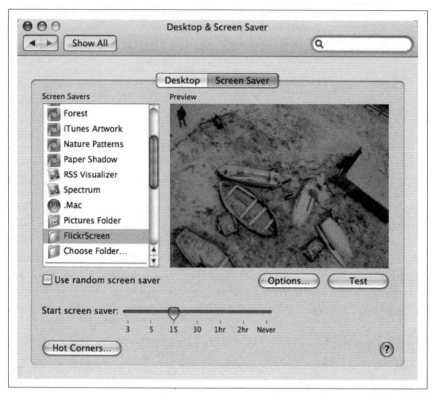

Figure 3-29. Setting a Mac screensaver folder

flickr_screen.pl on a regular schedule. To set a schedule, you can use the command-line application *cron*. Keep your Terminal window open, and type the following command:

```
crontab -e
```

This opens your scheduled tasks for editing. To run the script every day at 8 a.m. and keep a log of the photos the script downloads, you could enter something like this:

```
0 8 * * * perl /Users/pb/Desktop/flickr_screen.pl >> /Users/pb/Desktop/
screenlog.txt
```

Keep in mind, though, that the log file will fill up as the script runs every day. You might want to periodically open the log and delete old entries.

Be sure to include your own paths for the files. *cron* is a bit cryptic, but it works well for setting recurring background tasks. Now that the job is set, you can forget about the scripting and let *flickr_screen.pl* download photos from Flickr on a regular basis.

The default command-line editor on Mac OS X is *vim*, and it can be an intimidating interface if you're not familiar with it. To save your *cron* entry, hit the Esc key and then press i to insert some text. Add your *cron* entry, and when you're done, hit Esc again. Then type :wq to save (write) the file and quit.

When the script runs, it will save information about the photos it finds to *screenlog.txt*, and you can use this information to trace an interesting photo back to its detail page at Flickr.

On Windows XP. The process for setting up the screensaver on Windows is almost identical to the Mac OS X version. Unlike the Mac, however, Windows XP does not come with Perl installed, so you might need to do a bit more work to get started. If you want to run Perl on Windows, you can download the free ActivePerl for Windows by ActiveState from *http://www. activestate.com/Products/ActivePerl/*.

Once Perl is installed, create your new screensaver folder somewhere in your filesystem; *C:\FlickrScreen* is a good place. Run *flickr_screen.pl* from a command line (Start → Programs → Accessories → Command Prompt) to download some photos:

```
perl flickr_screen.pl
```

Now that some photos exist in the folder, set your screensaver by right-clicking any empty space on your desktop and clicking Properties. Choose the Screen Saver tab, and select My Picture Slideshow from the list of screensavers. Click the Settings button, and you should see the options pictured in Figure 3-30.

Under the "Use pictures in this folder" heading, click Browse and choose the Flicker screensaver folder you created. Click OK, and your screensaver will now show the photos you just downloaded from Flickr.

To run the script on a regular schedule, you can use the Windows version of *cron*, called *schtasks*. Go back to your command prompt, and type the following command:

```
schtasks /create /tn "FlickrScreen" /tr "perl c:\flickr_screen.pl >> c:\
screenlog.txt" /sc daily /st 08:00
```

This command tells Windows to run *flickr_screen.pl* every day at 8 a.m. and save the output to a file called *screenlog.txt*.

It takes a bit of work on either system to set up a custom Flickr screensaver, but you'll be rewarded with fresh images on a daily basis—though, sadly, no flying toasters. However, the Toaster Group pool (*http://www.flickr.com/ groups/toaster/pool/*) on Flickr might come close.

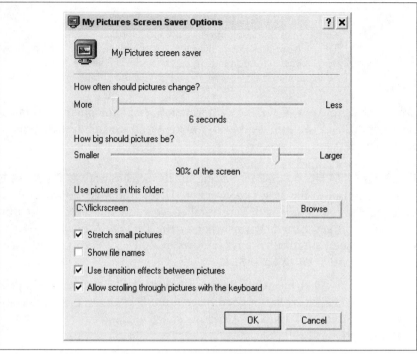

Figure 3-30. Windows XP Screen Saver options

View Flickr Photos on TiVo

#23 Flickr Central for TiVo's Home Media Engine lets you view Flickr photos on your television.

More and more, we share digital versions of the pictures we take. While it's easy to pass around printed photos in any setting, showing digital photos to friends and family can be trickier. Most computers are set up for one user at a time, and it's not always easy to crowd a bunch of people around the monitor.

However, our televisions are almost always set up to accommodate a good number of comfortable viewers. And if you've already joined the digital television age with TiVo, with a bit of setup you can browse Flickr photos on your TV.

What You Need

Flickr on TV is possible thanks to TiVo's release of the Home Media Engine (HME), a way for outside developers to create little programs that run on

TiVo. Developers have created games, weather applications, and even RSS readers that you can use through your TV. The HME system uses your home PC to run the applications and a home network to transfer data, and the TiVo displays the applications on your television.

To run HME, you'll need a TiVo Series 2 that's connected to your home network. If you're using the phone line to update your program data, you'll need to add a network adapter to your TiVo setup. You'll find a list of compatible adapters at *http://customersupport.tivo.com/knowbase/root/public/ tv2006.htm?*. Figure 3-31 shows a TiVo Series 2 with a Linksys WUSB12 wireless network adapter.

Figure 3-31. A Series 2 TiVo with a wireless network adapter

> In addition to running HME applications, a network adapter will allow you to download the television schedule over your Internet connection instead of your phone line. That means no more battles with TiVo over who gets to use the phone!

Once your TiVo is on your home network, you'll want to be sure you can run HME applications. Browse to the HME project page (*http://tivohme. sourceforge.net*), and click the HME Quick Start link under the For Hobbyists heading. Take a look at the system requirements, download HME Quick Start, and follow the instructions. If you run HME Quick Start and see a new option under your TiVo Music, Photos & More menu, you'll know you have everything set to run Flickr Central.

Starting Flickr Central

Once you've confirmed that your TiVo can run HME applications, download the Flickr Central application from *http://home.comcast.net/~major_clanger/TiVo/*. Unzip the file, open the new *FlickrCentral* directory, and double-click *run.bat*. You should see the Flickr Central launcher shown in Figure 3-32.

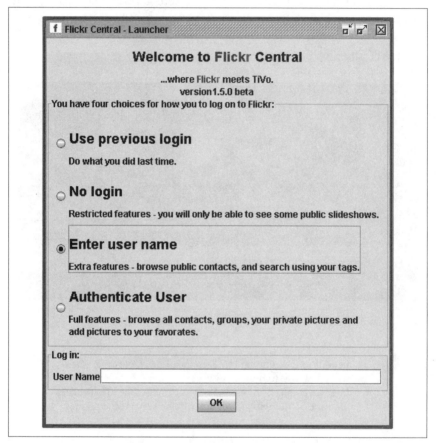

Figure 3-32. Flickr Central launcher

To use all of the features available, choose the Authenticate User option and add Flickr Central to your list of approved applications. To have a few more features, you can enter your Flickr username, or, for a bare-bones version, choose the "No login" option (but be aware that with this option you'll be able to view only a couple of public photo sets).

Once Flickr Central is running, you should see "Welcome to Flickr Central" with a note that the application is running. Now, leave your PC, turn on your TV, and hit the TiVo button on your remote.

Navigating Flickr Central

From the main TiVo menu, choose Music, Photos & More. You should see the option for Flickr Central at the top of the page. Select Flickr Central to bring up the initial menu shown in Figure 3-33.

Figure 3-33. Flickr Central main menu

You can access much of what you find on the Flickr web site through Flickr Central, though navigation is much different. Click Photos to see the options for viewing photos, as shown in Figure 3-34.

The Everyone's option will show you the photos found at *http://www.flickr.com/photos/* (i.e., the most recent photos from anyone posting to Flickr). The Contacts' option will show you photos from your contacts, like you'd find at *http://www.flickr.com/photos/friends/*.

Figure 3-34. The Flickr Central Photos menu

You can also view your own photos in order or at random and browse photos you've marked as favorites. Choosing the Tags option will take you to a menu where you can enter any tag you'd like to search for, as shown in Figure 3-35.

Each photo that you view takes up the entire television screen; there are no thumbnail views of photos in Flickr Central. While you're browsing a photostream or set, you can click the right or left arrow on the remote control to change the direction of browsing. The up arrow ends your trip through the photos.

If you click the info button, you'll get a screen that includes the title, the description, and the name of the Flickr member who posted the photo, as shown in Figure 3-36.

From the main menu, you can also view the latest photos posted to your groups, view your photo sets, or browse a list of your contacts, as shown in Figure 3-37.

You can use Flickr Central to monitor any new Flickr activity, but it doesn't work well for participation. For example, you can't post photos, comment on others' photos, or add notes or tags to any photos.

Figure 3-35. Entering a tag at Flickr Central

Figure 3-36. Viewing photo details with Flickr Central

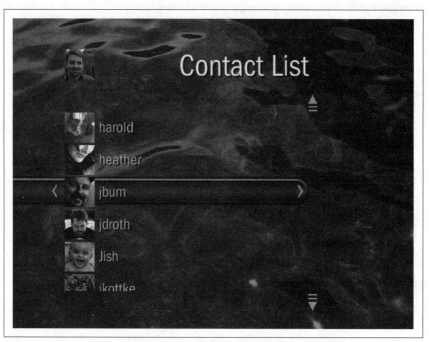

Figure 3-37. Browsing Flickr contacts at Flickr Central

Despite these limitations, Flickr Central is a great way to view what's happening on Flickr on TV, and it might be handy for family gatherings as a new way to share your photos.

Community

Hacks 24–29

Flickr is part of a new category of web applications called *social software*. It's considered social because Flickr lets you connect with other members in a number of ways. Sharing is built into the fabric of Flickr. Instead of posting your photos to a personal, isolated gallery, you can share them with friends by passing around your URL. By inviting people [Hack #24] to participate at Flickr, you can build a contact list, and by posting comments and adding other members to your contact list, you can meet other photographers and have conversations about photos across Flickr.

This chapter will show you how to add contacts at Flickr and follow their activity both on and off Flickr. You'll find out how to track your friends' favorite photos [Hack #25], visualize where your Flickr friends are located [Hack #27], and even compile a list of your Flickr contacts' web sites [Hack #29].

By extending the social features of Flickr, you'll discover some new things about your Flickr contacts and see their photos in a new light.

Add and Track Contacts

Half the fun of using Flickr is staying in touch with friends and family by watching their photographs.

Your Flickr contact list represents the other Flickr members that you want to keep track of. If you add your friends, family, and other photographers you admire to your list, keeping up with their new photos is a snap.

Adding Contacts

As you explore photos on Flickr, you might spot a particular photographer whom you'd like to keep up with as she adds new photos. To add any Flickr user to your contact list, you first need to get to that user's photostream.

From any photo's detail page, look for a byline in the upper-right corner. The byline will say, "Uploaded on [date] by [member]." Clicking the member's name brings you to her photostream. At the top of the photostream you'll see a link to add that member as a contact. Click the link, mark her as a friend or family member if you want, and then click OK. That member will now be listed among your contacts.

> Keep in mind that adding someone as a Flickr contact is a one-way operation. If you add someone to your contact list, you won't automatically appear on her contact list; she'll receive a notification that you've added her, but she'll have to manually add you as a contact if she wants to.

If you want to add someone to your contact list who isn't yet a member, you can send an email invitation. Click Invite from the top of any Flickr page to bring up the Invitation page shown in Figure 4-1.

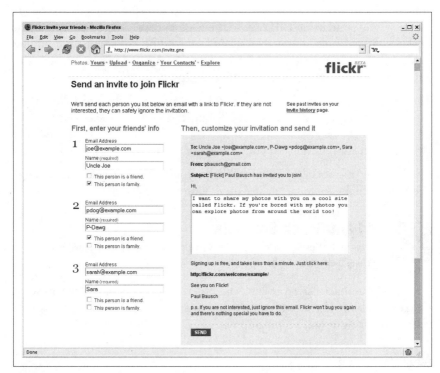

Figure 4-1. Inviting contacts via email

Enter up to three email addresses (and their Friend or Family status, if applicable), customize the message, and click Send. The people you listed will

receive emails from Flickr asking them to join. Once they join, they'll be added to your contact list with the relationships you specified. Specifying people as Friend or Family means they'll be able to see photos that are just for them [Hack #2].

Watching Contacts' Photos

Once you have a list of contacts, you can keep up with their daily postings on your contacts page (Figure 4-2).

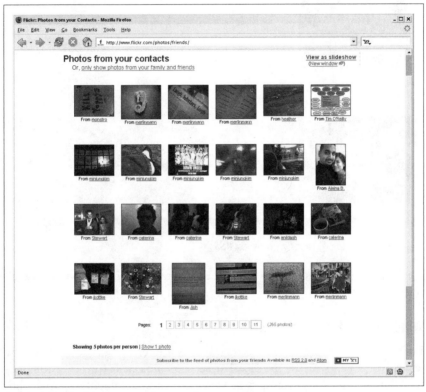

Figure 4-2. All of your contacts' recent photos appear on one page

Click 'Your Contacts' at the top of your Flickr home page to see recent photos. You can choose to limit the page to contacts you've designated as friends or family members, or to limit the page to one photo per contact. Viewing your contacts' recent photos is a great way to see what your friends and relations have been up to lately.

If you'd rather not have to visit Flickr to keep up with your contacts, you can use the RSS and Atom links at the bottom of the contacts page to keep

up with their photos in a newsreader [Hack #17]. Figure 4-3 shows the contacts feed in the Safari web browser, which doubles as an RSS newsreader.

Figure 4-3. Viewing contacts' photos via RSS

Clicking on any of the photos in the feed will take you to that photo's detail page.

Watching Contacts' Activity

Friends, family, and other Flickr members can interact with your photos by leaving comments. Click the "Recent activity" link next to the "Your photos" link on your Flickr home page to see the latest comments on your photos. As with many other spaces around Flickr, you can also subscribe to your recent activity via RSS or Atom [Hack #17], so you can keep up with comments in your preferred newsreader.

Recent activity feeds are typically used to keep tabs on one's own photos, but you can use those feeds to see recent activity with your contacts' photos, too. This will let you know which of your contacts' photos are getting the most comments, and what people are saying about them.

To start reading others' recent activity feeds, you need to know a bit about Flickr member IDs. In addition to the member ID you see on a user's photo-stream (e.g., *pb*), every Flickr member has an internal NSID—an alphanu-meric string that represents that user behind the scenes (e.g., *33853652177@N01*). Once you have an NSID in hand, you can build your own recent activity feed URL.

A quick way to find your own NSID is to browse to your Flickr home page, choose View → Page Source on your browser's menu, and search for the variable global_nsid toward the top of the page. Whatever this variable is set to is your Flickr NSID.

To find someone else's NSID, browse to his photostream and click on the Profile link on the right side of the page. From the Profile page, you'll find a link that says, "Send [member] a message." Right-click the link, choose Copy Link Location or Copy Shortcut from the menu, and paste the link into a text editor such as Notepad. You should see a URL like this:

```
http://www.flickr.com/messages_write.gne?to=33853652177@N01
```

Everything after the equals sign is the member's NSID. Jot down the mem-ber's name and the NSID, and go to your favorite RSS newsreader. Here's the format for recent activity feed URLs:

```
http://www.flickr.com/recent_comments_feed.gne?id=insert NSID&format=rss_200
```

Insert the NSID, and add the URL to your newsreader. Repeat the process for as many of your contacts as you want to watch. If possible, group the feeds together so you can browse them all at once. Figure 4-4 shows a group of contact activity feeds in the RSS reader Bloglines (*http://www.bloglines.com*).

The feeds will still be titled "Comments on your photos," but don't let the title fool you—you'll be seeing your contacts' photos and recent comments people have left about them. It's a good way to see which of your contacts' photos are generating the most conversation.

See Also

- "Subscribe to Flickr" [Hack #17]

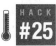

Track Your Friends' Favorites

#25 With a weblog tool called Blosxom and some extra Perl, you can set up a page to show your Flickr contacts' favorite photos.

Flickr makes it easy to see new photos posted by your contacts—simply log in and click the Your Contacts' link at the top of the page (or browse directly to *http://www.flickr.com/photos/friends/*) to keep up with your

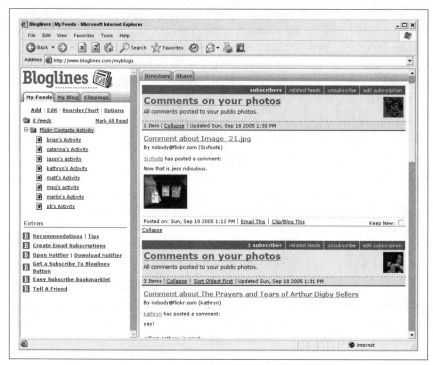

Figure 4-4. Watching contacts' activity at Bloglines

friends' photos. Flickr also makes it easy to bookmark your favorite photos
by clicking the "Add to Favorites" button above any photo. It's not easy to
see which photos your friends and family have marked as favorites,
though—you have to view each of your contacts' favorites lists individually
by going to each one's photostream page and clicking the Favorites link at
the top right.

If you find this a bit cumbersome, instead of viewing all of your friends'
favorites pages individually and looking for new photos, you can let some
scripting assemble them for you. You'll need to do some work to put the
pieces into place, but in the end you'll have a web page that automatically
shows any photos your contacts mark as favorites. Watching your friends'
favorites is a fun way to see photos that are interesting to your circle of con-
tacts, and you can use the page to be sure you're not missing great photos.

This hack uses the Flickr API to gather a list of contacts and find those con-
tacts' favorite photos. The weblog system *Blosxom* (*http://www.blosxom.
com*) then displays the latest photos in reverse-chronological order, like
posts on a weblog.

What You Need

The first step to implementing this hack is setting up Blosxom to run on your server. Blosxom is an extremely lightweight weblog tool; in fact, it's only one Perl script (so, of course, you'll need web space that can run Perl CGI scripts).

To set up Blosxom, grab a copy of the script *blosxom.cgi* from *http://www. blosxom.com* and modify the first few lines of the script to match your environment. You'll find the settings under the "Configurable variables" heading. Be sure to enter the full path to the directory where the script is installed.

You also might want to reduce the default number of entries shown on the home page from 40 to 25; because each entry will be a photograph, a lower number will help the page load faster. With those settings configured, copy *blosxom.cgi* to a CGI-capable directory on your server. If you run into trouble, click the Install link on the left side of the Blosxom home page for detailed installation instructions for various operating systems.

One key to Blosxom's simplicity is that the system stores posts as text files in the filesystem. There's no need to have access to a database or understand how to access a database.

To add posts to a Blosxom weblog, you simply create a text file in the proper location. Blosxom recognizes the new file and places the text contents of the file at the top of the weblog. Thus, to create an automated weblog, you need a script that can automatically write text files.

The Code

This Perl script finds all of the contacts for a specific Flickr user, finds those contacts' favorite photos, and writes the HTML to display the photos as text files.

You'll need a few nonstandard Perl modules before you can run the script. The first is `Flickr::API` (*http://search.cpan.org/~iamcal/Flickr-API/lib/Flickr/ API.pm*), a module that makes working with the Flickr API a snap. The second is `XML::Parser::Lite::Tree::XPath` (*http://search.cpan.org/~iamcal/ XML-Parser-Lite-Tree-XPath-0.02/XPath.pm*), a module that helps navigate the Flickr API's response XML.

Create a text file called *getFavorites.pl* and add the following code. Be sure to include your own Flickr NSID and API key (available at *http://www.flickr. com/services/api/*) and the absolute path to your Blosxom directory, including a trailing slash.

```perl
#!/usr/bin/perl
# getFavorites.pl
#
# Find out which photos your Flickr contacts are
# marking as favorites. This script contacts the
# Flickr API, gets a list of your contacts, and
# finds their favorite photos. You can get a Flickr
# API key and look up your Flickr NSID at:
#
# http://www.flickr.com/services/api/
#
# This script works in conjuction with the weblog
# system Blosxom to display the photos. You can
# download Blosxom and find out how to install it at:
#
# http://www.blosxom.com/
#
# Usage: getFavorites.pl

use strict;
use Flickr::API;
use Flickr::API::Response;
use XML::Parser::Lite::Tree::XPath;

# --- Configurable variables -----
my $nsid = 'insert your Flickr NSID';
my $api_key = 'insert your API key';
my $dir = 'insert path/to/blosxom/directory/';

# --- Script begins -----
# Get list of your contacts
my $api = new Flickr::API({'key' => $api_key});

my $response = $api->execute_method('flickr.contacts.getPublicList', {
                'user_id' => $nsid,
});

# Make sure there's a response
if (!$response->{success}) {
    die "Contact list not found! $response->{error_message}";
}

# Parse the response and loop through contacts
my $xpath = new XML::Parser::Lite::Tree::XPath($response->{tree});
my @contacts = $xpath->select_nodes('/contacts/contact');
foreach (@contacts) {
    my $username = $_->{attributes}->{username};
    my $usernsid = $_->{attributes}->{nsid};
    my $userdir = $username;
    $userdir =~ s/^\s+//g; # trim leading spaces
    $userdir =~ s/\s+$//g; # trim trailing spaces
    $userdir =~ s/:://g; # transform other spaces
    $userdir =~ s/'//g; # transform apostrophes
```

```
$userdir =~ s/\///g; # transform slashes
$userdir =~ s/\?//g; # transform question marks
$userdir =~ s/\*//g; # transform asterisks
$userdir =~ s/\.//g; # transform periods
$userdir =~ s/\s/_/g; # underscore spaces, etc.

my $full_dir = $dir . "/" . $userdir;
unless (-d $full_dir) {
    mkdir($full_dir);
}

# Find this contact's favorites
my $user_res = $api->execute_method('flickr.favorites.getPublicList', {
            'user_id' => $usernsid,
            'extras' => 'owner_name',
});

# Make sure there's a response
if (!$user_res->{success}) {
    warn "Favorite photos not found! $user_res->{error_message}";
}

# Parse the response and loop through photos
my $userxpath = new XML::Parser::Lite::Tree::XPath($user_res->{tree});
my @photos = $userxpath->select_nodes('/photos/photo');
my $cntPhoto = 0;
foreach (@photos) {
    my $id = $_->{attributes}->{id};
    my $title = $_->{attributes}->{title};
    my $server = $_->{attributes}->{server};
    my $secret = $_->{attributes}->{secret};
    my $owner = $_->{attributes}->{owner};
    my $ownername = $_->{attributes}->{ownername};
    my $img_src = "http://static.flickr.com/$server/$id\_$secret\_m.
jpg";
    my $href = "http://www.flickr.com/photos/$owner/$id/";
    # Make sure there's a title
    if (!$title) {
        $title = $id;
    }

    # Write post file with image HTML
    my $file = "$full_dir$id.txt";

    unless (-e $file) {
        open FILE, ">$file" or warn "Can't open $file\n";
        print FILE <<"END_POST";
$title

<a href="$href"><img src=\"$img_src\" /></a><br />
<div class="clsByline">photo by <a href="http://www.flickr.com/photos/
$owner/">$ownername</a></div>
```

```
<div class="clsFavline">favorite of <a href="http://www.flickr.com/photos/
$usernsid/favorites/">$username</a></div>
END_POST
            close FILE;
        }
        $cntPhoto++;
        last if ($cntPhoto == 5);
    }
}
```

This script creates a directory for every Flickr member in your contact list.
Be aware that if you have 300 contacts, the script will create 300 directories
on your server. In each directory, the script will write one text file for every
favorite photo from that contact. The text file includes the title of the photo
and a bit of HTML to display the photo. Each bit of HTML includes a link
to the original photographer's photostream, and to the complete list of
favorites by the person who marked the photo as a favorite. Blosxom han-
dles the work of organizing the mass of folders and text files into something
coherent.

Running the Hack

To run the script, simply call it from a command line like this:

```
perl getFavorites.pl
```

The first time you run the script, it will generate text files for every favorite
photo it can find. Flickr doesn't provide dates for when a photo was marked
a favorite, so there's no way to backdate photos as marked as favorites on a
certain date. This means that when Blosxom initially displays the list, it
won't be very meaningful. You'll simply see potentially hundreds of photos
under the same date heading. But as you run the script in the future, any
new favorite that's displayed will be noted with the time it was found as a
favorite.

To take advantage of the script, you'll want to run it on a regular schedule—
every hour or two. You can do this with *cron* on Unix-based systems, or
with the Windows Scheduler on Windows systems.

Visit the Blosxom script in a web browser to see the photos. With the script
up and running regularly, you should see a frequently updated listing of any
photos your contacts mark as favorites, as shown in Figure 4-5.

You'll probably need to tweak the default templates in Blosxom to change
the look and feel of your friends' favorites page. Blosxom has a robust tem-
plate system that lets you control every aspect of the display. In fact,
Blosxom includes a built-in RSS template, so you'll find an RSS feed of your
friends' favorites available at:

```
http://www.example.com/blosxom.cgi?flav=rss
```

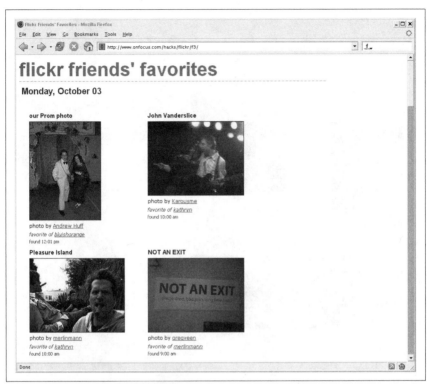

Figure 4-5. Friends' favorites weblog

You'll also find a number of prebuilt templates you can choose from at the Blosxom web site.

As you watch your friend's favorites, you'll see a number of photos that you wouldn't have otherwise, and they'll have more meaning than a random sampling of photos across Flickr.

Hacking the Hack

Blosxom is a very hackable system, and there are dozens of plug-ins available that can add even more features to your automated weblog. For example, a plug-in called *categorylist* can print a list of all the folders under the Blosxom directory. With this hack, that means you could have a list of all your contacts running down the side of the page, and clicking one contact's name would give you just that person's favorites on one page, as shown in Figure 4-6.

Visit the Blosxom plug-in registry at *http://www.blosxom.com/plugins/* for a look at some of the other available plug-ins.

Figure 4-6. Flickr friends' favorites sidebar

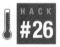

Find Your Friends' Favorite Tags

HACK #26

With some Perl and the Flickr API, you can see which tags are most popular among your contacts.

Tagging individual photos [Hack #10] on Flickr can help you organize your own photos. It also means Flickr can show interesting group patterns, like the Tags page shown in Figure 4-7.

With this page, at a glance you can see which tags are being used most often by all Flickr members. With a bit of scripting, you can narrow down this list and find out which tags are being used most by just your Flickr contacts. This list of contacts' tags is a good way to visualize what your friends are interested in, and it's a bit more personal than the overall tags page.

The Code

To run this hack, you'll need a couple of nonstandard Perl modules. Make sure you have `Flickr::API` (*http://search.cpan.org/~iamcal/Flickr-API/lib/*

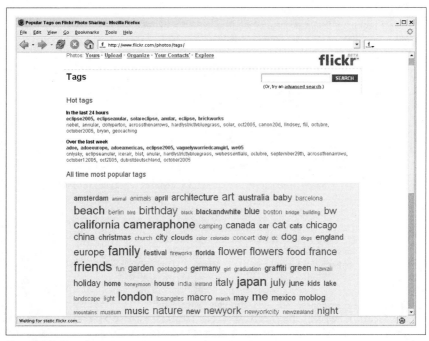

Figure 4-7. Popular tags page

Flickr/API.pm) for working with Flickr, and `XML::Parser::Lite::Tree::Xpath` (*http://search.cpan.org/~iamcal/XML-Parser-Lite-Tree-XPath-0.02/XPath.pm*) for sorting through the API responses.

With those two modules in place, copy the following code to a file called *friends_tags_list.pl*. Add your NSID and Flickr API key (both of which you can find at the Flickr API site, *http://www.flickr.com/services/api/*) to the code.

```
#!/usr/bin/perl
# friends_tags_list.pl
#
# Find out which tags your Flickr contacts are
# using most often. This script contacts the
# Flickr API, gets a list of your contacts, and
# finds their most popular tags. The script then
# adds up the totals and lists the tags by the
# most popular. You can get a Flickr
# API key and look up your Flickr NSID at:
#
# http://www.flickr.com/services/api/
#
# Usage: perl friends_tags_list.pl

use strict;
```

```perl
use Flickr::API;
use Flickr::API::Response;
use XML::Parser::Lite::Tree::XPath;

# Set your NSID
my $nsid = 'insert your NSID';
my $api_key = 'insert your Flickr API key';
my @tags;
my @sortTags;

# Get your list of contacts
my $api = new Flickr::API({'key' => $api_key});

my $response = $api->execute_method('flickr.contacts.getPublicList', {
              'user_id' => $nsid,
});

# Make sure there's a response
if (!$response->{success}) {
    die "Contact list not found! $response->{error_message}";
}

# Parse the response and loop through contacts
my $xpath = new XML::Parser::Lite::Tree::XPath($response->{tree});
my @contacts = $xpath->select_nodes('/contacts/contact');
foreach (@contacts) {
    my $usernsid = $_->{attributes}->{nsid};

    # Find this contact's tags
    my $user_res = $api->execute_method('flickr.tags.getListUserPopular', {
                  'user_id' => $usernsid,
    });

    # Make sure there's a response
    if (!$user_res->{success}) {
        warn "Tags not found! $user_res->{error_message}";
    }

    # Parse the response and loop through photos
    my $userxpath = new XML::Parser::Lite::Tree::XPath($user_res->{tree});
    my @utags = $userxpath->select_nodes('/who/tags/tag');
    foreach (@utags) {
        my $match_index = 0;
        my $usertagcount = $_->{attributes}->{count};
        my $usertag = $_->{children}[0]->{content};

        # Make sure there's only one entry for each tag
        for my $i ( 0 .. $#tags) {
            if ($tags[$i]->{tag} eq $usertag) {
                $match_index = $i;
            }
        }
```

```
          # If a tag already exists, add to the total
          # otherwise, add the new tag to the hash
          if ($match_index > 0) {
$tags[$match_index]->{tagcount} = $tags[$match_index]->{tagcount} +
$usertagcount;
          } else {
              my $thisTag = {
                  tag => $usertag,
                  tagcount => $usertagcount,
              };
              push @tags, $thisTag;
          }
      }
}

# --- Begin Output -----

# Sort the hashes numerically to put popular tags first
@sortTags = sort { $b->{'tagcount'} <=> $a->{'tagcount'} } @tags;

# Print the tags in a simple text list
foreach (@sortTags) {
    my $tagcount = $_->{tagcount};
    my $tag = $_->{tag};
    print "$tag ($tagcount)\n";
}
```

The script fetches a list of contacts for the given NSID and uses the flickr.
tags.getListUserPopular API method to find the 10 most popular tags for
each contact. The script also adds the totals of the tags to see which tags are
the most popular across all of your contacts.

Running the Hack

To run the script, call it from a command prompt, piping the output to a
text file, like so:

```
perl friends_tags_list.pl > friends_tags.txt
```

Take a look at *friends_tags.txt* and you should see something like the follow-
ing list of tags:

```
cameraphone (7676)
sanfrancisco (3345)
archive (2999)
7610 (2628)
nyc (1765)
sxsw (1608)
2001 (1512)
sxswi (1259)
travel (1248)
sf (1212)
```

```
moblog (1198)
europe (1109)
sxswinteractive (1018)
livemusic (986)
austintx (945)
oregon (733)
sharptm150 (636)
dog (606)
2005 (570)
s700i (559)
lifeblog (523)
nokia6630 (522)
seattle (479)
...
```

You'll see your contacts' most popular tags, along with the number of times each tag has been used by your contacts. You might learn some things about your friends that you didn't know already, and you might find some tags that you can start using as well.

Hacking the Hack

If you want to display your contacts' tags in a tag map with relative font sizes similar to the Tags page at Flickr, you can tweak this script a bit to output HTML instead of text. Replace everything after the # --- Begin Output --- comment with the following code:

```
# --- Begin Output -----

# Sort the hashes alphabetically
@sortTags = sort { $a->{'tag'} cmp $b->{'tag'} } @tags;

# Print the top of the page
print <<"END_HEADER";
<html>
<head>
    <style type="text/css">
        body { font-family:arial; width:760px;}
        h3 { font: normal 18px Arial, Helvetica, sans-serif; color: #FF0084;
margin-bottom: 5px; }
    </style>
</head>
<body>
<h3>My Contacts' Tags</h3>
END_HEADER

# Print the tags as an HTML Tag Map with relative sizes
foreach (@sortTags) {
    my $fontsize;
    my $tagcount = $_->{tagcount};
    $tagcount /= 10;
```

```
    my $tag = $_->{tag};
    my $minfontsize = 9;
    my $fontsize = 9 + $tagcount;
    if ($fontsize >= 60) {
        $fontsize = 60;
    }
    $fontsize = sprintf("%.0f", $fontsize);
    print "<a href=\"http://www.flickr.com/photos/tags/$tag\"";
    print "style=\"font-size:$fontsize";
    print "px;font-weight:normal;text-decoration:none;";
    print "line-height:110%;\">$tag</a>  \n";
}

# Print the bottom of the page
print <<"END_FOOTER";
</body>
</html>
END_FOOTER
```

This new code sorts the tags alphabetically instead of by the number of times each tag has been used by your contacts. The script then generates an HTML page, giving each tag a font size based on the number of times it has been used. Run the code in the same way, but send the output to an HTML file, like this:

```
perl friends_tag_list.pl > friends_tags.html
```

Open *friends_tags.html* in a browser, and you'll see a list of tags like the one in Figure 4-8.

Each tag links to the public tag page for that particular tag, so you can see how Flickr members across the site have used the tag. With some more Flickr API work, you could probably find a way to link to your contacts' photos for a given tag, but that's another hack! In the meantime, you can get a quick glance at your friends' tagging. And once you've mastered your friend's tags, you might want to try your hand at other ways to make tag clouds [Hack #14].

HACK #27 Map Your Contacts

By combining the Flickr API and the Google Maps API, you can see how your Flickr contacts are dispersed throughout the world.

As you connect with other Flickr members, you'll notice that they can be anywhere in the world. You might admire a photographer who lives in a far-off country, and find another photographer who lives just down the street. Even though Flickr makes geography irrelevant, it's still an important part of our lives. Learning where your Flickr contacts are based can tell you more about them and help you visualize just how geographically dispersed your virtual contacts really are.

Figure 4-8. Viewing friends' tags as a tag map

As part of its member profiles, Flickr allows any member to include his location. The location can range from something very specific, like a city and state, to something general, like a country. Figure 4-9 shows my own Flickr profile, with the location "Corvallis, OR" listed directly under my web site.

To find out where a particular location is, you can go to Google Maps (*http://maps.google.com*) and type in the full address. Figure 4-10 shows a Google Map with a point for the O'Reilly headquarters in Sebastopol, CA.

Clicking on the point brings up an information window that includes more Google Maps options and the full address.

Google also provides a way for developers to create their own maps with their own points and information windows, called the Google Maps API (*http://www.google.com/apis/maps/*). Using this API, you can take a data source such as your list of Flickr contacts and build a map based on the location information they've provided.

Geocoding a Location

The Google Maps API needs information about points on a map in the form of *coordinates*, or listings of latitude and longitude that represent specific

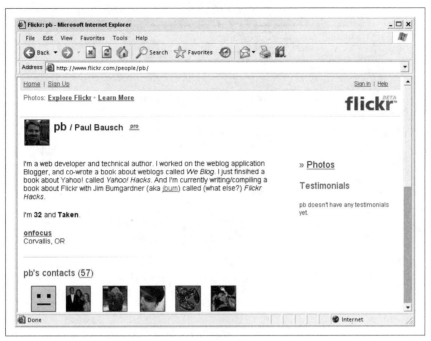

Figure 4-9. Flickr profile page with a location set

geographic points. Most of us don't know our current longitude and latitude, and Flickr doesn't expect us to. That's why the simple city/state/country location information that people enter into Flickr needs to be *geocoded* before you can build your map—that is, a listing like Corvallis, OR, needs to be translated into its latitude and longitude pair: 44.564722, –123.260833.

Unfortunately, at the time of this writing, Google doesn't explicitly offer a geocoding service. However, you can use Google Maps to get the longitude and latitude of a place name by tweaking a Google Maps URL. A Google Maps URL like the following will return a bit of JavaScript that's intended to be used in some Google Maps applications:

```
http://maps.google.com/maps?q=insert location&output=js
```

The URL for our example location would be:

```
http://maps.google.com/maps?q=Corvallis,%20OR&output=js
```

Note that the space in the location has been encoded as %20 because spaces aren't allowed in URLs. Inside this page, you'll find some code that includes the center coordinates of the location, like this:

```
viewport: {center: {lat: 44.564722,lng: -123.260833}
```

Figure 4-10. An address plotted on a Google Map

As you can see, you can enter a location and get back coordinates. With some simple scripting, you can automate this process and geocode a large number of place names. With this hurdle out of the way, you can simply assemble your list of places and plot them on a map. However, you'll need to make sure you have what you need before you begin.

What You Need

The most difficult part of assembling this hack is making sure you have the prerequisites in place. You might have to spend some time gathering the pieces you need, but once your environment is set, building the map takes only a few minutes.

As with any of the hacks in this book that use the Flickr API, you'll need an API key. You'll also need your own Flickr user ID (NSID) so you can request a list of your contacts from the Flickr API. You can find both of these at the Flickr API page (*http://www.flickr.com/services/api/*).

To build your own Google Map, you'll need a Google Maps API key associated with a public domain. For example, if you're going to view your map at a specific web address such as *http://www.example.com*, you'll need to register that domain with Google when you request your key. And if you're going

to view your map at a subdirectory such as *http://www.example.com/path/to/map/*, you'll need to specify the path as well when you register for a key. The requirement for a specific domain is a limitation of Google Maps, but it's a free service and you'll need to play by their rules. You can register your domain and get an associated key at *http://www.google.com/apis/maps/*.

> If you're not planning to make your Flickr contacts map public, you can associate your Google Maps API key with the URL *http://localhost/*. That way, you can access the map on a web server running on your local machine.

The Perl script for this hack that writes the JavaScript requires several Perl modules that aren't usually preinstalled on most systems. Flickr::API (*http://search.cpan.org/~iamcal/Flickr-API-0.07/lib/Flickr/API.pm*) handles working with the Flickr API, and XML::Parser::Lite::Tree::XPath (*http://search.cpan.org/~iamcal/XML-Parser-Lite-Tree-XPath-0.02/XPath.pm*) helps parse the Flickr responses. You'll also need URI::Escape (*http://search.cpan.org/~gaas/URI-1.35/URI/Escape.pm*) for encoding locations for use in a URL and LWP::Simple (*http://search.cpan.org/~gaas/libwww-perl-5.803/lib/LWP/Simple.pm*) for passing those locations to Google Maps for geocoding.

The Code

The following Perl script does the heavy lifting for the hack by finding the locations associated with your Flickr contacts, looking up the coordinates for those locations at Google, and writing the necessary JavaScript to display the points on a map. The script also assembles the HTML necessary to display your contacts' buddy icons in the map itself.

Copy the following code to a file called *gmap-contacts.pl*, and be sure to include your own Flickr NSID and API key in the code:

```perl
#!/usr/bin/perl
# gmap-contacts.pl
# This script creates a JavaScript file that plots points
# on a Google Map for a given Flickr member's contacts.
#
# You can get a Flickr API key, find your NSID, and read the
# full documentation for the Flickr API at:
#
# http://www.flickr.com/services/api/
#
# You can get a Google Maps API key and read the full
# documentation for the Google Maps API at:
#
# http://www.google.com/apis/maps/
```

```perl
use strict;
use Flickr::API;
use Flickr::API::Response;
use LWP::Simple;
use XML::Parser::Lite::Tree::XPath;
use URI::Escape;

# Set your NSID
my $nsid = 'insert your Flickr NSID';
my $api_key = 'insert your Flickr API key';

# Start the API
my $api = new Flickr::API({'key' => $api_key});

my @users;
my @locations;

# Start the JavaScript file, and set the initial center point
# for the Google Map
print <<JSHEADER;
function addMapPoints( ) {
    map.addControl(new GSmallMapControl( ));
    map.centerAndZoom(new GPoint(-96.66, 40.817), 13);
JSHEADER

# Get a list of contacts
my $response = $api->execute_method('flickr.contacts.getPublicList', {
                'user_id' => $nsid,
});

# Make sure there's a response
if (!$response->{success}) {
    die "Contact list not found! $response->{error_message}";
}

# Parse the response and loop through contacts
my $xpath = new XML::Parser::Lite::Tree::XPath($response->{tree});
my @contacts = $xpath->select_nodes('/contacts/contact');
foreach (@contacts) {
    my ($location,$lat,$lon,$lonlat,$near);
    my $usernsid = $_->{attributes}->{nsid};

    # Find this contact's location
    my $user_res = $api->execute_method('flickr.people.getInfo', {
                'user_id' => $usernsid,
    });

    # Make sure there's a response
    if (!$user_res->{success}) {
        warn "\nLocation for user $usernsid not found! $user_res->{error_
message}";
    }
```

```
# Grab location w/ regex
if ($user_res->{_content} =~ m!<location>(.*?)</location>!gis) {
    $location = $1;
} else {
    warn "\nNo location found for user $usernsid";
}

# Find Lat/Lon for location at Google
if ($location ne "") {
    my $esc_location = uri_escape($location);
    my $url = "http://maps.google.com/maps?q=$esc_location&output=js";
    my $response = get($url);
    # Note if the location has a related longitude/latitude
    if ($response =~ m!<point lat="(.*?)" lng="(.*?)"/>!gis) {
        $lat = $1;
        $lon = $2;
        $lonlat = "$lon,$lat";
    # Otherwise, warn the user that the coordinates can't be found
    } else {
        warn "\nNo coordinates found for location $location";
    }
    # Normalize the name, if possible
    while ($response =~ m!<line>(.*?)</line>!gis) {
        $near = $1;
        $near =~ s! \d{5}!!gs; #Remove Zips
    }
}

# Save location to the locations array
my $exists = grep $locations[$_]{lonlat} eq $lonlat, 0 .. $#locations;
if (($exists eq 0) && ($lonlat ne "")) {
    my $thisLoc = {
        lonlat => $lonlat,
        lon => $lon,
        lat => $lat,
        near => $near,
    };
    push(@locations, $thisLoc);
}

# Save user to the user array
my ($iconserver,$username,$realname,$photosurl);
if ($user_res->{_content} =~ m!iconserver="(\d{1,2})"!s) {
    $iconserver = $1;
}
if ($user_res->{_content} =~ m!<username>(.*?)</username>!s) {
    $username = $1;
}
if ($user_res->{_content} =~ m!<realname>(.*?)</realname>!s) {
    $realname = $1;
}
if ($user_res->{_content} =~ m!<photosurl>(.*?)</photosurl>!s) {
    $photosurl = $1;
}
```

```
        my $thisUser = {
            nsid => $usernsid,
            iconserver => $iconserver,
            username => $username,
            realname => $realname,
            photosurl => $photosurl,
            lonlat => $lonlat,
        };
        push(@users, $thisUser);
}

# Loop through the locations, adding users for that location
# to info window HTML
for my $i ( 0 .. $#locations) {
    my $lonlat = $locations[$i]{lonlat};
    my $near = $locations[$i]{near};

    # Start HTML for info window
    my $html = "<b>$near</b><div style=\"width:200px;\">";

    # Find users for this location
    for my $j ( 0 .. $#users) {
        my $user_lonlat = $users[$j]{lonlat};
        if ($lonlat eq $user_lonlat) {
            my $nsid = $users[$j]{nsid};
            my $username = $users[$j]{username};
            my $realname = $users[$j]{realname};
            $realname = s!'!\\'!g; #Escape apostrophes for JavaScript
            my $photosurl = $users[$j]{photosurl};
            my $iconserver = $users[$j]{iconserver};
            my $iconsrc;
            # If no buddy icon is found, use the standard default
            if ($iconserver eq 0) {
                $iconsrc = "http://www.flickr.com/images/buddyicon.jpg";
            } else {
                $iconsrc = "http://photos$iconserver";
                $iconsrc .= ".flickr.com/buddyicons/$nsid";
                $iconsrc .= ".jpg";
            }
            $html .= "<div style=\"float:left;padding:3px;\">";
            $html .= "<a href=\"$photosurl\" title=\"$realname\">";
            $html .= "<img src=\"$iconsrc\" width=\"48\" height=\"48\"";
            $html .= " border=\"0\" />";
            $html .= "</a>";
            $html .= "</div>";
        }
    }
    $html .= "</div>";

    # Print out the line of JavaScript for this point
    if ($lonlat ne "") {
        print "\tcreateMarker(new GPoint($lonlat),'$html');\n";
```

```
    }
}

# Print the last character to close the JavaScript function
print "}\n";
```

As you can see, the code is fairly complex, but it assembles everything you need for your map quickly. Because many Flickr users can be from the same location, the script stores both locations and Flickr member information in the arrays @locations and @users. At the end of the script, the last loop runs through the locations, building the HTML necessary to display buddy icons from members in each location.

Running the Hack

Once the script is ready to go, run it from the command line and specify a descriptive name for the JavaScript file, such as *addMapPoints.js*, like this:

```
gmap-contacts.pl > addMapPoints.js
```

The script will build the JavaScript file and note any locations it couldn't translate into coordinates. Next, you'll need to put together the standard HTML file that will hold the map. Create a text file called *contacts-map.html* and add the following HTML, making sure to include your Google Maps API key and the JavaScript file you just created in the header:

```
<!DOCTYPE html PUBLIC "-//W3C//DTD XHTML 1.0 Transitional//EN"
  "http://www.w3.org/TR/xhtml1/DTD/xhtml1-transitional.dtd">
<html xmlns="http://www.w3.org/1999/xhtml">
<head>
    <meta http-equiv="Content-Type" content="text/html; charset=utf-8" />
    <title>Flickr Contacts, Mapped</title>
    <script src="addMapPoints.js" type="text/javascript"></script>
    <script src="http://maps.google.com/maps?file=api&v=1&key=insert key"
        type="text/javascript"></script>
    <style type="text/css">
    body {
        font-family:arial,helvetica,sans-serif;
    }
    </style>
</head>

<body onload="addMapPoints();">
<h1>Flickr Contacts, Mapped</h1>
<div id="map" style="width:800px;height:600px;border:solid #C3CEAE 1px);">
</div>
    <script type="text/javascript">
    //<![CDATA[
    // Create a "tiny" green marker icon
    var icon = new GIcon();
    icon.image = "http://labs.google.com/ridefinder/images/mm_20_green.png";
```

```
      icon.shadow = "http://labs.google.com/ridefinder/images/mm_20_shadow.
  png";
      icon.iconSize = new GSize(12, 20);
      icon.shadowSize = new GSize(22, 20);
      icon.iconAnchor = new GPoint(6, 20);
      icon.infoWindowAnchor = new GPoint(5, 1);

      var map = new GMap(document.getElementById("map"));

      // Creates a tiny green marker at the given point
      function createMarker(point,html) {
          var marker = new GMarker(point, icon);
          map.addOverlay(marker);
          GEvent.addListener(marker, "click", function( ) {
              marker.openInfoWindowHtml(html);
          });
      }

      //]]>
      </script>
  </body>
  </html>
```

Note in the <body> tag that the page will run the addMapPoints() function once the page has loaded. This function—generated by *gmaps-contacts.pl* and stored in *addMapPoints.js*—initializes the Google Map and adds all of the points and contact information.

Also note that, in this example, the initial center of the map is set to –96.66, 40.817—roughly the middle of the United States. If most of your Flickr contacts are in the UK, you might want to change this value so that you don't have to drag the Google Map to a new location to see your contacts' locations. You can change this value by editing the third line of *addMapPoints.js* or by changing the coordinates in the *gmaps-contacts.pl* script that writes that file.

Once both files are in place on your server, bring up *contacts-map.html* in a web browser, and you should see a map like the one shown in Figure 4-11.

Click any of the green points on the map, and you'll see an info window containing the Flickr buddy icons that represent your contacts from that location. You can hover over a buddy icon to see the member's real name, or click the icon to view that member's photostream at Flickr.

And, of course, you can zoom or click and drag the map, just as you can with any Google Map. You can even drag the map to other countries and see if you have contacts there. Most importantly, you'll see how your Flickr contacts are dispersed, which might help you realize that Flickr really is a way to share photos with people throughout the world.

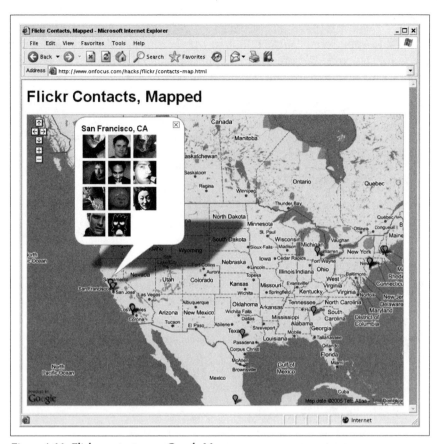

Figure 4-11. Flickr contacts on a Google Map

Find Flickrites in Your Mac Address Book

HACK #28

Find anyone in your Address Book that has a Flickr photostream.

If you use the Mac Address Book to organize your contacts, you probably have dozens of entries for friends, family members, coworkers, and acquaintances. With a large list, the odds are good that at least a few of them have Flickr memberships. You might be connected to your closest contacts on Flickr already, but finding out who else in your list of personal contacts is on Flickr can give you more people to connect with.

You could copy and paste each of your contacts' email addresses into the People Search page at Flickr (*http://www.flickr.com/find.gne*), but some quick scripting can save you time. Mac OS X is a highly scriptable environment, and this hack shows how you can use AppleScript and the underlying Unix tool called *curl* to find people in your Address Book that also have Flickr photostreams.

The Code

Open the AppleScript Script Editor in */Applications/AppleScript* and enter the following code. Be sure to enter your own Flickr API key, and save the script with a memorable name, such as *Find Flickrites*.

```
(*
Find Flickr Members in Address Book

The script loops through people in your Address Book, checking Flickr
to see if they're members. If a photostream is found, you
have the option to view it in your default browser. You can get a
Flickr API key at http://www.flickr.com/services/api/.

by Paul Bausch
*)

-- set your Flickr API key

set apiKey to "insert your API key"

-- set some variables for the curl command

set userAgent to "Mozilla/5.0 (Macintosh; U; PPC Mac OSX; en-us)"
set curlCommand to "curl -i -b -A -L \"" & userAgent & "\" "

-- open Address Book and loop through people

tell application "Address Book"
    repeat with thisPerson in the people
        set thisName to name of thisPerson
        repeat with thisAddress in email of thisPerson
            set thisEmail to value of thisAddress

            -- build the URL that will search for the Wish List

            set baseURL to "http://www.flickr.com/services/rest/?method="
            set thisURL to baseURL & "flickr.people.findByEmail\\&api_key=" \
& apiKey
            set thisURL to thisURL & "\\&find_email=" & thisEmail
            -- use curl to fetch the search page

            set thisResponse to do shell script curlCommand & thisURL

            -- if the Wish List URL is found in headers, prompt user for\
action
            if thisResponse contains "nsid=" then
                set theAction to display dialog thisName & " has a Flickr\
photostream." buttons {"View", "Ignore"}
                if button returned of theAction is "View" then

                    -- build Flickr URL based on returned NSID, and bring it up
```

```
                set beginID to (offset of "nsid=" in thisResponse) + 6
                set thisNSID to get text beginID thru (beginID + 15) of\
thisResponse

                set beginID to 1
                set endID to (offset of "\"" in thisNSID) - 1
                set thisNSID to get text beginID thru endID of thisNSID

                tell application "Safari"
                    activate
                    open location "http://www.flickr.com/photos/" & thisNSID
                end tell
            end if
        end if
    end repeat
  end repeat
end tell
```

The top of the script sets some variables for *curl* that will be used later.

> If you'd like to learn more about *curl* and what the settings
> in the script mean, open a Terminal window (found in
> *Applications/Utilities/*) and type man curl. You'll get the com-
> plete documentation that explains what all of the command
> switches do, and a list of all of the options available.

With the variables set, the script loops through all of the entries in the
Address Book, looking for email addresses. Each individual email address
found is used to build a Flickr API request URL with the flickr.people.
findByEmail method. Once the URL is set, the do shell script command
uses *curl* to fetch the response, and the contains command looks for a Flickr
NSID associated with the email address.

If a Flickr NSID is found, the script uses display dialog to bring up a win-
dow with View and Ignore options. If you click View, the script will open
the Safari browser, which will take you to that Flickr member's photo-
stream. From there, you can view that person's photos, take a look at her
profile details, or add her as a contact.

Running the Hack

You can run the script by clicking the Run button in the Script Editor. As
you find people in your Address Book who are also on Flickr, you'll have the
option to view their photostreams, as shown in Figure 4-12.

To keep this script one click away from your Address Book, move the script
to the */Library/Scripts/Address Book Scripts* folder. This way, you can access
the script from your Address Book's Scripts menu. Run the script at any

Figure 4-12. AppleScript prompt to view a contact's photostream

time by selecting Script Menu → Find Flickrites from the Address Book application's menu bar.

Finding fellow Flickr users via your Address Book may help you learn more about some people you know casually and build your own list of contacts at Flickr.

HACK #29 Surf Your Contacts

Find out what your contacts are up to outside of Flickr.

Most of your Flickr contacts really do have lives outside of Flickr, and you can often find a link to a friend's other life on his Flickr profile page. When you create a Flickr profile, you have the option to enter your web site URL and web site name, which will show up in your profile just above your location. Most Flickr members use this space to point to their home pages or weblogs.

If you don't already regularly visit your Flickr contacts' external sites, you might learn something more about your acquaintances and the photographers you admire by taking a look. If you have just a handful of contacts, you could visit each of your contacts' profile pages one by one and make a list of URLs you'd like to visit; but if you have more than a dozen contacts, a bit of PHP scripting can help you put together a master surfing list in a few minutes.

This hack compiles a list of your contacts, assembles their profile page URLs, and visits each one, looking for a web site. You'll need a free Flickr API key and your Flickr NSID, both of which can be found at the Flickr API documentation page (*http://www.flickr.com/services/api/*). This hack also relies on the simple XML tools built into PHP 5, which make working with Flickr API responses a snap.

The Code

Copy the following code to a file called *flickr_surf.php*, and be sure to put in your own Flickr API key and Flickr NSID:

```php
<?php
// flickr_surf.php
// Finds web sites of Flickr contacts for given
// Flickr NSIDs. Use it to gather your Flickr
// contacts' web sites onto one page for easy
// surfing.
//
// You can get an API key and read the full documentation
// for the Flickr API at http://www.flickr.com/services/api/

// Set your Flickr API key and your user NSID
$api_key = "insert your Flickr API key";
$my_nsid = "insert your Flickr NSID";

// This is a greedy script requiring lots of time
set_time_limit(0);

// Construct a Flickr query to grab your contacts
$req_url = "http://www.flickr.com/services/rest/";
$req_url .= "?method=flickr.contacts.getPublicList";
$req_url .= "&api_key=$api_key";
$req_url .= "&user_id=$my_nsid";

// Make the request
$flickr_contacts = file_get_contents($req_url);

// Parse the XML
$fc_xml = simplexml_load_string($flickr_contacts);
?>
<html>
<head>
    <style type="text/css">
    BODY {
        font-family:verdana,arial;
        font-size:10pt;
        line-height:130%;
    }
    </style>
</head>
<body>
<h2>Surf Flickr Friends</h2>
<ul>
<?php
// Loop through the contacts
foreach ($fc_xml->xpath('//contact') as $contact) {
    $nsid = $contact['nsid'];
    $username = $contact['username'];

    // Construct a Flickr query to grab contact info
    $req_url = "http://www.flickr.com/services/rest/";
    $req_url .= "?method=flickr.people.getInfo";
    $req_url .= "&api_key=$api_key";
    $req_url .= "&user_id=$nsid";
```

```
    // Make the request
    $contact_info = file_get_contents($req_url);

    // Parse the XML
    $ci_xml = simplexml_load_string($contact_info);

    // Get contact info
    $iconserver = $ci_xml->person[0]['iconserver'];
    $realname = $ci_xml->person[0]->realname;
    $profile_url = $ci_xml->person[0]->profileurl;

    // See if a web site exists on the member's profile page
    // with screen-scraping
    $profile_html = file_get_contents($profile_url);
    $regex = '!<p style="font-size: 14px;">.*?<a ';
    $regex .= 'href="(.*?)"><strong>(.*?)</strong></a>!is';
    if (preg_match($regex,$profile_html, $matches)) {
        $contact_siteurl = $matches[1];
        $contact_sitename = $matches[2];

        // If a web site is found, print out the web site URL
        // and contact info
        print "<li style=\"margin-bottom:10px;\"><a href=\"$contact_siteurl\
">";
        print "$contact_sitename</a><br />";
        print "<span style=\"font-size:8pt;color:#666;\">";
        print "by <a href=\"$profile_url\">$username</a> /";
        print " $realname</span></li>\n";
    }
    $matches = "";

    // Sleep for 3 seconds to give the Flickr
    // servers a break
    sleep(3);
}
?>
</ul>
</body>
</html>
```

You'll notice that the script contacts the Flickr API to find your list of contacts, and then contacts the API again for each contact to find the user's real name and profile URL. Flickr doesn't make site information available via the API, so the script relies on *screen-scraping* the profile pages to find that data. Screen-scraping involves downloading the HTML of the page and picking through it with regular expressions to cherry-pick the required information. It's a notoriously brittle process, and if Flickr changes the HTML of the profile page, the script won't be able to find the information you want. Be aware that you may need to tweak the regular expression set as $regex to find the web site name and URL.

Note also that the script is fairly request-intensive. For every person in your contact list, this script will make two requests of the Flickr servers. To give the Flickr servers a bit of a break, the script then rests for three seconds by calling sleep(3). This will give the Flickr servers a small rest between each contact, but it also means you'll need to be patient while the script is compiling your list.

Running the Hack

To run the code, upload the script to your web server and browse to the page. The URL should look something like this:

```
http://www.example.com/flickr_surf.php
```

Because of the numerous HTTP requests and the built-in delay, expect your script to take several minutes to execute. And, of course, the more contacts you have, the more time the script will need to compile the list. When it's finished, you should see a list of web sites from your Flickr contacts like the one in Figure 4-13.

Figure 4-13. A list of the author's Flickr contacts' web sites

If you want to visit the page over and over again, you'll want to save the HTML the script generated rather than rebuilding the list each time you visit

the page. To save the HTML, choose File → Save As... (or File → Save Page
As...) from your browser's menu. Your contacts' web sites shouldn't change
too often, and when you add or remove contacts you can visit *flickr_surf.php*
again to recompile the list and bring it up to date.

Maintenance
Hacks 30–36

Once you're a Flickr power user, you'll find that if you want to keep your photo collection in top shape, it helps to go beyond the existing tools on Flickr. While maintenance can be a chore, there are some ways to speed things up so you can get back to the more fun features of Flickr.

This chapter will show you some tips and tricks for managing a large collection of photos on Flickr, including editing several photos at once [Hack #35] and downloading a complete list of your photos [Hack #33]. If you have a large collection of photos on Flickr, you'll find out how to back up your photos [Hack #30] and comments [Hack #31] to your local computer for safekeeping. And if you've started a Flickr group, you'll find out how to extend the management features by creating a maintenance bot [Hack #36] to help you keep the group running smoothly.

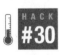

HACK #30 Back Up Your Photos

A Java application called FlickrBackup can snag copies of all of your Flickr photos so you have local backups.

If you use your computer to upload photos to Flickr, chances are you already have local copies of all of your original images (especially if you follow the instructions in "Resize Photos for Flickr" [Hack #4] before sending them). But if you use Flickr to store photos taken with your mobile phone [Hack #6], the photos at Flickr might be your only copies. In this case, you'll definitely want to back up your photos once in a while by saving copies of your Flickr photos locally.

You could write your own Flickr API script to grab all of your photos, but luckily, Andrew Serff has saved you the trouble by writing a free Java program called FlickrBackup (*http://www.sunkencity.org/flickrbackup/*). The program runs on both Macs and PCs, and it provides a visual interface for

backing up your Flickr photos. You can download a copy of FlickrBackup from its SourceForge project page at *http://www.sourceforge.net/projects/ flickrbackup*.

Once you've downloaded the file, unzip the contents. To start the program on Mac OS X, open the folder and double-click *FlickrBackup.jar*. On Windows, open a command prompt (Start → Programs → Accessories → Command Prompt), change directory (cd) to the *FlickrBackup* folder, and type the following command:

```
java -jar FlickrBackup.jar
```

This command will start the program, and you'll be greeted with the authentication request shown in Figure 5-1.

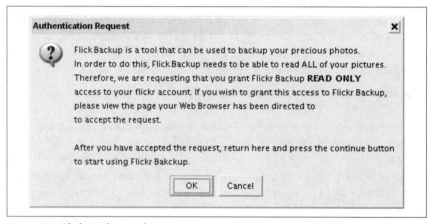

Figure 5-1. FlickrBackup authentication request

Once you've authenticated at Flickr in your browser, return to the request window and click OK. The program will save your authentication information, so you'll have to authorize it only once.

FlickrBackup will download thumbnails of all of your photos, and you'll see a grid of your photos like the one shown in Figure 5-2.

From here, you can select which photos to back up. At the time of this writing there's no way to select all photos at once, so you'll need to click each photo individually. Alternately, you can choose to back up complete photo sets at Flickr by clicking the Sets tab.

Once you've made your selection, click Backup Selected, and you'll see the Flickr Backup Wizard window. Click the Browse button and choose a local folder to store images in, and Start Backup will begin the process. A status bar will let you know how the program is doing.

Figure 5-2. Flickr Backup photo selection window

FlickrBackup doesn't store titles, descriptions, tags, notes, or comments—just photos. It's a quick way to copy your Flickr photos, but keep in mind that it won't give you backups of the associated data stored at Flickr. If you'd like to save backups of comments about your photos, check out the next hack.

Photos will be stored with their Flickr IDs, and when the operation is complete you should find a series of JPEGs in your backup folder with names like *4574244_ff80b1164f_o.jpg*. You can leave the backups on your hard drive, or copy your photos to a CD or DVD for long-term storage. FlickrBackup is a quick way to copy a large number of photos without writing a line of code.

 Back Up Photo Comments

#31

Flickr photo comments are usually light chit-chat, but you might want to save them for posterity.

One of the key features of Flickr is that it enables its users to have conversations about photos on the site. When you post photos on Flickr, you're posting them not into an empty space, but into a space with lots of other members. Because Flickr is an interactive environment, your contacts and other viewers can not only view your photos, but also post comments about them, perhaps asking questions, offering praise, observations, or providing useful critiques. Figure 5-3 shows three comments under a photo.

Figure 5-3. Photo comments

Even though Flickr will be around for the foreseeable future, you might want to have your own personal backups of the comments that have been generated around your photos. The conversations about a photo are often nothing more than idle chit-chat, but as with any conversation, there may be times when you'll wish you had a copy to refer back to or search through, or just to have a record of what was said.

With a bit of Perl, some queries to the Flickr API, and some screen-scraping, you can create an archive of your comments. With the conversations stored on your own hard drive, you can search them and refer back to them as much as you'd like.

The Code

Unfortunately, Flickr doesn't give access to comments via its API, so this code relies on *screen-scraping*—downloading the HTML of the relevant pages and picking through it with regular expressions—to gather comments. Screen-scraping is a notoriously brittle process. Keep in mind that if Flickr changes the HTML of its pages even slightly, this code will no longer work.

You'll need several Perl modules installed on your system for this script to work. Flickr::API (*http://search.cpan.org/~iamcal/Flickr-API-0.07/lib/Flickr/API.pm*) is used to find a list of photos for a given user. XML::Simple (*http://search.cpan.org/~grantm/XML-Simple-2.14/lib/XML/Simple.pm*) then parses the API response. LWP::Simple (*http://search.cpan.org/~gaas/libwww-perl-5.803/lib/LWP/Simple.pm*) grabs the HTML at Flickr to scrape comments for a specific photo.

To get started, create a file called *comments-backup.pl* and add the following code. Be sure to include your own Flickr NSID and API key (available at *http://www.flickr.com/services/api/*). You'll also want to specify a directory in which to store the backups. In this example, the directory is set to the local folder *flickr-comments*, but you can change this to any location.

```perl
#!/usr/bin/perl
# comments-backup.pl
# Creates a text file for each photo with comments
# at Flickr, and saves the comments to the file
#
# You can get an API key, find your NSID, and read the
# full documentation for the Flickr API at:
#
# http://www.flickr.com/services/api/

use strict;
use Flickr::API;
use Flickr::API::Response;
use LWP::Simple;
use XML::Simple;

# Set your variables
my $nsid = 'insert your NSID';
my $api_key = 'insert your API key';
my $dir = "flickr-comments";

# Create the directory if necessary
unless (-d $dir) { mkdir($dir); }

# Start the API
my $api = new Flickr::API({'key' => $api_key});

# Get a list of photos
```

```
my $response = $api->execute_method('flickr.people.getPublicPhotos', {
                'user_id' => $nsid,
                'per_page' => 500,
                'extras' => 'date_taken'});

# Parse the XML
my $xmlsimple = XML::Simple->new( );
my $flickr_xml = $xmlsimple->XMLin($response->{_content});
my $photolist = $flickr_xml->{photos}->{photo};

# Sort the hash numerically, with largest IDs first
my @photos = sort { $b <=> $a } keys %{$photolist};

# Loop through the items returned, adding as items to feed
foreach my $id (@photos) {
   my $secret = $photolist->{$id}->{secret};
   my $server = $photolist->{$id}->{server};
   my $owner = $photolist->{$id}->{owner};
   my $username = $photolist->{$id}->{username};
   my $title = $photolist->{$id}->{title};
   my $datetaken = $photolist->{$id}->{datetaken};
   my $img_src = "http://static.flickr.com/$server/$id\_$secret.jpg";
   my $img_tag = "&lt;img src=\"$img_src\" /&gt;";
   my $link = "http://www.flickr.com/photos/$owner/$id/";

   my $page = get($link);
   if ($page =~ m!<h3>Comments</h3>!mgis) {
      print "Backing up comments for photo $id: $title\n";
      my $section;
      my $file = "$dir$id.txt";
      open FILE, ">$file" or warn "Can't open $file\n";
      print FILE "$title\n$datetaken\n$link\n\n";
      ($section) = $page =~ m!<h3>Comments</h3>(.*?)</table>!s;
      while ($section =~ m!<tr valign="top">.*?<h4>(.*?)</h4>.*?<p>(.
*?)<span class=.*?</tr>!gis){
         my $commenter = $1;
         my $comment = $2;
      $comment =~ s!<.+?>!!gs;
      ($commenter) = $commenter =~ m!<a href.*?>(.*?)</a>!gis;
      print FILE "$commenter: $comment\n";
      }
      print FILE "\n\n";
      close FILE;
   }
}
```

Once the script has a list of photos, it downloads each photo's detail page from Flickr and extracts any comments with regular expressions. For each photo that has comments, the script creates a text file with the photo ID and adds to it the title, date, URL, and, of course, comments.

Running the Hack

To start your backup, run the script from a command prompt like this:

```
perl comments-backup.pl
```

The script will report its activity as it goes along, indicating which photos it's creating text files for. In the end, you should have one text file in your specified backup directory for each of your Public photos on Flickr that has comments. Figure 5-4 shows the backup text file for the conversation pictured in Figure 5-3.

Figure 5-4. Flickr comments backup file

These text files aren't a particularly structured format for the data, but the script should be easy to tweak if you'd rather store the backups as XML or CSV (Comma-Separated Values). A more structured format could be helpful if you plan to import them into a database, for example.

Hacking the Hack

One of the big advantages of having local copies of your conversations on Flickr is the ability to search them. In our example, for instance, if you couldn't quite remember where those other covered bridges were you could search for mentions of the phrase "covered bridge" to find relevant matches.

Google Desktop Search (*http://desktop.google.com*) does a fine job of searching through local files for specific phrases. Figure 5-5 shows the results of a Google Desktop Search for the phrase "covered bridge," which has turned up the Flickr comments backup file.

Click the file to see the full conversation; to see it in its original context, copy the URL in the file and paste it into your browser's address bar.

Figure 5-5. Google Desktop Search results

Backing up comments isn't a necessity, but if you want to know that your comments are going to be available for years to come—and give yourself the ability to search through them—you might want to try it.

HACK #32 Make a Contact Sheet

You want to see your photos. Lots of them. In an attractive grid. But how do you do it?

People have lots of names for these things: contact sheets, proofs, galleries, enormous grids of doom. Basically, we're talking about a bunch of photos, all on one page. There are a number of ways to produce this result:

Photo-management software
> Chances are, the software that came with your digital camera or the software you use to manage your photos on your computer has a feature to produce contact sheets. In Picassa, for example, this feature is available on the folder menu as Print Contact Sheet. But if you want to print a contact sheet of Flickr photos tagged with *bunnies*, which don't necessarily reside on your hard drive (yet), this solution might not seem ideal.

QOOP
> The QOOP photo printing service has a service geared toward Flickr users (*http://www.qoop.com/photobooks/flickr_user/*). QOOP will print books or posters containing hundreds of photos and ship to them to

you for a pretty reasonable price. This is a good way to produce gift books, or to impress the folks sitting at your coffee table.

ImageMagick

ImageMagick (*http://www.imagemagick.org*) is a free suite of image-processing software that comes with a set of powerful command-line applications. These apps will let you slice and dice photos to your heart's content. The software is available as a binary install for Windows, Mac OS X, and most flavors of Unix/Linux.

The most flexible of the three options is ImageMagick. Other hacks in this book, such as [Hack #44], show how to use the ImageMagick API with your favorite scripting language (okay, *my* favorite scripting language), Perl, to produce stunning mosaics and collages, but you can use ImageMagick to build a contact sheet without any scripting at all.

ImageMagick comes with a large collection of powerful command-line tools. Here are the two that I use the most:

convert

Converts between image formats, such as PNG, GIF, or JPG. You can also use it to resize photos, blur or sharpen them, crop them, perform noise reduction, and do many other things that you might otherwise do with a program such as Photoshop or GIMP.

montage

Offers various options for compositing multiple images together into a single large image. It makes a great all-purpose contact sheet generator.

What You Need

You'll need a couple of things for this hack:

ImageMagick

You can download ImageMagick from *http://www.imagemagick.org/ script/binary-releases.php*; binary releases are available for all the major platforms. You'll also need to install PerlMagick, the ImageMagick API for Perl.

Photos—lots of 'em

You can use the downloading scripts developed in [Hack #33] and [Hack #34] to grab the photos you're interested in. With these scripts in place, you can get a bunch of pictures of bunnies by typing the following commands.

This command will produce a text file named *bunnies.ph* that contains a list of all the images tagged with *bunnies*:

```
getPhotoList.pl bunnies
```

This command downloads all the images in the *bunnies.ph* file and puts them into a similarly named directory:

```
getSnaps.pl bunnies
```

Running the Hack

Get to the command line and change directory (cd) to where your images reside. Then invoke the montage command, as follows:

```
montage *.jpg montage.png
```

If the directory in which you've invoked the command contains a few hundred very large images, go out for doughnuts (or maybe a new CPU). When you get back, you'll find a new image file (*montage.jpg*) waiting for you that looks like Figure 5-6.

Figure 5-6. A contact sheet made with the montage command

In the above example, the *.png* extension is used to specify the output file, giving it the PNG file format. You can also use *.jpg* (JPEG), *.gif* (GIF), *.tif* (TIFF), and many other extensions. I prefer PNG for two reasons: it is a lossless format that looks nice, and it prevents the montage output from having the same extension as the JPEG images I'm working with. This way, I can continue to use *.jpg to create new montages without accidentally incorporating the previous montage images.

 Be sure to specify an explicit output image name on the command line! The last image name you specify is assumed to be the output image, and it's a little too easy to accidentally overwrite one of your input images by accidentally omitting this parameter.

Hacking the Hack

The montage command has a huge amount of options for tweaking the output. If you enter the command montage, without any arguments, it'll spit out the following list (or you can read about them at *http://www.imagemagick. org/script/montage.php*):

```
-adjoin                 join images into a single multi-image file
-affine matrix          affine transform matrix
-authenticate value     decrypt image with this password
-blue-primary point     chromaticity blue primary point
-blur factor            apply a filter to blur the image
-border geometry        surround image with a border of color
-channel type           Red, Green, Blue, Opacity, Index, Cyan, Yellow,
                        Magenta, Black, or All
-clone index            clone an image
-colors value           preferred number of colors in the image
-colorspace type        alternate image colorsapce
-comment string         annotate image with comment
-compose operator       composite operator
-compress type          image compression type
-crop geometry          preferred size and location of the cropped image
-debug events           display copious debugging information
-define format:option
                        define one or more image format options
-density geometry       horizontal and vertical density of the image
-depth value            image depth
-display server         query font from this X server
-dispose method         Undefined, None, Background, Previous
-dither                 apply Floyd/Steinberg error diffusion to image
-draw string            annotate the image with a graphic primitive
-encoding type          text encoding type
-endian type            LSB or MSB
-extract geometry       extract area from image
-fill color             color to use when filling a graphic primitive
-filter type            use this filter when resizing an image
-flip                   flip image in the vertical direction
-flop                   flop image in the horizontal direction
-frame geometry         surround image with an ornamental border
-gamma value            level of gamma correction
-geometry geometry      preferred tile and border sizes
-gravity direction      which direction to gravitate towards
-green-primary point    chromaticity green primary point
-interlace type         None, Line, Plane, or Partition
-help                   print program options
```

```
-label name            assign a label to an image
-limit type value      Area, Disk, Map, or Memory resource limit
-log format            format of debugging information
-matte                 store matte channel if the image has one
-mode type             Frame, Unframe, or Concatenate
-monochrome            transform image to black and white
-page geometry         size and location of an image canvas (setting)
-pointsize value       font point size
-profile filename      add, delete, or apply an image profile
-quality value         JPEG/MIFF/PNG compression level
-red-primary point     chromaticity red primary point
-repage geometry       size and location of an image canvas (operator)
-resize geometry       resize the image
-rotate degrees        apply Paeth rotation to the image
-sampling-factor geometry
                       horizontal and vertical sampling factor
-scenes range          image scene range
-shadow                add a shadow beneath a tile to simulate depth
-size geometry         width and height of image
-strip                 strip image of all profiles and comments
-stroke color          color to use when stroking a graphic primitive
-support factor        resize support: > 1.0 is blurry, < 1.0 is sharp
-texture filename      name of texture to tile onto the image background
-thumbnail geometry    create a thumbnail of the image
-tile geometry         number of tiles per row and column
-transform             affine transform image
-transparent color     make this color transparent within the image
-treedepth value       color tree depth
-trim                  trim image edges
-type type             image type
-verbose               print detailed information about the image
-version               print version information
-virtual-pixel method
                       Constant, Edge, Mirror, or Tile
-white-point point     chromaticity white point
```

Here are a few of the more useful options in action.

This produces a montage with a sky-blue background color:

```
montage -background #87CEEB *.jpg montage.png
```

This does the same thing:

```
montage -background SkyBlue *.jpg montage.png
```

> For a list of color names that ImageMagick recognizes, check the table on this page: *http://www.imagemagick.org/script/color.php*.

This produces a montage with only three tiles per row, instead of the default five:

```
montage -tile 3 *.jpg montage.png
```

This command includes the filename beneath each image and resizes each image to 200 pixels on the longest side:

```
montage  -label %f -size 200 *.jpg montage.png
```

This gives each color a two-pixel black border:

```
montage -border 2 -bordercolor black *.jpg montage4.jpg
```

This one is just plain annoying:

```
montage -blur 5 -rotate 45 -border 5 -bordercolor DeepPink *.jpg montage
```

Try it and see. Of course, for a tool to be truly useful, it also has to have the potential to be truly annoying.

If you enter the filenames separately, you can add individual options for each file. This allows you to rotate specific images that are flopped over, or give them other special treatments, such as individual border highlights.

See Also

- "Cache Photos Locally" [Hack #34]
- "Mash Up Your Photos" [Hack #43]
- "Make a Photo Mosaic" [Hack #49]

HACK #33 Download a List of Photos

Obtaining a list of photos is the first step in many projects.

If you poke around Flickr for more than a few minutes, one thing becomes evident: there are a *lot* of photos on the site. When I first joined the Squared Circle group, there were nearly 3,000 photographs of circular objects in the group pool. At the time of this writing, the number is over 20,000. The Flowers group has over 50,000 photos. Some prolific photographers, such as Fubuki, have uploaded over 10,000 of their own photos. And then there are the tags. At this moment, there are approximately 2,300 photos that contain the tag *pie*; 21,000 photos that contain the tag *apple*; and 111,000 photos that contain the tag *sunset*.

As a human with a limited capacity to process information, these numbers are overwhelming. Few people have the time, patience, or mental energy to wade through the entire group pool of one of the larger groups or more popular tags, and most people don't bother.

Flickr provides various means to help you find the good stuff, such as the "interestingness" feature, but as a hacker, it's fun to use silicon to crunch the photos up and spit them out in various ways. We'll start with a set of Perl scripts for downloading lists of photos. These are basic workhorse

scripts that I use all the time, in conjunction with other scripts that operate on these lists of photos.

It might be tempting to try to build a big monolithic application that does everything you might possibly want to do with Flickr, but I've found it simpler and more flexible to work with a set of small modular command-line scripts that are designed to work together. This is the same philosophy used to build many of the command-line utilities in Unix. If you're comfortable with the command line, you'll like this approach.

Useful API Methods

Many Flickr API methods (see Chapter 6) return lists of photos. These methods include:

`flickr.photos.search`
> Returns a list of photos matching a tag or other search criteria.

`flickr.people.getPublicPhotos`
> Returns a list of Public photos belonging to a particular person. Note that if you wish to filter these photos by a particular tag, `flickr.photos.search` is more appropriate.

`flickr.groups.pools.getPhotos`
> Returns a list of the photos in a group pool.

For each of these methods, the data returned looks pretty similar. Here is a typical result from `flickr.photos.search`, in which I searched for photos matching the tags *zipper* and *ride*:

```
<rsp stat="ok">
<photos page="1" pages="1" perpage="100" total="7">
<photo id="41865069" owner="26084283@N00" secret="ccb3eed603" server="31"
title="spinning" ispublic="1" isfriend="0" isfamily="0"/>
<photo id="40147327" owner="28226466@N00" secret="2388324058" server="22"
title="Zipper" ispublic="1" isfriend="1" isfamily="1"/>
<photo id="35777919" owner="43091440@N00" secret="78cd0de7c7" server="31"
title="at the end of time" ispublic="1" isfriend="0" isfamily="0"/>
<photo id="33824150" owner="10202855@N00" secret="6368d0a654" server="23"
title="carnivalzipper" ispublic="1" isfriend="1" isfamily="1"/>
<photo id="33824088" owner="10202855@N00" secret="1aeed42f5f" server="21"
title="carnival5" ispublic="1" isfriend="1" isfamily="1"/>
<photo id="24152735" owner="35294562@N00" secret="b3766cfdd7" server="18"
title="The Zipper" ispublic="1" isfriend="0" isfamily="0"/>
<photo id="1465720" owner="44146188@N00" secret="2d5487bbe5" server="2"
title="The Zipper" ispublic="1" isfriend="0" isfamily="0"/>
</photos>
</rsp>
```

I produced this list by using Flickr's API Explorer. You can find the API Explorer for any Flickr API method by going to *http://www.flickr.com/services/api/* and clicking on the name of the method you are interested in. At the bottom of the page describing the method is an API Explorer link. The API Explorer is a web-based app in which you can enter parameters for the API method and view the XML results—a great way to familiarize yourself with each API method. In this case, I entered zipper,ride in the tags field and set tag_mode to all.

For each photo, the following fields are provided:

photo_id
> A unique ID string for tracking the photo. Flickr represents these as 64-bit integers, but you should treat them as strings, in case the format changes.

secret
> A hexadecimal string used to construct URLs to the photo.

server
> The server or directory on/in which the photo resides (also used to construct URLs to the photo).

owner
> The user_id of the person who uploaded the photo.

title
> The photo's title.

ispublic
> Indicates whether the photo is visible to the general public.

isfriend *and* isfamily
> Indicates whether the photo is visible to friends or family members on the owner's contact list. If the photo is marked as Public (ispublic="1"), these settings are irrelevant.

The fields I am usually the most interested in are photo_id, secret, and server. As you'll see in "Cache Photos Locally" [Hack #34], these fields provide the information you need to construct a URL to the photo, so you can download the image itself.

For you to be able to access the photo, either ispublic must be set or you must be on the owner's friend or family list (and the corresponding bit must be set on the photo). Most of the methods mentioned earlier return lists of Public photos only, so usually ispublic will be on.

What You Need

To talk to the Flickr API, you'll need an API key and its associated shared secret. If you don't already have one, you can apply for an API key at *http://www.flickr.com/services/api/key.gne* (see "API Keys and Secrets" in Chapter 6 for more information).

The Perl scripts in this hack require that you have access to Perl on the command line (Mac OS X ships with Perl installed; Windows users might have to download ActivePerl from *http://www.activestate.com/Products/ActivePerl/*). The scripts make use of the following publicly available modules:

`Flickr::API`

> This is an interface to the Flickr API for Perl, written by Cal Henderson, one of Flickr's employees. It is a subclass of `LWP::UserAgent`. You can find it at *http://search.cpan.org/~iamcal/Flickr-API/*.

`XML::Simple`

> Although `Flickr::API` performs XML parsing, it uses the `XML::Parser::Lite::Tree` parser, which produces a data structure that can be needlessly cumbersome to parse. Fortunately, it also retains the data as a raw string, so you can use any of the myriad XML parsers available for Perl. I prefer the simpler data structures produced by `XML::Simple`.

`Data::Dumper`

> These scripts produce output in the form of a text file that can be parsed by other Perl scripts. An easy way to accomplish this is to build up the data structure in Perl and then use `Data::Dumper` to dump it out into a text file. `Data::Dumper` is also a great tool for exploring the data returned by all the Flickr API methods.

If you're missing any of these modules, you can install each of them from CPAN, like this:

```
perl -MCPAN -e shell
cpan> install package name
```

In Windows, particularly with ActiveState Perl, it is easier to use the *ppm* utility. For example:

```
ppm install package name
```

With the modules in place, you're ready to move on to the script.

The Code

Create a file called *getPhotoList.pl* and type or paste in the following code:

```
#!/usr/bin/perl -s
#
```

```perl
# getPhotoList.pl - Jim Bumgardner
#

use Flickr::API;
use XML::Simple;
use Data::Dumper;
$Data::Dumper::Terse = 1;  # avoids $VAR1 = * ; in dumper output
$Data::Dumper::Indent = $verbose? 1 : 0;  # more concise output

# You will need to create this file...
# it supplies the authentication-related vars
# $api_key and $sharedsecret
require 'apikey.ph';

print "verbose = $verbose\n" if $verbose;

$syntax = <<EOT;

  getPhotoList.pl [options] <tags> [<tags...>]
  getPhotoList.pl [options] -g group_id [<tag>]
  getPhotoList.pl [options] -u username [<tags>]

Options:
  -all      Photos must match all tags (tag search only)
  -recent=X  Only provide photos posted within the last X days (tag searches
only)
  -limit=X   Provide no more than X photos
  -license=X Provide photos with license X
EOT

die $syntax if @ARGV == 0;

my $api = new Flickr::API({'key' => $api_key, secret => $sharedsecret});

# determine method to use
$method = 'flickr.photos.search';
if ($g) {
  $group_id = shift;
  $tags = shift;
  $method = 'flickr.groups.pools.getPhotos';
  print "Searching for photos in group $group_id\n";
  # determine output filename
  $ofname = $group_id . '.ph';
}
elsif ($u) {
  $username = shift;
  $tags = join ',', @ARGV;
  $method = 'flickr.people.getPublicPhotos' if !$tags;
  print "Searching for photos by user $username using $method\n";
  # determine output filename
```

```
      $ofname = $username;
      $ofname .= '_' . $tags if $tags;
      $ofname =~ s/,\s*/_/g;
      $ofname .= '.ph';
    }
    else {
      $tags = join ',', @ARGV;
      print "Searching for photos with tags=$tags ...\n";
      # determine output filename
      $ofname = $tags . '.ph';
      $ofname =~ s/,\s*/_/g;
    }

    $nbrPages = 0;
    $photoIdx = 0;

    $limit = 5000 if $limit;

    open (OFILE, ">$ofname");

    print OFILE "\@photos = (\n";

    $user_id = '';
    $min_taken_date = '';
    $max_taken_date = '';

    $xmlp = new XML::Simple ();

    if ($recent)
    {
      die "-recent option only valid for tag search\n"
          if $method ne 'flickr.photos.search';
      ($sec,$min,$hour,$mday,$mon,$year,$wday,$yday,$isdst) =
          gmtime(time - $recent*24*60*60);
      $min_taken_date = sprintf
      "%04d-%02d-%02d 00:00:00",1900+$year,$mon+1,$mday;
      ($sec,$min,$hour,$mday,$mon,$year,$wday,$yday,$isdst) =
          gmtime(time);
      $max_taken_date = sprintf
      "%04d-%02d-%02d 00:00:00",1900+$year,$mon+1,$mday;
    }

    if ($username)
    {
      # look up user ID if a username was provided
      #
      my $response = $api->execute_method('flickr.people.findByUsername', {
                        username => $username} );
      die "Problem determining user_id: $response->{error_message}\n" if
    !$response->{success};

      print Dumper($response) if $verbose;
      # explore results of call using -verbose
```

```perl
    my $xm = $xmlp->XMLin($response->{_content});
    $user_id = $xm->{user}->{id};
    print "Userid: $user_id\n";
}

do
{
  my $params = {  per_page => 500,
                  page => $nbrPages+1};

  $params->{tags} = $tags if $tags;
  $params->{user_id} = $user_id if $user_id;
  $params->{group_id} = $group_id if $group_id;
  $params->{min_taken_date} = $min_taken_date if $min_taken_date;
  $params->{max_taken_date} = $max_taken_date if $max_taken_date;
  $params->{license} = $license if $license;
  $params->{extras} = $extras if $extras;
  $params->{tag_mode} = 'all' if $all;

  my $response = $api->execute_method($method, $params );
  die "Problem: $response->{error_message}\n" if !$response->{success};

  print Dumper($response) if $verbose;
  # explore results of call using -verbose

  my $xm = $xmlp->XMLin($response->{_content},forcearray=>['photo']);

  $photos = $xm->{photos};
  print "Page $photos->{page} of $photos->{pages}\n";

  # loop thru photos
  $photoList = $xm->{photos}->{photo};
  foreach $id (keys %{$photoList})
  {
    my $photo = $photoList->{$id};
    $photo->{id} = $id;
    print OFILE ($photoIdx++? ",\n" : "") . Dumper($photo);
  }
  ++$nbrPages;
} while ($photos->{page} < $photos->{pages} && (!$limit || $photoIdx <
$limit));

print OFILE "\n);\n1;\n";
close OFILE;

print "$photoIdx photos found matching tags $tags written to $ofname\n";
```

Also create a file called *apikey.ph*, and add code like the following:

```perl
$api_key = '12345';
$sharedsecret = '6789';
```

Replace *12345* with your actual API key, and replace *6789* with your actual shared secret. (See Chapter 6 for more information on API keys and shared secrets.)

Running the Hack

To test the script, try running the following command:

```
getPhotoList.pl aardvark
```

This will produce a file called *aardvark.ph*, which contains a list of the photos matching the tag *aardvark*. The first few lines read as follows:

```
@photos = (
{ 'owner' => '24512271@N00', 'isfriend' => '0', 'ispublic' => '1', 'secret'
=> '4551f2bed3',
'title' => 'Groupportrait', 'server' => '3', 'id' => '5024662', 'isfamily'
=> '0' } ,
{ 'owner' => '66208233@N00', 'isfriend' => '0', 'ispublic' => '1', 'secret'
=> 'fef397ccee',
'title' => 'Grooming is important', 'server' => '8', 'id' => '11999049',
'isfamily' => '0' } ,
{ 'owner' => '44124388719@N01', 'isfriend' => '1', 'ispublic' => '1',
'secret' => 'bee4525170',
'title' => 'The Night Visitor', 'server' => '4', 'id' => '5043567',
'isfamily' => '1' } ,
{ 'owner' => '66208233@N00', 'isfriend' => '0', 'ispublic' => '1', 'secret'
=> '94ae5c70ce',
'title' => 'Buffy_close', 'server' => '7', 'id' => '6883675', 'isfamily' =>
'0' } ,
...
```

To use the script with multiple tags, separate the tags with spaces, like so:

```
getPhotoList.pl rose americanbeauty
```

If you want to require that each photo match *all* the tags, use the optional -all argument:

```
getPhotoList.pl -all rose americanbeauty
```

If you don't provide the -all argument, the script defaults to doing an OR-style search (i.e., photos matching *any* of the tags will be returned).

To get all of Fubuki's photos, use the -u (user) option, like so:

```
getPhotoList.pl -u fubuki
```

Add additional arguments to restrict Fubuki's photos to those matching a particular tag or set of tags. To produce a list of Fubuki's photos that contain the tag *macro*, use this command:

```
getPhotoList.pl -u fubuki macro
```

To produce a list of photos that are in a group pool, you'll need to determine the group_id. You can get the IDs of the groups you belong to by calling the flickr.groups.pools.getGroups method or from the Flickr API Explorer web page, located at *http://www.flickr.com/services/api/explore/ ?method=flickr.groups.pools.getGroups.*

Once you know the group_id, use the script with the -g (group) option, like so:

```
getPhotoList.pl -g group_id
```

Other scripts described in this book can use the files produced by this script. For example, to download a cache of Fubuki's images, use the script in conjunction with the *getSnaps.pl* script from "Cache Photos Locally" [Hack #34], like so:

```
getPhotoList.pl -u fubuki
getSnaps.pl fubuki
```

The first command downloads a list of Fubuki's photos and saves the information to the file *fubuki.ph*. The second command downloads thumbnail versions of each of the photos.

Other hacks in this book demonstrate how to use these lists for projects that involve large-scale image manipulation, such as photo mosaics [Hack #49] or color pickers [Hack #45].

To use one of these photolist files in your own Perl scripts, get the filename from the command line and then require it, like so:

```
$photoList = shift;
require "$photoList";
```

My own scripts usually automatically add the *.ph* extension if it hasn't already been provided:

```
$photoList = shift;
$photolist .= '.ph' if !($photolist =~ m/\./);
require "$photoList";
```

Here's a basic loop that walks through the images and converts them into URLs pointing to thumbnails:

```
$suffix = "_t"; # thumbnail suffix
foreach $photo (@photos)
{
    sprintf "http://static.flickr.com/%d/%d_%s%s.jpg",
        $photo->{server},$photo->{id}, $photo->{secret}, $suffix;
}
```

Finally, here's a little script, *getSnap.pl*, that will download one of the photos contained in one of these lists:

```
#!/usr/bin/perl
use LWP::Simple;
```

```
$photolist = shift;
$photolist .= '.ph' if !($photolist =~ m/\./);
$photo_id = shift;
die "getSnap.pl [photolist_file] [photo_id#]\n" if !$photo_id;

require "$photolist";

foreach $p (@photos)
{
    if ($p->{id} eq $photo_id)
    {
        $photo = $p;
        last;
    }
}

die "image $photo_id not found in $photolist.\n" if !$photo;

$purl = sprintf "http://static.flickr.com/%d/%d_%s.jpg",
  $photo->{server},$photo_id, $photo->{secret};
$pimg = get $purl;
$fname = "${photo_id}.jpg";
open (OFILE, ">$fname ") || die ("can't open $fname\n");
binmode OFILE;
print OFILE $pimg;
close OFILE;
```

See "Cache Photos Locally" [Hack #34] for a way to download all of them more efficiently.

See Also

- "Cache Photos Locally" [Hack #34]
- "Mash Up Your Photos" [Hack #43]
- "Make a Photo Mosaic" [Hack #49]

HACK #34 Cache Photos Locally

Flickr has tons of photos, but your hard drive is faster.

If you're working on a project that involves large numbers of Flickr photos, such as a mosaic [Hack #49], you will probably want to make local copies of the photos on your hard drive. Reading photos locally is much faster than downloading them from Flickr. I find that my scripts might download medium-sized photos as slowly as one per second, but they can process hundreds per second when reading them off my hard drive. If you end up running your script more than once, this hack will save you a huge amount of time.

When downloading photos from Flickr, please be a good Flickr citizen and follow these guidelines:

- Don't download photos that are larger than you need. For most of my projects, I require only small thumbnail images. These download faster from Flickr and put less of a strain on their servers.

- Don't download more photos than you need. If you are interested only in photos of lighthouses, don't download every single photo posted to Flickr Central. Use the various filtering options in the `flickr.photos. search` API method [Hack #33] to identify just the images you need.

Constructing Flickr URLs

Downloading photos from Flickr involves taking the following three identifying fields that Flickr associates with each photo and converting them into a URL:

photo_id
> This is a unique number associated with the photo. Flickr stores this internally as a 64-bit integer, but you might want to treat it as a string, in case Flickr changes the format in the future.

secret
> This is a hexadecimal string that must be incorporated into the URL to obtain the photo. Secrets are not necessarily unique, but each photo_id has one and only one secret.

server
> To handle the enormous load, Flickr divides the photos among a number of servers, each of which has a number. Each photo is assigned a server number when it is first uploaded to Flickr.

The photos themselves can be accessed using one of the following URL systems:

```
http://static.flickr.com/<server>/<photo_id>_<secret>.jpg
http://static.flickr.com/<server>/<photo_id>_<secret>_<size>.jpg
```

If the `<size>` qualifier is left out, as in the first variant, you'll get a medium-sized version of the image, which is 500 pixels on the longest side. This is the version people see on the photo's detail page.

The following values are available for the `<size>` qualifier:

s
> Small square—75×75 pixels

t
> Thumbnail—100 pixels on the longest side

m

Small—240 pixels on the longest side

No qualifier

Medium—500 pixels on the longest side (this is the default setting)

b

Large—1024 pixels on the longest side (exists only for very large original images)

o

Original—original dimensions; either a JPEG, GIF, or PNG, depending on the source format (the vast majority are JPEGs)

For example, consider a photo with the following information:

photo_id	3263379
secret	21ee6ccacf
secret	3

You could access this photo using any of the following URLs:

http://static.flickr.com/3/3263379_21ee6ccacf.jpg
http://static.flickr.com/3/3263379_21ee6ccacf_s.jpg
http://static.flickr.com/3/3263379_21ee6ccacf_t.jpg
http://static.flickr.com/3/3263379_21ee6ccacf_m.jpg
http://static.flickr.com/3/3263379_21ee6ccacf_b.jpg
http://static.flickr.com/3/3263379_21ee6ccacf_o.jpg

(Although, as it turns out, the URL with the b value for `<size>` doesn't work, because the original photo is only 700 pixels across.)

What You Need

The Perl scripts in this hack require you to have access to Perl on the command line and make use of the publicly available `LWP::Simple` module. This module enables you to retrieve data from a web site by issuing a simple get() command.

If you're missing the `LWP::Simple` module, you can install it from CPAN, like this:

```
perl -MCPAN -e shell
cpan> install LWP::Simple
```

The Perl scripts in this hack also require that you have the *getPhotoList.pl* script from "Download a List of Photos" [Hack #33].

The Code

Create a file called *getSnaps.pl* and enter the following code into it:

```perl
#!/usr/bin/perl -s

# getSnaps.pl - Jim Bumgardner
#
# grab tagged photos and put small thumbnails into a named folder
#
# use -med option for medium-sized photos

use LWP::Simple;

$photolist = shift;
$dirname = shift;
die "getSnaps.pl [-big] <photolist_file> [dirname]\n" if !$photolist;

$dirname = $photolist if !$dirname;
$dirname =~ s/\.ph// if $dirname =~ /\.ph$/;
$photolist .= '.ph' if !($photolist =~ /\./);

require "$photolist";

$nbrAdded = 0;

if (!(-e $dirname))
{
    print "Making directory $dirname\n";
    `mkdir $dirname`;
}

$suffix = $big? '' : '_t';

foreach $photo (@photos)
{
    $purlt = sprintf "http://static.flickr.com/%d/%d_%s%s.jpg",
                $photo->{server},$photo->{id}, $photo->{secret}, $suffix;

    $fnam = "$dirname/$photo->{id}$suffix.jpg";

    $hasSmall = 0;

    print "Checking $fnam...\n" if $verbose;

    # printf "Checking $fnam...\n";
    if (!(-e $fnam))
    {
      print "Adding $fnam...\n";
        foreach (0..5)
        {
            $pimg = get $purlt;
            last if $pimg;
```

```
              print "Retry...\n";
              sleep 1;
        }
        die "Couldn't get image $purlt\n" if !$pimg;
        open (OFILE, ">$fnam") || die ("can't open $fnam\n");
        binmode OFILE;
        print OFILE $pimg;
        close OFILE;
        print "$nbrAdded...\n" if ++$nbrAdded % 50 == 0;
    }
}

print "$nbrAdded added\n";
```

Running the Hack

To use this code, you'll need the *getPhotoList.pl* script developed in "Download a List of Photos" **[Hack #33]**.

To download a set of images with a particular *tag*, use the following commands:

```
getPhotoList.pl tag
getSnaps.pl tag
```

Here is a sample run:

```
$ getPhotoList.pl aardvark
Searching for photos with tags=aardvark ...
Page 1 of 1
31 photos found matching tags aardvark written to aardvark.ph

$ getSnaps.pl aardvark
Making directory aardvark
Adding aardvark/5024662_t.jpg...
Adding aardvark/11999049_t.jpg...
Adding aardvark/5043567_t.jpg...
(etc...)
Adding aardvark/23418439_t.jpg...
31 added
```

When the second script is done running, you'll find a new folder named *aardvark*, which contains all the thumbnails that are referenced in the photolist file *aardvark.ph* that was created by the first script. If you wish to store the photos in a different directory, specify it on the command line, like so:

```
getSnaps.pl aardvark myAnimalPics
```

If the directory doesn't already exist, the script will create it.

Hacking the Hack

There are two strategies you can use for caching images: you can put images used for a particular project into a single folder, as we did in the previous

example; or you can keep all the images for all your projects in a central repository, which might consist of multiple folders. I use the second method, because I have a lot of projects and it puts less strain on Flickr; if a photo is used in more than one project I need to download it only once, which reduces the amount of time I spend downloading images and the amount of space they take up on my hard drive.

I have downloaded hundreds of thousands of photos to my local cache, so I have developed a subdivision system that ensures that no one folder holds more than a thousand photos. This makes it faster to traverse the directories and look at photos. Windows, in particular, can be quite slow to display the contents of a folder containing tens of thousands of files.

My cache resides in a root folder called *snaps*. This, in turn, contains one folder for each Flickr server (*snaps/1*, *snaps/2*, etc.). Each server folder contains a set of folders that hold up to 1,000 photos each. My example file from server 3 with photo_id 3263379 gets the following local pathname: *snaps/3/3263/3263379.jpg*.

If you want to use this centralized storage strategy, replace the line that generates the output filename:

```
$fnam = "$dirname/$photo->{id}$suffix.jpg";
```

with this block of code:

```
$rootdir = "snaps"; # make this directory ahead of time
$servdir = "$rootdir/server$photo->{server};"
$kilodir = "$servdir/" . int($photo->{id}/1000);
$fnam = "$kilodir/$photo->{id}$suffix.jpg";
```

This constructs the (more complicated) path to the file.

Before creating the file, you should make the directories leading up to the file, if necessary, like so:

```
`mkdir $rootdir` if !(-e $rootdir);
`mkdir $servdir` if !(-e $servdir);
`mkdir $kilodir` if !(-e $kilodir);
```

If you keep downloading photos, you'll eventually build up a huge local cache, which you can use as source material for giant photo collages and the other impressive projects in the hacks to come.

See Also

- "Download a List of Photos" [Hack #33]
- "Mash Up Your Photos" [Hack #43]
- "Make a Color Picker" [Hack #45]
- "Make a Photo Mosaic" [Hack #49]

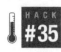 **Edit Photos as a Batch**

#35 Make changes to your photos en masse with batch editing.

Often, when you're browsing around Flickr you'll notice a way that some-
one else is using tags that you could apply to your own photos. For exam-
ple, you might have tagged several of your photos taken in national parks
with the words *Yosemite* or *Yellowstone*, but you didn't include the tag
national park.

You could browse to each photo's detail page and add the tag manually, or
you could take advantage of Flickr's batch-editing features to add the tag to
all the relevant photos in one fell swoop.

Batch Editing in Flickr

Batch editing involves making a change to a collection of photos. That col-
lection can be as simple as the first page of your photostream, or a more
complex result set based on a multiple-tag search. The key to editing photos
in a batch is keeping an eye out for the "Edit as a batch" links.

If you browse to your photostream, you'll see an "Edit these as a batch?"
link on the right side of the page. Click the link and you can edit all of the
photos on the first page of your photostream at once. You can also gather
together a group of photos by tags. Enter a tag (or a group of tags separated
by commas) into the "Search by tag" form on your photostream page, and
you'll see a list of results like those shown in Figure 5-7.

At the top of the search results page, you'll see the number of results, along
with a link to edit all of the photos in the results as a batch. Click the link to
bring up the Title/Descriptions batch-editing page shown in Figure 5-8.

On the Title/Descriptions batch-editing page, you'll see each of the photos
in the batch, along with a form to change the title, description, and tags
associated with each of the photos. You can go down the list and make your
adjustments, saving you the time involved with visiting each photo's detail
page. Click Save at the bottom of the page when you're finished, and all of
the photos will be updated.

If you'd rather simply add a tag to all of the photos, you can click the Batch
Operations tab at the top of the page for even more editing options, as
shown in Figure 5-9.

You can add a specific tag to all of the photos, change the privacy settings,
or even delete all of these photos from your photostream. (Of course, delet-
ing the photos means the photos will no longer be available at Flickr, so
delete with caution!)

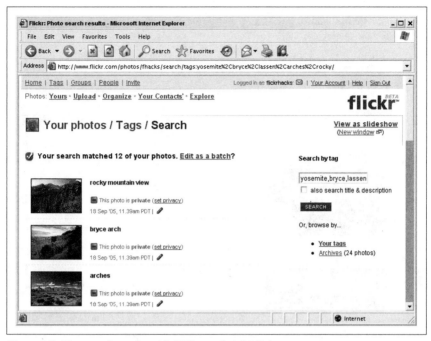

Figure 5-7. Tag search results with "Edit as a batch" link

While these batch-editing features can handle most changes you'll want to make, some ingenious Flickr members have extended the batch-editing capabilities even further with some help from Greasemonkey.

Extending Batch Editing

Greasemonkey is a plug-in for the Firefox browser that lets users inject code into pages. A couple of Greasemonkey scripts add even more features to Flickr's batch-editing pages to enable users to edit other aspects of photos in a group. To get started, install Greasemonkey by visiting *http://greasemonkey.mozdev.org*. Once it's installed, you'll be set to use the following scripts.

The Flickr Batch Operations Enhancer by Flickr member Lachie (*http://www.flickr.com/photos/lachie/*) adds several options to the Batch Operations page. To install the script, point Firefox to *http://members.iinet.net.au/~lachiec/greasemonkey/flick_batch.user.js*.

Choose Tools → Install This User Script... from the menu, and then reload the Batch Operations page at Flickr. Click the Show Enhancements link under the standard options, and you'll see the new options available, as shown in Figure 5-10.

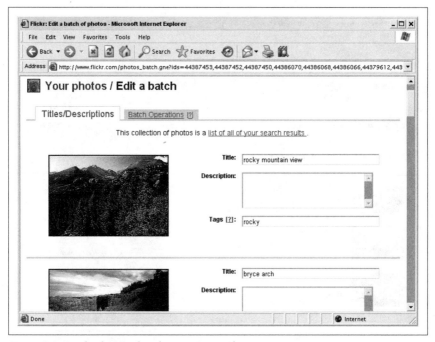

Figure 5-8. Batch editing titles, descriptions, and tags

With the script installed, you can edit the date and time for each photo in the batch, adjust the photo licensing [Hack #16], and set extended permissions for each photo, including who can comment or add notes and tags.

Another Greasemonkey script, Flickr Title + Descriptions Batch Tools by Flickr member Steeev (*http://www.flickr.com/photos/steeev/*), adds some options to the Title/Descriptions batch-editing page. To install this Greasemonkey script, browse to *http://steeev.f2o.org/flickr/flickr.title+desc.batch.user.js.*

Go through the script addition process and browse to the Flickr Title/ Descriptions batch-editing page. You'll see the additions shown in Figure 5-11.

Two new links at the top of the page let you append text to all titles or descriptions, saving the time of pasting text into each field by hand. The arrows to the right of the form fields in the first entry let you specify the initial field's value as the value for all fields on the page. Using the arrows will delete any value that was in the fields before, so be sure that you really want every photo in the batch to have exactly the same title, description, and tags before you use them.

Figure 5-9. Adding a tag to a group of photos with batch editing

Updating more than a handful of photos doesn't have to be a chore if you know how to use the built-in batch-editing tools. And the Firefox/Grease-monkey combination can provide even more options for changing your photos quickly.

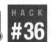

HACK #36 Clean the (Group) Pool

Cleaning the pool is all in a day's work for this bot.

As moderator of some large groups on Flickr, such as the Squared Circle (*http://www.flickr.com/groups/circle/*) and Flowers (*http://www.flickr.com/groups/florus/*) groups, I've found it helpful to make some power tools to assist with moderating them.

In a large group, several hundred new photos might be submitted to the group photo pool each day, so it can be cumbersome for humans to weed through them all. Furthermore, some enterprising individuals might try to add huge batches of photos to a group's photo pool all at once. When this happens, new photos submitted by other users quickly get buried under the avalanche, and no one gets a chance to really appreciate them.

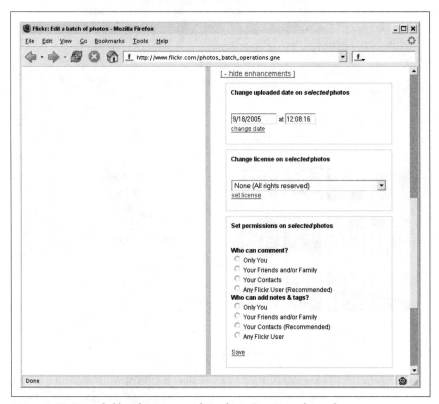

Figure 5-10. Extended batch options with Lachie's Greasemonkey enhancement

Some large groups deal with this problem by posting an upload limit in the group description, such as "No more than three photos a day." However, many contributors either don't notice these rules, don't speak the language they are posted in, or simply don't care. Manually enforcing upload limits can be a chore; if there are tons of people submitting photos, it's difficult to keep track of who has submitted what. And unfortunately, Flickr has no mechanism for limiting uploads to group pools.

The Flickr API, however, provides a method called `flickr.groups.pools.remove` that can be used as the basis of a group robot, or *bot*, designed to do just that. The bot is a script, tied to one of the group administrator's accounts, that automatically removes photos from the group pool. My bot Hipbot (whose profile is shown in Figure 5-12) was the first such pool-cleaning bot on Flickr, and I'm going to share one of the principal Hipbot scripts in this hack.

Figure 5-11. *Extended batch options with Steeev's Greasemonkey script*

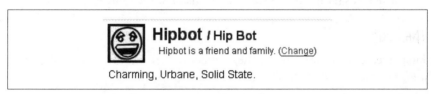

Figure 5-12. *Hipbot's profile*

The script scans a collection of different groups that Hipbot administers and applies slightly different policies to each of these groups, removing photos that exceed the submission limits of each particular group.

> If you haven't used the Flickr API before, we suggest you check out the first few sections of Chapter 6 before you get started. You may also want to try some of the hacks in that chapter before using this script.

What You Need

To run this script, you'll need an *API key*, a *shared secret*, and an *authorization token*, as explained in "Authenticate Yourself" **[Hack #40]**. These parameters will be used to tell the API that you have sufficient permissions to delete photos from the group pool.

 This script works only if you are an administrator of the group or groups whose pool(s) you are trying to clean.

This particular example is configured for Hipbot's groups. If you want to use this script with your own groups, you'll need the group IDs of the groups you are administering. You can obtain group IDs by visiting the API Explorer page for flickr.groups.pools.getgroups, which is located at *http://www.flickr.com/services/api/explore/?method=flickr.groups.pools.getGroups*.

Click the Call Method... button on this page to see a list of your groups and their group IDs.

You'll also need the Flickr::API module, which is available from CPAN. This module simplifies communicating with the Flickr API.

If you're missing this module, you can install it from CPAN, like this:

```
$ perl -MCPAN -e shell
cpan> install Flickr::API
```

You'll also need XML::Simple, which I commonly use to simplify parsing the data structures returned by Flickr::API. Install it the same way.

The Code

First, create a file for storing the authentication information. Call it *bot_auth.ph*, and store the following code in it:

```
$api_key = '928c994908f02385d1d97a457003cb71';
$shared_secret = '8698bb062a08ca11';
$auth_token = '127122-92395db066e82035';
1;
```

Instead of the values shown here, use your own api_key, shared_secret, and auth_token.

Next, create the file for the main bot script, *cleanPool.pl*. I'll describe this code in sections, starting with some basic setup to specify which modules we are going to use and require the *bot_auth.ph* file:

```
#!/usr/bin/perl -s

use Flickr::API;
```

```
use XML::Simple;

require 'bot_auth.ph'; # provides api_key, shared_secret, and auth_token
```

Next is a data structure, which describes the rules for each group we are administering:

```
@groups = (
    {name=>'Flowers', id=>'13378274@N00', limit=>3,
        submitWindow=>7*60*60, cutoffTime => time - 1*24*60*60},
    {name=>'JPG Mag', id=>'52240402017@N01', limit=>1,
        submitWindow=>7*60*60, cutoffTime => time - 1*24*60*60},
    {name=>'Least Interesting', id=>'55489371@N00', limit=>1, keepNewest=>1,
        submitWindow=>0, cutoffTime => 0},
    {name=>'Your Favorites', id=>'74565724@N00', limit=>2, keepNewest=>1,
        submitWindow=>0, cutoffTime => 0},
    {name=>'Body Language', id=>'82402134@N00', limit=>3,
        submitWindow=>12*60*60, cutoffTime => time - 1*24*60*60},
    {name=>'Hand Signals', id=>'80263920@N00', limit=>3,
        submitWindow=>12*60*60, cutoffTime => time - 1*24*60*60},
    {name=>'Critique - Advanced',id=>'48467233@N00', limit=>0,
        submitWindow=>0, cutoffTime=>0},
    {name=>'Critique - For Starters',id=>'16162753@N00', limit=>0,
        submitWindow=>0, cutoffTime=>0},
    {name=>'Critique - Intermediate',id=>'71433669@N00', limit=>0,
        submitWindow=>0, cutoffTime=>0}
);
```

The Flowers group allows posting of a maximum of three photos every seven hours. Other groups, such as the Critique groups, allow no photos at all. The Least Interesting group allows each member to have only one photo in the pool; if a new photo is added, the old one gets deleted. The cutoffTime parameter is used to optimize data loading, as you'll see later.

Now, initialize the Flickr::API module, using the fields defined in the *bot_info.ph* file:

```
# Set up the Flickr::API
#
my $api = new Flickr::API({'key' => $api_key, secret => $shared_secret});
```

Then loop for each group, performing the following actions on each group:

```
# loop for each group
#
foreach $group (@groups)
{
    print "$group->{name}...\n";
```

This is the same technique used in [Hack #33], and it will provide us with a list of the photos we're interested in. Group photo lists are sorted by order of submission to the group, with the most recent photos listed first.

The script uses the cutoffTime variable to break the loop prematurely if we start seeing photos from a time period we've already administered:

```
# Get list of photos
#
#
@photos = ( );
$nbrPages = 0;
$photoIdx = 0;
do
{
  $nbrAdded = 0;

  my $response = $api->execute_method('flickr.groups.pools.getPhotos', {
                  group_id => $group->{id},
                  per_page => 500,
                  page => $nbrPages+1}
              );

  my $xml = $response->{_content};
  $xml =~ s/ownername="[^"]+"//g;  # Get rid of stuff that
  $xml =~ s/title="[^"]+"//g;      # may causing parsing problems...
  $xm = XMLin($xml);
  $photolist = $xm->{"photos"}->{"photo"};
  $maxTime = 0;
  foreach $id (keys %{$photolist})
  {
    $photo = $photolist->{$id};
    $photo->{id} = $id;
    push @photos, $photo;
    $maxTime = $photo->{dateadded} if $photo->{dateadded} > $maxTime;
    $photoIdx++;
    $nbrAdded++;
  }
  print "$photoIdx...\n";
  ++$nbrPages;
} while ($nbrAdded > 0 && $maxTime > $group->{cutoffTime});
```

The cutoffTimes variable can be used only for groups that have a "no more than N photos in N hours" rule; otherwise, we have to load all the photo data.

Next, the script sorts the photos by time. Some groups have a policy that newer submissions should cause older submissions to be deleted. In this case, we sort in reverse-chronological order. Otherwise, we sort in chronological order:

```
# Collect photos by owner
#
%owners = ( );
@photos = sort {$a->{dateadded} <=> $b->{dateadded} } @photos;
@photos = reverse @photos if $group->{keepNewest};
```

The script then collects the photos that each person has submitted into a
hash called $owners:

```
foreach $photo (@photos)
{
  $owner = $photo->{owner};
  $owners{$photo->{owner}} = {photos=>[]} if !(defined $owners{$photo->
{owner}});
  push @{$owners{$photo->{owner}}->{photos}}, $photo;
}
```

It then walks through the $owners hash and identifies photos that need to be
rejected, based on our rules. The photo records are pushed onto an array
called @rejects:

```
# Select photos to reject
#
@rejects = ( );
foreach $ownid (keys %owners)
{
  # print "Owner $ownid...  SubmitWindow $group->{submitWindow}\n";
  $photoList = $owners{$ownid}->{photos};
  $n = 0;
  foreach $photo (@{$photoList})
  {
    if ($n >= $group->{limit} && (!$group->{submitWindow} || abs($photo->
{dateadded} - $photoList->[$n-$group->{limit}]->{dateadded}) < $group->
{submitWindow}))
    {
      # print "$n exceeds $group->{limit}  (dateadded: $photo->
{dateadded})\n";
      push @rejects, $photo;
    }
    $n++;
  }
}
```

Next, the script rejects these photos using the API method flickr.groups.
pools.remove:

```
# Reject photos
#
my $totRejected = 0;
my $totGroup = @photos;
foreach $photo (@rejects)
{
  print "Rejecting $photo->{id}...\n";
  my $res = $api->execute_method('flickr.groups.pools.remove', {
                                    group_id => $group->{id},
                                    photo_id => $photo->{id},
                                    auth_token => $auth_token }
             );

  if (!$res->{success})
  {
```

```
    print "Error rejecting $photo->{id}: $res->{error_message}\n";
  }
  else {
    $totRejected++;
  }
}
```

This is the only call that requires authentication, so we pass the authentication token here. As we reject photos, we count successful rejections.

We then show the results for this group and loop onto the next one:

```
# Show results
#
print "$totRejected rejected of $totGroup for group $group->{name}\n";

# end of loop
}
```

And that's the script!

Running the Hack

This script can (and should) be automated to run periodically by using a batch script or *cron* job, but first you'll probably want to test it manually. Here's a sample run:

```
$ cleanPool.pl
Flowers...
500...
1000...
0 rejected of 1000 for group Flowers
JPG Mag...
499...
999...
0 rejected of 999 for group JPG Mag
Least Interesting...
500...
731...
0 rejected of 731 for group Least Interesting
Your Favorites...
500...
1000...
1500...
2000...
2500...
3000...
3101...
0 rejected of 3101 for group Your Favorites
Body Language...
500...
1000...
0 rejected of 1000 for group Body Language
Hand Signals...
```

```
277...
0 rejected of 277 for group Hand Signals
Critique - Advanced...
0...
0 rejected of 0 for group Critique - Advanced
Critique - For Starters...
0...
0 rejected of 0 for group Critique - For Starters
Critique - Intermediate...
0...
0 rejected of 0 for group Critique - Intermediate
```

I run this script every 20 minutes, so there's usually little that needs cleaning; indeed, in this run, nothing actually got deleted.

I should point out that technically, this script rejects photos that exceed some limit (such as three postings) in any 12-hour period. This is not quite the same thing as "three per day," but it is easier to detect. Since Flickr users come from all over the world, it's difficult to precisely define what "once a day" means; however, this method works pretty well.

To give Hipbot a little extra personality, I created a separate Flickr account for him and gave him a snazzy-looking icon and appropriate profile, including photos of his robot friends. I suggest you do the same with your bot. Pretty soon it'll start getting awesome testimonials, like the ones in Figure 5-13 (and maybe even marriage proposals from other bots!).

Figure 5-13. Hipbot testimonials

See Also

- "Authenticate Yourself" [Hack #40]

API Basics
Hacks 37–42

There's an obvious reason why Flickr has a larger and more active community of hackers, tinkerers, and geeks than most other photo-sharing services. It's the incredible application programming interface (API), which lets you interact with Flickr in unique and powerful ways. The API makes it possible to perform Herculean tasks that would otherwise be impossible, or at least extremely tedious, for a human. For example, Chapter 7 shows how to use the API to download thousands of photographs and build an elaborate and beautiful photo mosaic [Hack #44]. In this chapter, you'll learn the fundamentals of communicating with the API, as well as the important kinds of information that the API traffics in.

The API Page

You can learn to use the Flickr API without memorizing anything, but there is one URL you might want to commit to memory:

http://www.flickr.com/services/api/

This is the location of Flickr's API documentation page (which we'll refer to as "the API page" for short). The API page contains a list of each of the API methods, which are services that Flickr can perform for you. Each method listed on the page is linked to a description of that particular method.

Some programmers, this one included, access the API page frequently enough that we can type the URL faster than we'd be able to find the bookmark.

API Methods

The Flickr API methods are organized into groups by functionality. This section provides a quick overview of API as a whole, but we recommend that you view the individual API information pages on Flickr for the particular

calls that pique your interest. Also, bear in mind that Flickr's API is still rapidly growing and gaining in functionality. Check the current method list at *http://www.flickr.com/services/api/* to find new additions and changes.

Authorization

These methods are used to *authenticate* (i.e., authorize) applications that use the Flickr API:

```
flickr.auth.checkToken
flickr.auth.getFrob
flickr.auth.getFullToken
flickr.auth.getToken
```

You might need to use these methods if you intend to use other API methods that perform more invasive tasks, such as deleting photos or viewing your own private photos. However, we recommend that, if possible, you avoid using these methods by making use of one of the API kits that performs authentication internally. phpFlickr (for PHP users) and Flickr::API (for Perl users) are two excellent choices. See "Authenticate Yourself" **[Hack #40]** and "Authenticate Users" **[Hack #41]** for examples.

Blogs

These methods permit you to interact with any blogs that you have configured to work with Flickr:

```
flickr.blogs.getList
flickr.blogs.postPhoto
```

Contacts

These methods permit you to produce lists of your contacts, or some other user's contacts:

```
flickr.contacts.getList
flickr.contacts.getPublicList
```

Favorites

These methods permit you to manipulate and view favorites (photos that you or other people have marked for special attention):

```
flickr.favorites.add
flickr.favorites.getList
flickr.favorites.getPublicList
flickr.favorites.remove
```

 At the time of this writing, it is not yet easy to determine with the API how many people have marked a particular photo a favorite, although this information is displayed on the photo's detail page.

Groups

Groups, which are used both as discussion boards and as a means for disparate users to collect and interact with photos in interesting ways, are one of the great features of Flickr. The following methods permit you to obtain group IDs and to produce lists of groups and of the photos in group photo pools:

```
flickr.groups.browse
flickr.groups.getInfo
flickr.groups.search
flickr.groups.pools.add
flickr.groups.pools.getContext
flickr.groups.pools.getGroups
flickr.groups.pools.getPhotos
flickr.groups.pools.remove
```

People

Flickr is a social web site, so it's important to be able to find out more about the people using it. These methods allow you to do so:

```
flickr.people.findByEmail
flickr.people.findByUsername
flickr.people.getInfo
flickr.people.getPublicGroups
flickr.people.getPublicPhotos
flickr.people.getUploadStatus
```

Some of the methods in this group, such as `flickr.people.findByUsername`, enable you to determine a user's ID number. You can then pass the user's ID to other API calls, such as `flickr.people.getInfo` to find out more info about the user or `flickr.people.getPublicPhotos` to obtain a list of the photos in that user's stream.

Photos

Of course, photos are the bread, the butter, and the manna of Flickr, so the majority of the API calls are in the `flickr.photos` group:

```
flickr.photos.addTags
flickr.photos.getAllContexts
```

```
flickr.photos.getContactsPhotos
flickr.photos.getContactsPublicPhotos
flickr.photos.getContext
flickr.photos.getCounts
flickr.photos.getExif
flickr.photos.getInfo
flickr.photos.getNotInSet
flickr.photos.getPerms
flickr.photos.getRecent
flickr.photos.getSizes
flickr.photos.getUntagged
flickr.photos.removeTag
flickr.photos.search
flickr.photos.setDates
flickr.photos.setMeta
flickr.photos.setPerms
flickr.photos.setTags
flickr.photos.transform.rotate
flickr.photos.upload.checkTickets
```

The two calls you're likely to use most frequently are `flickr.photos.getInfo`, which retrieves information about a particular photo, and `flickr.photos.search`, which can retrieve lists of photos that match a particular tag, set of tags, or other criteria.

Licenses

Flickr supports the Creative Commons licensing system [Hack #16], and these calls permit you to manipulate and query license information:

```
flickr.photos.licenses.getInfo
flickr.photos.licenses.setLicense
```

Most other calls in the API that retrieve information about photos, such as `flickr.photos.search` and `flickr.groups.pool.getPhotos`, will also return license information for photos.

Notes

You may have already noticed that on Flickr, you can place notes [Hack #10] directly on top of your photos, or other people's photos. These methods allow you to manipulate those notes:

```
flickr.photos.notes.add
flickr.photos.notes.delete
flickr.photos.notes.edit
```

Use flickr.photos.getInfo to list the notes and tags for a particular photo.

Photo Sets

The photos in your stream can be organized into *sets*, which are collections of related photos (such as all the photos you took on your vacation in Fresno). Use these methods to manipulate and access those sets of photos:

```
flickr.photosets.addPhoto
flickr.photosets.create
flickr.photosets.delete
flickr.photosets.editMeta
flickr.photosets.editPhotos
flickr.photosets.getContext
flickr.photosets.getInfo
flickr.photosets.getList
flickr.photosets.getPhotos
flickr.photosets.orderSets
flickr.photosets.removePhoto
```

Reflection: API Information

These methods return information about the API methods themselves, producing a current list of the API methods and describing the information they provide:

```
flickr.reflection.getMethodInfo
flickr.reflection.getMethods
```

You can also get this same information (in more human-readable form) by visiting the API documentation page at *http://www.flickr.com/services/api/*.

Tags

Users can attach tags [Hack #10] to photos on Flickr, and these API methods enable you to view those tags:

```
flickr.tags.getListPhoto
flickr.tags.getListUser
flickr.tags.getListUserPopular
flickr.tags.getRelated
```

You can also use flickr.photos.getInfo to list the tags, as well as copious other information, for a particular photo.

Test

These methods are intended for hackers like us to test the API:

```
flickr.test.echo
flickr.test.login
```

You might find it just as easy to use some of the other API calls, which is how we'll accomplish the first tests in this chapter.

URLs

On Flickr, you can find users, photos, and groups at predictable and fixed URLs. It's simple enough to construct these URLs out of their constituent parts by conjoining strings, but you can also use the first three methods in this group:

```
flickr.urls.getGroup
flickr.urls.getUserPhotos
flickr.urls.getUserProfile
flickr.urls.lookupGroup
flickr.urls.lookupUser
```

The last two methods convert URLs to group IDs and user IDs, respectively.

 You'll find that most of the hacks in this book use only a small subset of the entire collection of API methods. You can accomplish an extraordinary amount with just two API methods: flickr.photos.search and flickr.groups.pools.getPhotos.

API Keys and Secrets

All of the API methods have one required parameter, api_key, which identifies your application to Flickr. Since all the methods require an API key, you should get one before you start experimenting with the API.

To get an API key, sign in to Flickr and go to the following URL (which should look familiar by now):

http://www.flickr.com/services/api/

Click the API Keys link (under "Read these first:"), and then click the "Apply for your key online now" link. Alternatively, just go directly to the following URL, which is where you'll end up:

http://www.flickr.com/services/api/key.gne

Fill out the form, and press the Apply button. You'll be presented with an API key, as shown in Figure 6-1. You can record this information in a text file, or just return to the Flickr API page when you need to see it.

Figure 6-1. An API key

 You need only one API key for experimenting, but we recommend getting a unique API key for each application that you intend to share with other people. This way, people can assign different permissions to each of your apps.

Each API key is issued with an accompanying *shared secret*, an alphanumeric string that must be provided for the authentication process. You can view the shared secret that goes with your API key by visiting the API page and clicking the word "Yours" on the line that says "API Keys (Yours)." For more info about authentication, see "Authenticate Yourself" [Hack #40].

Identifying Users

Many of the API methods accept a few parameters relating to Flickr users (like yourself).

The username is the name other users see next to your buddy icon, such as when you post messages in Flickr groups. These are the names you see most commonly on Flickr.

The user_id is an alphanumeric string that uniquely identifies each user. It can be used in any URL that refers to the user, such as the user's photostream or profile page.

user_ids and group_ids are both instances of Network Service IDs (NSIDs), unique strings used to identify both users and groups on Flickr. A typical NSID is a string of numbers, followed by an at sign (@), an N, and two more numbers (often *00* or *01*). Here's a typical NSID: *94832693@N00*. If you learn to recognize this pattern, it'll be easier to pick it out of URLs.

Flickr is now beginning to integrate its services into Yahoo!, so the user_id and group_id strings might eventually deviate from the NSID format. Because of this, most API calls that return IDs provide both an ID and an NSID. At time of this writing, these two fields are always identical, but you should be careful to use one or the other consistently to avoid future problems with your scripts.

An easy way to discover your own user_id without using the API is to view the image properties of your Flickr icon and examine the URL of the image. My icon's URL reads as follows (my user_id is shown in bold):

```
http://photos2.flickr.com/buddyicons/94832693@N00.jpg?1119657139
```

The link to your RSS feed on your photostream page also contains your user_id.

Finally, the alias is a name you can choose to give your Flickr page a permanent, more readable URL, in addition to the URL that contains the user_id. This alias is not necessarily the same as your username, and unlike your username, once you create the alias you cannot change it. People sometimes start with aliases that are the same as their usernames but then change their usernames. For example, on Flickr, my username is *jbum*, but my alias is *krazydad*, so my photos can be found here:

http://www.flickr.com/photos/krazydad/

It's easier for other people to guess your Flickr web address if you make your alias the same as your username. I probably should have chosen *jbum* for my alias, but now it's too late. Oh well!

Not every user has an alias. You can tell if the user does by visiting her photo page. If the URL still contains an NSID, it means the user has not picked out an alias yet. However, even after the user picks out an alias, the NSID will still work for constructing URLs to the user's pages. Thus, you can also reach my photos by using this URL:

http://www.flickr.com/photos/94832693@N00/

There are far more calls in the API that provide user IDs than aliases, so it's usually easier for programs to construct URLs using IDs.

Identifying Groups

The group_id is an NSID that uniquely identifies a group and can be used in any URL that refers to the group.

The poolname is to a group what the alias is to a user. A poolname provides a permanent, readable web address for the group. Once assigned, a poolname cannot be changed. Like an alias, the poolname does not necessarily correspond to the group's name as it appears in the group listing. For example, the poolname of the Squared Circle group is just *circle*, as illustrated in the group's URL:

> *http://www.flickr.com/groups/circle/*

Again, it's easiest for users if the poolname corresponds to the group name, but in actuality this doesn't happen that often, since there are often multiple groups that deal with the same kinds of subjects. If you want to create a group for collecting pictures of mushrooms, chances are you're not the first! Mushrooms, Fungi, and Fungus are already taken. At the moment, Mycology is still free. Grab it while you can!

Identifying Photos

Just about every API method that returns information about photos returns the following three pieces of information:

photo_id
> A decimal number that identifies a photo. Each photo gets a unique number, and the numbers have been rising since Flickr has been in existence. Like rings on a tree trunk, you can come up with a rough guess of when a photo was uploaded to Flickr by looking at how low its ID number is.

secret
> An alphanumeric string that is required to form a valid URL to a photo's image file.

server
> A number that, like the secret, is required to form a valid URL to a photo's image file. At one time, these numbers corresponded to individual Ludicorp servers, although that might now be a pleasant fiction. Nonetheless, the number is still necessary.

While the photo_id is often displayed publicly in the browser's address bar (as part of the URL for the photo's detail page), the secret and server are normally not visible to end users, making it slightly harder for casual browsers to swipe photos from Flickr. Fortunately for us, there's an easy way to retrieve this info without even using the API.

If you're on a photo's detail page, you can get the goods by invoking the photo's image properties and examining the URL. For example, I have a photo with the following URL:

http://www.flickr.com/photos/krazydad/16804205/

From this, we can see that the photo's ID is *16804205* and my alias is *krazydad*.

To access the image properties, right-click (Control-click on a Mac) the photo. You'll see the following URL to the photo's JPEG file:

http://static.flickr.com/13/16804205_814653c78b.jpg?v=0

Ignoring the shmutz after the question mark, the URL is constructed thusly:

```
http://static.flickr.com/server/id_secret.jpg
```

This tells us that the photo's secret is *16804205* and its server is *13*.

Deconstructing Flickr URLs

You may have noticed in the previous section that Flickr uses consistent naming conventions for its URLs. This makes it easy to construct these URLs, given crucial bits of information such as user_ids and photo_ids. Here are some examples:

- URLs for photostreams:
  ```
  http://www.flickr.com/photos/<user_id>
  http://www.flickr.com/photos/<alias>
  ```
- URLs for profiles:
  ```
  http://www.flickr.com/people/<user_id>
  http://www.flickr.com/people/<alias>
  ```
- URLs for groups:
  ```
  http://www.flickr.com/groups/<group_id>/
  http://www.flickr.com/groups/<poolname>/
  ```
- URLS for photo pages:
  ```
  http://www.flickr.com/photos/<user_id>/<photo_id>/
  http://www.flickr.com/photos/<alias>/<photo_id>/
  http://flickr.com/photo.gne?id=<photo_id>
  ```
- URLS for photo image files:
  ```
  http://static.flickr.com/<server>/<photo_id>_<secret>.jpg
  http://static.flickr.com/<server>/<photo_id>_<secret>_<size>.jpg
  ```

Note that the underscores between *<photo_id>* and *<secret>* and between *<secret>* and *<size>* in the preceding URLs are required. The underscores themselves are not part of the replaceable values.

If the *<size>* qualifier is left out, you'll get the medium-sized version of the image, which is 500 pixels on the longest side. For a list of *<size>* options, see "Cache Photos Locally" **[Hack #34]**.

Talking to the API

You communicate with the Flickr API by sending it requests via the HTTP protocol and then parsing the results, which are returned as XML.

The simplest way to talk to the API is by typing these requests in your browser's address bar **[Hack #37]**. However, you will usually talk to it with a programming language, such as Perl **[Hack #38]** or PHP **[Hack #39]**.

The Flickr API currently supports three different request/response protocols (or *formats*), corresponding to currently popular standards for communicating with services on the Internet. In each format the underlying data being communicated is the same, but the XML data is gift-wrapped in a different way:

REST
> REST is a rapidly growing informal "standard" that is the simplest (by far!) of the three protocols listed here. This simplicity is the reason for its popularity. Requests are made by issuing simple HTTP GET or POST actions, and responses are returned via XML with few additional trappings.

XML-RPC
> XML-RPC requests are specially formatted XML data posted to a URL. You can find out more about XML-RPC at *http://www.xmlrpc.com*.

SOAP
> SOAP is another popular standard protocol for communicating via XML. You can find out more about SOAP at *http://www.w3.org/TR/soap/*.

 If trying to pick one of these protocols is wearing you out, might we suggest taking a REST? REST is the protocol that the majority of Flickr developers actually use, because it carries the least baggage and requires the smallest amount of overhead to parse the results. It is the only protocol that you can easily experiment with by typing requests in your web browser's address bar. The most compelling reason for using XML-RPC or SOAP is if you are integrating Flickr into an app that already uses one of these more complex formats. Most of the API examples in this book use the REST protocol.

So, now that you've gotten a glimpse of the different pieces of the API, let's start playing with it, shall we?

HACK #37 Talk to the API with Your Web Browser

Making requests with your web browser is a great way to familiarize yourself with the Flickr API.

Before using a programming language (such as Perl [Hack #38] or PHP [Hack #39]) to talk to the Flickr API, it's a good idea to test it using your web browser. If you are using a new API method, this is an excellent way to get used to it and to view the XML that is returned by the call. If you are unfamiliar with the mechanics of REST and XML, it is also a good way to explore how these protocols work.

There are two simple ways to talk to the API using your web browser: you can type REST URLs directly into your browser's address bar (the hard way), or you can use Flickr's API Explorer (the easy way).

Using REST URLs

The first method, using your browser's address bar, is mainly of historical interest, because the second method is so much easier. But let's see how it works, for completeness's sake.

You can use any Flickr API method, such as `flickr.test.echo`, by entering its name and any required parameters into your browser's address bar in the Flickr REST format.

Here's an example. Try pasting this into your web browser's address bar:

```
http://www.flickr.com/services/rest/?method=flickr.test.echo&api_key=your_
api_key&param1=value1&param2=value2
```

Substitute your own API key for *your_api_key*, and substitute the name of any Flickr API method for `flickr.test.echo`. You can also add any parameters that are required by the call, just as the above example uses `param1` and `param2` with `flickr.test.echo`.

If you use a valid API key, you'll get a result like this:

```
<rsp stat="ok">
<method>flickr.test.echo</method>
<api_key>81a8f5d6c402d26f425e4361d07f85ba</api_key>
<foo>bar</foo>
</rsp>
```

The main problem with typing API URLs directly is that you need a valid API key, and you might not have one handy.

> You can apply for an API key at *http://www.flickr.com/ services/api/key.gne*.

Also, it is often difficult to determine correct values for the various parameters you might want to use without issuing other API methods, which creates a kind of chicken-and-egg problem when you want to test the API.

To solve this problem, the Flickr folks have come up with an excellent tool called the *API Explorer*, the "easy way" mentioned earlier and discussed in the following section.

Using the API Explorer

The API Explorer generates a temporary Flickr API key and gives you the option of signing each call with full permissions. It also produces a list of helpful values, such as photo IDs, group IDs, and so on, which are quite useful for generating example results.

To use the API Explorer, visit the documentation page for the particular method you are interested in. You'll find a link to the API Explorer at the bottom of the page. The table of contents for all of the API methods is located at an address that's well worth bookmarking:

http://www.flickr.com/services/api/

From there, you can find the API Explorer for each method pretty quickly.

The next few hacks use flickr.photos.getInfo as an example. This is the API call that retrieves detailed information about a particular photo. The documentation page for flickr.photos.getInfo is located at *http://www. flickr.com/services/api/flickr.photos.getInfo.html*.

Clicking the API Explorer link at the bottom of this page will take you to the API Explorer form shown in Figure 6-2, which resides at *http://www.flickr. com/services/api/explore/?method=flickr.photos.getInfo*.

You'll notice that there is a required parameter for this call, which is the photo_id of the photo we're interested in learning about. Since we're testing the method and don't particularly care about which photo we're getting info on, we can use one of the photo IDs shown in the Useful Values column on the right. A few values should be listed under "Your recent photo IDs."

Copying and pasting the ID of the photo labeled "All the cat toys on amazon" (*60147370*) and then pressing the Call Method... button produces the following XML:

Figure 6-2. Flickr API Explorer for flickr.photos.getInfo

```
<rsp stat="ok">
<photo id="60147370" secret="0bdfee3691" server="30"
dateuploaded="1131226468" isfavorite="0" license="1" rotation="0">
<owner nsid="94832693@N00" username="jbum" realname="Jim Bumgardner"
location="Burbank, USA"/>
<title>All the cat toys on Amazon</title>
<description>
All the cat toys on Amazon.

Interactive version here:

<a href="http://www.coverpop.com/pop/cattoys/">http://www.coverpop.com/pop/
cattoys/</a>

</description>
<visibility ispublic="1" isfriend="0" isfamily="0"/>
<dates posted="1131226468" taken="2005-11-05 13:34:28" takengranularity="0"
lastupdate="1131233595"/>
<permissions permcomment="3" permaddmeta="2"/>
<editability cancomment="1" canaddmeta="1"/>
<comments>1</comments>
<notes>
</notes>
<tags>
<tag id="197715539" author="94832693@N00" raw="cats">cats</tag>
<tag id="197715540" author="94832693@N00" raw="cat toys">cattoys</tag>
<tag id="197715541" author="94832693@N00" raw="amazon">amazon</tag>
<tag id="197715542" author="94832693@N00" raw="mosaic">mosaic</tag>
<tag id="197715543" author="94832693@N00" raw="coverpop">coverpop</tag>
```

```
</tags>
<urls>
<url type="photopage">http://www.flickr.com/photos/krazydad/60147370/</url>
</urls>
</photo>
</rsp>
```

It's also instructive to enter invalid information and see what kind of result you get. For example, entering *aaaa* for the photo_id (which is not a valid photo_id) returns the following result:

```
<rsp stat="fail">
<err code="1" msg="Photo not found"/>
</rsp>
```

The XML results from all the Flickr API methods exhibit this same rudimentary structure. There is an <rsp> tag container, which has either an ok or fail stat property. If the call is a failure, there will also be an <err> tag, which contains a helpful error message in the msg property. If the call succeeds, the <rsp> container will contain the result of the call, which varies from API method to API method.

In the next couple of hacks, we'll see how to use flickr.photos.getInfo, as well as some other API methods, with Perl [Hack #38] and PHP [Hack #39]. We'll also see different ways to parse the XML and make use of it. Before proceeding, get yourself a Flickr API key by visiting *http://www.flickr.com/services/api/key.gne*. You're going to need it very soon!

See Also

- "Talk to the API with Perl" [Hack #38]
- "Talk to the API with PHP" [Hack #39]

H A C K Talk to the API with Perl
#38 Perl is a good choice for talking to the API from the command line.

This hack presents a few different Perl scripts that talk to the Flickr API. First, some simple examples show the basic method; the two different techniques that follow it accomplish a more useful task. The programs in [Hack #39] mirror the programs in this hack.

What You Need

Talking to the Flickr API requires you to solve two fundamental problems. The first problem is how to issue a call to the API. To do this, this hack uses two different modules. The first few programs use the commonly available LWP::Simple module, and the final program uses Flickr::API, which is a higher-level module built on top of the LWP::Simple module.

The second problem you need to solve is how to interpret the result you get back—specifically, how to parse the XML. In the Perl community, a bewildering number of XML parsers are available. Flickr::API actually does some XML parsing for you, but I don't particularly like the XML parser it uses, so this chapter uses XML::Simple, which produces a simpler and more elegant data structure than some of the other XML parsers.

Regardless of which XML parser you use, it is much easier to figure out how to use it if you examine the data structures it produces using the Data:: Dumper module.

So, to sum up, we're going to use these four Perl modules:

```
LWP::Simple
Flickr::API
XML::Simple
Data::Dumper
```

You can download all of these modules from CPAN. On Linux and Mac systems, you can install the modules on the command line using Perl. For example, here's how to install Flickr::API:

```
> perl -MCPAN -e shell
cpan> install Flickr::API
```

In Windows, particularly with ActiveState Perl, it is easier to use the *ppm* utility. For example:

```
ppm install Flickr::API
```

Let's start with a program that does the bare minimum.

Getting a User's ID

The first program uses LWP::Simple to talk to the API, converting a username into a Flickr user ID. Since most of the Flickr API calls that return information about users require a user_id as a parameter, this is a useful call to master. Create a new text file called *testapi.pl* and enter the following code:

```perl
#!/usr/bin/perl -s

use LWP::Simple;

$username = shift;
die ("Please specify a Flickr username\n") if !$username;

$api_key = 'your_api_key'; # insert your API key here
$method = 'flickr.people.findByUsername';
```

```
$url = "http://www.flickr.com/services/rest/?method=$method&api_key=$api_
key&username=$username";
$xml = get $url;

print $xml;
```

You'll need to change the following line:

```
$api_key = 'your_api_key'; # insert your API key here
```

so that it includes your own API key, like this:

```
$api_key = 'e072dadf32c2a6da1b7b7592e88ebe9e';
```

 You can apply for an API key at *http://www.flickr.com/services/api/key.gne*.

As you can see, this program basically constructs a REST URL that is the same as the URLs you can type directly into your web browser's address bar [Hack #37]. It retrieves the result using the get() function, which is provided by LWP::Simple, and then displays the result as text.

Here's a sample run:

```
> testapi.pl jbum
<?xml version="1.0" encoding="utf-8" ?>
<rsp stat="ok">
        <user id="94832693@N00" nsid="94832693@N00">
                <username>jbum</username>
        </user>
</rsp>
```

If all you want to do is find out a user ID, this might be all you need. However, it would be nice to display it in a more readable fashion. You can extract the user ID using Perl's pattern matching:

```
($id) = $xml =~ m/nsid="(.*)"/;
print "User ID: $id\n";
```

But there's a more flexible way, which is to use an XML parser. This might seem a bit complicated now, but it will make parsing more complex XML easier. Here's a rewrite of the program using the XML::Simple parser and the Data::Dumper module:

```
#!/usr/bin/perl -s

use LWP::Simple;
use XML::Simple;
use Data::Dumper;
```

```
$username = shift;
die ("Please specify a Flickr username\n") if !$username;

$api_key = 'your_api_key'; # insert your API key here
$method = 'flickr.people.findByUsername';

$method = 'flickr.people.findByUsername';
$url = "http://www.flickr.com/services/rest/?method=$method&" .
       "api_key=$api_key&username=$username";
$xml = get $url;
$xm = XMLin($xml);

print Dumper($xm),"\n" if $debug;

if ($xm->{err})
{
    print "Error getting user id: ",$xm->{err}->{msg},"\n";
    exit;
}
$user_id = $xm->{user}->{id};
print "User ID: $user_id\n";
```

This program takes an optional option, -debug, which can be used to dump the contents of the data structure produced by XMLin(), the parsing function provided by XML::Simple. The program dumps it using the Dumper() function provided by Data::Dumper, an incredibly helpful way to figure out what kind of data structures you are being confronted with. Here's a sample run with debugging turned on:

```
> testapi2.pl -debug jbum
$VAR1 = {
          'user' => {
                      'nsid' => '94832693@N00',
                      'id' => '94832693@N00',
                      'username' => 'jbum'
                    },
          'stat' => 'ok'
        };

User ID: 94832693@N00
```

You might have noticed that the nsid and id fields in the returned data structures are the same. At the moment, Flickr IDs and NSIDs are identical, and we'll tend to use them interchangeably in this book. It is possible, though, that at some time in the future the two ID systems will diverge.

The $VAR1 = at the beginning of the Dumper() output is mean-
ingless. VAR1 is a placeholder for the variable you are dump-
ing. I prefer to omit it by setting Data::Dumper to terse mode.
You can accomplish this by adding this line near the top of
the program:

```
$Data::Dumper::Terse = 1;  # avoids $VAR1 = * ;
                           # in dumper output
```

You'll see this in use in the next example.

Viewing a User's Latest Photo

The next program uses the same basic techniques but introduces two new
API calls. The program takes a username, converts it into a user_id, and
then uses that user_id to look up the most recent photo in the user's stream,
using flickr.people.getPublicPhotos. It then gets a little more info about
the photo using flickr.photos.getInfo and generates an HTML page that
contains a view of the photo and the information that was retrieved.

Create a new file called *getUsersLatest.pl* and add the following Perl code:

```perl
#!/usr/bin/perl -s

use LWP::Simple;
use XML::Simple;
use Data::Dumper;
$Data::Dumper::Terse = 1;  # avoids $VAR1 = * ; in dumper output

$api_key = 'your_api_key'; # insert your Flickr API key here

$username = shift;
die ("Please specify a Flickr username\n") if !$username;

#
# Get user's ID
#
$method = 'flickr.people.findByUsername';
$url = "http://www.flickr.com/services/rest/?method=$method" .
       "&api_key=${api_key}&username=${username}";
$xml = get $url;
$xm = XMLin($xml);

print Dumper($xm),"\n" if $debug;

if ($xm->{err})
{
    print "Error getting user id: ",$xm->{err}->{msg},"\n";
    exit;
}
```

```perl
$user_id = $xm->{user}->{id};

#
# Get user's most recent photos
#

$method = 'flickr.people.getPublicPhotos';
$url = "http://www.flickr.com/services/rest/?method=$method" .
            "&api_key=$api_key&user_id=$user_id&per_page=1";
$xml = get $url;
$xm = XMLin($xml);
print Dumper($xm),"\n" if $debug;

if ($xm->{err})
{
    print "Error getting most recent photo: ",$xm->{err}->{msg},"\n";
    exit;
}
$photo_id = $xm->{photos}->{photo}->{id};
$photo_secret = $xm->{photos}->{photo}->{secret};
$photo_server = $xm->{photos}->{photo}->{server};

#
# Formulate URL to the photo (image)
#
$imgUrl = sprintf "http://static.flickr.com/%d/%d_%s.jpg",
                $photo_server,$photo_id, $photo_secret;

#
# Formulate URL to the photo's Flickr page
#
$pageUrl = sprintf "http://www.flickr.com/photos/%s/%d/",
                $user_id, $photo_id;

#
# Get photo info
#
$method = 'flickr.photos.getInfo';
$url = "http://www.flickr.com/services/rest/?method=$method" .
                "&api_key=$api_key&photo_id=$photo_id";
$xml = get $url;
$xm = XMLin($xml);
print Dumper($xm),"\n" if $debug;

if ($xm->{err})
{
    print "Error getting most recent photo: ",$xm->{err}->{msg},"\n";
    exit;
}
```

```
#
# Get title
#
$title = $xm->{photo}->{title};

#
# Get date uploaded
#
$dateuploaded = $xm->{photo}->{dateuploaded};
($sec,$min,$hour,$mday,$mon,$year,$wday,$yday,$isdst) =
localtime($dateuploaded);
$datestr = sprintf '%4d-%02d-%02d %2d:%02d',
$year+1900,$mon+1,$mday,$hour,$min;

#
# Join tags into a single string
#
$tags = $xm->{photo}->{tags}->{tag};
$taglist = join ', ',map {$tags->{$_}->{content}} keys %{$tags};

#
# Output HTML page containing URL to photo, image, and tags.
#
print <<EOT;
<html>
<head>
<title>Sample Photo Page</title>
</head>
<body>
<center>
The latest from $username...<br>
<a href="$pageUrl"><img src="$imgUrl" /></a><br>
Title: $title<br>
Uploaded: $datestr<br>
$taglist
</center>
</body>
</html>
EOT
```

The final section of this program outputs some HTML to standard output.
To use the program, redirect it into an HTML file, and then view the HTML
file in your web browser.

Here's a sample, run, showing the HTML:

```
> getUsersLatest.pl jbum
<html>
<head>
<title>Sample Photo Page</title>
</head>
<body>
```

```
<center>
The latest from jbum...<br>
<a href="http://www.flickr.com/photos/94832693@N00/61321455/"><img
src="http://s
tatic.flickr.com/25/61321455_eee1263b27.jpg" /></a><br>
Title: The visitor<br>
Uploaded: 2005-11-08 10:47<br>
alien, coverpop, mosaic, ufo, visitor, paranormal
</center>
</body>
</html>
```

Figure 6-3 shows the result as it looks in my web browser.

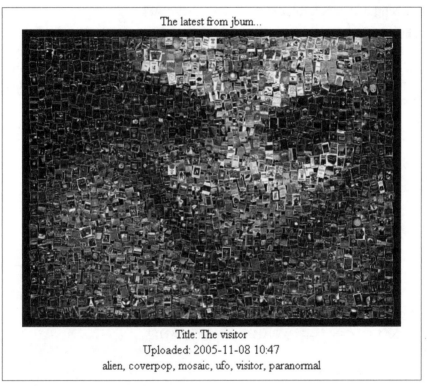

Figure 6-3. Viewing a user's latest photo

The HTML code here that displays the photo embeds it within a link back to the Flickr page for that particular photo. The Flickr Terms of Service request that you always provide a link back to Flickr with each photo you display, and this is a common way of doing it.

Some of the data structures involved here are bit complicated, and it is not easy to predict how to generate the complex references needed to extract certain fields, as in this line:

```
$photo_id = $xm->{photos}->{photo}->{id};
```

In each case, I first implemented the Dumper() part of the program and ran it, so I could view the data structure that I needed to traverse. Regardless of which XML parser you choose to use, this is a helpful technique for figuring out what you're dealing with. I've left the data-dumping feature in this program, to be triggered by the –debug option.

Viewing a User's Latest Photo Using Flickr::API

This next program is a port of the previous one with exactly the same features. The only difference is that it uses Flickr::API instead of LWP::Simple. Flickr::API is intended to provide a layer of glue, freeing you from the nitty-gritty details of dealing with the API. In this case, however, you'll notice that both programs are nearly the same length!

Create a new file called *getUsersLatest2.pl* and add the following Perl code:

```perl
#!/usr/bin/perl -s

use Flickr::API;      # replaces use of LWP::Simple
use XML::Simple;
use Data::Dumper;
$Data::Dumper::Terse = 1;  # avoids $VAR1 = * ; in dumper output

$api_key = 'your_api_key'; # insert your Flickr API key here
$username = shift;
die ("Please specify a Flickr username\n") if !$username;

#
# Initialize Flickr API
#
my $api = new Flickr::API({'key' => $api_key});

#
# Get user's ID
#

my $response = $api->execute_method('flickr.people.findByUsername', {
                            username => $username}
                 );
if (!$response->{success})
{
    print "Error getting user id: ",$response->{error_message},"\n";
    exit;
}
$xm = XMLin($response->{_content});
```

```
print Dumper($xm),"\n" if $debug;

$user_id = $xm->{user}->{id};

#
# Get user's most recent photos
#

my $response = $api->execute_method('flickr.people.getPublicPhotos', {
                                    user_id => $user_id,
                                    per_page => 1}
                            );

if (!$response->{success})
{
    print "Error getting most recent photo: ",
        $response->{error_message},"\n";
    exit;
}
$xm = XMLin($response->{_content});
print Dumper($xm),"\n" if $debug;

$photo_id = $xm->{photos}->{photo}->{id};
$photo_secret = $xm->{photos}->{photo}->{secret};
$photo_server = $xm->{photos}->{photo}->{server};

#
# Formulate URL to the photo (image)
#
$imgUrl = sprintf "http://static.flickr.com/%d/%d_%s.jpg",
                                    $photo_server,$photo_id, $photo_secret;

#
# Formulate URL to the photo's Flickr page
#
$pageUrl = sprintf "http://www.flickr.com/photos/%s/%d/",
                                    $user_id, $photo_id;

#
# Get photo info
#
my $response = $api->execute_method('flickr.photos.getInfo', {
                                    photo_id => $photo_id}
                            );
if (!$response->{success})
{
    print "Error getting photo info: ",$response->{error_message},"\n";
    exit;
}
$xm = XMLin($response->{_content});
print Dumper($xm),"\n" if $debug;
```

```
#
# Get title
#
$title = $xm->{photo}->{title};

#
# Get date uploaded
#
$dateuploaded = $xm->{photo}->{dateuploaded};
($sec,$min,$hour,$mday,$mon,$year,$wday,$yday,$isdst) =
localtime($dateuploaded);
$datestr = sprintf '%4d-%02d-%02d %2d:%02d',
$year+1900,$mon+1,$mday,$hour,$min;

#
# Join tags into a single string
#
$tags = $xm->{photo}->{tags}->{tag};
$taglist = join ', ',map {$tags->{$_}->{content}} keys %{$tags};

#
# Output HTML page containing URL to photo, image, and tags.
#
print <<EOT;
<html>
<head>
<title>Sample Photo Page</title>
</head>
<body>
<center>
The latest from $username...<br>
<a href="$pageUrl"><img src="$imgUrl" /></a><br>
Title: $title<br>
Uploaded: $datestr<br>
$taglist
</center>
</body>
</html>
EOT
```

If you look closely, you'll see that the two programs are nearly identical and that in this case, Flickr::API isn't really buying you very much. An additional line has been added near the top to initialize Flickr::API:

```
my $api = new Flickr::API({'key' => $api_key});
```

The calls to get() have been replaced by calls to api->execute_method(), and the results are processed slightly differently. This program *could* be made slightly shorter, by taking advantage of the XML parsing that Flickr:: API does. For example, to read the first photo's ID, instead of saying this:

```
$xm = XMLin($response->{_content});
$photo_id = $xm->{photos}->{photo}->{id};
```

you could omit the XMLin() step and say this, in just one line:

```
$photo_id = $response->{tree}->{children}->[1]->{children}->[1]->
{attributes}->{id};
```

However, you'll notice that the data structure that must be traversed to find the photo ID (a data structure produced by XML::Parser::Lite::Tree, the XML parser used internally by Flickr::API) is more intricate (and, to my eye, less intuitive because of all those generic-looking children) than the structure returned by XML::Simple. This intricacy generally leads to more coding mistakes, so I prefer to use XML::Simple.

So, why use Flickr::API at all? As you'll see in "Authenticate Yourself" [Hack #40], it is enormously helpful for API calls that require authentication, one of the more complicated bits of the Flickr API.

See Also

- "Talk to the API with Your Web Browser" [Hack #37]
- "Talk to the API with PHP" [Hack #39]
- "Authenticate Yourself" [Hack #40]

HACK #39 Talk to the API with PHP

PHP is a good choice for creating web-based Flickr tools.

Having looked at how to talk to the API in Perl [Hack #38], this hack accomplishes the same tasks in PHP. Again, we'll start with a simple example and then move on to a more complicated task using the two available API kits: PEAR::Flickr_API and phpFlickr. Accomplishing the same task in each kit will enable you to contrast and compare them.

What You Need

Since we're programming in PHP, you'll need a web server with PHP installed. All the programs in this hack require PHP 4 or later.

Some of the XML parsing can be made much simpler if you have access to PHP 5 and the SimpleXML extensions, but since many folks are forced to live with PHP 4, we'll keep these programs compatible with the earlier version.

We'll be using the two currently available API kits for talking to Flickr from PHP: PEAR::Flickr_API (available at *http://code.iamcal.com/php/flickr/*) and phpFlickr (available at *http://www.phpflickr.com*).

Any new API kits that become available after the publication of this book will be listed at the Flickr API page (*http://www.flickr.com/services/api/*).

Talking to the Flickr API in any language requires that you solve two fundamental problems. The first problem is how to issue a call to the API. The second is how to parse the XML you get back. In PHP 4, solving the first problem is quite simple, but picking your way through the tangly XML thicket can be a challenge.

We'll start with a program that does the bare minimum.

Getting a User's ID

This first program talks to the API without using an API kit.

Create a new text file called *testapi.php* and enter the following code:

```
<?

$api_key = 'your_api_key';  # Insert your Flickr API key here

$username = 'jbum';
if (isset($_GET['username']))
    $username = $_GET['username'];

#
# Get user's ID
#
$method = 'flickr.people.findByUsername';
$url = "http://www.flickr.com/services/rest/?method=$method&" .
        "api_key=$api_key&username=$username";
$response = file_get_contents($url);

echo htmlspecialchars($response);
?>
```

You'll need to change the following line:

```
$api_key = 'your_api_key';  # Insert your Flickr API key here
```

so that it includes your own API key, like this:

```
$api_key = 'e072dadf32c2a6da1b7b7592e88ebe9e';
```

You can apply for an API key at *http://www.flickr.com/services/api/key.gne*.

As you can see, this program is constructing a REST URL that is the same as the URLs you can type directly into your web browser's address bar [Hack #37].

It retrieves the result using the file_get_contents() function and then displays the result as text. Since the result is XML and contains tags, the htmlspecialchars function is used to get it to display properly in your browser.

To test the program (and all the programs in this hack), upload it to your web server and then type the address of the program into your browser's address bar:

 http://www.yourdomain.com/testapi.php

You can test it with a username other than *jbum* (say, *Special*) by adding it as an optional parameter:

 http://www.yourdomain.com/testapi.php?username=**special**

Here's an example of the XML produced by a sample run:

 <?xml version="1.0" encoding="utf-8" ?> <rsp stat="ok">
 <user id="36521955290@N01" nsid="36521955290@N01">
 <username>Special</username> </user> </rsp>

As you can see, invoking the API is relatively simple. The hard part is extracting the data you need out of the XML.

Since the API kits available for PHP include XML parsing, this is a good time to start using them. We'll start with the first API kit that was made for PHP.

Getting a User's ID Using PEAR::Flickr_API

Here is a modification of the previous program, using PEAR::Flickr_API:

```
<?

require_once 'Flickr/API.php';

$api_key = 'your_api_key'; # Insert your Flickr API key here

$api =&new Flickr_API(array('api_key'  => $api_key));

$username = 'jbum';
if (isset($_GET['username']))
    $username = $_GET['username'];

#
# Get user's ID
#
$response = $api->callMethod('flickr.people.findByUsername',
                        array(    'username' => $username ));

if (!$response)
{
```

```
      echo "Error getting user id: ".$api->getErrorMessage( )."\n";
      exit;
}

$user = $response->getElement(array(0));
$user_id = $user->getAttribute('id');

print "User_ID: $user_id<p>";

?>
```

To use this program, you'll need to again replace $api_key with an actual API key. You'll also need to have already installed PEAR::Flickr_API. A simple way to install it is to copy the four directories in its archive (*Flickr*, *HTTP*, *Net*, and *XML*) into the same directory where your PHP scripts reside.

Viewing a User's Latest Photo with PEAR::Flickr_API

The next program expands upon the previous program and introduces two new API calls. The program takes a username, converts it into a user_id, and then uses that user_id to look up the most recent photo in the user's stream, using flickr.people.getPublicPhotos. It then gets a little more info about the photo using flickr.photos.getInfo and generates an HTML page that contains a view of the photo and the information that was retrieved.

Create a new file called *getUsersLatest.php* and add the following code:

```
<?

require_once 'Flickr/API.php';

$api_key = 'your_api_key'; # insert your actual API key

$api =&new Flickr_API(array('api_key'  => $api_key));

$username = 'jbum';
if (isset($_GET['username']))
    $username = $_GET['username'];

#
# Get user's ID
#
$response = $api->callMethod('flickr.people.findByUsername',
                             array(   'username' => $username ));

if (!$response)
{
    echo "Error getting user id: ".$api->getErrorMessage( )."\n";
```

```
        exit;
}

$nom = $response->getElement(array(0));
$user_id = $nom->getAttribute('id');

#
# Get user's most recent photos
#

$response = $api->callMethod('flickr.people.getPublicPhotos', array(
            'user_id' => $user_id,
            'per_page' => 1     ));

if (!$response)
{
    print "Error getting most recent photo: ".$api->getErrorMessage()."\n";
    exit;
}
$photo = $response->getElement(array(0,0));
$photo_id = $photo->getAttribute('id');
$photo_secret = $photo->getAttribute('secret');
$photo_server = $photo->getAttribute('server');

#
# Formulate URL to the photo (image)
#
$imgUrl = "http://static.flickr.com/$photo_server/" .
          "{$photo_id}_{$photo_secret}.jpg";

#
# Formulate URL to the photo's Flickr page
#
$pageUrl = "http://www.flickr.com/photos/$user_id/$photo_id/";

#
# Get photo info
#
$response = $api->callMethod('flickr.photos.getInfo',
                        array( 'photo_id' => $photo_id     ));

if (!$response)
{
    print "Error getting most recent photo: ".$api->getErrorMessage()."\n";
    exit;
}

#
# Get title
#
$photo = $response->getElement(array(0));
$title = $photo->getElement(array(1));
```

```
$title = $title->content;

#
# Get date uploaded
#
$dateuploaded = $photo->getAttribute('dateuploaded');
$ltime = localtime((int) $dateuploaded, 1);
$datestr = $dateuploaded;

$datestr = sprintf('%4d-%02d-%02d %2d:%02d',
        $ltime['tm_year']+1900,
        $ltime['tm_mon']+1,
        $ltime['tm_mday'],
        $ltime['tm_hour'],
        $ltime['tm_min']);

#
# Join tags into a single string
#
$tags = $photo->getElement(array(8));
$n = 0;
$taglist = '';
foreach ($tags->children as $tag)
{
    if ($n++ > 0)
        $taglist .= ', ';
    $taglist .= $tag->content;
}

#
# Output HTML page containing URL to photo, image, and tags.
#
print <<<EOT
<html>
<head>
<title>Sample Photo Page</title>
</head>
<body>
<center>
The latest from $username...<br>
<a href="$pageUrl"><img src="$imgUrl" /></a><br>
Title: $title<br>
Uploaded: $datestr<br>
$taglist
</center>
</body>
</html>
EOT;

?>
```

The final section of this program outputs the same HTML as the Perl programs in "Talk to the API with Perl" [Hack #38]. To use the program, upload it

to your web server and type in its URL. The result will be same as in Figure 6-3.

Viewing a User's Latest Photo Using phpFlickr

This next program is a port of the previous one with exactly the same features. The only difference is that it uses phpFlickr, which is a higher-level API kit than PEAR::Flickr_API. I think you'll find the code easier to understand. In addition, the support web site for phpFlickr contains considerably more documentation and a few actual code examples. Huzzah!

```php
<?

# getLastPhoto - phpFlickr version

require_once("phpFlickr.php");

$api_key = 'your_api_key';

$api = new phpFlickr($api_key);

# This is a good spot to enable caching -- see the ransom note hack
# in Chapter 7 for an example

#
# Get user's ID
#
$username = 'jbum';
if (isset($_GET['username']))
    $username = $_GET['username'];
$user_id = $api->people_findByUsername($username);

#
# Get user's most recent photo
#

$photos = $api->people_getPublicPhotos($user_id,NULL,1);

$photo = $photos['photo'][0];
$photo_id = $photo['id'];
$photo_secret = $photo['secret'];
$photo_server = $photo['server'];

#
# Formulate URL to the photo (image)
#
$imgUrl = "http://static.flickr.com/$photo_server/{$photo_id}_{$photo_secret}.jpg";

#
# Formulate URL to the photo's Flickr page
```

```
#
$pageUrl = "http://www.flickr.com/photos/$user_id/$photo_id/";

#
# Get Photo Info
#
$photoInfo = $api->photos_getInfo($photo_id);

#
# Get title
#
$title = $photoInfo['title'];

#
# Get date uploaded
#
$dateuploaded = $photoInfo['dateuploaded'];
$ltime = localtime($dateuploaded, 1);
$datestr = $dateuploaded;

$datestr = sprintf('%4d-%02d-%02d %2d:%02d',
        $ltime['tm_year']+1900,
        $ltime['tm_mon']+1,
        $ltime['tm_mday'],
        $ltime['tm_hour'],
        $ltime['tm_min']);

#
# Join tags into a single string
#
$tags = $photoInfo['tags'];
$n = 0;
$taglist = '';
foreach ($photoInfo['tags']['tag'] as $tag)
{
    if ($n++ > 0)
        $taglist .= ', ';
    $taglist .= $tag['_value'];
}

#
# Output HTML page containing URL to photo, image, and tags.
#
print <<<EOT
<html>
<head>
<title>Sample Photo Page</title>
</head>
<body>
<center>
The latest from $username...<br>
```

```
<a href="$pageUrl"><img src="$imgUrl" /></a><br>
Title: $title<br>
Uploaded: $datestr<br>
$taglist
</center>
</body>
</html>
EOT;

?>
```

Comparing the two programs, you'll see that phpFlickr has an individual function for each API call that returns a data structure that is hand-tailored for that call. For example:

```
$user_id = $api->people_findByUsername($username);
...
$photos = $api->people_getPublicPhotos($user_id,NULL,1);
...
$photoInfo = $api->photos_getInfo($photo_id);
```

This makes the code more readable, but it also means that phpFlickr is closely tied to the particular state of the API at the time it was released. If a new call is added to the API, phpFlickr won't support it until it is updated to add new glue. At the moment, however, things are pretty stable, and Dan Coulter (the developer of phpFlickr) has been pretty attentive to updates.

Because of its ease of use, phpFlickr is a great choice for most of your PHP-related Flickr projects, and you'll see it crop up a few more times in this book.

See Also

- "Talk to the API with Your Web Browser" **[Hack #37]**
- "Talk to the API with Perl" **[Hack #38]**
- "Authenticate Users" **[Hack #41]**
- "Make a Ransom Note" **[Hack #47]**

HACK #40 Authenticate Yourself

For single-user apps, authentication isn't all that complicated.

Flickr has a nifty little API method called flickr.photos.transform.rotate that can rotate a photo by 90, 180, or 270 degrees. This is a cool thing to do, but it's probably not something you want other people doing to your photos. It would be kind of annoying to sign into Flickr only to discover all your photos upside down! This is why this method, and a few others like it, requires authentication: it allows you, the user, to control which apps get to do annoying things to your photos.

However, this also means that if you are the author of an app, and you are the only person using the app, you'll still need to jump through the hurdle of giving your app permission to access your own photos. At the time of this writing, Flickr's older, easier-to-use authentication mechanism still works: you can pass your email address and password as parameters to any Flickr API call that requires authentication. But this method is currently being phased out, because it isn't very secure.

Flickr is now phasing in a more cumbersome but more secure authentication API. This hack shows a relatively simple way to authenticate your own apps, using this new API, for your own private use. This method involves only a tiny bit of scripting and is useful for situations in which you are the only one who will be using the app.

If you want to authenticate users other than yourself, see "Authenticate Users" **[Hack #41]**.

Authentication Modes

Your application can use one of three different authentication procedures or modes. Documentation describing the three authentication modes can be found at *http://www.flickr.com/services/api/misc.userauth.html*.

Each of the three authentication modes is a procedure that accomplishes the same thing: they each produce an authentication token. This token is passed as a parameter to API calls that require authentication, such as flickr. groups.pools.remove.

Flickr uses the token to figure out which Flickr user is using your app and what permissions that user has granted to your app. The differences in the procedures of each mode are due to the nature of the apps for which they are intended to be used.

Web Applications. This authorization mode is intended to be used by apps that are hosted on web servers. It provides a more seamless navigational path. If your app needs authorization, it automatically redirects the user to a Flickr-hosted web page, in which the user grants permissions before being automatically directed back to your app.

Flickr passes some information back to your app (the *frob*, described later in this hack), which is then used to obtain the authorization token. This is the best mode to use if your app is running on a web server and is used by more than one person. It provides the best ease of use from the user's point of view, but it's probably the hardest of the three modes for the programmer to

implement (although a number of the API toolkits that are available, such as phpFlickr [Hack #41], simplify this considerably).

Desktop Applications. This authorization mode is similar to the Web Applications mode, but it's designed for standalone (desktop) applications in which there is no direct navigational path back to the application from the authentication page. Therefore, the procedure doesn't require that Flickr return a frob back to the calling application, as the Web Applications procedure does.

Instead, the app requests the frob before the user is sent to the Flickr-hosted permissions page, using the Flickr API `flickr.auth.getFrob` method. This way, when the user grants permission on Flickr, the app already has all the information it needs to generate an authentication token.

Mobile Applications. This is the most rudimentary of the authentication modes, and it's the one we'll use for authenticating yourself. It is intended to be used on mobile devices and provides an authentication page that is formatted for the small screens on these devices.

The simplicity of this method also makes it ideal for command-line apps or apps that have only a single user, such as apps you write for your own private use. This is a good authentication mode to use for *bot* scripts that administer groups on Flickr, such as the one developed in "Clean the (Group) Pool" [Hack #36].

Frobs and Mini-Tokens

Each of the previous authentication modes generates a random-looking string, which is not the token but is used to obtain the token. In the Web Applications and Desktop Applications modes, this string is called a *frob* (hackerese for "a little random thing-a-ma-bob"). Your app converts the frob into a token by issuing the API method `flickr.auth.getToken`.

The Mobile Applications authentication mode does something similar, but instead of generating a frob, it generates a *mini-token*, which is basically the same thing as a frob, but shorter, so it'll fit in a smaller space (such as the screen of a cell phone). A mini-token is converted into an authentication token via the API method `flickr.auth.getFullToken`. The authentication tokens returned by `flickr.auth.getToken` and `flickr.auth.getFullToken` are the same thing; what's different are the frobs and mini-tokens used to obtain them.

Once you've obtained an authentication token (using either a frob or a mini-token), you can continue using it indefinitely. Tokens don't expire unless

the user changes the permissions. Users can remove the permissions for any of the apps they've granted permission by visiting *http://www.flickr.com/ services/auth/list.gne.*

Getting Started

First, get an API key for your app, if you haven't already. Sign in to Flickr and go to the following URL:

http://www.flickr.com/services/api/

Click the API Keys link (under "Read these first:"), and then click the "Apply for your key online now" link. For more information about getting an API key, see "API Keys and Secrets," earlier in this chapter.

After you get your API key, you'll need to get your shared secret and authentication URL. Reload the API services page (*http://www.flickr.com/services/ api/*) and click the word "Yours" on the line that says "API Keys (Yours)."

This will take you to the following URL:

http://www.flickr.com/services/api/registered_keys.gne

You'll see a list of all your API keys, one for each app, as shown in Figure 6-4.

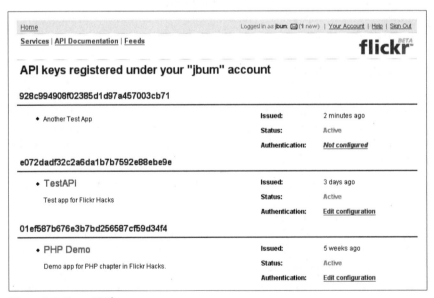

Figure 6-4. Your API keys

Your new app will appear at the top of the list, since you just acquired the API key. If you don't see it there, wait a minute and reload the page.

To the right will be a link that says "Authentication: Not configured." (If you've already done this once, the link will read "Authentication: Edit configuration.") Click this link to configure your authentication, as shown in Figure 6-5.

Services | API Documentation | Feeds

flickr™

Flickr API Documentation

API Key Authentication Setup

Your Key: 928c994908f02385d1d97a457003cb71

Shared Secret: 8698bb062a08ca11

Application Title: CoolApp

Application Description: My App is going to do awesome things, if I ever get past this whole authentication thing!

- This description will be shown to users of your application when they are asked to authenticate.

Application Logo: CoolLogo.gif Browse...
(Optional)

- Logos must be in GIF format, with a maximum size of 600 x 300 (we recommend 300 x 90)
- The logo is shown on the flickr page where the user is asked to authenticate.

Application URL: http://www.krazydad.com/CoolApp/
(Optional)

Authentication Type:
- ○ Web Application
- ○ Desktop Application
- ● Mobile Application

Mobile Permissions:
- ○ Read
- ○ Write
- ● Delete

- Please read the how-to for more information.
- Your authentication URL is http://www.flickr.com/auth-6192

SAVE CHANGES

About Flickr | Sitemap | Forums | Terms of Use | Privacy Policy

a YAHOO! company

Figure 6-5. API Key Authentication Setup screen

Fill out this form, giving your app a title and description. For Authentication Type, choose Mobile Application. There are two pieces of information on this form to record in your text file. At the top, it will show you the shared secret:

```
Shared secret: 8698bb062a08ca11
```

At the bottom, it will show the authentication URL for granting permissions to your app:

```
Your authentication URL is http://www.flickr.com/auth-6192.
```

Paste the authentication URL into your browser's address bar, and press Return to bring up the screen shown in Figure 6-6.

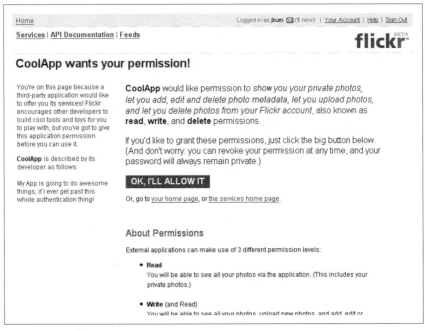

Figure 6-6. Authentication request screen

Press the button that says "OK, I'll Allow It." You'll be taken to the page shown in Figure 6-7, which displays a mini-token.

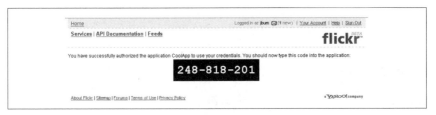

Figure 6-7. Authorization success screen with mini-token

Copy the mini-token into the text file containing your API key and shared secret.

The Code

Now, you'll need to use flickr.auth.getFullToken to convert the mini-token into a full token. This is the only step that requires programming, but not a heck of a lot of it, since we'll be using the Flickr::API Perl module.

The following Perl script makes use of two publicly available modules: Flickr::API and XML::Simple. If you're missing a module, you can install it from CPAN, like this:

```
> perl -MCPAN -e shell
cpan> install XML::Simple
```

Create a file called *getFullToken.pl* and add this code:

```perl
#!/usr/bin/perl

# Convert Mini-Token to a Full Token - Jim Bumgardner

use Flickr::API;
use XML::Simple;

# This information is provided on the command line
#
#
$api_key = shift;
$shared_secret = shift;
$mini_token = shift;

die "Syntax: getFullToken.pl api_key shared_secret mini_token\n"
  if !mini_token;

my $api = new Flickr::API({key => $api_key, secret => $shared_secret});
my $response = $api->execute_method('flickr.auth.getFullToken',{mini_token=>
$mini_token});
die ("GetFullToken Failed: " . $response->{error_message} . "\n" ) if
!$response->{success};

$auth_token = XMLin($response->{_content})->{auth}->{token};
print "auth_token: $auth_token\n";

# This is commented out but is useful for debugging problems
# with this type of script.
# I used it to figure out how to extract the $token field.
#
# use Data::Dumper;
# print Dumper($response);
exit;
```

Running the Hack

To run the hack, you'll need the information we collected in the preceding steps. In our example, the values are:

API key	928c994908f02385d1d97a457003cb71
Shared secret	8698bb062a08ca11
Mini-token	248-818-201

Type the script's name followed by these three parameters on the command line to get the full authentication token:

```
> GetFullToken.pl 928c994908f02385d1d97a457003cb71 8698bb062a08ca11 248-818-
201
auth_token: 127122-92395db066e82035
```

Add the authentication token to the collection of information you have saved. You can now issue API calls that require authentication using these three pieces of information (substitute in your own values):

API key	928c994908f02385d1d97a457003cb71
Shared secret	8698bb062a08ca11
Authentication token	127122-92395db066e82035

You can record this information directly in your app and use the app indefinitely, as long as you don't revoke your own permissions.

However, a better system is to record these fields in a separate file and include it in the application—for example, using Perl's require command. This way, the authentication information is stored separately from your application source code, and you can share the application source code more easily. This is the technique used in "Clean the (Group) Pool" [Hack #36], which uses these authentication parameters in a script for Flickr group administration.

See Also

- "Authenticate Users" [Hack #41]
- "Clean the (Group) Pool" [Hack #36]

HACK #41 Authenticate Users

phpFlickr takes most of the grunt work out of authentication.

Authenticating people is one of the more hassle-prone features of the API. This is why it's a good idea to use an API wrapper: it handles the nitty-gritty details.

For PHP programmers, Dan Coulter's phpFlickr does this job admirably well. I've found it to be the most well supported of the PHP wrappers currently available for Flickr. It even has its own web site, with documentation and example code, located at *http://www.phpFlickr.com.*

This hack creates a web application that displays a few of a user's most recent photos. We'll use authentication so that we can display the user's Private photos as well as Public photos.

What You Need

These scripts were written for PHP 4, so you'll need a web server with PHP 4 support.

You'll also need the phpFlickr package of API wrappers, which is available from *http://www.phpFlickr.com.* The package includes the following:

phpFlickr.php
> This is the main source code file for phpFlickr. The remaining files are support files that are referenced from within *phpFlickr.php.*

auth.php
> This is a sample callback script for authentication that Dan provides. We'll be making some modifications to it.

xml.php
> This source file, written by Aaron Colflesh, provides an XML parser that is used by phpFlickr.

PEAR/
> This directory contains source code for PEAR database access, which is used to implement phpFlickr's optional caching feature. I highly recommend that you install this code and use caching, because it will greatly improve the performance of phpFlickr and reduce the load on Flickr.

The phpFlickr archive also includes some additional files that serve as sample code and are not strictly required for a phpFlickr installation. You should install all of the preceding files and the *PEAR/* directory to a location where PHP can find them, such as in the php_include path. You might find it simplest, at first, to keep these files in the same directory as the first test application you write.

Getting Started

First, get a new API key for the new app, following the instructions in "API Keys and Secrets."

After you've been issued the API key, you'll want to configure the new app for web authentication. Reload the API services page (*http://www.flickr.com/ services/api/*), and click the word "Yours" on the line that says "API Keys (Yours)."

This will take you to the following URL:

http://www.flickr.com/services/api/registered_keys.gne

You'll see a list of all your API keys, one for each app, as shown in Figure 6-8.

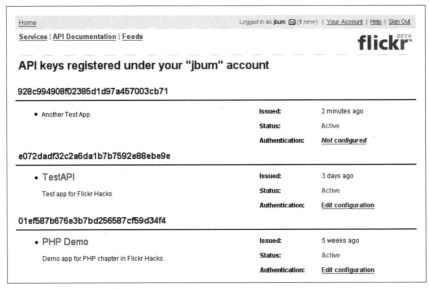

Figure 6-8. Your API keys

Your new app will appear at the top of the list, since you just acquired the API key. If you don't see it there, wait a minute and reload the page.

To the right will be a link that says "Authentication: Not configured." Click on this link to configure your authentication. After you've done this once, the link will read "Authentication: Edit configuration."

After clicking the link, fill out the form, as shown in Figure 6-9.

For Authentication Type, select Web Application. For Callback URL, enter the URL where you installed (or plan to install) *auth.php*. You'll find your shared secret at the top of the page. Copy it, and click Save Changes to set the authentication.

rtrtrtrtrtrt

Figure 6-9. API Key Authentication Setup screen

The Code

Create a file called *testauth.php* and add the following code:

```php
<?php

// testauth.php - based on code by Dan Coulter
//
//

ini_set("error_reporting ", E_ALL);

// Configuration stuff
$flickrAPIKey = "your API key goes here";
$flickrSharedSecret = "your shared secret goes here";

// Caching configuration stuff
```

```
$cachingenabled = false;
$dbUser = "your database username";
$dbPass = "your database password";
$dbAddress = "your database domain name (or localhost)";
$dbTable = "database table name";

// Create new phpFlickr object
require_once("phpFlickr.php");
$f = new phpFlickr($flickrAPIKey,$flickrSharedSecret);
if ($cachingenabled == true)
{
  $f->enableCache(
    "db",
    "mysql://$dbUser:$dbPass@$dbAddress/$dbTable");
}
$f->auth();
$token = $f->auth_checkToken();

// Parse parameters
$page = 1;
if (isset($_GET['page']))
    $page = $_GET['page'];

$columns = 6;
if (isset($_GET['columns']))
    $columns = $_GET['columns'];

$rows = 6;
if (isset($_GET['rows']))
    $rows = $_GET['rows'];

$per_page = $columns * $rows;

// Find the NSID of the username inputted via the form
$nsid = $token['user']['nsid'];

// Get the friendly URL of the user's photos
$photos_url = $f->urls_getUserPhotos($nsid);

// Get the user's first 36 public photos
$photos = $f->photos_search(array("user_id" => $nsid, "per_page" =>
  $per_page, "page" => $page));

// Loop through the photos and output the HTML
$i = 0;
foreach ($photos['photo'] as $photo) {
    echo "<a href=$photos_url$photo[id]>";
    echo "<img border='0' alt='$photo[title]' ".
        "src=" . $f->buildPhotoURL($photo, "Square") . ">";
    echo "</a>";
    $i++;
    // If it reaches the sixth photo, insert a line break
    if ($i % $columns == 0) {
```

```
            echo "<br>\n";
        }
    }

    ?>
```

You'll need to modify the configuration section at the top. Change the flickrAPIKey and flickrSharedSecret variables to your actual API key and shared secret. If you intend to use database caching (and I highly recommend it, because it will make your app zippier), you'll need to edit the database-related variables as well. Here are the configuration lines, showing sample values:

```
// Configuration stuff
$flickrAPIKey = "928c994908f02385d1d97a457003cb71";
$flickrSharedSecret = "8698bb062a08ca11";

// Caching configuration stuff
$cachingenabled = true;
$dbUser = "krazydad";
$dbPass = "ignatiusluvsdonuts";
$dbAddress = "localhost";
$dbTable = "myflickrbase";
```

After editing the configuration, save the file.

You will also need to make similar modifications to *auth.php*. Add your API key and shared secret to these two lines:

```
$api_key             = "[your API key]";
$api_secret          = "[your API secret]";
```

Now, upload both *testauth.php* and the modified version of *auth.php* to your web server. You're ready to test your app!

Running the Hack

Enter the address of the PHP file in your web browser's address bar, like so:

```
http://www.yourdomain.com/testauth.php
```

The first time you do this, the routine f->auth() will notice that there is no authentication token for you and will redirect you to the Flickr application permissions page, which looks something Figure 6-10.

When phpFlickr redirects you to this page, it adds a parameter, extra, that contains the URL of your test application.

After you press the "OK, I'll Allow It" button, you'll be redirected back to the *auth.php* application. The extra parameter will be passed back, so that *auth.php* knows where to ultimately redirect you.

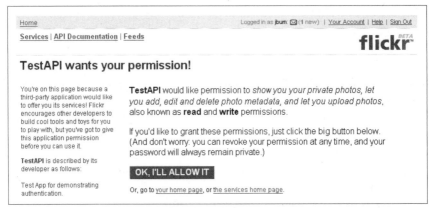

Figure 6-10. Flickr's application permissions page

The *auth.php* app will convert the frob **[Hack #40]** to a full authentication token and store it in the PHP session variables; then, it will redirect you back to *testauth.php*. When *testauth.php* runs again, it will retrieve the authentication token from the session variables, and the app will finally be able to make API calls that require authentication.

As a user, fortunately, all this magic happens under the hood. The apparent result of pressing the "OK, I'll Allow It" button is that your pictures will start appearing on the screen, as shown in Figure 6-11.

Congratulations, you've been authenticated! Now, any other users who visit this web page can authenticate themselves in the same way, easily and painlessly... at least, for them!

See Also

- "Authenticate Yourself" **[Hack #40]**
- "Make a Flickr-Style Tag Cloud" **[Hack #14]**

HACK #42 Build a Custom Upload Script

If the existing Flickr upload tools aren't your cup of tea, try brewing your own upload script.

The Tools page at Flickr (*http://www.flickr.com/tools/*) points to a number of different programs that are available to help you upload your photos to Flickr **[Hack #5]**. Many include some extra features, such as the ability to add tags, set photo privacy options, and resize photos. But if the existing tools don't quite fit with how *you* want to upload photos, you can create your own upload program, thanks to the Flickr API.

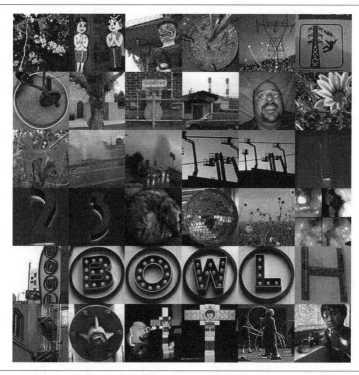

Figure 6-11. A test run of testauth.php

Say you perform a certain number of steps for each photo that you upload to Flickr. With some automation, you should be able to combine those steps with the upload procedure, saving you time in the process. This hack shows how to put together a custom upload script that resizes photos and adds a copyright notice before sending them off to Flickr. You can adapt it to suit your needs.

Authorizing Your Script

The first step to creating a custom upload script is giving your script the authority to add photos to your Flickr photostream. The Flickr API has a user authentication system **[Hack #40]** that makes sure only authorized programs can add, edit, or delete photos at Flickr.

The key to authorizing your own script is requesting an *authentication token*—a string of characters that represents your unique combination of user ID and API key. You'll also need a special string called a *shared secret*, which you can pick up when you configure your API key. This step is a bit of a hassle, but it ensures your security. Plus, it's a one-time process; once

you have your authentication token, you won't need to request one again (for this application, anyway).

To get started, go to the Flickr API page (*http://www.flickr.com/services/api/*) and request a unique API key by clicking the API Keys link on the left side of the page. Note that even if you have an API key for another application, you'll want to request a unique key for each application you create. Once you have the key, be sure to copy it to a safe place. Then, go back to the Flickr API page and click the Yours link in parentheses next to the API Keys link.

On the Registered Keys page, you'll see a list of all your API keys. Each key has an authentication configuration. Click the "Not configured" link associated with your new key to set it up.

On the API Key Authentication Setup page, you'll find your key and your shared secret, and you can specify a title, description, logo, URL, and authentication type for your application. Because you're authenticating an application for yourself only, you don't need to worry too much about what you enter here. Give your application a memorable name such as "My Upload Script," and choose Desktop Application as the Authentication Type. Copy your shared secret, and click Save Changes to set the authentication.

The following script will request an authentication token for your script. You'll need the nonstandard modules Flickr::API (*http://search.cpan.org/ ~iamcal/Flickr-API-0.07/lib/Flickr/API.pm*) and XML::Simple (*http://search. cpan.org/~grantm/XML-Simple-2.14/lib/XML/Simple.pm*) for working with API responses, and Digest::MD5 (*http://search.cpan.org/~simkin/Apache-LoggedAuthDBI-0.12/MD5.pm*) for formatting requests.

Copy the following code to a file called *get_auth_token.pl*, and be sure to include your Flickr API key and shared secret at the top of the script:

```perl
#!/usr/bin/perl
# get_auth_token.pl
# This script requests an authentication token for a user
# given a specific API key and shared secret.
#
# You can get a Flickr API key and shared secret and read the
# full documentation for the Flickr API at:
#
# http://www.flickr.com/services/api/

use strict;
use Flickr::API;
use XML::Simple;
use Digest::MD5 qw/md5_hex/;

# Set your Flicker variables
my $api_key = 'insert Flickr API key';
```

```perl
my $shared_secret = 'insert Flickr shared secret for API key';
my $permission_wanted = 'write';

# Start the API
my $api = new Flickr::API({'key' => $api_key,
                'secret' => $shared_secret});
my $response = $api->execute_method('flickr.auth.getFrob');

# Grob the frob
my $xmlsimple = XML::Simple->new();
my $flickr_xml = $xmlsimple->XMLin($response->{_content});
my $frob = $flickr_xml->{frob};

# Get authorization for read access
my $url = $api->request_auth_url($permission_wanted, $frob);

# Open browser with auth URL (Windows only!)
$url =~ s/&/^&/gis; #Escape URL for command line
system "start $url";

# Non-Windows systems should print out the URL
# print "Go to the following URL in a web browser:\n\n$url\n\n";

# Tell the user to check out the Flickr window
print "Return to this window after you've finished the authorization process
on Flickr.com and press Enter.";
<STDIN>;

# Get the auth token
my $response = $api->execute_method('flickr.auth.getToken', {
                'frob' => $frob});
my $flickr_xml = $xmlsimple->XMLin($response->{_content});

my $auth_token = $flickr_xml->{auth}->{token};
die "Couldn't get authentication token!" unless defined $auth_token;

print "\nYour auth token is: $auth_token";
```

You can run the script by calling it on the command line:

```perl
perl get_auth_token.pl
```

The script will contact the Flickr API and assemble the URL for requesting authorization. It will then open a browser window with that URL, and you'll need to log in and grant your application permission to read and write photos.

> The system "start $url"; command in this script will open a browser with the specified URL on Windows systems only. If you're using a Mac, you can use the system "open $url"; command. In a Unix environment, comment out this line and uncomment the line that prints out the URL. You'll need to copy and paste the URL into your browser's address bar.

Once you've granted the application permission, return to the command window and hit Enter. You should receive a string of characters that represents your authentication token. Copy down this string, and you'll be ready to build your custom script.

The Code

The following code looks for any photos in a special *Flickr drop folder*, resizes the photos, adds a copyright notice to each of them, and uploads them automatically. Once uploaded, the photos are moved to a *Flickr sent folder*. You'll need to set the $flickrdrop and $flickrsent variables to folders on your system.

The copyright notice can be any string of text; just set the $copyright variable to something like Copyright 2005 Paul Bausch. You'll also need to set the $maxsize variable, which represents the maximum size in pixels you want to upload—this can help you get the most out of your Flickr bandwidth limit [Hack #4]. This image process is handled by the Image::Magick module, which you'll want to be sure is installed on your system. You can download ImageMagick from *http://www.imagemagick.org*; be sure to install the PerlMagick module when you install the program.

The final piece you'll need is the Flickr::Upload module (*http://search.cpan. org/~cpb/Flickr-Upload-1.22/Upload.pm*), which you can install with CPAN. This module encapsulates all of the necessary Flickr API calls into a single handy upload() function.

Copy the following code to a file called *flickr_upload.pl*, and be sure to include your Flickr API key, shared secret, and recently acquired auth token:

```perl
#!/usr/bin/perl
# flickr_upload.pl
# This script loops through photos in a directory, resizes each
# photo to the set maximum size, adds a copyright notice to each
# photo, and uploads each photo to Flickr. You can also specify a
# number of tags to associate with each photo on the command line.
#
# Usage: flickr_upload.pl [tag] [tag] [tag]
#
# You'll need an auth token, which you can aquire by running the
# accompanying get_auth_token.pl script.
#
# You can get a Flickr API key and shared secret and read the
# full documentation for the Flickr API at:
#
# http://www.flickr.com/services/api/

use strict;
use Flickr::Upload;
```

```
use Image::Magick;
use File::Copy;

# Set your environment variables
my $flickrdrop = 'c:/flickrDrop/';
my $flickrsent = 'c:/flickrDrop/sent/';
my $copyright = 'insert your copyright notice';
my $maxsize = 500;

# Set your Flickr variables
my $api_key = 'insert Flickr API key';
my $shared_secret = 'insert Flickr shared secret for API key';
my $auth_token = 'insert Flickr auth token';

# Grab any tags on the command line
my $tags = join(' ', @ARGV);

# Start the Flickr Uploader
my $ua = Flickr::Upload->new({'key'=>$api_key,'secret'=>$shared_secret});

# Open the Flickr drop directory and grab .jpg files
my @IDs;
opendir(DIR, $flickrdrop) || die "Cannot open directory: $flickrdrop: $!";
my @photos = grep { /.jpg/i } readdir DIR;
closedir DIR;
@photos = sort @photos;

foreach my $photo (@photos) {

    # Tell user which photo is going
    print "Uploading $photo...";

    my $photopath = "$flickrdrop$photo";

    # Read the photo and get the size with Image::Magick
    my $image = new Image::Magick;
    $image->Read($photopath);

    my $width = $image->Get('width');
    my $height = $image->Get('height');

    # Resize the photo with Image::Magick if necessary
    if ($height > $width) {
        if ($height > $maxsize) {
            my $new_height = $maxsize;
            my $new_width = $width * ($maxsize / $height);
            $image->Resize(
                width=>$new_width,
                height=>$new_height,
                blur=>0.5,
                filter=>'Box');
            print "Resized...";
        }
```

```
    } else {
        if ($width > $maxsize) {
            my $new_width = $maxsize;
            my $new_height = $height * ($maxsize / $width);
            $image->Resize(
                width=>$new_width,
                height=>$new_height,
                blur=>0.5,
                filter=>'Box');
            print "Resized...";
        }
    }

    # Add copyright information to the photo with Image::Magick
    $image->Annotate(
        font=>'c:/windows/fonts/verdanab.TTF',
        pointsize=>11,
        fill=>'white',
        text=>$copyright,
        gravity=>'SouthEast',
        antialias=>1,
        translate=>5,5);

    # Save the photo with changes
    $image->Write($photopath);

    # Upload the photo to Flickr
    my $photoid = $ua->upload(
        'photo' => $photopath,
        'auth_token' => $auth_token,
        'tags' => $tags,
        'is_public' => 1,
        'is_friend' => 1,
        'is_family' => 1,
        'async' => 0,
    ) or warn "Couldn't upload $photo\n";

    if ($photoid ne '') {
        # Tell the user this photo is at Flickr
        print "Done!\n";

        # Store the Flickr ID in an array
        push(@IDs, $photoid);

        # Copy photo to the sent folder
        copy($photopath, "$flickrsent$photo")
          or die "Can't copy $photo.";

        # Delete the original photo
        unlink($photopath);
    }
}
```

```
# Build the review images URL
my $flickrURL = "http://www.flickr.com/tools/uploader_edit.gne?ids=";
foreach my $id (@IDs) {
    $flickrURL .= $id . ",";
}

# Open browser with the review images URL (Windows only!)
system "start $flickrURL";
```

As each photo in the folder is processed and sent to Flickr, the script stores each photo's new Flickr ID in the @IDs array. At the end of the process, the script builds a URL that will let you edit the title, description, and tags of each of the newly uploaded photos.

Windows users will see the page in their browser, thanks to the final system "start $flickrURL"; command. If you're working in another environment, you might want to simply print the URL to the command prompt, like so:

print $flickrURL;

Running the Hack

To process a batch of photos with the script, copy the photos to the specified Flickr drop folder and run the script from a command prompt, like this:

perl flickr_upload.pl

 Be sure to put copies of the photos in the Flickr drop folder, rather than the original photos. Processing a photo could significantly alter the file, and without a backup, you'll lose the ability to go back to the original version.

You can also specify tags as you run the script. For example, if you know you just dumped a bunch of photos of trees into the Flickr drop folder, you could automatically tag each photo like this:

perl flickr_upload.pl tree green leaves

Once at Flickr, each photo will have the tags *tree*, *green*, and *leaves*.

Figure 6-12 shows a photo at Flickr with the copyright notice added to the lower-right corner.

Each photo is moved to the Flickr sent folder once it's uploaded, so when the script is finished, the Flickr drop folder will be ready for another batch of photos to process. A new browser window will open, so you can review all of the photos you uploaded and add titles, descriptions, and tags if necessary.

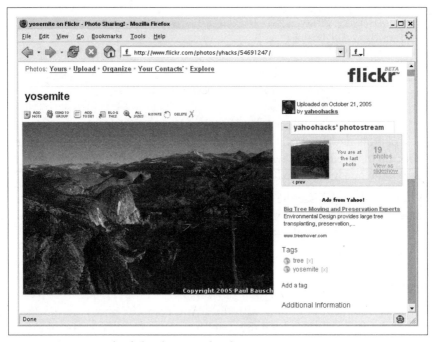

Figure 6-12. Image uploaded and processed with a custom script

Building your own upload script takes a bit of time, but if you can encapsu-
late photo processing and Flickr uploading into one step, you'll make up
that time easily in the future. And you'll have a script that's tailor-made for
you!

Custom Applications

Hacks 43–50

Many independent developers have taken photos beyond the Flickr web site and into completely new applications, thanks to the Flickr API. In the same spirit of sharing, they've made their custom Flickr apps available to anyone who wants to play with them.

Some of these Flickr toys can turn your photos into motivational posters [Hack #46] or puzzles [Hack #48]. With a bit of programming, you can also mash up Flickr photos into collages [Hack #43], ransom notes [Hack #47], or complex photo mosaics [Hack #49].

This chapter will show you what's possible when you go beyond the Flickr API basics into the realm of more fully realized custom applications.

HACK #43 Mash Up Your Photos

ImageMagick is the ultimate tool for making collages.

This is the first in a series of hacks about creating mosaic images. In this hack, we'll build an image that contains a number of other photographs, randomly positioned and rotated. In the course of doing this, we'll learn a bit about the incredibly useful ImageMagick library (plus, we'll make a pretty interesting-looking collage).

What You Need

To build a collage from Flickr images, you'll need some Flickr images, of course. I like to work with 100×100 thumbnails (these are the ones with the _t extension) until I'm happy with the final result. Then, I download larger images for the final draft.

This hack relies on the *getPhotoList.pl* script [Hack #33] and the *getSnaps.pl* script [Hack #34].

Finally, you'll need ImageMagick and the `Image::Magick` Perl module. You can obtain both of these from the ImageMagick web site (*http://www. imagemagick.org*).

ImageMagick

ImageMagick is a library that enables you to automate most image-processing chores—nearly everything that you might otherwise do with Photoshop or GIMP.

I usually work with ImageMagick in Perl (via the `Perl::Magick` module); however, ImageMagick has APIs for lots of other languages, including C, C++, Java, Python, PHP, and Ruby.

ImageMagick also comes with some useful command-line programs that allow you to do many common tasks, such as image format conversions.

To illustrate the power of ImageMagick, here's a simple Perl program that reads an input file (such as a PNG image) and saves it out in some other format (such as a JPEG image):

```perl
#!/usr/bin/perl
use Image::Magick;
($infile, $outfile) = @ARGV;    # read command-line arguments: infile outfile
$image = Image::Magick->new;    # create an image handle
$image->Read($infile);          # load in the source image
$image->Write($outfile);        # save it back out (in some other format)
```

> This is something that ImageMagick's convert tool does very well, but this code illustrates the basic technique of opening and saving images.

ImageMagick automatically recognizes common image file extensions such as *.png*, *.gif*, *.jpg*, *.tif*, and so on. If you use one of these extensions for the output filename, it will automatically convert to the appropriate format.

Here's a program that creates a new image, fills it with a white background, writes some text on it, and saves it:

```perl
#!/usr/bin/perl
use Image::Magick;
$image = Image::Magick->new;
$image->Set(size=>"800x600");
$image->Read('xc:white');
$image->Annotate(text=>'Hello World', x=>50, y=>50);
$image->Write('hello.jpg');
```

Commands such as `Annotate()` offer a wealth of options. Here's a fancier version of the annotation in the previous program:

```
$image->Annotate(text=>'Hello World', x=>50, y=>50,
    font=>'comicbd.ttf', pointsize=>72, style=>'oblique',
    rotate=>30, antialias=>'true', fill=>'#702948');
```

Finally, here's a program that takes two existing images and composites them together to create a third image (this is the basis of the collage program that we'll develop in a moment):

```
#!/usr/bin/perl
use Image::Magick;
$outimage = Image::Magick->new;
$outimage->Set(size=>"800x600");
$outimage->Read('xc:white');

$img = Image::Magick->new;
$img->Read("hello.jpg");
$outimage->Composite(image=>$img, x=>10, y=>10);
undef $img;

$img = Image::Magick->new;
$img->Read("hello.jpg");
$outimage->Composite(image=>$img, x=>410, y=>10);
undef $img;

$outimage->Write('hello2.jpg');
```

Note the use of undef to undefine each image when it's no longer being used. Although this isn't strictly necessary for this sample program, it's important for larger collages that use lots of tiles, to reduce memory usage.

The Code

Create a file called *makeCollage.pl* and add the following code to it:

```
#!/usr/bin/perl -s
#
# makeCollage.pl - Jim Bumgardner
#

use Image::Magick;

$photolist = shift;
$collageName = shift;
die "makeCollage.pl [-big] <photolist_file> [collagename]\n" if !$photolist;

$collageName = $photolist if !$collageName;
$collageName =~ s/\.ph// if $collageName =~ /\.ph$/;

$photolist .= '.ph' if !($photolist =~ /\./);

require "$photolist";

($outW,$outH) = (1024 * ($big? 2 : 1), 768 * ($big? 2 : 1));
```

```perl
$outimage = Image::Magick->new;
$outimage->Set(size=>"${outW}x${outH}");
$outimage->Read('xc:black');

$dirname = $photolist;
$dirname =~ s/\.ph// if $dirname =~ /\.ph$/;

$suffix = $big? '' : '_t';

$n = 0;

foreach $photo (@photos)
{
  $fnam = "$dirname/$photo->{id}$suffix.jpg";
  $img = Image::Magick->new;
  $err = $img->Read($fnam);
  die "Problem reading $fnam: $err" if $err;

  $img->Resize(geometry=>'200x200') if $big;

  ($w, $h) = $img->Get('width','height');

  # this code gives the image a random rotation & opacity
  # the mask prevents the bounding rectangle on the rotated image
  # from painting over the images underneath
  $rot = rand( )*90-45;
  $v = int(rand( )*256);
  $mcolor = sprintf '#%02x%02x%02x', $v, $v, $v;
  $mask = Image::Magick->new;
  $mask->Set(size=>"${w}x${h}");

  $mask->Read("xc:$mcolor");
  $img->Rotate(degrees=>$rot,color=>'black');
  $mask->Rotate(degrees=>$rot,color=>'black');

  ($w, $h) = $img->Get('width','height');
  $x = rand( )*($outW-$w);
  $y = rand( )*($outH-$h);

  $outimage->Composite(image=>$img, mask=>$mask, x=>$x, y=>$y);
  undef $img;
  undef $mask;
  print "$n...\n" if ++$n % 100 == 0;
}

$outimage->Write("collage$suffix.png");

# done
```

Running the Hack

To run the hack, we'll first use some scripts we developed in "Download a List of Photos" [Hack #33] and "Cache Photos Locally" [Hack #34].

The following command downloads a list of photo records from my friend Fubuki's photostream that have the tag *macro* and saves the information about the photos into a file called *fubuki_macro.ph*:

```
getPhotolist.pl -u fubuki macro
```

Next, we'll download thumbnails of Fubuki's macro photos (using the information in the *fubuki_macro.ph* file we just created) and save them into a folder called *./fubuki_macro*:

```
getSnaps.pl fubuki_macro
```

Finally, we'll execute the collage script we created in this hack:

```
makeCollage.pl fubuki_macro
```

The script reads in the information about the photos from *fubuki_macro.ph*, loads in the photos themselves (from the *./fubuki_macro* subdirectory), and composites them into a new collage image that is saved to the hard drive as *collage_t.png*.

The result is a collage that looks something like Figure 7-1.

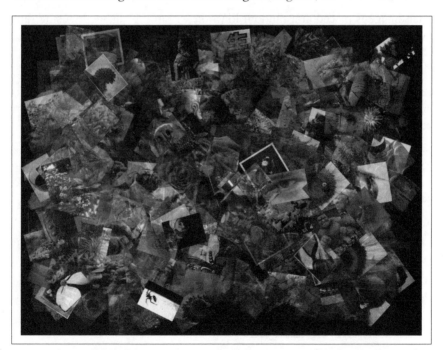

Figure 7-1. A sample collage

As you can see, this script produces a pretty interesting-looking image. In the script, I've given each image a random rotation, using this line:

```
$rot = rand( )*90-45;
```

This assigns a rotation to each image from −45 to +45 degrees. When you rotate images in ImageMagick, the rotated image is contained within a larger square bounding box, which will be visible when the image is composited. To avoid this problem, I've created an image mask, which is also rotated, so that the bounding box corners don't appear in the final result when images are stacked on top of each other.

When I create the mask, I assign it a random color, using these lines:

```
$v = int(rand( )*256);
$mcolor = sprintf '#%02x%02x%02x', $v, $v, $v;
$mask = Image::Magick->new;
$mask->Set(size=>"${w}x${h}");
$mask->Read("xc:$mcolor");
```

The color of the mask determines the opacity of the image that is being composited. If the mask is white (#FFFFFF), the image is fully opaque. If the mask is black (#000000), the image is transparent. By using a range of random values for the mask color from black to white, we get a variety of opacities in the final image, which produces a more impressionistic result.

Each image is placed at a random location within the collage by using random x and y coordinates:

```
$x = rand( )*($outW-$w);
$y = rand( )*($outH-$h);
```

I subtract the photo's width and height from the range of possible values to ensure that the photos don't accidentally bleed over the right or bottom edge of the collage.

Since this script uses random numbers, your results won't exactly match the results shown here, and you'll get different results each time you run the script. If you want more predictable results, add a line at the beginning to seed Perl's random number generator with a fixed value, like so:

```
srand(27);
```

I chose 27 because it's my favorite number. Try different numbers until you get a result you like.

If you want a high-resolution version, download the larger images and use them like so:

```
getSnaps.pl -big fubuki_macro
makeCollage.pl -big fubuki_macro
```

These commands will download the medium-sized versions of Fubuki's images and will produce a nice big collage without the _t suffix in the filename: *collage.png*.

See Also

- "Download a List of Photos" [Hack #33]
- "Cache Photos Locally" [Hack #34]
- "Make a Photo Mosaic" [Hack #49]

HACK #44 Find the Dominant Color of an Image

Flickr doesn't have a color search feature, but that shouldn't stop you from building one!

There are a lot of cool things you can do if you know the dominant colors of a group of images. For instance, you can make user interfaces for searching large quantities of photos by color, such as the Flickr Colr Pickr [Hack #45], and you can create fascinating collages by arranging the photos by luminance, saturation, or hue.

The simplest way I've found to find the dominant color of an image is to resize the image to 1 × 1 (producing a single pixel) and then record the color of that pixel. This will produce a value that is (or is close to, depending on the resizing algorithm) the average color of the image.

This hack provides two scripts: *samplePhoto.pl* samples a single photo, and *sampleSnaps.pl* samples a large collection of photos (thumbnails, hopefully) and saves the information in a file that can be read by other scripts.

What You Need

To run the scripts in this hack, you'll need the following two modules:

Image::Magick

This Perl module provides an API for the powerful ImageMagick image-processing library. You can find it at *http://www.imagemagick.org*, or you can download it from CPAN.

> For Windows, the Perl module comes with the latest installer from the ImageMagick site; however, you might have problems getting this version to install properly, depending on your Perl configuration. If, after installing ImageMagick, you have problems with the ActiveState version of Perl, use *ppm* to install the Perl module, by issuing the following command:
>
> ```
> ppm install Image-Magick ppd
> ```

Data::Dumper

The scripts in this hack produce output in the form of a text file that can be parsed by other Perl scripts. An easy way to accomplish this is to

build up the data structure in Perl and then use Data::Dumper to dump it into a text file.

The Code

Here's a basic script that outputs color information for a single photo, in HTML format, using the Image::Magick module. Create a file called *samplePhoto.pl* and enter the following code:

```perl
#!/usr/bin/perl -s

#
# samplePhoto.pl - Jim Bumgardner
#

use Image::Magick;

$Data::Dumper::Terse = 1;  # avoids $VAR1 = * ; in dumper output
$Data::Dumper::Indent = $verbose? 1 : 0;  # more concise output

$photoname = shift;
die "samplePhoto.pl <photoname>\n" if !$photoname;

my $image = Image::Magick->new;
$err = $image->Read($photoname);
die $err if $err;
my ($w,$h) = $image->Get('width','height');
$image->Resize(geometry=>'1x1');
($r,$g,$b) = $image->GetPixels(x=>0,y=>0,width=>1,height=>1,normalize=>1);
undef $image;

$colorspec = sprintf "#%02x%02x%02x", $r, $g, $b;
$textcolor = $g < 128? 'white' : 'black';

print <<EOT;

<html><body>
<table><tr>
<td><img src="$photoname" /></td>
</tr><tr>
<td bgcolor=$colorspec>
<font color=$textcolor>
R: $r<br>
G: $g<br>
B: $b<br>
</font>
</td></tr></table>
</body></html>

EOT
# end of script
```

The second script records color information for a large collection of photos, using a photo list created by the *getPhotoList.pl* script [Hack #33]. Save this script as *sampleSnaps.pl*:

```perl
#!/usr/bin/perl -s

#
# sampleSnaps.pl - Jim Bumgardner
#

use Image::Magick;
use Data::Dumper;
$Data::Dumper::Terse = 1;  # avoids $VAR1 = * ; in dumper output
$Data::Dumper::Indent = $verbose? 1 : 0;  # more concise output

$photolist = shift;
$dirname = shift;
die "sampleSnaps.pl <photolist_file> [dirname]\n" if !$photolist;

$dirname = $photolist if !$dirname;
$dirname =~ s/\.ph// if $dirname =~ /\.ph$/;
$photolist .= '.ph' if !($photolist =~ /\./);

require "$photolist";

$n = scalar(@photos);  # count photos
print "$n photos in file\n";

@sampledPhotos = ( );

$nbrSampled = 0;

$firstPhoto = $photos[0];
$suffix = '_t' if !$suffix;

foreach $photo (@photos)
{
  my ($owner, $secret, $server) = ($photo->{owner},$photo->{secret},$photo->
{server});
  $fnam = "$dirname/$photo->{id}$suffix.jpg";

  my $image = Image::Magick->new;
  $err = $image->Read($fnam);
  if ("$err") {
    warn "$err";
    next;
  }
  ($w,$h) = $image->Get('width','height');
  $x = $image->Resize(geometry=>'1x1');

  ($r,$g,$b) = $image->GetPixels(x=>0,y=>0,width=>1,height=>1,normalize=>1);
  undef $image;
```

```
($photo->{r},$photo->{g},$photo->{b}) = ($r,$g,$b);

    ++$nbrSampled;
    print "$nbrSampled...\n" if $nbrSampled % 50 == 0;
}

$ofname = "$dirname/samples.ph";

open (OFILE, ">$ofname");
print OFILE "\@photos = (\n";
$n = 0;
foreach $photo (@photos)
{
    print OFILE ($n++? ",\n" : "") . Dumper($photo);
}
print OFILE "\n);\n1;\n";
close OFILE;

print "$nbrSampled sampled to $ofname\n";
```

Running the Hack

To use the *samplePhoto.pl* script, you'll need a photo to work on. Here's a sample run using a JPEG file of a watermelon:

```
samplePhoto.pl watermelon.jpg >test.html
```

You can view the file *test.html* in a web browser to see the result, as shown in Figure 7-2.

You'll find that the color values produced using this method tend to be more subdued than the colors in the actual images. This is because the technique is averaging color values. If you average two bright colors that have opposite hues, you will end up with a subdued gray color. In the image in Figure 7-2, the green color of the watermelon rind and background help to neutralize the vivid color of the watermelon flesh.

Interestingly, I've found that if you take a large collection of digital photographs from Flickr and average the colors together, it tends to produce a dull brown or orange color, rather than gray, as you might expect. Why this is so, I'm not sure. Some say it has something to do with the qualities of indoor lighting and flash photography. Computer graphics guru Kevin Bjorke offers a more prosaic explanation: "It's the color of dirt and people."

To use the *sampleSnaps.pl* script, which samples a large group of images, you'll need the scripts developed in "Download a List of Photos" [Hack #33] and "Cache Photos Locally" [Hack #34]. Here's how to download and color-sample a set of images of aardvarks:

```
getPhotoList.pl aardvark
getSnaps.pl aardvark
sampleSnaps.pl aardvark
```

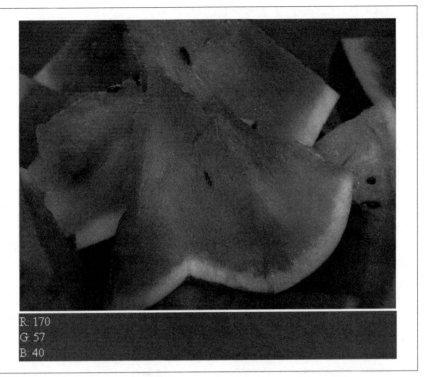

R: 170
G: 57
B: 40

Figure 7-2. Output of samplePhoto.pl

The first command uses the Flickr API to produce a list of relevant photos, which are saved in *aardvark.ph*. The second command downloads thumbnails of each of these images into the directory *aardvark*. The final command samples the colors of all the photos and saves the photo and color information into a file called *aardvark/samples.ph*. This file contains the same data that is in *aardvark.ph* but adds r, g, b, and l fields, which represent red, green, blue, and luminance, respectively. Here's an excerpt:

```
@photos = (

{'owner' => '24512271@N00','isfriend' => '0','r' => '0.
493690401315689','ispublic' => '1',
'secret' => '4551f2bed3', 'b' => '0.44110780954361','g' => '0.
447013050317764',
'title' => 'Groupportrait','server' => '3','id' => '5024662','isfamily' =>
'0'},

{'owner' => '66208233@N00','isfriend' => '0','r' => '0.
512062251567841','ispublic' => '1',
'secret' => 'fef397ccee', 'b' => '0.466559857130051','g' => '0.
491554141044617',
```

```
'title' => 'Grooming is important','server' => '8','id' =>
'11999049','isfamily' => '0'},

{'owner' => '44124388719@N01','isfriend' => '1','r' => '0.
60651558637619','ispublic' => '1','secret' => 'bee4525170','b' => '0.
508110165596008','g' => '0.565896093845367',
'title' => 'The Night Visitor','server' => '4','id' => '5043567','isfamily'
=> '1'},

# etc...
```

We'll use this data in "Make a Color Picker" [Hack #45] to build an interface that quickly searches and returns photos that match a specific color.

Hacking the Hack

The color values in these scripts are normalized color values, which are floating-point numbers that go from 0 to 1. You might prefer the more concise 8-bit integer representation, in which each color component is a number from 0–255. You can convert the normalized colors to 8-bit integers by adding this code to the script:

```
# Convert normalized RGB values to 8-bit integers:
$r = int($r*255);
$g = int($g*255);
$b = int($b*255);
($photo->{r},$photo->{g},$photo->{b}) = ($r,$g,$b);
```

The three values that we are so interested in—r, g, and b—represent the respective red, green, and blue color components of the pixel. But there are a variety of ways to analyze color, aside from boring old RGB. If you are interested in answering questions such as "How bright is the photo?" or "How colorful is the photo?," the RGB values are not necessarily ideal.

Other color spaces include CMYK (cyan, magenta, yellow, and black), commonly used in the print industry, and HSV (hue, saturation, and value; sometimes called HSB for hue, saturation, and brightness). The HSV color space is particularly useful for evaluating color in a more artistic and intuitive way. For example, if the saturation value (s) is high, you know the image is *colorful*. If the brightness value (v) is high, you know the image is *bright*. If you sort the images from left to right to correspond to their hue values (h), it produces a rainbow pattern.

I use the following Perl function to convert from RGB to HSV values:

```
sub RGBtoHSV($$$)
{
  my ($r,$g,$b) = @_;
  my $max = $r > $g? $r : $g;
  $max = $max > $b? $max : $b;
  my $min = $r < $g? $r : $g;
```

```
$min = $min < $b? $min : $b;
  my $v = $max;
  my $s = ($max != 0)? ($max-$min)/$max : 0;
  my $h;
  if ($s == 0) {
      $h = 0;    # undefined, actually
  }
  else {
      my $d = $max - $min;
      if ($r == $max) {
          $h = ($g - $b)/$d;
      }
      elsif ($g == $max) {
          $h = 2 + ($b-$r)/$d;
      }
      elsif ($b == $max) {
          $h = 4 + ($r-$g)/$d;
      }
      $h *= 60;
      if ($h < 0) {
          $h += 360;
      }
  }
  return ($h,$s,$v);
}
```

To incorporate this into the *sampleSnaps.pl* script, add the function to the bottom of the script. Then, after the line that generates the RGB values:

```
($r,$g,$b) = $image->GetPixels(x=>0,y=>0,width=>1,height=>1,normalize=>1);
```

you can convert them to HSV values:

```
($h,$s,$v) = RGBtoHSV($r,$g,$b);
```

Another useful quality to look for is *luminance*, which is a measure of how bright the color appears to the human eye. There are a few ways to measure luminance. The v value returned by the RGBtoHSV() comes pretty close, but it doesn't take into account the apparent differences in the brightness of hues; for example, pure green appears brighter to the eye than pure blue. A good RGB-to-luminance formula that I often use is Haeberli's luminance equation:

```
$lum = 0.3086*$r + 0.6094*$g + 0.0820*$b;   # compute luminance
```

In my own scripts, I usually don't bother storing either the HSV values or the luminance values, since I can easily convert the RGB values to HSV or luminance on the fly when I need them, using the techniques in this hack.

For an excellent introduction to color specification and image coding, check out the Color FAQ:

http://www.poynton.com/notes/colour_and_gamma/ColorFAQ.html

See Also

- "Download a List of Photos" [Hack #33]
- "Cache Photos Locally" [Hack #34]
- "Mash Up Your Photos" [Hack #43]
- "Make a Photo Mosaic" [Hack #49]

H A C K
#45 Make a Color Picker

This colorful interface is fun to use and functional.

The Flickr Colr Pickr (*http://www.krazydad.com/colrpickr/*) was one of the first Flickr-powered applications I built, and it has been the inspiration for a lot of my other Flickr-related work. The basic idea was to combine an HSV color picker, a common feature in many paint and illustration programs, with a photo browser. When you click on a color on the color wheel, a group of thumbnail images that match the color pops up nearly instantaneously.

Most users quickly grasp the basic concept of "point at a color, see pretty pictures" and have a lot of fun playing with it. Many artists and designers have told me they find this a useful interface for searching for photos that match a particular palette.

People often assume that this interface makes use of a color-search capability built into Flickr, but alas, Flickr offers no such service (yet). To make a color picker, you must first precompute the average colors of the photos you wish to search. This is done using the Perl script developed in "Find the Dominant Color of an Image" [Hack #44]. Here, we'll use a new Perl script to convert that information to an ActionScript text file, which we can then include in a Flash movie. The HSV color picker interface is created using Flash ActionScript.

What You Need

This hack uses the modular Perl scripts developed in "Download a List of Photos" [Hack #33], "Cache Photos Locally" [Hack #34], and "Find the Dominant Color of an Image" [Hack #44]. The Flash template used in this hack requires Macromedia Flash MX or a later version.

To view the color picker, you'll need a web browser with a Flash plug-in capable of displaying Flash 6 movies or later.

The scripts and the Flash template are all available in a single archive, which you can download here:

http://www.krazydad.com/sware/JimsFlickrScripts.zip

The Code

This Perl script is responsible for converting image data from Perl syntax into ActionScript syntax, so we can include the data in a Flash movie.

This script is included in the collection of Perl scripts in the *JimsFlickrScripts.zip* archive mentioned in the previous section.

Create a new text file called *makeFlashDB.pl* and enter the following Perl code:

```perl
#!/usr/bin/perl -s
#
# Convert Perl Photo List to Flash/ActionScript list for use in Colr Pickrs.
# - Jim Bumgardner
#
$photolist = shift;
$dirname = shift;
$dirname = $photolist if !$dirname;
$dirname =~ s/\.ph// if $dirname =~ /\.ph$/;
$ifname = "$dirname/samples.ph";

die "makeFlashDB.pl <photolist_file> [<dirname>]\n" if !$photolist;
die "Photos have not yet been sampled with sampleSnaps.pl\n" if !(-e
$ifname);

require "$ifname";

$poolname = $dirname;

open (OFILE, ">$poolname.as");
print OFILE "poolname='$poolname';\n";
print OFILE "imgdb = [\n";

$n = 0;
foreach $photo (@photos)
{
  print OFILE ",\n" if $n;
  printf OFILE "{r:%d,g:%d,b:%d,owner:'%s', secret:'%s', server:%d, id:%d}",
        int($photo->{r}*255.999), int($photo->{g}*255.999), int($photo->
{b}*255.999),
        $photo->{owner}, $photo->{secret},$photo->{server}, $photo->{id} ;
  ++$n;
}
print OFILE "\n];\n";

close OFILE;
```

Running the Hack

A color picker can be made for any collection of photos on Flickr, but it works best if the collection has more than 500 photos. However, you will also encounter performance problems if the number of photos exceeds 20,000 or so. The more photos there are in the database, the longer it will take to identify photos by color and to load the Flash movie.

This hack will make a color picker using the photos in the Stock Repository group pool at *http://www.flickr.com/groups/stock/*. At last count, this group had 1,658 photos in the pool, which is a good number for a color picker.

Start by identifying the group's Flickr group ID. You can do this using a Flickr API call, such as `flickr.groups.pools.getGroups`, but there is a faster way. In your web browser, examine the URL of the group's image icon (by viewing its properties):

```
http://static.flickr.com/1/buddyicons/49503068103@N01.jpg?1091560577
```

The group ID is the part of the icon filename that precedes the *.jpg* extension—in this case, *49503068103@N01*.

Next, download information about each of the photos in the group, using the script developed in "Download a List of Photos" [Hack #33]:

```
> getPhotoList.pl -g 49503068103@N01

Searching for photos in group 49503068103@N01
Page 1 of 4
Page 2 of 4
Page 3 of 4
Page 4 of 4
1658 photos written to 49503068103@N01.ph
```

Then, rename the resulting file to make it a little easier on the eyes:

```
> mv 49503068103@N01.ph stock.ph
```

You now have a file called *stock.ph*, which contains a description of each photo in the Stock Repository pool.

Next, download a thumbnail image for each photo in the group, using the script developed in "Cache Photos Locally" [Hack #34]. This will create a directory called *stock/*, which will contain all the thumbnail images:

```
> getSnaps.pl stock.ph

Adding stock/48828925_t.jpg...
Adding stock/20569503_t.jpg...
Adding stock/30148198_t.jpg...
Adding stock/24745811_t.jpg...
Adding stock/56897033_t.jpg...
Adding stock/40633875_t.jpg...
Adding stock/51200366_t.jpg...
```

```
Adding stock/26152510_t.jpg...
[etc...]
1610 added
```

Now it's time to sample the colors, using the script developed in [Hack #44]. This will create a file called *stock/samples.ph*, which contains the color information:

```
> sampleSnaps.pl stock.ph

1658 photos in file
50...
100...
150...
200...
250...
[etc...]
1658 sampled to stock/samples.ph
```

You now must use the script you just created, *makeFlashDB.pl*, to convert the information in *stock/samples.ph* (which is in Perl syntax) to a file with ActionScript syntax (*stock.as*), which you'll be able to use in the Flash movie:

```
makeFlashDB.pl stock
```

If you look at the resulting *stock.as* file, you'll see an ActionScript table that looks like this:

```
poolname='stock';

imgdb = [
{r:179,g:170,b:104,owner:'74112673@N00', secret:'f0d1bae053', server:21,
    id:24841261},
{r:70,g:55,b:52,owner:'73624728@N00', secret:'ffb2f98e7d', server:7,
    id:9848052},
{r:131,g:129,b:109,owner:'46172547@N00', secret:'a396cdca40', server:26,
    id:56851454},
{r:139,g:137,b:135,owner:'86497205@N00', secret:'44607ffa2d', server:16,
    id:21641780},
[etc...]
```

You're almost ready to use the Flash template. Copy the Flash template provided in *JimsFlickrScripts.zip* to a new Flash project file:

```
mv colrpickr_template.fla stockPickr.fla
```

Then, open the new template, *stockPickr.fla*, in the Flash authoring environment. You'll see that the movie has two frames in the timeline. The first frame includes a script that contains the bulk of the code for the color picker:

```
// Colr Pickr Template - by Jim Bumgardner
#include "colrpickr.as"
```

You don't need to modify this script.

The second frame includes a script that is supposed to contain the image database:

```
#include "myphotolist.as"

doPick( );
```

Modify this line:

```
#include "myphotolist.as"
```

to read like this, substituting the name of the ActionScript database file you just created:

```
#include "stock.as"
```

The color picker is now ready to be tested.

You can use the Control/Play command to test the movie within the Flash authoring environment. The resulting color picker looks like Figure 7-3.

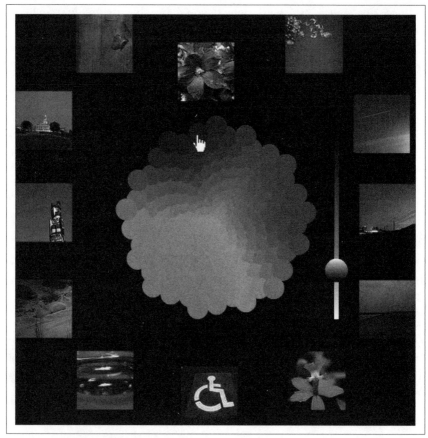

Figure 7-3. A Flickr color picker

Click on the color wheel (or manipulate the light/dark slider) to view photos that match a particular color. Click on any photo to be transported to its web page on Flickr.

If you like the results, select the Publish command on the File menu to create a Flash movie file. This will create two files, *stockPickr.swf* and *stockPickr.html*, which you can upload to your own web server.

Hacking the Hack

Although not printed in this book, the code for the color picker interface is contained within *colrpickr.as* and is included in the *JimsFlickrScripts.zip* archive.

The ActionScript code draws the HSV color-wheel interface, which allows the user to select an HSV color. This color is converted from HSV to RGB, and the 12 photos closest to the RGB value are selected (from the list of photos we embedded). The script then downloads thumbnails for the photos from Flickr and displays them.

Since the list of photos is embedded within the Flash movie itself, there is a limit to how many photos can be searched this way. The script works best with no more than a few thousand photos. The more photos you add, the bigger the Flash movie gets and the longer it takes to search through them.

In addition to working with Flickr, the code is designed such that it can easily be modified to work with other web-based image-archiving services.

The two key routines that you will need to modify to work with other services are GetThumbUrl(), which creates a URL to a thumbnail image, and GetExternalUrl(), which creates a URL to the site where the image is hosted. These routines each receive a single argument, which is a record corresponding to the photo:

```
// These two routines can be modified to make the colr pickr work
// with other image archives...

GetThumbUrl = function(imgRec)
{
  return 'http://static.flickr.com/' +
        imgRec.server + '/' + imgRec.id + '_' + imgRec.secret + '_s.jpg';
}

GetExternalUrl = function(imgRec)
{
    return 'http://www.flickr.com/photos/' + imgRec.owner +
        '/' + imgRec.id;
}
```

The only important fields in the image records that are used by the remainder of the program are the r, g, and b fields, which identify the color of each image in 8-bit RGB space. You can add any additional fields you like to these records in order to formulate URLs.

Once you grasp the essentials of this interface, you might want to try extending it. How about adding the ability to search for photos that match two or three colors, or a server-powered color search capability? These features will greatly increase the power and utility of this playful interface.

See Also

- "Download a List of Photos" [Hack #33]
- "Cache Photos Locally" [Hack #34]
- "Find the Dominant Color of an Image" [Hack #44]

HACK
#46 Make a Motivational Poster and Other Swag

Create your own movie posters, magazine covers, and trading cards in seconds.

FD's Flickr Toys (*http://www.flagrantdisregard.com/flickr/*) are a great collection of online apps that will convert your Flickr photographs into all kinds of cool stuff, such as movie posters and magazine covers.

Flickr Toys

FD, who goes by the name John Watson in real life, currently offers 14 toys, with new ones on the way. The current list features the following:

Badge Maker
FD's first toy to achieve wide popularity allows you to make your own unofficial Flickr ID badge, suitable for laminating, as shown in Figure 7-4. This has become a popular meme on Flickr, and it's a good way to identify yourself in public to other Flickrites. Don't be seen without your badge.

Billboard
Put your photo on a freeway billboard, or at least on a photo of a freeway billboard.

Calendar
Feature your photo in a monthly calendar, suitable for hanging in the garage or planning important events, such as cleaning the garage.

Figure 7-4. A Flickr badge

Flickr Uploadr

Upload your photos to Flickr using a Konfabulator widget (this is a different widget than the one discussed in "Add Photos Quickly" [Hack #5]). Konfabulator, available at *http://www.konfabulator.com*, is a cool tool for filling your desktop with gadgets and gewgaws.

Fortune

View a random photo, accompanied by a random fortune, pithy saying, or astrological prediction—the best random oracle since the I Ching!

Framer

Put your photo into one of 19 unique frames that transform it into something else. Available frames include realistic-looking postage stamps, complete with postmarks (as shown in Figure 7-5); autumn leaves; 35mm film; and Polaroids.

Magazine Cover

Incorporate your photo into a slick-looking magazine cover, with suitable story titles, as shown in Figure 7-6. Choose from several different designs.

Mosaic Maker

Here's yet another method to put a handful of photos into columns and rows. For more methods, see "Make a Contact Sheet" [Hack #32].

Figure 7-5. A stamp made with Framer

Motivator

Make a motivating (or unmotivating) poster, suitable for picking up the spirits of your coworkers (or possibly trampling up and down on those same spirits). See the following section for an example.

Movie Poster

Make an attractive lobby card with title, taglines, release date, and credits, just like Figure 7-7.

On Black

Make a permanent web page displaying your photo on a lovely all-black (or all-white) background—a helpful tool for those making web galleries.

Random Photo Browser

Browse a selection of random photos, each of which was made a favorite by at least one person—a chaotic assortment of the crème de la crème.

Slideshow

Create a (JavaScript) slideshow from a group of your photos. Slideshows are hosted on FD's web site. (For another method of making slideshows, see "Make a Slideshow" [Hack #50].)

Figure 7-6. A magazine cover

Trading Card Maker

Make a trading card, in the style of Pokemon or Magic, as shown in Figure 7-8. Create custom cards for your own customized role-playing games.

Figure 7-7. A movie poster

Most of these toys use a Flickr photograph as source material and then add text, graphic overlays, and other elements to produce an authentic-looking

Figure 7-8. A trading card

result. The great thing about these toys is that FD has excellent design skills, so his scripts amount to free graphic design jobs from a professional.

Many of the toys produce images that make great gifts for birthdays, retirement parties, and other occasions that call for something a little special.

We'll use the Motivator as an example here to show how the toys work. Fill out a few fields in a form, and it will produce a suitably inspiring (or pretentious-looking) motivational poster.

Creating an Unmotivational Poster

To see how FD's toys work, we'll make an unmotivational poster. First, go to your Flickr photostream and find a photo you like. Copy the URL of the page from your browser's address bar. For our example, we'll use the photo found at *http://www.flickr.com/photos/krazydad/60145421/*.

Then, go to FD's Flickr Toys site (*http://www.flagrantdisregard.com/flickr/*) and click the Motivator link. You'll be presented with the form shown in Figure 7-9.

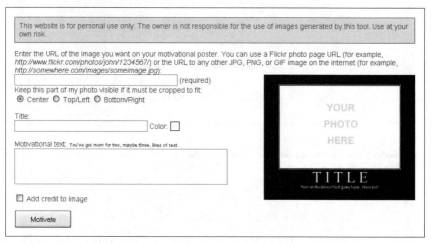

Figure 7-9. FD's Motivator

Paste in the address of your photo, and then enter a title and some motivational text for your poster.

When you press the Motivate button, FD's script will do some processing and then produce an attractive and inspiring result like the one shown in Figure 7-10.

Rolling Your Own

If you're interested in making your own toy, you're in luck! FD has kindly provided some PHP source code that reproduces the Motivator script but uses a stripped-down form. This is an excellent starting point for making other PHP tools that tweak Flickr photos.

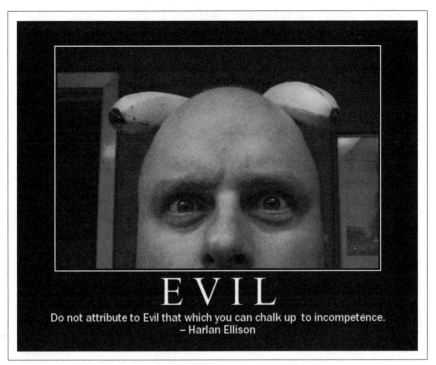

Figure 7-10. An unmotivational poster

 Before rolling your own, be sure to check out FD's site! Since this was written, he has probably added a few more Flickr Toys to the collection.

The code. Create a file called *motivator.php* and enter the following code:

```php
<?php
// Configuration stuff
$flickrAPIKey = "<your_api_key>";
require_once("phpFlickr.php");
$f = new phpFlickr($flickrAPIKey);

// Fonts to use on the poster
$font1 = "times";
$font2 = "verdana";

// Get input variables and defaults
$url = '';
$title = '';
$text = '';
$color = "ffffff";
if (isset($_GET['url'])) $url = $_GET['url'];
if (isset($_GET['title'])) $title = $_GET['title'];
```

```
if (isset($_GET['text'])) $text = $_GET['text'];
if (isset($_GET['color'])) $color = $_GET['color'];

if (isset($_GET['button'])) {
    // Create a 750x600-pixel canvas, on which we'll draw everything
    $canvas = imagecreatetruecolor(750, 600);

    // Fill the canvas with a black background
    imagefill($canvas, 0, 0, hexdec("#000000"));

    // Add a border by drawing a colored rectangle
    // and then a black rectangle inside of that
    imagefilledrectangle($canvas, 70, 45, 679, 454, hexdec($color));
    imagefilledrectangle($canvas, 72, 47, 677, 452, hexdec("#000000"));

    // Get the Large (_b) version (or the Original
    // (_o) size if Large isn't available)
    $jpg = null;
    $info = array();
    if (preg_match('!http://.*?/photos/.*?/(\d+)!i', $url, $match)) {
        $id = $match[1];
        $info = $f->photos_getInfo($id);
        $sizes = $f->photos_getSizes($id);
        foreach($sizes as $size => $sizedata) {
            if ($size == "Large" || $size == "Original") {
                $source = $sizedata['source'];
                if (preg_match('/\.(jpg|jpeg)$/i', $source)) {
                    $jpg = imagecreatefromjpeg($source);
                }
                if (preg_match('/\.png$/i', $source)) {
                    $jpg = imagecreatefrompng($source);
                }
                if (preg_match('/\.gif$/i', $source)) {
                    $jpg = imagecreatefromgif($source);
                }
                break;
            }
        }
    }

    // Center the image on the canvas
    imagecopy($canvas, $jpg, 75, 50, (imagesx($jpg)-600)/2,
(imagesy($jpg)-400)/2, 600, 400);

    // Draw the title text
    // imagettfbbox() is a function that returns the
    // coordinates of a box that would contain the text to be drawn.
    // The output of that function is used to determine how
    // to center the image on the canvas.
    $title = strtoupper(join(preg_split('//', $title), ' '));
    $bbox = imagettfbbox(56, 0, $font1, $title);
    $x = (imagesx($canvas) - $bbox[2])/2; // x-coordinate to center the
text
    $y = abs($bbox[7]-$bbox[1])+465; // y-coordinate
```

```
            imagettftext($canvas, 56, 0, $x, $y, hexdec($color), $font1,
$title);

            // Draw the motivational text
            $bbox = imagettfbbox(16, 0, $font2, $text);
            $x = (imagesx($canvas) - $bbox[2])/2; // x-coordinate to center the
text
            imagettftext($canvas, 16, 0, $x, $y+30, hexdec("#ffffff"), $font2,
$text);

            // Save a copy of the image
            imagejpeg($canvas, "motivator.jpg", 90);
        }
    }
?>
<!DOCTYPE HTML PUBLIC "-//W3C//DTD HTML 4.01 Transitional//EN" "http://www.
w3.org/TR/html4/loose.dtd">
<html>
    <head>
        <title>Motivator</title>
    </head>
    <body>
        <form action="motivator.php" method="get">
            Url: <input name="url">
            Title: <input name="title">
            Text: <input name="text">
            Color: <input name="color"> (Use HTML color codes, e.g. ff0000)
            <input type="submit" name="button" value="Create">
        </form>
        <?php if (isset($_GET['button'])) { ?>
        <img src="motivator.jpg?v=<?php echo rand(1,1000000) ?>"
alt="Motivator">
        <?php } ?>
    </body>
</html>
```

Running the Hack

You will need to edit the first line at the top of the file, replacing *<your_api_ key>* with your actual API key. Then, upload the script to your web server.

The code is written to use the Times and Verdana truetype fonts. You can either upload the *C:\WINNT\Fonts\times.ttf* and *C:\WINNT\Fonts\verdana. ttf* files from a Windows machine, or modify the code to use different fonts (and upload those).

 You'll also need write permissions so that the script can create the file *motivator.jpg*.

Most of FD's tools are PHP scripts that use the GD graphics library. The ImageMagick library (*http://www.imagemagick.org*) is also a good choice for this kind of work and is perhaps a bit more powerful than GD, but many hosting providers provide GD as a built-in part of their PHP installations, whereas ImageMagick can be harder to find.

See Also

- "Mash Up Your Photos" **[Hack #43]**
- "Make a Ransom Note" **[Hack #47]**
- "Make a Slideshow" **[Hack #50]**

HACK
#47
Make a Ransom Note

Say it with photos, and defy handwriting analysts everywhere!

In these uncertain days of paperless offices and instant messaging, it can be difficult for harried kidnappers to find magazines, newspapers, scissors, and glue. So, it's good to know that high-tech kidnappers can use their stolen laptops to make good old-fashioned ransom notes with Flickr!

Flickr contains a few groups that collect photos of individual characters or glyphs. The first such group was One Letter (*http://www.flickr.com/groups/oneletter/*), which collects photos of the letters A through Z. This was followed by One Digit (*http://www.flickr.com/groups/onedigit/*), which collects photos of the digits 0 through 9. And then came Punctuation (*http://www.flickr.com/groups/punctuation/*), which collects photos of, uh, punctuation—you know, the stuff that cartoon characters use to curse with.

The PHP script in this hack translates a string of ASCII text into a sequence of photos from these groups, producing a typesetting job only a felon could love.

> In "Exploit Compound Tags" **[Hack #13]**, we looked at the One Word group (*http://www.flickr.com/groups/oneword/*), which contains photos of individual words. You can build a ransom note out of whole words using the techniques in this hack, but here we'll build our words one letter at a time.

What You'll Need

To use this PHP script, you'll need a web server that supports PHP 4 or later and your own Flickr API key. See "Authenticate Yourself" **[Hack #40]** for information on how to get an API key.

You'll also need the phpFlickr scripts [Hack #41]. (These scripts also make authenticating other people a snap, but you won't need authentication for this hack.) You can download these scripts from *http://www.phpflickr.com*.

The Code

Create a file called *ransomNote.php* and add the following code:

```php
<?php

// Ransom Note - Jim Bumgardner
//
// Pulls glyphs from One Letter, One Digit, and Punctuation groups.
//
ini_set("error_reporting ", E_ALL);

// Configuration stuff
$flickrAPIKey = "your API key";
$cachingenabled = true;
$dbUser = "user"; //database user here
$dbPass = "pass"; //database password here
$dbAddress = "localhost"; //location of database
$dbName = "dbName"; //name of database, will create one if it doesn't exist

// Create new phpFlickr object
require_once("phpFlickr.php");
$f = new phpFlickr($flickrAPIKey);
if ($cachingenabled == true)
{
  $f->enableCache("db", "mysql://$dbUser:$dbPass@$dbAddress/$dbName");
}

// Exceptional tags - all others are the letter or digit.
$exTags = array(
                'a' => 'aa',
                'i' => 'ii',
                '0' => '00',
                '%' => 'percent',
                '+' => 'plussign',
                '.' => 'period',
                ',' => 'comma',
                '$' => 'dollarsign',
                '!' => 'exclamationpoint',
                '?' => 'questionmark',
                ';' => 'semi colon',
                ':' => 'colon',
                '/' => 'slash',
                '-' => 'dash',
                '&' => 'ampersand',
                '>' => 'greaterthan',
                '<' => 'lessthan');
```

```
$oneLetterGroup = '27034531@N00';   // group_id of 'One Letter'
$oneDigitGroup  = '54718308@N00';   // group_id of 'One Digit'
$punctuationGroup = '34231816@N00'; // group_id of 'Punctuation'

$phrase = 'pay-up or else!';
if (isset($_GET['phrase']))
  $phrase = $_GET['phrase'];

$size = 'thumbnail';
if (isset($_GET['size']))
  $size = $_GET['size'];

$len = strlen($phrase);
$ltrphotos = array();

for ($i = 0; $i < $len; ++$i)
{
  $char = strtolower(substr($phrase,$i,1));
  if ($char == ' ')
    continue;
  // Get photo list for unique letters
  if (!isset($ltrphotos[$char]))
  {
    if (isset($exTags[$char]))
      $tag = $exTags[$char];
    else
      $tag = $char;

    if ($char >= 'a' && $char <= 'z')
      $group_id = $oneLetterGroup;
    else if ($char >= '0' && $char <= '9')
      $group_id = $oneDigitGroup;
    else
      $group_id = $punctuationGroup;
    $photos = $f->groups_pools_getPhotos($group_id,$tag);
    $ltrphotos[$char] = $photos;
  }
}

function buildPhotoSourceURL ($photo)
{
    return "http://www.flickr.com/photos/" .
           $photo['owner'] . "/" . $photo['id'] . "/";
}

?>

<html>
<head>
<title>ransom note</title>
</head>
```

```
<body>
<center>

<?php

for ($i = 0; $i < $len; ++$i)
{
  $char = strtolower(substr($phrase,$i,1));
  if ($char == ' ')
    echo "<br>\n";
  else {
    $photoIdx = array_rand($ltrphotos[$char]['photo']);
    $photo = $ltrphotos[$char]['photo'][$photoIdx];
    echo "<a href=" .
         buildPhotoSourceURL($photo) .
         "><img border='0' alt='$photo[title]' src=" .
         $f->buildPhotoURL($photo, $size) . "></a>";
  }
}

?>

</center>
</body>
</html>
```

Before uploading the script, edit the following line to use your own API key:

```
$flickrAPIKey = "your API key";
```

The phpFlickr wrapper has an optional caching feature. If you wish to use it, modify these lines to provide access information for a database on your server:

```
$cachingenabled = true;
$dbUser = "user"; //database user here
$dbPass = "pass"; //database password here
$dbAddress = "localhost"; //location of database
$dbName = "dbName"; //name of database, will create one if it doesn't exist
```

If you do not wish to use caching, turn it off by replacing this line:

```
$cachingenabled = true;
```

with this:

```
$cachingenabled = false;
```

Running the Hack

To run the hack, upload the edited script to your web server, and invoke it by typing the URL in your browser's address bar:

```
http://www.yourdomain.com/ransomNote.php
```

You'll see a ransom note appear, like the one shown in Figure 7-11.

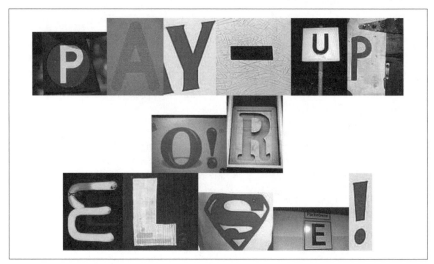

Figure 7-11. Flickr ransom note

If the default message, "Pay-up or else!," isn't threatening enough, you can specify a different message by passing the variable phrase. Here's an example:

 http://www.yourdomain.com/ransomNote.php?phrase=I+love+kittens

You can also specify different photo sizes by using the size parameter. Here are the available choices (from smallest to largest):

 square
 thumbnail
 small
 medium
 large
 original

For example:

 http://www.yourdomain.com/ransomNote.php?phrase=teensy+photos&size=square

Finally, if you want to support your fellow kidnappers, please join the One Letter, One Digit, and Punctuation groups on Flickr, and contribute to these valuable photo pools! With enough photos, we'll be able to typeset longer works of literature than the one shown in Figure 7-12.

See Also

- "Authenticate Users" **[Hack #41]**
- "Exploit Compound Tags" **[Hack #13]**

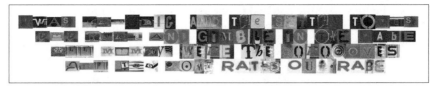

Figure 7-12. Excerpt from "Jabberwocky" by Lewis Carroll

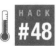

Make a Slider Puzzle

Mix up your photos with this simple puzzle.

In "Make a Slideshow" [Hack #50], we build a simple application in which a PHP script passes parameters to a Flash movie. This hack extends that concept by using a slightly more complex Flash movie that breaks photographs apart into separate tiles to make a slider puzzle.

What You Need

This hack uses a modified version of the script developed in "Make a Slideshow" [Hack #50], so it might help if you look at that hack first (although it isn't strictly necessary). Since this hack uses PHP, you will need a web server with PHP support.

To view the results, you'll also need a web browser with a Flash plug-in capable of displaying Flash 7 movies or later.

The hack uses a ready-made Flash movie I developed called FlickrPuzzle. FlickrPuzzle will make a puzzle from images from any web site, not just Flickr; however, it works best with 500×500 square images.

Download the archive from *http://www.krazydad.com/flickrPuzzle/* and include the *flashPuzzle.swf* movie file in the directory where you are developing your customized version of the puzzle.

You'll also need the phpFlickr scripts [Hack #41]. (These scripts also make authenticating other people a snap, but you won't need authentication for this hack.) You can download these scripts from *http://www.phpflickr.com*.

The Flash Movie

FlickrPuzzle.swf, the Flash movie, accepts two parameters, which can be passed in via HTML:

imgUrl

This is the full URL of the image file to use for the puzzle—typically, a JPG, GIF, or PNG. You can use images from any source, not just Flickr, but I recommend using images that are 500×500 squares, such as most

of the images in the Squared Circle group (*http://www.flickr.com/groups/
circle/*) on Flickr. If the image does not have these dimensions, it will be
stretched to fit.

TD

This is the horizontal (or vertical) dimension of the puzzle, in tiles. If
you specify 5 (the default), the puzzle will have 5×5 tiles. I recommend
using the numbers 3, 4, or 5. If you use numbers larger than 5, the puz-
zle will take longer to load, because Flash must load duplicate copies of
the image for each tile in the puzzle. Unfortunately, this is a limitation
of Flash. At any rate, puzzles with dimensions of more than 5×5 tiles
are not much fun to solve.

These parameters are passed in two separate locations within the HTML
<object> tag that loads the Flash movie, as you'll see in the PHP script
below.

The Code

The following PHP script is responsible for loading random images from
Flickr and then passing the URL of one of those images to the Flash movie
that makes the puzzle. It is a modified version of the script developed in
"Make a Slideshow" [Hack #50], which uses similar techniques.

Create a new text file called *flickrPuzzle.php* and enter the following PHP
code:

```php
<?php
ini_set("error_reporting ", E_ALL);

// Configuration stuff
$flickrAPIKey = "your API key";
$cachingenabled = true;
$dbUser = "user"; //database user here
$dbPass = "pass"; //database password here
$dbAddress = "localhost"; //location of database
$dbName = "dbname"; //name of database, will create one if it doesn't exist

function buildPhotoSourceURL ($photo)
{
    return "http://www.flickr.com/photos/" .
           $photo['owner'] . "/" . $photo['id'] . "/";
}

// Create new phpFlickr object
require_once("phpFlickr.php");
$f = new phpFlickr($flickrAPIKey);
if ($cachingenabled == true)
{
```

```php
    $f->enableCache("db","mysql://$dbUser:$dbPass@$dbAddress/$dbName");
}

$per_page = 6;

// Parse parameters
$page = mt_rand(2,3700);
if (isset($_GET['page']))
  $page = $_GET['page'];

$idx = mt_rand(1,$per_page);
if (isset($_GET['idx']))
  $idx = $_GET['idx'];

$TD = 5;
if (isset($_GET['TD']))
  $TD = $_GET['TD'];

$group_id = '52242140489@N01';
if (isset($_GET['group_id']))
  $group_id = $_GET['group_id'];

$photos = $f->groups_pools_getPhotos($group_id,NULL,NULL,$per_page,$page);

?>
<!DOCTYPE html PUBLIC "-//W3C//DTD XHTML 1.0 Transitional//EN" "http://www.
w3.org/TR/xhtml1/DTD/xhtml1-transitional.dtd">
<html xmlns="http://www.w3.org/1999/xhtml" xml:lang="en" lang="en">
<head>
<meta http-equiv="Content-Type" content="text/html; charset=iso-8859-1" />
<title>Flickr Puzzle</title>
</head>
<body>
<center><table><tr>
<td valign=bottom width=100><a href="http://www.krazydad.com/flickrPuzzle/">
new random images</a></td>
<?php
$i = 1;
foreach ($photos['photo'] as $photo) {
    echo "<td align=center width=81><a href=http://www.krazydad.com/
flickrPuzzle/index.php?idx=$i" .
        "&TD=$TD&page=$page><img border='0' width=75 height=75
alt='$photo[title]' src=".
        $f->buildPhotoURL($photo, 'square') . "></a><br><a href=" .
        buildPhotoSourceURL($photo) . ">flickr</a></td>";
    if($i == $idx)
      $imgUrl = $f->buildPhotoURL($photo, 'medium');
    $i++;
}
print <<<EOT
<td valign=bottom width=100 align=right><a href="http://www.krazydad.com/
flickrPuzzle/index.php?idx=$idx&TD=3&page=$page">3x3</a><br>
```

```
<a href="http://www.krazydad.com/flickrPuzzle/index.
php?idx=$idx&TD=4&page=$page">4x4</a><br>
<a href="http://www.krazydad.com/flickrPuzzle/index.
php?idx=$idx&TD=5&page=$page">5x5</a>
</td></tr></table>

<object classid="clsid:d27cdb6e-ae6d-11cf-96b8-444553540000"

 codebase="http://fpdownload.macromedia.com/pub/shockwave/cabs/flash/
swflash.cab#version=7,0,0,0"
 width="500" height="500" id="flickrPuzzle" align="middle">
<param name="allowScriptAccess" value="sameDomain" />
<param name="movie" value="flickrPuzzle.swf?imgUrl=$imgUrl&TD=$TD" />
<param name="quality" value="high" />
<param name="bgcolor" value="#FFFFFF" />
<embed src="flickrPuzzle.swf?imgUrl=$imgUrl&TD=$TD"
 quality="high" bgcolor="#FFFFFF" width="500" height="500"
name="flickrPuzzle"
 align="middle" allowScriptAccess="sameDomain"
 type="application/x-shockwave-flash"
 pluginspage="http://www.macromedia.com/go/getflashplayer" />
</object>
EOT;
?>
</center>
</body>
</html>
```

You'll need to modify the configuration information at the top, providing your API key, shared secret, and database information if you want caching. For more information about this, see "Authenticate Users" [Hack #41].

Upload this PHP file, *flickrPuzzle.php*, as well as the Flash movie, *flickrPuzzle.swf*, to your web server.

Running the Hack

To run the hack, enter the address of *flickrPuzzle.php* into your web browser's address bar:

```
http://www.yourdomain.com/flickrPuzzle.php
```

If all goes well you'll see something like Figure 7-13, a set of photograph tiles with one missing.

This is a typical slider puzzle. You solve it by clicking on tiles that are adjacent to the hole, causing them to fill the hole. When the puzzle is unscrambled, the original photo will appear in its place. Click the photo to reset the puzzle (with different scrambling) and start over. You can also use the links at the upper left to reload the page and cause the puzzle to use different numbers of tiles: 3×3, 4×4, or 5×5.

new random
images

flickr flickr flickr flickr flickr flickr

3x3
4x4
5x5

Figure 7-13. flickrPuzzle

Hacking the Hack

You can manually modify the puzzle by passing any of the following parameters to the app. I suggest experimenting with these by entering them in your browser's address bar:

group_id

> The group ID of the Flickr group to pull images from. By default, the PHP app uses the ID of the Squared Circle group, whose images make excellent square puzzles.

page

> The page number of images to load (6 per page). If you don't specify this, you'll get a random page.

idx

> The particular image on the page (from 1–6) to use to make the puzzle.

TD

> The tile dimensions of the puzzle. If you specify 4, the puzzle will be 4 tiles wide by 4 tiles high. This parameter is passed directly to the Flash movie. If it is left unspecified, it defaults to 5.

For example:

 http://www.yourdomain.com/flickrPuzzle.php?page=2&idx=4

Although it's not included here, you'll find the source code for the 2K Flash movie that animates the puzzle at *http://www.krazydad.com/flickrPuzzle/*.

See Also

- "Authenticate Users" [Hack #41]
- "Make a Slideshow" [Hack #50]

HACK #49 Make a Photo Mosaic

Using Flickr, any portrait can be more than the sum of its parts.

Photo mosaics—composite artworks in which the mosaic tiles are themselves photographs—were first invented by Joseph Francis at the R/Greenberg ad agency in the early 1990s. They weren't popularized until the late '90s, though, when Robert Silvers, a Master's student at the MIT Media Lab, came up with the idea independently. Knowing he had a good thing on his hands, Silvers trademarked the name PhotoMosaic, applied for a patent, formed his own company, and started selling them. Soon, Silvers' beautiful and impressive mosaics were showing up in books, on posters, and on magazine covers.

Not so long ago, photo mosaics would have been hard to make on cheap desktop computers at home. You needed fast processing speeds, very large disk capacity, and thousands of photographs to work with. These days, the cheapest desktop PCs have all the processing power and disk capacity you need, and services such as Flickr provide the final missing ingredient: a huge library of images.

This hack uses a Perl program I wrote to make photo mosaics. But before going down this road, you should know that there are quite a few good third-party applications out there for making photo mosaics (although not all of them are well integrated with Flickr, yet).

Two other popular mosaic-making applications are AndreaMosaic for Windows (*http://www.andreaplanet.com/andreamosaic/*) and MacOSaiX for the Macintosh (*http://homepage.mac.com/knarf/MacOSaiX/*). A third excellent choice is FlickrMosaic (*http://flickrmosaic.sourceforge.net*). This program, written in Java, will work on most platforms, including Linux, and is designed to work specifically with Flickr.

Making Great Mosaics

To build a photo mosaic, the software selects tiles from a large pool of candidate images. The tiles are picked so that each one matches an area of a target image. For each tile, the software picks the candidate image that is the closest match, typically by comparing the color distance in Euclidean space. So, a candidate image that is pinkish would be chosen for a tile representing a red area over another candidate image that is green, because pink is closer to red. The closer the tiles match, the more the final mosaic will resemble the target image.

A number of factors affect how well your photo mosaics will come out. Let's take a look at some of the things you'll need to consider.

The choice of target image. The target image should reproduce well at a very low resolution (it should look good as a thumbnail). Any detail you can't see in a very tiny thumbnail will probably not be visible in the mosaic, unless you use a lot of very small tiles.

It is often best to edit the target image, using Photoshop or another image editor, before making a mosaic from it. Try cropping out a detail such as a face or even an eye. Sometimes, it helps to increase the contrast in the target photo; this will cause a wider intensity range in the candidate tiles that are chosen.

If you are using off-the-shelf mosaic software, you might need to resize the target image down to a smaller size so that the mosaic software doesn't take forever trying to make a huge image.

> In the script introduced later in this hack, this is handled automatically. The size of the final mosaic is based on the number of tiles used.

The choice of candidate tiles. Photo mosaics are most effective when the subject matter of the tiles has something to say (descriptively, affectionately, ironically) about the target image. Thousands of photo mosaics portraits have been constructed from generic stock photos of seascapes and barns. These are technically impressive, but ultimately meaningless, unless the subject of the portrait is a sailor or a farmer.

My mosaic of Botticelli's Venus (*http://www.flickr.com/photos/krazydad/4894509/*) contains photos that match the word *love*, with lots of valentine hearts, people kissing, and people holding hands. My mosaic of my friend Fubuki (shown later in this hack, in Figure 7-14) consists entirely of photos taken by Fubuki.

The overall number of candidate tiles to choose from. Generally, the more tiles you have to choose from, the more accurate the result will be. On the other hand, you might like the results you get when there aren't many choices available; this tends to produce more abstract images, and sometimes accidents can be cool.

I have produced a number of mosaics in which I used every single candidate image. In general, these reproductions don't come out as faithfully as mosaics in which you use only a subset of a much larger pool, but it is a fun challenge to try to use every single tile. If you are forced to do so, and you want a high-fidelity result, it helps if the distribution of colors in the target image is close to the distribution of colors in the candidate images. If your target has a brown face, but most of your candidate images are green, you're going to get a green face. If you have a choice of target images, pick one that more closely matches the colors in your candidate tiles.

The number of candidate tiles used to overlay the target image. I usually do a few runs trying different numbers of tiles until I find a coverage I like. I prefer to try to use the smallest number of tiles I can get away with, because this makes the individual tiles larger and easier to appreciate. If there are a gazillion teensy, tiny tiles, you may as well be looking at the target image itself. However, there is a trade-off between tile size and fidelity to the target image: fewer tiles means less fidelity. Experiment with different tile sizes and try to use the largest one you can while still retaining good fidelity.

What You Need

To run the script in this hack, you'll need the `Image::Magick` Perl module, which provides an API for the powerful ImageMagick image-processing library. You can find it at *http://www.imagemagick.org*, or you can download it from CPAN.

You'll also need the following two modules, which I wrote: `Image::Mosaic` and `Image::FlickrSet`. You can find these on my web site in the following archive, which also contains a copy of the script developed in this hack:

> *http://www.krazydad.com/sware/JimsFlickrScripts.zip*

`Image::Moasic` depends on `Clone`, which you can obtain from CPAN.

You'll also need the scripts developed in "Download a List of Photos" **[Hack #33]** and "Cache Photos Locally" **[Hack #34]**.

The Code

Here's my script for making photo mosaics with Flickr photos, using my `Image::Mosaic` module. Create a file called *makeMosaic.pl* and enter the fol-

lowing code (or grab the latest version from the archive mentioned in the previous section):

```perl
#!/usr/bin/perl -s

#
# sub-sampling photo mosaic - Jim Bumgardner
#
# this script uses a subset of images from a larger set
# to make a mosaic against a target image
#
# work on reducing globals - store shared variables in an object...

use Image::Mosaic;
use Image::FlickrSet;

$photolist = shift;
$basepic = shift;
$max_images = shift;
$imagedir = shift;

$imagedir = $photolist if !$imagedir;
$photolist .= '.ph' if !($photolist =~ m/\.ph/);

$syntax = <<EOT;
pmosiac_subset.pl [options] <photolist> <basepic> [<max_images>]

Options:
   -dupesOK     Allow duplicate tiles
   -noborders   Reject images with solid-color borders or over 2:1 aspect
ratio
   -noflops     Images may not be swapped horizontally
   -reso=\#     Subsamples per photo - default = 7
   -cellsize=\# Size of tiles - default = 20

EOT

die "$syntax\n" if !$basepic;

require "${photolist}";

#
# these are all command-line options
#
$reso = 7 if !$reso;  # number of subsamples per tile = reso x reso
$cellsize = 20 if !$cellsize;
$cellsize = 100 if $big;
$doflops = 1 if !$noflops && !$noflips;

$max_images = scalar(@photos)/4 if !$max_images;

my $imageset = Image::FlickrSet->new(\@photos, {imageDir => $imagedir,
verbose=>1});
```

```
my $moz = Image::Mosaic->new({reso=>$reso,
                              max_images=>$max_images,
                              imageset=>$imageset,
                              basepic=>$basepic,
                              noborders=>$noborders,
                              doflops=>$doflops,
                              cellsize=>$cellsize,
                              verbose=>1
                });

$moz->generate_mosaic();
```

Running the Hack

To use the *makeMosaic.pl* script, you'll need a target photo to work with and a pool of candidate photos. To make a mosaic of my friend Fubuki, I first downloaded a list of Fubuki's photos to a file called *fubuki.ph*, using this command:

 getPhotoList.pl -u fubuki

Then I downloaded thumbnail versions of each of his photos, using the information in the file I had just created:

 getSnaps.pl fubuki.ph

This step is actually optional, because the Image::FlickrSet module used in the *makeMosaic.pl* script will automatically download photos if you don't already have them. I like to do this separately, though, as it's the most time-consuming part of the process.

Next, I chose a specific target image I wanted to make a mosaic of. I did this by examining Fubuki's Flickr photostream in my web browser to locate a portrait, right-clicking the image, and saving the JPEG as *fubuki_portrait.jpg*. The actual image I used is at *http://www.flickr.com/photos/fubuki/2303451*.

Finally, I made the mosaic by entering the following command:

 makeMosaic.pl fubuki fubuki_portrait.jpg 800

The first argument references the name of the *fubuki.ph* file that contains the list of candidate photos. It is also used to specify a subdirectory, *fubuki/*, to find the thumbnails in. The second argument indicates the name of the target image file. The last argument, 800, indicates the approximate number of tiles to use in the mosaic. The number actually used might be slightly more or less, in order to fill out the rectangular shape of the mosaic.

By default, the script produces a low-resolution version of the mosaic. I generally try a few different versions (experimenting with editing the target

image and altering the number of tiles) till I find one I like. If you like the result, you can produce a high-resolution mosaic using the –big option:

```
makeMosaic.pl -big fubuki.ph fubuki_portrait.jpg 800
```

When you use the -big option, the script will automatically download large versions of the tiles that will eventually be chosen to be used in the image. This saves time, because you don't need large versions of every single candidate image; you just need the thumbnails, unless the image goes into the final mosaic.

Figure 7-14 shows how my mosaic of Fubuki came out.

Pretty sweet, eh?

How It Works

If you're interested in the nitty gritty, I suggest taking a closer look at the Image::Mosaic module, which does most of the heavy lifting.

This module is written to be service-agnostic; it doesn't know anything about Flickr. Instead, it works with an iterator class, which provides a list of images to work with. The iterator class must implement a method called get_image(), which retrieves images one at a time. I designed Image::Mosaic this way so that it can be used with other image services, such as Google Image Search, or with my own collections of photographs. My Flickr-based iterator class is called Image::FlickrSet. This class is designed to work with the image lists produced by the *getPhotoList.pl* script from "Download a List of Photos" [Hack #33].

Image::Mosaic performs four main steps:

1. Examines all the candidate images and records their overall luminance values. During this step, Image::Mosaic calls the image iterator's get_ image() routine and asks for thumbnail-sized images. If Image:: FlickrSet, our iterator, can't find a particular image referenced in its image list, it will download the thumbnail from Flickr. Image::Mosaic records the luminance values to build an index so that the images can be grouped by luminance, which speeds up step 3, in which we select tiles for the mosaic.

2. Sets up a data structure describing each of the cells in the target image that will be occupied by a tile. For each cell, it records the colors contained in that cell in the target image. To speed things up, the target image is reduced in size to match the subsampling resolution (which defaults to 7), so that each cell contains no more than 7×7 pixels. The cell list is sorted so that cells that contain edges are resolved first; this produces a better-looking final result.

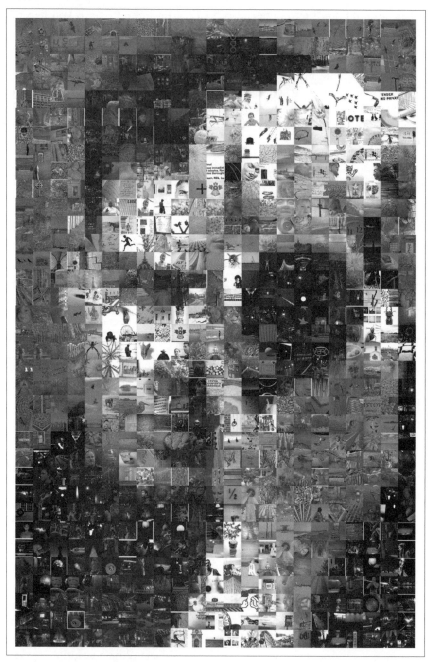

Figure 7-14. Fubuki mosaic

3. Selects the most appropriate candidate image to fill each target cell. For each target cell, a subgroup of candidate images is chosen, using the luminance group closest to the target cell. Each of the candidates in the subgroup is evaluated for the target cell by comparing the differences in the color values. The candidate with the fewest differences (the closest in the RGB space) is chosen. If it fails to pick a tile because all the tiles in the luminance group have already been selected for other cells, it looks further afield, at nearby luminance groups.

4. Loads in the selected tiles and builds a composite image from them. During this step, if the -big option was employed, larger versions of the selected tiles will be downloaded by the Image::FlickrSet module, as necessary.

Hacking the Hack

Although some people might feel that photo mosaics are passé, there is still enormous potential for innovations in making them. For example, while existing photo mosaic software produces mosaics with square or rectangular tiles, there is certainly no reason why photo mosaics have to have square tiles on a rectangular grid.

Try using hexagonal tiles, diamonds, or other shapes. How about a hexagonal-tiled mosaic resembling a honeycomb, in which all the tiles contain images of bees and flowers? Try rotating the tiles, or giving them more randomized placements. Experiment with circular tiles arranged in a Fibonacci spiral, like the seeds in a sunflower.

The tiles don't need to have hard, sharply defined edges, either. You can use image masking to give the tiles fuzzy edges that blend into each other.

Finally, photo mosaics do not need to be static pieces of art that hang on a wall. You can build an interface, using Flash or Ajax, that will make your mosaic interactive, perhaps providing individual photo credits for the tiles or making the tiles come to life. I've created such interfaces for my CoverPop web site (*http://www.coverpop.com*), which contains interactive mosaics built from various sources. See the CoverPop FAQ (*http://www.coverpop.com/faq/*) for more information about building interfaces for interactive mosaics.

See Also

- "Download a List of Photos" [Hack #33]
- "Cache Photos Locally" [Hack #34]
- "Mash Up Your Photos" [Hack #43]
- "Find the Dominant Color of an Image" [Hack #44]

 Make a Slideshow

#50 PHP and Flash combine to create eye candy with extreme flexibility.

In "Authenticate Users" [Hack #41], we built an app that displays a grid of images. Wouldn't it be nice to get those same images to appear in an animated slideshow? That's what this hack is about.

What You Need

This hack uses a modified version of the script developed in [Hack #41], so you'll need to have successfully completed that hack before starting this one. You'll also need a web server with PHP 4 support.

In this hack, we'll be making a Flash movie that is compatible with Flash 7. You'll need a version of Macromedia Flash that is at least as recent as Flash MX 2004.

The Flash Movie

If you're a programmer who has never learned Flash, you'll like this hack, because the movie requires virtually no authoring using the Flash UI (which is artist-friendly but hacker-unfriendly). Instead, the effects in the movie are accomplished exclusively via ActionScript, Flash's scripting language.

Create a text file called *slideshow_script.as* and add the following Action-Script code:

```
// Basic Looping Slideshow for Flash 7
//
// - Jim Bumgardner
//
// Parameters:
//   flickrSnaps - list of server/id/secret triplets (delimited by commas)
//   timeBetweenSlides  (milliseconds)
//   fadeTime (milliseconds)
//   debug  (adds status msgs)

flickrSnapAry = _root.flickrSnaps.split(',');

// Create containers/loadees here...
containers = [];
curSlide = 0;
curSlot = 0;
if (!timeBetweenSlides)
  timeBetweenSlides = 5000;
if (!fadeTime)
  fadeTime = 3000;

doNextSlide = function( )
{
```

```
  clearInterval(this.intH);
  curSlide = (curSlide + 1) % flickrSnapAry.length;
  this.altSlot.doLoad(curSlide);
}

fadeInStep = function()
{
  var r = (getTimer() - this.fxStart)/this.fxDuration;
  if (r >= 1) {
    r = 1;
    clearInterval(this.intH);
    this.intH = setInterval(this, "doNextSlide", timeBetweenSlides);
  }
  // This applies an ease in/out to the fade effect
  r = r*r*(3-2*r);
  this._alpha = r*100;
  this.altSlot._alpha = (1-r)*100;
  // This next line provides the barn-door effect
  // Comment it out for a more standard-looking
  // cross-fade effect
  this._xscale = r*100;
}

doFadeIn = function(duration)
{
  this.fxStart = getTimer();
  this.fxDuration = duration;
  this.fxStep = fadeInStep;
  this.intH = setInterval(this,"fxStep",1000/30);
}

handleLoadInit = function(target)
{
    // Center the slide
  this._x = (Stage.width - target._width)/2;
  this._y = (Stage.height - target._height)/2;
  this.doFadeIn(fadeTime);
}

handleLoadError = function(target, errorCode)
{
  _root.errMsg.text = 'got load error ' + errorCode + ' on image ' +
    this.itsURL;
}

doLoad = function(slideNbr)
{
  if (_root.debug)
    _root.errMsg.text = "loading " + slideNbr + ' ' +
flickrSnapAry[slideNbr];
  var fVars = flickrSnapAry[slideNbr].split('/');
  this._alpha = 0;
  this.itsURL = 'http://static.flickr.com/' + fVars[0] + '/' +
```

```
            fVars[1] + '_' + fVars[2] + '.jpg';
  this.itsLoader.loadClip(this.itsURL, this.loadee);
}

// Initialize two movieclips for slideshow
for (var i = 0; i < 2; ++i)
{
  var mc = _root.createEmptyMovieClip('ctr_'+i,i+1);
  mc.createEmptyMovieClip('loadee', 1);
  mc.idx = i;
  mc.doLoad = doLoad;
  mc.doFadeIn = doFadeIn;
  mc.doNextSlide = doNextSlide;
  mc.onLoadInit = handleLoadInit;
  mc.onLoadError = handleLoadError;
  var loader = new MovieClipLoader( );
  loader.addListener(mc);
  mc.itsLoader = loader;
  containers[i] = mc;
}
containers[0].altSlot = containers[1];
containers[1].altSlot = containers[0];

_root.createTextField('errMsg', 10, 10, 10, 480, 50);
_root.errMsg.textColor = 0xFFFFFF;

// Load the first slide
if (flickrSnapAry.length <= 0)
  _root.errMsg.text = "No snaps specified";
else
  containers[curSlot].doLoad(curSlide);
```

Then, run Flash and create a new project. Use the Modify → Document menu and specify the following settings for the movie:

Dimensions
 500 × 500 pixels

Background Color
 Black

Frame Rate
 30 fps

Select the first frame of the movie on the timeline, and then open the Action-Script editing window by selecting Window → Development Panels → Actions from the menu.

In the ActionScript window, enter the following one-line script, which causes the script you just created to be included:

```
#include "slideshow_script.as"
```

That's about all the Flash authoring you need to do. As you can see, most of the interesting stuff is in the ActionScript file.

> If you like Flash's text editor, feel free to put the complete script inside the ActionScript window, rather than using an include file. I prefer to keep my scripts separate, so I can use a more full-featured text editor.

Save the project as *slideshow.fla*, and then select File → Publish. This will produce a Flash movie file called *slideshow.swf*, which should be approximately 1 KB in size. This is one of the nice things about making Action-Script-centric Flash movies: they tend to be small and don't require annoying preloaders.

Upload *slideshow.swf* to your web server.

The Flash movie does not talk to the Flickr API directly. Instead, it accepts a list of Flickr photos as one of its parameters. The list uses two kinds of delimiters. Each individual photo is specified by three strings—the server number, the photo ID, and the photo secret—which are delimited using slashes. Each of these triplets is separated by a comma. Thus, a list of two photos looks like this:

```
29/44754794/29dbf5c75a,29/47126414/42ce67e060
```

The Flash movie takes this information and uses it to construct URLs that are used to pull the photos off of Flickr. The PHP web page that loads the Flash movie will build this list of photos by querying the Flickr API for information about your photostream.

The Code

The PHP script is a modified version of the script developed in "Authenticate Users" **[Hack #41]**.

Create a new text file called *testSlideshow.php* and enter the following PHP code:

```php
<?php
ini_set("error_reporting ", E_ALL);

// Configuration stuff
$flickrAPIKey = "your API key goes here";
$flickrSharedSecret = "your shared secret goes here";

// Caching configuration stuff
$cachingenabled = false;
$dbUser = "your database username";
$dbPass = "your database password";
```

```
$dbAddress = "your database domain name (or localhost)";
$dbTable = "database table name";

// Create new phpFlickr object
require_once("phpFlickr.php");
$f = new phpFlickr($flickrAPIKey,$flickrSharedSecret);
if ($cachingenabled == true)
{
  $f->enableCache(
    "db",
    "mysql://$dbUser:$dbPass@$dbAddress/$dbTable");
}
$f->auth();
$token = $f->auth_checkToken();

// Parse parameters
$page = 1;
if (isset($_GET['page']))
    $page = $_GET['page'];

$per_page = 30;
if (isset($_GET['per_page']))
    $per_page = $_GET['per_page'];

$fade_time = 2000;
if (isset($_GET['fade_time']))
    $fade_time = $_GET['fade_time'];

// Find the NSID of the username inputted via the form
$nsid = $token['user']['nsid'];

// Get the friendly URL of the user's photos
$photos_url = $f->urls_getUserPhotos($nsid);

// Get a set of the user's photos
$photos = $f->photos_search(array("user_id" => $nsid, "per_page" =>
$per_page, "page" => $page));

$flickr_snaps = '';
$i = 0;
foreach ($photos['photo'] as $photo) {
  if ($i++)
      $flickr_snaps .= ',';
    $flickr_snaps .= $photo['server'] . '/' . $photo['id'] . '/' .
$photo['secret'];
}

print <<<EOT
<!DOCTYPE html PUBLIC "-//W3C//DTD XHTML 1.0 Transitional//EN" "http://www.
w3.org/TR/xhtml1/DTD/xhtml1-transitional.dtd">
<html xmlns="http://www.w3.org/1999/xhtml" xml:lang="en" lang="en">
<head>
<meta http-equiv="Content-Type" content="text/html; charset=iso-8859-1" />
```

```
<title>slideshow</title>
</head>
<body bgcolor="#000000" color=white><?php
<object classid="clsid:d27cdb6e-ae6d-11cf-96b8-444553540000"
 codebase="http://fpdownload.macromedia.com/pub/shockwave/cabs/flash/
swflash.cab#version=7,0,0,0"
 width="500" height="500" id="slideshow" align="middle">
<param name="allowScriptAccess" value="sameDomain" />
<param name="movie" value="slideshow.swf?fadeTime=$fade_
time&flickrSnaps=$flickr_snaps" />
<param name="quality" value="high" />
<param name="bgcolor" value="#000000" />
<embed src="slideshow.swf?fadeTime=$fade_time&flickrSnaps=$flickr_snaps"
 quality="high" bgcolor="#000000" width="500" height="500" name="slideshow"
 align="middle" allowScriptAccess="sameDomain"
 type="application/x-shockwave-flash"
 pluginspage="http://www.macromedia.com/go/getflashplayer" />
</object>
</body>
</html>
EOT;
?>
```

You'll need to modify the configuration information at the top, providing your API key, shared secret, and database information if you want caching. For more information about this, see "Authenticate Users" [Hack #41].

Upload *testSlideshow.php* to your web server, into the same location where you uploaded the *slideshow.swf* file.

Running the Hack

To run the hack, enter the address of *testSlideshow.php* into your web browser's address bar:

```
http://www.yourdomain.com/testSlideshow.php
```

If you have not yet been authenticated, you'll see the Flickr permissions screen. Once you've granted permission, the slideshow should begin.

The slideshow provides a transition effect between photos by using both an alpha cross-fade and a scaling effect that makes each new photo appear to move like a closing door.

You can modify the slideshow by passing any of the following parameters to the app:

per_page

This controls how many photos are used in the slideshow before it loops.

page

This controls which page of photos from your photostream is loaded.

fade_time
> This specifies, in milliseconds, how long the cross-fade effect lasts. This particular parameter gets passed into the Flash movie.

Here's an example URL that passes these parameters to the PHP script:

```
http://www.yourdomain.com/testSlideshow.php?per_page=10&page=4&fade_
time=1000
```

Hacking the Hack

To keep things simple, I've written this script to pass only one adjustable parameter, fade_time, to the Flash movie, but I would suggest adding a whole slew of parameters so you can customize the slideshow to your liking.

If you want to pass additional parameters to the Flash movie, they can be accessed from within the ActionScript as predefined variables (which are attached to the _root timeline). Follow the PHP variable fade_time, which gets converted to the ActionScript variable fadeTime, to see how this works.

> Because of differences between web browsers, parameters to the Flash movie need to be specified in two different locations within the <object> tag.

I would suggest adding additional transition effects to the slideshow Action-Script and adding additional parameters to select and control these effects.

A great number of web developers never get past learning one language or technology, but you'll find that combining multiple languages and technologies, as we have done here, can greatly enrich the kinds of end-user experience you can provide.

See Also

- "Authenticate Users" [Hack #41]
- "Make a Color Picker" [Hack #45]

Index

A

We'd like to hear your suggestions for improving our indexes. Send email to *index@oreilly.com*.

mosaics, photo, 306–313
 candidate tiles, choosing, 307
 candidate tiles overlaying tagret
 image, 308
 Image::Mosaic module, 311–313
 innovations in, 313
 makeMosaics.pl script, 308–311
 number of candidate tiles to choose
 from, 308
 prerequisites for, 308
 target image, choosing, 307
Motivator application, 288, 292
 motivator.php script, 292–296
Movable Type weblogs, 53
Movie Poster application, 288
My Yahoo!, 101
 automatically adding feeds, 99

N

NetNewsWire, 103
Network Service IDs (see NSIDs)
news feeds, 97
 email and browser solutions, 104
Newsgator plug-in (Outlook), 104
newsreaders, 97, 101
 Bloglines, 103
 My Yahoo!, 101
 NetNewsWire, 103
 watching contacts' photos, 141
No Derivatives (NoDerivs) condition,
 CC licenses, 93
Non-Commercial condition, CC
 licenses, 94
normalized color values, 278
notes, 65
 annotating maps with personal
 stories, 66
 collaborative, 66
 describing everyone in a photo, 66
 Flickr API methods for, 215
 linking photos, 66
NSIDs
 constructing URLs to user
 pages, 219
 finding for recent activity feed, 143
 Flickr feeds, 99
 Flickr IDs and, 229
 getting from Flickr API web
 page, 158

group_id, 220
user_ids and group_ids, 219

O

o (URL code), 58
Oberkampf PHP library, 52
On Black application, 288
One Digit group, 74, 296
One Letter group, 74, 296
One Word group, 74, 296
opacity of composited images, 272
Organizr tool, 7
orientation property, 18
Originality rating, 105
Outlook, Newsgator plug-in, 104
$owners hash, 209

P

parsers, XML, 227
 using XML::Simple parser, 228
 xml.php file, 253
PEAR/ directory, 253
PEAR::Flickr_API, 237
 downloading, 237
 getting user ID, 239
 viewing user's latest photo, 240–243
people methods, Flickr API, 214
People Search page at Flickr, 165
Perl
 on Mac OS X, 125
 function converting RGB to HSV
 values, 278
 on Mac OS X, 188
 talking to the Flickr API, 226–237
 converting username to user_
 id, 227–230
 prerequisites for, 226
 viewing user's latest
 photo, 230–237
 on Windows, 131, 188
Perl scripts
 color picker, 280
 makeFlashDB.pl, 281
 comments-backup.pl, 177–178
 converting mini-token to full
 token, 251–252
 custom upload script, 262–266
 downloading a photo from a list, 193

X

XML parsers, 227
 using XML::Simple parser, 228
XML results from Flickr API
 methods, 224
XML syndication formats, 46
XML-based eXtensible Metadata
 Platform (XMP), 19
XML::Parser::Lite::Tree::XPath
 module, 145, 151, 159
xml.php file, 253

XML-RPC, 222
XML::RSS module, 46
XML::Simple module, 116, 125, 188
 parser, using, 228

Y

Yahoo!, 1
 account, setting up, 3
 automatically adding feeds to news
 portal, 99
 Hacks group, 10

Colophon

The tool on the cover of *Flickr Hacks* is a slide projector. A slide projector, an opto-mechanical device used to examine photographic slides, is comprised of four main parts: a light source (commonly a fan-cooled electric bulb), a reflector lens to direct the light through the slide, a slide holder, and a focusing lens. The light first passes through the transparent slide and then through the enlarging lens to create a projection of the image onto a flat surface, such as a screen or a wall, which allows an audience can view its reflection.

The Magic Lantern, the predecessor to both the slide projector and the motion picture projector, is believed to have existed as early as 1676. But it wasn't until the 1850s that magic lanterns could display photographic images. William and Frederick Langenheim, Philadelphia daguerreotypists, wanted to use the projector to display their daguerreotypes, but couldn't because they were opaque and the images wouldn't project. So the brothers invented hyalotypes, which eventually became known as "magic lantern slides." Unlike daguerreotypes, hyalotypes were transparent positive images of photographs in the form of glass slides that allowed the images to be projected.

Initially, hyalotypes were used with the projectors mostly for entertainment purposes. Using levers to move the slides to make it appear as though the images themselves were moving, the Langenheims put on picture shows and charged a fee to visitors. But it wasn't long before the slides also helped to revolutionize educational lectures, especially those in art and architectural history, making it possible to study objects from all over the world in detail.

Throughout the 1950s and 1960s, slide projectors were popular in American households, often used for entertainment instead of a television. Family and friends would gather to look at slides of holidays and vacations. Since then, low-cost paper prints, digital cameras, video display monitors, and digital projectors have largely replaced slide projectors.

The cover image is from Getty Images (*http://www.gettyimages.com*). The cover font is Adobe ITC Garamond. The text font is Linotype Birka; the heading font is Adobe Helvetica Neue Condensed; and the code font is LucasFont's TheSans Mono Condensed.

Better than e-books

Buy *Flickr Hacks* and access the digital
edition FREE on Safari for 45 days.

Go to www.oreilly.com/go/safarienabled
and type in coupon code 9YEX-EMUF-XAIK-TRGQ-BW62

Search
thousands of
top tech books

Download
whole chapters

Cut and Paste
code examples

Find
answers fast

Search Safari! The premier electronic reference
library for programmers and IT professionals.

Related Titles from O'Reilly

Digital Media

Adobe InDesign CS2 One-on-One

Adobe Encore DVD: In the Studio

The DAM Book: Digital Asset Management for Photographers

Digital Audio Essentials

Digital Photography: Expert Techniques

Digital Photography Hacks

Digital Photography Pocket Guide, *3rd Edition*

Digital Video Hacks

Digital Video Pocket Guide

Digital Video Production Cookbook

DV Filmmaking: From Start to Finish

DVD Studio Pro 3: In the Studio

GarageBand 2: The Missing Manual, *2nd Edition*

Home Theater Hacks

iLife '05: The Missing Manual

iMovie HD & iDVD 6: The Missing Manual

InDesign Production Cookbook

iPhoto 6: The Missing Manual

iPod & iTunes Hacks

iPod & iTunes: The Missing Manual, *3rd Edition*

iPod Fan Book

iPod Playlists

iPod Shuffle Fan Book

PDF Hacks

Stephen Johnson on Digital Photography

Window Seat: Photography and the Art of Creative Thinking